MOSES THE EGYPTIAN
IN THE ILLUSTRATED
OLD ENGLISH HEXATEUCH

MOSES THE EGYPTIAN IN THE ILLUSTRATED OLD ENGLISH HEXATEUCH

(LONDON, BRITISH LIBRARY COTTON MS CLAUDIUS B.IV)

HERBERT R. BRODERICK

University of Notre Dame Press
Notre Dame, Indiana

University of Notre Dame Press
Notre Dame, Indiana 46556
undpress.nd.edu

Published in the United States of America

Library of Congress Cataloging-in-Publication Data

Names: Broderick, Herbert Reginald, 1945– author.
Title: Moses the Egyptian in the illustrated Old English Hexateuch (London, British Library Cotton MS Claudius B.iv) / Herbert R. Broderick.
Description: Notre Dame : University of Notre Dame Press, 2017. | Includes bibliographical references and index. |
Identifiers: LCCN 2017030363 (print) | LCCN 2017031315 (ebook) | ISBN 9780268102074 (pdf) | ISBN 9780268102081 (epub) | ISBN 9780268102050 (hardback) | ISBN 0268102058 (hardcover)
Subjects: LCSH: Moses (Biblical leader)—Art. | British Library. Manuscript. Cotton Claudius B. IV. | Christian art and symbolism—England—Medieval, 500-1500. | Illumination of books and manuscripts, Anglo-Saxon—Themes, motives. | Art, Egyptian—Influence. | BISAC: ART / History / Medieval. | RELIGION / Christianity / Literature & the Arts. | RELIGION / Biblical Studies / Old Testament.
Classification: LCC N8110 (ebook) | LCC N8110.B76 20117 (print) | DDC 704.9/482—dc23
LC record available at https://lccn.loc.gov/2017030363

∞ *This paper meets the requirements of ANSI/NISO Z39.48-1992 (Permanence of Paper).*

To Camilla

"maior autem horum est caritas"
　　　—1 Corinthians 13:13

CONTENTS

ILLUSTRATIONS

Illustrations follow p. 78.

ACKNOWLEDGMENTS

Work on this project, *mirabile dictu*, began almost forty years ago with research that ultimately resulted in my doctoral dissertation at Columbia University titled "The Iconographic and Compositional Sources of the Drawings in Oxford, Bodleian Library MS Junius 11," completed in 1978 under the direction of Florentine Mütherich of the Zentralinstitut für Kunstgeschichte in Munich and Jane Rosenthal of Barnard College and Columbia University. It is customary in German universities to speak of one's *Doktorvater*, what in this country is referred to as a dissertation "advisor." At Columbia, I had the unique distinction of having not one but two *Doktormütter*, to whom I am most grateful for advice, criticism, and good counsel. Any lingering error in the present work, however, is entirely my own.

Many things intervened during those forty years, some good, such as the privilege of teaching at Lehman College of the City University of New York for the past thirty-nine years, and some not so good, such as the Vietnam War, which interrupted my years in graduate school. The sum total of these delayed completion of this project until now.

Thanks to the good fortune of living in a great metropolitan city like New York, I have been able to pursue the research for this project at the libraries of Columbia University, New York University, Union Theological Seminary, the Metropolitan Museum of Art, and the Jewish Theological Seminary of America, to whose staffs I am most grateful. Trips to that magnificent "Palace of the People," the New York Public Library on Forty-Second Street, the Index of Christian Art at Princeton University, and the Library of Lehman College of the City University of New York were of great help as well.

Despite having put in innumerable pleasant and productive hours in these and other houses of learning (may it ever be so!), I would nonetheless like to register a truly awed note of thanks to Google Scholar, JSTOR, Worldcat, and other marvels of the digital age. Although, upon reflection, even if one might now have only traded in hangnails from combing through card catalogs for carpel tunnel syndrome and even more necessary *Sitzfleisch*, the shoe leather saved for the odd missing reference by a click or two of the mouse is incalculable.

The fundamental research for this project was generously supported at the dissertation stage by a Whiting Foundation Fellowship at Columbia University and at a later stage by a Fellowship for Independent Study and Research from the National Endowment for the Humanities (NEH) in 1980–81, coupled with a Scholar Incentive Award from the City University of New York, which permitted a year's respite from teaching and the opportunity to pursue research at the then British Museum Library in London as well as the libraries of the Victoria and Albert Museum and the Warburg Institute. I am indeed grateful to the curators of the British Library, Division of Western Manuscripts, especially Kathleen Doyle, lead curator of illuminated manuscripts, and of the Bodleian Library at Oxford, the Biblioteca Laurenziana in Florence, and the Biblioteca Apostolica, Vatican City, Rome, for the privilege of examining manuscripts in their collections.

Images for this project were purchased in part with funds from an honor accorded me by Lehman College of the City University of New York as Outstanding Teacher of the Year for 2001–2, as well as grants from the Research Foundation of the City University of New York. I would also like to express appreciation to the Schoff Fund at the University Seminars at Columbia University for their help in publication. The ideas presented here have benefited from discussions in the University Seminar on Medieval Studies.

The Bible says, "Let us now praise famous men" (Sirach 44:1). In what at this point seems like an almost mythic golden age of undergraduate teaching at Columbia College in the late 1960s—the era of Gilbert Highet, Jacques Barzun, Lionel Trilling, and Moses Hadas, among others—I am mindful of my undergraduate mentors in art history who first inspired me on this path, all of them now, sadly, deceased: Howard Hibbard, Meyer Schapiro, Rudolf Wittkower, and, especially, Howard McP. Davis. As a graduate student in what may indeed have been a golden age of medieval studies at Columbia, I benefited from the teaching of Wayne Dynes, William Hinkle, and Robert Branner. And I would be remiss indeed if I did not invoke the memory of an extraordinary high school English teacher, Flavia Helen Wyeth, whose spirited example demonstrated to me early on what thought, scholarship, and writing were all about.

I am deeply grateful to my colleagues at Lehman College of the City University of New York, especially George A. Corbin, professor emeritus of the Department of Art; Forrest D. Colburn, Department of Latin American and Caribbean Studies; and Walter Blanco, professor emeritus in the Department of English, who offered encouragement and support at crucial stages of this project. Jay Gates of John Jay College of the City University of New York provided much helpful advice on various aspects of Old English texts. My good friend, C. Edson Armi, University of California, Santa Barbara, professor emeritus, has offered advice and constructive criticism over the many years since we were undergraduates together at

Columbia. I would also like to thank, unfortunately posthumously, Joseph Gutmann of Wayne State University for his continued interest in my work in the late 1970s and 1980s.

I would like to thank Jane Rosenthal, professor emerita of Columbia University, and Robert Melzak, formerly of the Index of Christian Art at Princeton, for their comments and advice on an earlier version of this project. I am also grateful for the scholarly good counsel over the years of Herbert L. Kessler of the Johns Hopkins University, emeritus. I owe a special debt of gratitude to Massimo Bernabò, Dipartimento di Musicologia e Beni Culturali, Cremona, of the Università degli Studi di Pavia, for his keen editorial advice and good counsel. I am also deeply grateful on numerous accounts, editorial and otherwise, to Michelle P. Brown, professor emerita of medieval manuscript studies at the School of Advanced Study, University of London. I have benefited as well from the comments and criticism of the anonymous readers solicited by the University of Notre Dame Press. At the press, Stephen Little, acquisitions editor, has been as beneficent and accommodating a patron saint as one could possibly ask for. Special thanks as well are due to Rebecca DeBoer, managing editor, Matthew Dowd, editor, Susan Berger and staff in marketing and promotions, Wendy McMillen and staff in design and production, and Sheila Berg, copy editor.

Due to the exotic nature of the imagery of Moses in MS Claudius B.iv that I am investigating here, I have ventured into zones of scholarship in Egyptology, history of religions, and the ancient Greco-Roman world at large that are, to say the very least, vast and far beyond my previous academic preparation in Western medieval biblical iconography. As a consequence, I would like to thank Richard Fazzini, curator emeritus of Egyptian Art at the Brooklyn Museum; Dietrich Wildung, director emeritus of the Ägyptiches Museum and Papyrussammlung of the Staatliche Museen, Berlin; and especially Ann Macy Roth of New York University for their help and advice on a variety of issues Egyptological. In thanking these distinguished scholars, I do not mean to suggest that they necessarily agree with any aspect of the hypothesis I present in this study. Moreover, any errors of fact or interpretation, of course, are entirely my own. A preliminary version of this research was presented before the Medieval Studies Colloquium of Princeton University, Princeton, New Jersey, in October 2008, thanks to Colum Hourihane, director emeritus of the Index of Christian Art at Princeton, to whom I am most grateful.

A special note of thanks goes to Veronica Mason, Morgan Long, and especially Maia Dean, Tony Gedrich, and Wayne Harrison for help with preparation of the manuscript at various stages in its evolution. Thanks for all kinds of IT assistance, often at the eleventh hour, are due to Carlo Diego at Lehman College and Josh Kwassman at New York University. I am deeply grateful for the diligent assistance of Wendy Doremus and Kamal Tamraz in obtaining photographs from the Egyptian

Museum, Cairo. And for invaluable assistance with all things in the realm of digital imaging, I am most thankful for the expertise of Robin Sand.

In the end, I would like to invoke in gratitude the memory of my grandparents, Herbert and Ida McCameron Broderick and William and Ethel Kilpatrick Carrigan. I would also like to thank my parents, Herbert and Ann Carrigan Broderick, for their generous support of all my endeavors over the years and to invoke in gratitude the memory of my wife's parents, Abraham and Ethel Remine Glaser. And finally, I would like to thank my wife, Mosette, who has patiently suffered the protracted labor pains of this work, our second "child."

Herbert R. Broderick, FSA
Professor
Lehman College of the City University of New York
Vestigia Patrum Prosequendo
New York City, 2017

Introduction

And the Lord said to Moses: Behold I have appointed thee the God
of Pharaoh.

—Exodus 7:1

And Moses was instructed in all the wisdom of the Egyptians; and he
was mighty in his words and in his deeds.

—Acts 7:22

For he also was called the god and king (*theos kai basileus*) of the whole
nation.

—Philo of Alexandria

In his book *Moses the Egyptian*, the renowned Egyptologist Jan Assmann sets out
to investigate the "history of Europe's remembering Egypt" through the lens of
what he calls mnemohistory, a methodology that is concerned "not with the past as
such, but only with the past as it is remembered."[1] Assmann pursues this trajectory
through analyses of various written texts, an essentially logocentric undertaking.[2]
By taking into account a large body of visual imagery in an extraordinary Anglo-
Saxon manuscript of the second quarter of the eleventh century known as the Il-
lustrated Old English Hexateuch (London, British Library Cotton MS Claudius
B.iv), I present here a body of evidence for a visual construct of Moses that preserves
a Moses who has been largely forgotten, a Moses who was characterized in the
works of Hellenistic Egyptian Jewish writers such as Philo, Artapanus, Ezekiel "the
Tragedian," and others with the attributes of a Hellenistic king,[3] military com-
mander,[4] prophet, priest, and scribe. The illustrations in Claudius B.iv (as I refer to

the manuscript throughout this book), potentially based in part, I will argue, on a no longer extant Late Antique exemplar, preserve a *visual* memory of this Hellenistic Egyptian Jewish Moses, the original meaning of which may not have been fully understood by the eleventh-century Anglo-Saxon artists who availed themselves of its contents.

Moses appears an astonishing 127 times in the illustrations accompanying the text of Claudius B.iv.[5] The artist, or artists,[6] who made these illustrations have given him nine distinctive visual attributes, seven of which are unique to this manuscript.[7]

The relationship of the illustrations to the text they accompany in Claudius B.iv, a translation into Old English of the first six books of the Bible with over three hundred illustrations, is complex and not subject to any one general principle. George Henderson has remarked on the iconography of Claudius B.iv in general that "some of the illustrations . . . seem to derive from a model or models of extreme antiquity, which has left no trace in Christian art."[8] Henderson is in agreement here with M. R. James, Otto Pächt, and Francis Wormald, among others, who have studied the manuscript and its illustrations.[9] Francis Wormald, the renowned historian of Anglo-Saxon manuscript art, speculating on the nature of Claudius B.iv's model (or models), concluded succinctly that "it was ancient and *it was exotic*."[10]

Contrary to C. R. Dodwell's opinion that the majority of its illustrations were inspired directly by its Old English text,[11] other studies of the manuscript have demonstrated that the illustrations of Claudius B.iv exhibit a not unfamiliar wide-ranging mix of motifs derived in part from various preexisting pictorial models,[12] some belonging to well-known traditions of Early Christian biblical illustration,[13] as well as images that were created de novo for Claudius B.iv, reflecting at times specific idiosyncrasies of the Old English text they accompany. In addition, some motifs in the manuscript's illustrations were inspired by texts outside of Claudius B.iv itself, coming instead from extrabiblical, so-called apocryphal texts,[14] as well as theological commentaries. The depiction of Cain slaying Abel with an animal jawbone at the right on folio 8v (fig. 1), for example, the first extant illustration we have of this motif, which has a long afterlife in medieval and Renaissance art, a detail unspecified in either the Vulgate (Gen. 4:8)[15] or Old English texts, can now be shown, thanks to the work of Bernhard Bischoff and Michael Lapidge, to have been derived possibly from a theological commentary composed in the late seventh century by Archbishop Theodore of Canterbury and his associate, Abbot Hadrian, specifying that Cain killed Abel with the jawbone of an ass,[16] thus further linking Claudius B.iv to a Canterbury milieu. Many of the illustrations in Claudius B.iv exhibit iconographic characteristics from the earliest period of Christian art, such as the Sacrifice of Cain and Abel at the left on folio 8v, which shows the two brothers standing at either side of a seated figure of the Creator, unlike the majority of later medieval representations of the same scene but very much like that to be seen

in the sixteenth-century drawings after the lost fifth-century C.E. mosaics on the dome of the church of Santa Costanza in Rome.[17]

A notable feature of this extraordinary manuscript is that many of its illustrations exhibit distinctive "Egyptianizing" characteristics, for example, the representation of Noah's Ark as a ship on folios 13v–15r (fig. 2).[18] The earliest extant representations of the ark of Noah as a *boat*, rather than as a rectangular chest (*kibotos*), are Egyptian and date from the fourth and fifth centuries C.E. in paintings found in the Christian necropolis of El-Bagawat (El-Kharga Oasis) in Egypt (fig. 3).[19] George Henderson, in his 1972 book, *Early Medieval*, made the intriguing observation that the shrouded body of the dead Joseph on folio 72v of Claudius B.iv resembles an ancient Egyptian mummy case.[20] Dodwell, in his introduction to the facsimile of the manuscript in 1974, attempted to minimize this resemblance by stating that all medieval corpses were wrapped in shrouds.[21] However, square and/or hexagonal multilayered, recessed, cofferlike designs, such as we see on the shrouded Joseph in the Claudius B.iv image, are seen frequently on actual Late Antique Egyptian wrapped mummies as well as in painted representations of wrapped mummies such as those from the second- through fourth-century C.E. Kom el-Shoqafa catacombs in Alexandria, which look very similar indeed to the Claudius B.iv image.[22] Henderson remarks, "It is impossible that the eleventh-century Anglo-Saxon artist could have known how archeologically apt such a mode of burial would be for Joseph, 'ruler over all the Land of Egypt.' The Middle Ages had little or no antiquarian consciousness,"[23] suggesting that the artist(s) must have been relying on an older, perhaps much older, model or exemplar for this image. Interestingly, the greatest number of "Egyptianizing" traces in Claudius B.iv has to do with the representation of Moses.

Ælfric, the great Anglo-Saxon abbot and exegete responsible for a portion of the texts of Claudius B.iv, refers to Moses in his *Treatise on the Old and the New Testaments* as "se maere heretoga," the Great Commander,[24] and while Moses is depicted many times leading the Jewish people in their exodus from Egypt in Claudius B.iv, he is also visualized in this extraordinary manuscript as prophet, priest, and scribe. In its illustrations, then, the persona and role of Moses are expanded through a kind of parallel visual "text" that adds extrabiblical, exegetical information in a Christian soteriological context to the "bare" narrative of the Hebrew Bible and its Old English translation.[25] Thus, through images, the role and persona of Moses have been expanded to include attributes and meanings not strictly specified either in the canonical text of the Bible itself or its Old English translation in Claudius B.iv.

What is even more remarkable is that, through the illustrations, Moses is not only presented in Claudius B.iv as a military leader, prophet, priest, and scribe, but he has also been assimilated visually to a number of pagan divine and semidivine beings, such as Apollo, Hermes/Thoth, and Asclepius. The illustrations, then, as a

kind of parallel, visual "text," present Moses as a multifaceted Hellenistic hero in a manner well known to specialists in Jewish and early Christian apologetic literature of the period but not widely familiar to audiences outside these scholarly specializations.[26] In Claudius B.iv, a Christian Anglo-Saxon manuscript of the second quarter of the eleventh century, Moses is given visual attributes formerly known only in the theological and apologetic literature of the Jewish Hellenistic and early Christian periods.

M. David Litwa, in his 2014 book, *Iesus Deus: The Early Christian Depiction of Jesus as a Mediterranean God*,[27] explores the idea of the "construction" of the persona of Jesus in early Christian written sources that appropriate familiar verbal images and archetypes of Hellenistic, "pagan" divinities to express the Christ of faith. Thomas F. Matthews, in his controversial 1993 book, *The Clash of Gods*,[28] reassessed the traditional idea of the appropriation of Roman imperial iconography in the construction of the visualization of the persona of Jesus in Early Christian art, suggesting instead alternative visual models from a variety of Late Antique sources. Finn Damgaard, in his 2013 book, *Recasting Moses: The Memory of Moses in Biographical and Autobiographical Narrative in Ancient Judaism and 4th-Century Christianity*, makes the salient observation that "ancient culture was a culture of imitation" and provides the vivid example of Josephus in his *Antiquitates Judaicae* (*AJ* 2.347ff.) comparing Moses's crossing of the Red Sea to Alexander's crossing of the Pamphylian Sea.[29] Russell Gmirkin, in his 2006 study, *Berossus and Genesis, Manetho and Exodus*, posits that the figure of Moses in the Hebrew Bible was modeled on that of the last Egyptian pharaoh, Nectanebos II of the fourth century B.C.E., as part of his radical thesis that the Hebrew Bible was written in Alexandria, Egypt, around 273–272 B.C.E.[30]

What I am presenting here is an equivalent assessment of a visual "construction" of Moses, originally to be found in a now no longer extant illustrated model, or exemplar, from which the eleventh-century Anglo-Saxon artists of Claudius B.iv were deriving many of their specific motifs, as a Hellenistic general, prophet, priest, and scribe that has its ultimate origin in a number of originally Jewish Hellenistic exegetical and apologetic texts preserved in early Christian writings by authors such as Clement of Alexandria and Eusebius of Caesarea for their own Christian apologetic purposes, which are explored in detail in the chapters to come. I argue that the specific "Egyptianizing" details associated with the depiction of Moses in the original model on which the images in Claudius B.iv are based are no mere "antiquarian" flourishes but are instead meant to demonstrate *visually* the central thesis of a specific Hellenistic Jewish apologetic that asserted that Moses was indeed more ancient than all the gods and pharaohs of Egypt and, by extension, in the writings of Clement of Alexandria and Eusebius of Caesarea, were meant to testify to the

antiquity and legitimacy of Christianity itself as no novelty but rather a legitimate descendant of this venerable and ancient Ur-Judaism.

It should be noted at the outset that the nine distinctive visual attributes of Moses in the illustrations of Claudius B.iv constitute the largest number of such attributes in the entire corpus of Hellenistic Jewish, Early Christian, Byzantine, medieval, and Renaissance art as a whole, manuscript or otherwise. With the possible exception, according to Erwin Goodenough, of Moses represented with the "knobby" club of Hercules in the third-century C.E. frescoes of the synagogue of Dura-Europos in Syria,[31] prior to Claudius B.iv, Moses had been presented in art, both Jewish and Christian, in generalized Greco-Roman attire with no distinctive attributes other than an occasional halo or simple diadem on his head, as can be seen in a number of ninth-century Carolingian manuscript examples.[32]

AFTER A BRIEF DESCRIPTION OF THE MANUSCRIPT HERE, I OUTLINE IN chapter 1 aspects of my methodology in exploring the iconographic origins of its illustrations in general. In chapter 2, I explore a number of images in the Genesis cycle, beginning with the Fall of Lucifer and ending with the story of Noah, tracing some of their origins to a putative Late Antique exemplar. I then give an overview in chapter 3 of the range of motifs associated with Moses from the Exodus cycle of the manuscript and focus in chapter 4 on the most distinctive of them: the two horns on Moses's head beginning on folio 105v (fig. 10) and the different "horns" on Moses's head beginning at the upper left on folio 136v (fig. 18) as the misunderstood feathers of an Egyptian Isis priest. In the same chapter I explore the representation of Moses as a scribe at the bottom left of folio 136v (fig. 11) with the priestly "frontlet" (*tzitz* = Vulg. *lamina aurea*) on his forehead as described in the Bible (Exod. 28:36–38). The peculiar rendering of the veil, shown being held by Moses with his left hand in the image on folio 105v (fig. 10), with which the Bible says (Exod. 34:33–35) Moses covered his face after having come down from the mountain a second time, is discussed in chapter 5. Chapter 6 examines the possibility that the horns of Pan (fig. 23) might have served as the principal visual source of the horns of Moses beginning on folio 105v of Claudius B.iv. In chapter 7, the remaining attributes are explored: Moses represented at the lower left on folio 136v (fig. 11) as Apollo Delphoi seated on a jeweled "mountain-throne" like the omphalos at Delphi (fig. 15); the serpent-headed staff of Moses on folio 78v (fig. 13), and elsewhere in the manuscript, represented like an Egyptian *was* scepter; the round-topped Tablets of the Law, like a round-topped Egyptian stele (fig. 35), held by Moses on folio 105v (fig. 10); Moses with a distinctive cloth diadem wrapped around the base of his horns like the *vittae* of ancient Roman priests (fol. 138v; fig. 12); Moses represented with the Brazen Serpent on folio 124r (fig. 16) like the

healing god Asclepius with his snake-entwined *bakteria* (fig. 17); and finally, Moses represented as a giant on folio 139v (fig. 14). Chapter 8 presents some general conclusions about the image of Moses in Claudius B.iv, proposing, in the end, that it is primarily as a scribe, as a writer of sacred text, an amanuensis to the Lord— "Write thee these words by which I have made a covenant both with thee and with Israel" (Exod. 34:27)—that Moses is represented in this extraordinary manuscript.

THE MANUSCRIPT: A (VERY) BRIEF DESCRIPTION

The so-called Illustrated Old English Hexateuch, once part of Sir Robert Cotton's collection in the eighteenth century, now part of the Cotton legacy to the British Library, where its shelfmark is Cotton MS Claudius B.iv, is quite a large manuscript (approx. 328 x 217 mm).[33] As Benjamin Withers has observed, one could hold it on one's lap, but "resting it on a table makes for more comfortable reading."[34] Claudius B.iv, thought to have been produced some time in the second quarter of the eleventh century, probably at St. Augustine's Abbey, Canterbury,[35] contains an Old English "translation," although some have referred to it as a "paraphrase,"[36] of the first six books of the Bible (Genesis through the Book of Joshua) accompanied by 394 framed illustrations of some five hundred individual narrative episodes in various states of completion. In the past, Claudius B.iv had been referred to as "Ælfric's Pentateuch" or "Ælfric's Paraphrase of the Pentateuch and Joshua," due to the association of its Old English texts with the famous figure of Ælfric (ca. 955–ca. 1010), abbot of Eynsham,[37] who is indeed responsible for a significant portion of the text in the manuscript. Claudius B.iv has been described in great detail in two important studies in the twentieth century, C. R. Dodwell and Peter Clemoes's introduction to the 1974 facsimile edition for the Early English Manuscripts in Facsimile Series (vol. 18)[38] and Benjamin Withers's 2007 publication, *The Illustrated Old English Hexateuch, Cotton Claudius B.iv: The Frontier of Seeing and Reading in Anglo-Saxon England.*[39] Richard Marsden's 2008 study, *The Old English Heptateuch: And Ælfric's Libellus de Veteri Testamento et Novo,*[40] is the most recent and most succinct description of the manuscript to date. As my focus here is on the specific iconography of Moses in this extraordinary manuscript, I shall refrain from repeating the fundamental textual and codicological work of these three publications, but shall refer to them most gratefully throughout this present study. The differing terminology in the titles of these three works, *Hexateuch* versus *Heptateuch*, calls for some explanation. British Library Cotton MS Claudius B.iv (designated in the scholarly literature as *B*) contains most of the Old English translation of Genesis and lesser amounts of Exodus, Leviticus, Numbers, Deuteronomy, and Joshua and thus is a *Hexateuch*, that is, the first six books of the Bible. A second, considerably

smaller version of the same texts without illustrations, Oxford, Bodleian Library, Laud. Misc. 509 (designated as *L*), with the addition of a version of the Book of Judges, is thus a *Heptateuch*, that is, the first seven books of the Bible. These two principal manuscripts are part of a group of nine manuscripts, and manuscript fragments, that Richard Marsden prefers to refer to as a whole (as he says, "for convenience") as the Heptateuch, a "compilation of the work of at least three translators." "One of these, Ælfric," he continues, "is well known to us as the most important and prolific of writers in Old English."[41] Claudius B.iv is the sole illustrated version of this larger endeavor that renders the sacred text in the vernacular and as such stands at the head of a long tradition of translating the Bible into English.

Withers has suggested that at least two scribes and one artist worked together on this monumental project.[42] Significant stylistic differences lead me to posit that two different artists worked on the original illustrations, and that, as has been noted before, later hands overdrew some of them or essentially "vandalized" others.

Over the years, Claudius B.iv has been celebrated as the locus of a number of iconographic "firsts" in its many illustrations: the first extant example of Cain killing Abel with an animal jawbone, the first extant example of Moses with two horns on his head, the first extant example of the depiction of the Tablets of the Law with their familiar rounded tops, and one of the first works of northern medieval art to depict Noah's Ark as a boat rather than the traditional boxlike chest. In light of the widely acknowledged iconographic richness of late Anglo-Saxon manuscript art, these innovations have been largely credited to Anglo-Saxon ingenuity and creative invention.[43] Without detracting in the least from this general consensus, I hope to demonstrate that with respect to a number of these inventions precedents in ancient and earlier medieval art played an important role in their final adaptation and creation.

WORD AND IMAGE

> "And what is the use of a book," thought Alice, "without pictures or conversation?"
> —Lewis Carroll, *Alice's Adventures in Wonderland*

It should be emphasized at the outset that all the writers on Moses in the Hellenistic era I refer to are writing about *texts*, interpretations of texts, and one another's interpretations of texts. But in the case of something *visual*, an artist has to come up with an image himself, an image drawn either entirely from his own imagination or derived from some other source that can be adapted, or recycled, for a different purpose or meaning. So if Moses is said to have had his face become "horned" from

his conversation with the Lord, as in Jerome's Vulgate translation of the words of Exodus 34:29, what would this look like? Similarly, if Moses is said in the Bible to have received two Tablets of the Law from the Lord, but they are not described in the text, what should they look like? If Moses is said to be a great military commander of the Jewish people, what does this look like? If Moses is characterized as a great prophet, or the scribe of God, how does one represent this? If Moses is said to be a high priest, what should this look like? The answers to these questions are at the heart of this study. Again, and it cannot be emphasized enough, the results put before us by the artists of Claudius B.iv constitute the largest body of visual attributes of Moses in the entire corpus of Early Christian, medieval, and Renaissance art.

I should also say at this point that the focus of this study is the *image* of Moses in the illustrations of this early eleventh-century illustrated Anglo-Saxon manuscript, Claudius B.iv; it is not intended in any way either to support or to deny the idea that the *historical* Moses, if such a person indeed existed, was actually an ethnic Egyptian rather than the traditional idea that Moses was a Jew raised in the royal Egyptian court.[44]

Ways and Means

Methodology

Though this be madness, yet there is method in't.
 —*Hamlet*, act 2, scene 2

If thou wilt, I will go into the field, and glean the ears of corn that escape
the hands of the reapers.

—Ruth 2:2

Art history as a discipline could be said to be somewhat obsessed at this point in its evolution with methodology, how one goes about the task of explaining images.[1] It is incumbent on practitioners of the craft to be more transparent about what it is they are doing. At times this can take on an overly personal, confessional tone, but, be that as it may, I shall say a few things about how I have proceeded in this endeavor.

Two extensively illustrated Old Testament manuscripts other than psalters survive from late Anglo-Saxon England: Oxford, Bodleian Library MS Junius 11 (formerly referred to as the Caedmon Manuscript), of about 1000 or slightly earlier,[2] and London, British Library Cotton MS Claudius B.iv, of about 1025, also known as the Illustrated Old English Hexateuch, formerly as the Hexateuch of Aelfric or as the Aelfric Paraphrase of the Pentateuch and Joshua. Differing in style, technique, format, and iconography, the manuscripts are similar in terms of the large number of illustrations they contain (48 in Junius 11, 394 in Claudius B.iv), as well as the fact that they both accompany Old English texts based on the Bible rather than the canonical Latin text of the Bible itself. Both manuscripts have been

generally attributed to the monastic scriptoria of Canterbury, either St. Augustine's, in the case of Claudius B.iv, or Christ Church, with respect to Junius 11, although various other locations have been suggested for Junius 11.[3] While my focus here is Claudius B.iv, it is useful to compare how the artists of both manuscripts deal with some of the same material.

Both Junius 11 and Claudius B.iv have been the subject of intense study since the late nineteenth century, and the bibliography on both manuscripts is extensive.[4] The most recent studies of the illustrations of both works, that of Catherine Karkov on Junius 11 and Benjamin Withers on Claudius B.iv,[5] have, for critical and ideological reasons, moved away from the focus on nineteenth- and twentieth-century source study (*Quellenforschung*) and have chosen instead to explore the role played by the illustrations in both manuscripts as an integral factor in the construction of their meaning and to explicate, especially in Withers's study, the reader-viewer's experience by exploring in depth the phenomenology of the act of seeing and reading. Karkov and Withers have focused on the manuscripts and their illustrations as reflections of late Anglo-Saxon culture, its *Sitz im Leben*, as well as the manuscripts' role in shaping that culture. Some scholars may be of the opinion that the kind of detailed source study that dominated later twentieth-century investigations of these two manuscripts has exhausted the possibilities of what some might even consider an ill-advised undertaking in the first place. However, as I hope to demonstrate, there is still much to be learned about the origin of many of the most distinctive features of these complex and richly illustrated works. While the search for "sources" can seem to be an end in itself, my purpose here is to ascertain to the extent possible what it is that the artists of Claudius B.iv have done to alter and utilize their "sources" to create something entirely new, serving often quite different purposes.[6] It is an exaggeration to think of all utilization of sources, even in the highly tradition-minded culture of the European Middle Ages, as slavish "copying."[7] Often the most innovative creative work, even in modern and contemporary art, has "appropriated" and altered to different ends earlier motifs and compositions.

In his book *Bring Out Your Dead*, Anthony Grafton makes the observation that "in the fiercely competitive German universities and academies, in particular, those who could slaughter their intellectual ancestors stood a better chance of prospering than those who worshipped them"[8] While not lapsing into thoughtless idolatry, I hope, methodologically I am following in the footsteps of three very traditional and, at present, unpopular paradigms: the tripartite "iconological" schema of Erwin Panofsky, Kurt Weitzmann's much-criticized "picture criticism," and Franz Joseph Dölger's "Antike und Christentum" approach. While these methodologies are not without their shortcomings, important features of each for the art historical enterprise are perhaps being too quickly pushed aside. The importance of accuracy of observation in Panofsky's first, or "pre-iconographic," level of interpretation is still

essential even if there are epistemological issues with his second and third "levels."[9] While Panofsky would no doubt agree with St. Paul that in the iconological enterprise we may be at best only able to "see through a glass darkly" (*per speculum in aenigmate*; 1 Cor. 13–12), the so-called new art history may run the risk of seeing only itself.[10]

In terms of "seeing through a glass darkly," in the context of manuscript studies, it is worth recalling the perceptive remarks of Harvey Stahl relative to the question of the role played by earlier "exemplars" and "Weitzmannian" "models," that "the utility of these manuscripts to any discussion of models depends upon one's ability to read the contemporary style and to discount the artist's updating or mannerisms or the impact of other models."[11] This proves to be especially true in the case of Claudius B.iv's model, or models. Particularly apropos of this study are the words of Massimo Bernabò about the relationship of the Byzantine Octateuchs to their original models: "Over the course of centuries the changes accumulated so considerably that it becomes impossible to get a clear picture of the archetype. One can perceive it only at a distance, as if through a veil."[12]

Try as they may, none of Weitzmann's critics has thus far presented a coherent, thoroughgoing methodological substitute for the major outlines of his approach developed in his magisterial *Illustrations in Roll and Codex*, especially his concept of "migrating" imagery.[13]

In the pursuit of tracing sources for many of the specific peculiarities of individual images in Claudius B.iv, I have found Dölger's *Antike und Christentum* approach of great assistance. The implications and meaning of this approach are many but might briefly be summed up by Edwin Judge's assessment of Dölger's methodology as stepping "beyond the traditional use of patristic writers as sources" and turning instead "to the vast fund of non-patristic sources that lay ready to hand in the apocryphal or Gnostic writings, in the inscriptions, papyri and monuments."[14] In addition, the writings of the first-century C.E. Alexandrian Jewish exegete Philo have yielded important interpretive details especially relevant to a fuller understanding of some of the illustrations of Claudius B.iv, as I shall demonstrate in the case of the representation of the four Rivers of Paradise and Balaam's dream in addition to specific details of the characterization of Moses. Jewish legendary material in midrash and haggadah has been helpful in a number of specific instances,[15] but it should be kept in mind that a good deal of this Jewish exegetical material was well known to Christian writers and exegetes. As untutored as I am in it formally, I have learned perhaps the most, on my own, from the work of scholars in the field of history of religions, from whom art historians in the fields of ancient and medieval art also have a good deal to learn.

Much, of course, has changed in the past three decades in the art historical enterprise, as it must. There are now a number of new methodological "strategies" and

trajectories: intensified interest in the "social" history of art and questions of gender, race, and class. Some may see a study such as the present one of iconographic sources as a bit old-fashioned, yet there is much to be learned about works of art by looking for sources of imagery where justified in order better to understand just what is unique and creative about how later artists transformed these sources to serve different expressive ends and purposes.

The whole question of the relationship of the medieval manuscript artist to "models," "copies," and "exemplars" is hampered by an essentially nineteenth-century Romantic view of artistic creativity and individualism.[16] We can no more imagine a medieval artist sitting down to illustrate a text,[17] especially that of the Bible itself or something based on the Bible such as Claudius B.iv, and simply using whatever images come to mind any more than we can imagine a medieval theologian or exegete setting out to explain a biblical text by using whatever he thinks of at the moment. That does not rule out that both individuals, the artist and the theologian, might have a storehouse in memory of images and interpretations absorbed from preexisting paradigms.[18] But "sources" can be dealt with creatively, just as a "source" can be misunderstood or consciously contravened. In the end, what matters most for us is what the medieval artist has *done* with these sources, as no one is suggesting, I should think, that the artist is merely copying.[19] The operative term in contemporary artspeak is *appropriation*,[20] whether it is our eleventh-century Anglo-Saxon monk or a twentieth-century Picasso.

Working within a biblical concept of the fullness of time (*kairos*), this study of the illustrations of Claudius B.iv, and specifically the representation of Moses, has benefited greatly from important previous studies, and study aids, that have appeared in the intervening period. Paramount among a number of outstanding publications are Weitzmann and Kessler's study/reconstruction of the Cotton Genesis (1986),[21] Weitzmann and Bernabò's publication of the Byzantine Octateuchs (1999),[22] Bernabò's important study of the fundamental role played by pseudepigrapha as a source for extrabiblical details in Early Christian and later medieval manuscript illustration,[23] Kessler's study of the Carolingian Bibles from Tours (1977),[24] the immensely useful *Ikonologie der Genesis* (1989–95) of Hans Martin von Erffa,[25] Richard Gameson's *The Role of Art in the Late Anglo-Saxon Church* (1995),[26] Catherine Karkov's 2001 study of Junius 11,[27] and Benjamin Withers's 2007 study of Claudius B.iv,[28] to name but some of the most salient works that have appeared over the past three decades. Michelle Brown's *The Book and the Transformation of Britain, c. 550–1050* has done much to clarify a number of larger issues concerning the interaction of word and image.[29] In terms of conceptualizing how such a "radical" and "appropriated" visual construction of Moses such as I have discerned in the illustrations of Claudius B.iv could have been possible, I have found particularly enlightening M. David Litwa's 2014 study, *Iesus Deus: The Early Christian De-*

piction of Jesus as a Mediterranean God. Thanks to the outstanding work of Bernard J. Muir,[30] whose digital version of Junius 11 has made full-color images of the manuscript with commentary and scholarly apparatus available on CD-ROM, in addition to the Bodleian Library having made available the entire manuscript in color on its website, the full-color CD complete facsimile of Claudius B.iv published by the British Library, and the latter's publication of the complete full-color manuscript on its website,[31] these two extraordinary manuscripts are now available to a potentially global audience. The time seems ripe for a broad-based, detailed, additional look at what the artists of Claudius B.iv have accomplished in terms of how they have contrived to provide suitable images for the manuscript set before them, with specific emphasis on the representation of Moses.

The literature on both Junius 11 and Claudius B.iv is quite extensive as they have been the focus of scholarly attention, at least in the case of Junius 11, since the seventeenth century. I am especially appreciative that I have the benefit of hindsight and have been able to construct my work here on a foundation of important and careful work. I am especially indebted to the pioneering work of George Henderson,[32] whose studies of these two manuscripts have been a constant source of enlightenment even when, from time to time, I may disagree with some of his findings.

And finally, I have attempted throughout to adhere to Aby Warburg's famous guiding principle, "God is in the details" (Der liebe Gott steckt im Detail),[33] while keeping in mind that it has also been said that the devil is in the details.

Traces of a Late Antique Exemplar in MS Claudius B.iv

The Book of Genesis

Any study of the illustrations in Claudius B.iv must, given the large number, be incomplete. While my main interest is the representation of Moses, a closer look at other themes in this extraordinary work may help us clarify our understanding of the origin and function of the imagery in the manuscript as a whole, as well as specifically in the case of Moses. As Henderson has devoted an in-depth study to the Joshua cycle of Claudius B.iv,[1] with important conclusions bearing on my assessment of the Moses imagery, and Withers has done the same for the Joseph cycle,[2] I would like to turn my attention in this chapter to selected scenes from the Genesis cycle at the beginning of Claudius B.iv to explore what they may reveal about the artists' approach to the task of providing its illustrations.[3]

THE FALL OF LUCIFER AND THE REBEL ANGELS

> I will set about replying to the questioner who asks, "What was God doing before he made heaven and earth?" But I will not respond with that joke someone is said to have made: "He was getting hell ready for people who inquisitively peer into deep matters."
>
> —St. Augustine, *Confessions*, book 11

The first image one encounters upon opening Claudius B.iv, the Fall of Lucifer and the Rebel Angels, on folio 2r (fig. 4),[4] dramatically inaugurates the role of image as exegesis in the manuscript. As Withers has explored in some detail,[5] the image, along with the text of Ælfric's *Preface to Genesis* that it accompanies, serves to introduce an important exegetical construct, one essential to the raison d'être of Christianity itself, namely, the fall of Lucifer, as a result of pride, with his cohort of rebel angels thus leading to the creation of Adam as a "replacement" for the rebellious angels and with Adam's subsequent fall from grace the need for redemption through the incarnation of Christ, the son of God. None of this important doctrine, of course, is to be found in the "naked" narrative[6] of the Book of Genesis itself but represents the important, fundamental exegesis traditionally attributed to St. Augustine that the creation of the angels is associated with the Creation of Light on the first day, and the subsequent fall of the rebel angels, not literally narrated in the text of Genesis, can be inferred, according to Augustine, from the act of God separating Day from Night as recounted in Genesis 1:4–5.[7] While the motif of the rebellion of Lucifer and his subsequent fall is recounted in a number of apocryphal sources earlier in date than Augustine,[8] the earliest extant pictorial example of this motif occurs on page 3 of Oxford, Bodleian Library MS Junius 11, an Anglo-Saxon manuscript dating to around 1000 or perhaps slightly before. While the Junius 11 image shares the same subject as the full-page illustration on folio 2r of Claudius B.iv, its pictorial elements and overall composition are quite different in almost every way.[9]

To enhance the contrast between good and evil, the Claudius B.iv artist has contrived in a number of obvious and not so obvious ways to enhance his pictorial concept by means of multiple antithetical pairings. To begin with, he has divided his field in half horizontally, with God and his loyal angels above set against a background of wavy mauve-colored clouds and the eight rebel angels and Satan shown tumbling helter-skelter below against a pale pinkish background.[10] Among the obvious differences between the two cohorts is the fact that the rebel angels are shown, like Lucifer himself, fully naked or, in the case of four of the falling angels, wearing short ragged skirts,[11] while the loyal angels above are fully clothed. Curiously, while two of the loyal angels above are shown grasping the Creator's mandorla with bare hands, the four remaining angels are shown with colored cloths covering their arms and hands as if they were meant to be shown carrying some sacred object or offering, but nothing of the sort is depicted. The loyal angels are further distinguished by their multicolored wings and neatly coiffed blue hair.[12] The rebel angels, by contrast, are wingless and have dark-colored, nondescript hair, with the exception of Lucifer, whose hair is disheveled and "spiky."[13] Somewhat strangely, while Lucifer and his cohort are shown naked, Lucifer himself and almost all of the fallen angels show evidence of a line at the neck as if they were wearing some kind of T-shirt.

Quite striking is the diagonal trajectory of Lucifer's mandorla, crashing head-long into the lower left corner of the acanthus leaf frame of the composition in clear contradistinction to the vertical, centered mandorla occupied by the Creator above. And most astonishing of all, Lucifer is shown grasping with his own hands his once-bright frame of light.[14] Lucifer's mandorla is at the same time being bitten by the large black teeth of a two-footed vermilion-colored dragon at the bottom right of the composition whose curlicue tail loops around and through Lucifer's mandorla. On page 3 of Junius 11, the upturned Jaws of Hell are only a head, whereas the creature on folio 2r of Claudius B.iv has a dragonlike body with two short legs. A similar two-legged dragon with twisted curlicue body and wings is seen on folio 104v of London, British Library MS Egerton 3763, a prayer book dating to about 1000 possibly made for Archbishop Arnulf II of Milan.[15] The brilliant vermilion color of the dragon in the Claudius B.iv image might also be a reference to the de-vouring dragon described in Apocalypse 12:4, "behold a great red dragon." But this beast is said to have seven heads and ten horns as well as seven crowns upon its heads (Apoc. 12:4). The fact that the upturned Jaws of Hell in the Junius 11 image and the dragon of Claudius B.iv are engaged in acts of biting and ingestion might also link them, if at some distance, to the ancient Egyptian animal-bodied demon, Ammit, called "Devourer of the Dead," "Eater of Hearts," who appears in numer-ous illustrated examples of the so-called Egyptian Book of the Dead[16] waiting near the scales of justice to devour the hearts of the unjust whose sins outweigh the "Feather of Truth" on a pair of scales, themselves the possible ultimate source of the scales held by the archangel Michael in later medieval Christian images of the *psychostasis*,[17] or Weighing of Souls, in Last Judgment iconography.

Lucifer himself in the Claudius B.iv image also sports a snaky tail as part of his transformed persona as Satan. Lucifer's striking "hands-on" apprehension of his own mandorla, his former frame of light as his name *Luficer* signifies (i.e., bearer of light), as well as his headlong diagonal trajectory serve to enhance his fallen state and his separation from God but also recall a distinctive Late Antique iconogra-phy associated with the representation of Aion, a personification of time, as seen, for example, on the ca. late fourth-century C.E., silver-gilt Parabiago patera (fig. 5),[18] where Aion, as in other examples of this motif, is shown grasping the outer edge of an oval zodiacal frame within which he stands. There are also examples where Aion grasps both sides of the frame,[19] as does Lucifer in the Claudius B.iv image. Such a Late Antique "pagan" image might well have served as an inspira-tion for the now "demonized" Lucifer, perhaps in an earlier exemplar from which the Anglo-Saxon artist of Claudius B.iv may have been working. Other motifs to be found on the Parabiago plate, as I explore later, may also have served as "sources" to be transformed and reused in the service of illustrating the Old Testament text of Claudius B.iv.

One might want to argue that such resemblances from so chronologically widely separated images amount to nothing more than mere coincidence. But as has been shown in many other examples of Early Christian and early medieval "borrowing" and transforming of preexistent pagan imagery to other Christian (and Jewish) purposes—the well-known example of Jonah under the Gourd, a "recycled" sleeping Endymion,[20] comes to mind—certain images in Claudius B.iv cannot automatically be assumed to be coincidences.

One further visual detail of the composition on folio 2r of Claudius B.iv serves to enhance the theme of the binary opposition inherent in its subject, the separation of the "good" from the "evil" angels, and that is the "chiastic" color scheme employed by the artist in the acanthus infill of the rectangular frame. The light salmon tone of the vertical frame infill at the upper right corresponds with that at the lower left, and, similarly, the darker grayish tone of the infill panel at the lower right is echoed in that at the upper left.[21]

At the very outset, then, of providing illustrations for this vernacular translation of the first six books of the Bible, a major extrabiblical theme, the Fall of Lucifer and the Rebel Angels, along with the explanation provided by the accompanying text of Ælfric's *Preface to Genesis*, establishes a modus operandi for subsequent illustrations to expand on and at times "interpret" the bare bones of the "naked" text they accompany in the manner of a visual *catena*, or commentary. As will become apparent, the role of images as exegesis may have presumed more than a well-informed viewer-reader, especially given the premise of a non-Latin, Old English text, leading to the suggestion of a putative role for some kind of "lector," or "meturgamim," as the readers of the Aramaic *targums* (interpretive paraphrases of the Hebrew Bible for Aramaic-speaking Jews who no longer understood Hebrew)[22] were called, who, in addition to possibly reading the text out loud in Old English, might have elaborated some of the more abstruse exegetical elements of the illustrations themselves,[23] adding a "performative"[24] dimension to the illustrations and the manuscript as a whole by way of an eleventh-century PowerPoint presentation.

CREATION OF THE WORLD

Unlike the artist of Junius 11 who had to squeeze the six days of creation on one and a half pages, the artist of Claudius B.iv is able to spread the creation story over eight folios, beginning on folio 2v with the work of the second day, The Creation of the Firmament (Gen. 1:6–8). In a single picture, striking in its simplicity, we see a blue-robed, barefoot Creator standing on the wavy lines of the green waters below while pointing upward with a large hand, its single index finger indicating the wavy lines of the mauve-colored waters of the heavens above. The calm power of the

image is glaringly interrupted by the orange "Museum Brittanicum" stamp to the left of the Creator.

Many scenes of the work of the six days in medieval art involve a circle or orb referred to in German as a *Kosmoskugel*,[25] which can be understood, depending on the context, either as the cosmos or the heavens, where it appears, for example, in the twelfth-century Salerno ivory representing the fourth day of creation.[26] In other Italian examples, such as the lost fifth-century fresco cycle from San Paolo fuori le Mura in Rome or the eleventh-century ivory plaque now in Berlin, the Creator is shown seated on the *Kosmoskugel*, or *gyrus terrae*, as a visualization of Isaiah 66:1, "Heaven is my throne, and the earth is my footstool."[27] The image of the Lord seated on the *Kosmoskugel* could well be a Christianization of images of either a personification of Roma herself or, alternatively, Aeternitas or Italia seated on a globe or shield on Roman coins.[28]

While the work of the second day is not preserved in the Cotton Genesis itself, we see it depicted in the thirteenth-century mosaics of San Marco showing a standing Creator and a large, dark *Kosmoskugel* separating the undulating waters below from the band of waters above, with the two "angel-days" at the right signifying the work of the second day.[29] The artist of Claudius B.iv, interestingly enough, like Michelangelo in his scene of the Separation of the Waters from dry land on the Sistine Chapel ceiling,[30] has chosen not to have this "beach ball" of a *Kosmoskugel* in his composition but instead lets the Creator's expressive hand and pointing finger say it all and in so doing perhaps emphasizing the exegetical idea that God effects the creation solely *per verbum*, by his word. On this point, Ælfric in his *Exameron anglice*; or, *The Old English Hexaemeron* ("Concerning the Work of the Six Days of Creation"), quotes the Psalms, saying, "He spoke and they were made; he commanded and they were created."[31]

In describing the work of the second day, Ælfric has this to say: "On the second day our Lord created the firmament, which men call 'rodor'; it encloseth in its bosom all the breadth of the earth; and within it is placed all this earth. And it ever goeth about like a running wheel and it never standeth still altogether."[32] The last sentence, difficult as it is to envision, might seem to describe the "rolling" *Kosmoskugel* that we see at San Marco. In addition, the semicircular arc on which the Creator sits on page 6 of Junius 11 might well be understood as the firmament described by Ælfric.[33]

The creation story continues with the work of the third day (Gen. 1:9–13), the Creation of Grass and Plants on the dry earth,[34] on folio 3r of Claudius B.iv. At the top, in a separately framed image, the blue-robed Creator at the right is shown holding a yellow codex in his veiled left hand while gesturing with his right hand to a group of plants and a single tree with its lower branches lopped off in the manner of a lignum vitae motif as seen in later Anglo-Saxon images of the cross of

Christ.[35] This is represented in the mosaics of San Marco by a similar image of a standing Creator, without codex in hand, gesturing toward a group of plants and trees to the far right. Between the Creator and the plants are three winged figures, again symbolizing the third day.[36] The Creator at San Marco, as in Claudius B.iv and the Cotton Genesis itself, is shown in human form wearing a classical combination chiton/himation, nimbed and barefoot.

Directly below this scene, also on folio 3r of Claudius B.iv, is the work of the fourth day (Gen. 1:14–19), the Creation of the Sun, Moon, and Stars—the sun, a "greater light to rule the day," and the moon, a "lesser light" to rule the night.[37] The artist of Claudius B.iv, again as on folio 2v, shows the solitary figure of the standing Creator, this time clad in a pink garment strangely prophetic of Michelangelo's pink garments of the Creator on the Sistine Chapel ceiling of the sixteenth century,[38] gesturing vigorously with his large right hand toward the torch-bearing allegorical figure of one of the two lights shown driving a horned ox across the star-strewn wavy blue lines of the heavens above. This swath of the heavens crosses over the top and side borders of the frame in a prophetic glimpse of the extraordinary "transgressive" and creative attitude of the Claudius B.iv artist to the traditional protocols of the frame, and what it contains, as will be seen in later images from this manuscript.[39] Again, abandoning the circular *Kosmoskugel* seen at San Marco and on the Salerno ivory, the Claudius B.iv artist has retained the torch-bearing figures symbolizing the sun and moon that we see on the Salerno ivory and has combined them with the horned oxen that are seen pulling the Chariot of the Moon in several earlier Carolingian examples, such as folio 8r of the First Bible of Charles the Bald (Paris, Bibliothèque nationale, MS lat. 1).[40] The Carolingian examples themselves are derived from Late Antique sources such as the fifth-century C.E. patera of Parabiago in Milan (fig. 5), where the *Biga Lunae* at the upper right is pulled by two oxen and the *Quadriga Solis* at the upper left is pulled by four horses.[41] Oddly enough in the Claudius B.iv image, however, there are no chariots visible, and sun and moon are indistinguishable from each other, looking more like framed *imagines clipeatae* than chariot drivers. In addition, both figures are being pulled by a single ox rather than the two oxen and four horses of the Parabiago and other Late Antique examples. Interestingly, the two divine Egyptian bulls, Apis and Mnevis, are extolled as symbols of the sun and the moon in a second-century C.E. Coptic Gnostic text from the Nag Hammadi.[42] This strange detail in the Claudius B.iv picture of two bulls, or oxen, symbolizing the sun and the moon is the first of several possible Egyptianizing traces to be found in the illustrations of this remarkable manuscript, as discussed later.

The Creator on folio 3r of Claudius B.iv who treads on the frame of the image with his bare feet is a remarkably lively and mobile figure, beckoning the celestial chariots on like some kind of heavenly traffic cop. His energetic dancelike pose is

reminiscent of that of King Edgar on folio 2v of the late tenth-century New Min-
ster Charter (London, British Library Cotton MS Vespasian A. VIII)[43] and echoes
as well the upraised arms of the seated Creator on the Berlin plaque placing the sun
and the moon in the heavens.[44]

CREATION OF ADAM

The scene of the Creation of Adam (Gen. 1:26–27) on folio 4r of Claudius B.iv is
an excellent example of a possible convergence of sources, both written and visual,
that conveys several important exegetical ideas. In the Claudius B.iv illustration,
the Creator, at the left, shown without a nimbus and thus bearing an even closer
resemblance to Adam, at the right, who of course is also without a halo, although,
like the Creator, already bearded (he is only just being created), grasps Adam with
both arms around the shoulders. Of course, Adam and the Creator as mirror im-
ages of each other is an apt reflection of the biblical text (Gen. 1:26), "Let us make
man to our image and likeness." This creation of Adam by God with his own hands
distinguishes Adam's creation from the earlier works of God, which were accom-
plished through God's Word alone, as in the famous *Fiat Lux* (Let there be light)
of Genesis 1:3. Kessler has suggested that the Creation of Adam that once existed
in the Cotton Genesis was missing long before the manuscript served as a model
in Venice.[45] In the San Marco image the Creator is shown enthroned at the left of
the composition "modeling" with his hands the darkened clay figure of Adam be-
fore him, a scene referred to by Weitzmann as the "Forming" of Adam to distin-
guish it from other stages of the creation narrative culminating in the "Animation"
of Adam,[46] the giving of a soul to his lifeless body. Other early Western medieval
images reflect this artisanal iconography such as the scene of the Creation of Adam
on folio 50v of the ninth-century Stuttgart Psalter (Stuttgart, Würtembergische
Landesbibliothek, Cod. bibl. fol. 23) where both figures are shown standing, the
Creator grasping Adam about the shoulders.[47] While not showing God actually
grasping Adam by the shoulders as in the Stuttgart and Claudius B.iv images,
the first image at the upper left of the ninth-century Bamberg Bible shows Adam
seated upright on the earth somewhat more analogous to the Claudius B.iv image,[48]
although in Claudius B.iv Adam is not actually seated on the ground. Adam does
sit on the ground, however, in the drawing after the lost fifth-century C.E. fresco
cycle at San Paolo fuori le Mura in Rome while the Creator is shown seated at the
left on the *Kosmoskugel.*[49] Martin Büchsel has shown how the seated pose of Adam
with arm outstretched toward the Creator in both these examples may have been
modeled on images of a seated Adonis in distress on a number of Late Antique
sarcophagi.[50]

The idea that God created Adam with his own hands goes back to the first-century C.E. apocryphon 2 Enoch (2 En. 44:1), if not even earlier, where the text says that "the Lord with his own two hands created mankind in a facsimile of his own face."[51] Philo, the first-century C.E. Jewish Alexandrian exegete, specifies that Adam's "body was created by the Creator taking a lump of clay, and fashioning the human form out of it."[52] Theophilus of Antioch in his *Ad Autolycum* says, "For God having made all things by His Word, and having reckoned them all mere bye-works, reckons the creation of man to be the only work worthy of His own hands."[53] Irenaeus of Lyons emphasizes as well that Adam is created by "God's hands."[54] Augustine, on the other hand, emphasized that all things were created by God's *Word* and, in his *De Genesi ad litteram*, makes fun of the concept that God literally modeled man from the mud as a "childish" idea (*nimium puerilis cogitatio est*).[55] Ælfric, nevertheless, in two of his *Catholic Homilies* and in his *Treatise on the Old and New Testament* (based largely on the *Hexaemeron* of St. Basil the Great), the text of which is not included in Claudius B.iv, says that "Almighty God created man; Adam of the earth *with his own hands.*"[56]

The question here, of course, is whether this "hands-on" image was already in a putative exemplar from which the artists of Claudius B.iv were working or whether it was inserted specifically to make the exegetical point about the uniqueness of Adam's creation as emphasized in Ælfric's homilies and *Treatise*. The fact that we see the hands-on mode in a number of other pictorial venues, including that of the San Marco mosaics, suggests that this version of the Creation of Adam was an integral part of a specific iconographic tradition, possibly including the Cotton Genesis itself, even though such a scene has not been preserved there. The additional fact that this hands-on motif, originally emerging from a Jewish exegetical textual tradition, is to be found in a number of Eastern theological texts (e.g., Philo, Theophilus of Antioch, and St. Basil the Great), coupled with the fact that Augustine himself takes umbrage at it, would seem to strengthen the Weitzmann-Kessler hypothesis relative to the Eastern, possibly Alexandrian, origin of the Cotton Genesis.

Further strengthening the original, possibly Alexandrian, hypothesis advanced by Weitzmann, Kessler has brought forward a number of Egyptian visual *comparanda*, including a very important image of an enthroned Creator forming Adam from the earth on a Coptic textile medallion in the Ashmolean Museum in Oxford.[57]

Another point of consideration here is that the interpretation of God's direct hands-on creation of Adam could be seen as an anti-Manichaean iconography putting emphasis on the fleshly aspects of God's creation from an orthodox point of view by contrast to the spiritual and antimaterialist emphasis in Manichaean and Gnostic circles.[58] This possible anti-Manichaean emphasis might strengthen the hy-

pothesis that the artist of the Claudius B.iv image may have been working from a much earlier exemplar that was itself a product of an anti-Manichaean milieu.

Earlier it was noted that Adam already sports a beard in this scene of his creation in Claudius B.iv, an odd detail that, among others, makes this scene different from the darkened clay figure that God seems to model like a sculptor in the analogous scene at San Marco. But this strange detail of Adam's beard is not without its exegetical implications, as a good deal of time and attention is given over to a discussion in the Canterbury exegetical text by Archbishop Theodore, the *Laterculus Malalianus*, of the necessity of Adam (and Eve) being sufficiently mature at the time of the Fall, as James Siemens remarks in his study *The Christology of Theodore of Tarsus*, "in order to have fallen from grace as he did."[59] The idea here, on which Theodore spends an inordinate amount of time, is "that the first human beings can only have been fully competent when they succumbed to the temptation in the garden, presumably to emphasize their culpability."[60] The inclusion, then, of seemingly so small and incongruous a detail as Adam represented as bearded is a powerful indicator, yet again, that the illustrations in Claudius B.iv function as prompts, so to speak, for complex exegetical ideas.

As I was able to demonstrate in the case of several of the Byzantine Octateuchs, the later scene, the Naming the Animals, was often an opportunity, as in the case of the image on folio 4r of Claudius B.iv, the Creation of Adam, to represent Adam with a translucent white "garment of light," based on a fairly widespread apocryphal tradition that before the Fall and consequent expulsion from paradise, Adam and Eve were not truly naked but possessed a miraculous, translucent garment of purity and light.[61] Some apocryphal sources state that this covering was brittle and nail-like and that our fingernails are all that is left of this once-bright "garment of light."[62] In any event, the supposedly "naked" body of Adam on folio 4r of Claudius B.iv, as elsewhere in the manuscript (e.g., folios 6v and 7v), shows Adam with a T-shirt-like neckline, perhaps a misunderstood vestige from a much earlier exemplar from which the artist may have been borrowing appropriate images that may have included figures of Adam and Eve with these elusive "garments of light." As I mentioned earlier, Satan and his fallen angels on folio 2r also give evidence of this T-shirt-like neckline (see fig. 4), as does the fallen Abel on folio 8v (see fig. 1).

One further detail in the image of Adam's creation on folio 4r of Claudius B.iv needs mention, and that is that both Adam and the Creator are shown on top of a rocky outcropping where the creation is taking place. This may have originated in an exemplar from the extrabiblical tradition that Adam was created in Jerusalem on the future site of the Temple Mount at the middle point, the navel (*omphalos*), of the earth.[63] Adam is also shown standing on a prominent hillock while being "formed" by the Creator who grasps his right shoulder with both hands on folio 6 of the eleventh-century Roda Bible in Paris (Bibliothèque nationale MS lat. 6).[64] It is also

significant that Adam is created in the presence of animals who, in Claudius B.iv, give him their avid attention as they circle around him, thus emphasizing Adam's uniqueness,[65] as well as his lordship over them in accord with the words of Genesis 1:26 where God gives him "dominion over the fishes of the sea, and the fowls of the air, and the beasts, and the whole earth, and every creeping thing."

THE FOUR RIVERS OF PARADISE

Unlike the majority of medieval representations of the four rivers of paradise described in the Bible (Gen. 2:10–14), Claudius B.iv has four separately framed miniatures beginning on folio 5r and continuing on folio 5v (fig. 6). The first and fourth rivers appear to be unfinished as they are represented by outlined green washes. In devoting this much space to these rivers, as well as developing the second and third of them by including nine male figures before the Creation of Eve on folio 6v, the artist of the cycle signals a particular interest in developing their exegetical possibilities, a motif that had been explored in some detail by biblical commentators beginning with Philo in the first century C.E.

Rebecca Barnhouse has suggested that the Claudius B.iv artist may have been especially influenced by the text of St. Ambrose's *De Paradiso*, where Ambrose, borrowing heavily from Philo, attributes a number of moral lessons to the Bible's simple description of these four bodies of water.[66] What is of particular interest here is the complex interaction of the images themselves with four textual streams, as it were: that of the Old English text of Claudius B.iv itself that they accompany, the Latin text of the Vulgate Bible, the text of Ambrose's commentary in *De Paradiso*, and Philo's texts on which Ambrose himself depends.[67] This complex interaction is representative of a major aspect of the modus operandi in Claudius B.iv as a whole and is thus worthy of closer scrutiny.

As Barnhouse has already pointed out, the treatment of the four rivers of paradise in Claudius B.iv is unlike all other medieval depictions of this motif.[68] As a consequence we are dealing here with either an entirely unknown tradition of such a depiction or a unique creation of the artist of Claudius B.iv, or a combination of both. A "combination of both" is meant to indicate that the artist of Claudius B.iv has possibly altered in his own way a unique, no longer extant tradition of rendering the four rivers.

Ambrose, following Philo, associates the four rivers with four virtues: the Phison with Prudence, the Gehon (which both writers suggest is the Nile) with Temperance (Chastity), the Tigris with Fortitude (Courage), and the Euphrates with Justice. As Barnhouse has pointed out, the artist of Claudius B.iv has included four male figures at the top of folio 5v (fig. 6) standing on the edge of the Gehon (Nile), all of them tinted blue, all shown wearing black shoes, with the two center figures

facing each other carrying staves in their hands.[69] In addition, as Barnhouse notes, the figure to the far right wears over his tunic a ragged skirt around his waist that looks very much like the ragged skirts worn by the fallen angels on folio 2r of the manuscript (see fig. 4),[70] with the exception that the skirt on folio 5v is cadmium red in color and the figure points to it with his left index finger. The text of the Bible, as well as the Old English text of Claudius B.iv, makes no mention of such humans in describing the river Gehon. Ambrose, in his description of the river, however, associates it with Egypt, where the Israelites "girded up their loins" as a "sign of temperance" in celebration of the Passover.[71] Barnhouse sees this characterization as a reference to Exodus 12:11 (and as the source of specific details in the illustration), where, referring to the Paschal lamb, the Bible says, "And thus you shall eat it: you shall gird your reins, and you shall have shoes on your feet, holding staves in your hands, and you shall eat in haste."[72] Barnhouse has noted that all four men in the Claudius B.iv image are holding staves and are shown with shoes on their feet. In addition, all four figures are rendered in a bluish tone, signifying that they are Ethiopians in accordance with the Old English text of Claudius B.iv where the word *Sigelhearwa* is used to mean Ethiopians. As Barnhouse states, Ambrose associates the river Gehon with Exodus 12:11, but Ambrose himself does not specifically cite this passage, nor does he mention the staves and the shoes as in the Bible, but Philo does. In another text, *Questions and Answers on Genesis 1*, Philo, in speaking about the rivers of paradise, and specifically the river Gehon, as a "sign of sobriety," mentions "restraining the appetites of the belly, and of *those parts below the belly*."[73] The figure at the far right at the top of folio 5v pointing to the cadmium red, flamelike skirt beneath his belly might be seen as a pictorial reference to this concept of the "appetites" of those parts "below the belly" about which Philo speaks. An attitude on the part of the artists that is indicative of the complex interaction of word and image in the manuscript as a whole can be seen in these various references.

Similarly, the depiction of the river Tigris at the middle of folio 5v (see fig. 6) reflects Ambrose's characterization, based on that of Philo, that the river's name alludes to its swiftness.[74] Ambrose characterizes the Assyrians who dwell by the Tigris as guarding its course and therefore symbolizing "fortitude," the fortitude of those who hold in check "the guileful vices of the body."[75] In a particularly perspicacious observation, Dodwell was the first to point out that the "swiftness" of the Tigris indeed seems reflected in its energetic depiction on folio 5v and the avid gaze with which the five figures at the right regard its course.[76] And as Barnhouse indicates, Ambrose is not the only commentator to emphasize the speed of the river.[77]

As with the small detail of Philo's text quoted above describing "restraining the appetites of the belly and those below the belly" as possibly reflected in the figure at the far right of the depiction of the river Gehon on folio 5v pointing to the ragged red skirt below his waist,[78] Ambrose simply says that the Assyrians "dwell by it."[79] Minimal as it may be, the representation of the Tigris on folio 5v does indeed seem to flow "in front of" the gathered Assyrians to the right.

And finally, again in accordance with Philo, Ambrose says of the fourth river, the Euphrates, "we have no description of the regions through which" it flows, but it represents Justice.[80] Accordingly, the framed and unfinished image at the bottom of folio 5v has no additional figures or details.

Since neither the Vulgate text nor the Old English in Claudius B.iv includes any of these allegorical or symbolic details, the artist would have to have created these images himself based on the knowledge of a text like Ambrose's *De Paradiso*, or, alternatively, such images might already have been included from an earlier exemplar from which he was working. In either case the viewer-reader of Claudius B.iv would have to have some prior knowledge of this allegorical interpretation of the rivers of paradise and be able to call it to mind when looking at the pictures, or perhaps someone accompanying the viewer (who might indeed be called a lector, or reader) could have explained to him the meaning of these extrabiblical figures and details of the illustration. The fact that a later hand wrote in Latin commentaries on these pictures,[81] and elsewhere in the manuscript, reinforces the observation that in some form or another these illustrations, and others like them, called for further explanation or explication and may give us some insight into possible uses of the manuscript as a pedagogic and didactic tool, presenting in visual form exegetic or homiletic amplifications on the fuller meaning(s) of the "naked" biblical text.[82]

While the references to Philo and his allegorical interpretation of the four rivers of paradise might seem a bit of a stretch here, and the situation is somewhat complicated by the fact that it is well established that Ambrose based much of his Old Testament explication on Philo's writings, largely without acknowledgment, in other instances in Claudius B.iv the Philonic connection is much more direct. An important case in point is the scene of Balaam's dream (Num. 22:18, 20) in the illustration at the top of folio 125v where Balaam is shown reclining asleep at the right while the *manus dei* emerges from the edge of the frame above. Both the Vulgate and the Old English text, as Withers points out, clearly state that God himself speaks to and instructs Balaam. Examining the illustration under a raking light, however, Withers discovered an un-inked-in, dry-point sketch of a winged angel hovering at the top edge of Balaam's bed.[83] Withers questions why the artist went to the extent of sketching in this angel in complete contradiction to the Vulgate and Old English texts. His solution to this riddle is that the artist must have borrowed the image of a sleeping figure from another scene in his model, or from somewhere else in Claudius B.iv, showing a sleeping figure being visited by an angel.[84] Philo, however, in his account of the Balaam story, indicates that it is an angel and *not* God who is responsible for communicating with Balaam.[85] It would seem likely, then, that there may well have been an angel in some exemplar being consulted by the Claudius B.iv artist that the artist may have initially sketched in but upon encountering the Old English text with its specification that God is the source of Balaam's

oracle decided against painting in the "offending" angel. Here we see a potentially more direct connection to a Philo-inspired image similar in its specificity to the vivacity of the ragged vermilion skirt on the figure of the river Gehon.

THE STORY OF ADAM AND EVE

As Henderson and others have pointed out, the fact that the Creator is shown removing the rib from Adam links the image on page 9 of Junius 11 not only with the actual text of Genesis 2:21 but also with the Cotton Genesis tradition as we see it, for example, at San Marco.[86] Unlike the image at San Marco, and in the majority of the members of the Cotton tradition, the Creator in the Junius 11 illustration is shown both with a cruciform nimbus and bearded. However, in the Salerno ivory[87] and the Millstatt Genesis, as well as the *Hortus deliciarum*,[88] the Creator is shown bearded at the Creation of Eve, although only in the Millstatt Genesis and at San Marco does he exhibit a cruciform nimbus.

In her analysis of the Adam and Eve cycle in the *Hortus deliciarum*, Rosalie Green summarizes her conclusions in associating that cycle with the Cotton Genesis tradition by noting, among other things, that the Creation of Eve in the *Hortus* is shown as the rib-removing operation, in place of the familiar medieval picture showing Eve arising from Adam's side.[89] The Octateuch-inspired full-body form of the Creation at San Paolo may have been, in turn, in the Octateuchs themselves, "recycled" from a motif such as that showing a sleeping Alexander the Great behind whom stand the allegorical figures of the Nemeseis, as can be seen on a third-century C.E. coin from Smyrna.[90]

Eve, shown rising fully formed from Adam's side, can be seen in the following works also associated with the Cotton Genesis family: the eleventh-century southern Italian ivory plaque in Berlin[91] and the so-called Salerno antependium.[92] The fully formed Eve rising from Adam's side is generally characteristic of the Byzantine Octateuchs,[93] yet this detail can be found in the seventeenth-century drawing of the Early Christian fresco cycle of San Paolo fuori le Mura in Rome.[94] It can also be found in Claudius B.iv,[95] the Roda Bible,[96] although in a very confused form to be discussed momentarily, and in the Egerton Genesis,[97] to name but a few of the Western monuments exhibiting this iconography. In the face of these examples, one is prompted to ask why there are two such apparently opposed modes of representing the creation of Eve and why one of them, the fully formed Eve rising or being raised from Adam's side, is in apparent contradiction of the biblical text.

Massimo Bernabò and most recently Catherine Karkov have seen in the fully formed Eve rising from the side of a sleeping Adam a direct reference to an important and pervasive typology linking the creation of Eve to the birth of the church emerging from the pierced side of Christ at his crucifixion.[98] Bernabò has argued in his analysis of the Creation of Eve scenes in the Byzantine Octateuchs that this

typology is widespread in textual sources from the third century C.E. on,[99] a typology literally illustrated in later medieval depictions of the crucifixion such as in the thirteenth-century *Bibles moralisées*.[100] I have argued elsewhere[101] that while this is indeed a widespread, well-understood typology, there is nothing specifically represented in the Junius 11 image, which of course does not actually show Eve rising from Adam's side, to necessarily limit the exegetical possibility of this scene to the birth of the church from Christ's side. While this might indeed be in the mind of the late tenth-century Anglo-Saxon viewer-reader of the image, it may not ultimately be the origin of the iconography itself. Earlier Jewish midrashic sources indicate an interesting potential alternative explanation for the "two" creation of Eve modalities seen in a wide range of early medieval images.

The *Midrash Bereshith Rabba* refers to a twofold creation of Eve. First God created Eve while Adam watched. Adam "saw her full of discharge and blood," and rejected her.[102] God apparently destroyed this creation and created Eve a second time, now putting Adam in a deep sleep,[103] removing a rib from his side, and building Eve from a clean bone. This midrash seeks to explain the locution in Genesis 2:23, "And Adam said, this is now bone of my bones": "R. Judah b. Rabbi said: At first He created her for him and he saw her full of discharge and blood; thereupon He removed her from him and recreated her a second time. Hence he said: This time she is bone of my bone."[104]

Herbert Schade has noted that Adam's eyes are shown open during the rib-removing operation in the ninth-century San Paolo Bible and has attempted to link this detail to writings of St. Augustine on the ecstatic sleep of Adam during the creation of Eve when Adam beholds a prophetic vision of his union with Eve as the union of Christ and the church, as is illustrated literally on folio 1 of the Vienna *Bible moralisée* (Vienna, Österreichische Nationalbibliothek, Cod. 2554).[105] Schade notes the same detail of Adam's open eyes in the Creation of Eve miniature on folio 6v of Claudius B.iv and on folio 6r of the Roda Bible.

While it is true that Adam's eyes are actually shown open in the San Paolo Bible,[106] upon careful examination one cannot say that Adam's eyes are represented as open in the Claudius B.iv image, for as alert and animated as Adam's posture is, he turns and faces Eve, who is literally being lifted out of his side by the Creator, the small dot indicating the pupil of an open eye, as can be seen in the standing figure of Adam immediately to the right in the scene of the Prohibition, is definitely not present. This does not mean, however, that such a detail could not have been present in some exemplar but eliminated in the Claudius B.iv manuscript. It is difficult to say whether Adam's eyes are actually open in the Roda Bible image. Again, however, Adam seems inordinately alert, with his head directed toward the figure of Eve rather than the Creator. Two extraordinary, even bizarre details distinguish this representation of the creation of Eve; first, both Adam and Eve are shown par-

tially clothed, and Adam is even shown reclining on a bed, under the covers; and second, even more illogical, the Creator is shown at the left, behind Adam, with a rib held in his right hand, to which Eve seems to point. A similar confusion occurs in the Creation of Eve scene from the *Annales Colbazenses*, where the Creator is also shown at the left holding a rib in his left hand while gesturing toward two confused figures at the right, presumably Adam and Eve.[107] In the Millstatt Genesis, folio 9v, a mixed type occurs in which the Creator extracts a partially formed Eve (only a head) from Adam's left side.[108] In the *Hortus deliciarum*, folio 17r, the Creator is shown modeling Eve on the rib that he holds in his left hand. Here Eve is shown as a bust, with arms outstretched in an orant posture.[109]

Given these examples, and especially that of the Roda Bible with the Creator holding a rib while Eve already exists fully formed, it is not inconceivable that in a fuller, more detailed cycle there may have been the following hypothetical scenes: (1) the first creation of Eve fully formed from Adam's side; (2) the extraction of the rib; and (3) the building up of Eve on the rib by the Creator. These three individual scenes, then, in addition to a fourth, such as we see at San Marco,[110] where the Creator touches the fully formed, standing Eve on the shoulder while he holds her by the wrist, would explain the variations and conflations to be seen in the previously cited examples. Such a prototype would seem to be reflected in the Creation of Eve miniature on folio 3r in the early fourteenth-century Holkham Bible Picture Book now in the British Library (Add. MS 47682),[111] where the Creator at the upper left approaches Adam from Adam's right side, much in the same manner as in the Junius 11 drawing, and seems to probe carefully for the rib while touching Adam on the right forearm. Directly below, the Creator is shown bent over in the process of extracting a fully formed, orant Eve, oddly enough this time from Adam's left side. The pose of Eve in the Holkham miniature, with knees close together and slightly bent and with both hands raised above her shoulders, palm facing outward, is remarkably like that of Eve in the Junius 11 drawing.

If there are to be distinguished two creations of Eve, one showing her rising fully formed from Adam's side as favored in the Byzantine Octateuchs and the other, as found in the majority of monuments associated with the Cotton Genesis tradition, showing the creation of Eve as a series of events beginning with the extraction of the rib, and if such Cotton Genesis–related monuments as the Salerno ivory and the Berlin plaque exhibit the raising of the fully formed Eve from Adam's side, then, as Robert Bergman has suggested, the Cotton tradition in the West must have contained, or assimilated, certain elements previously associated only with the Byzantine Octateuchs at a very early date.[112] One further possibility presents itself, and that is, as Kessler has suggested, the Cotton tradition as we see it in the Cotton Genesis itself and at San Marco already represents something of a revised and emended version in which certain elements of the iconography have been altered or

deleted to conform to a more Christologically orthodox outlook. As Kessler has shown, however, many apocryphal and perhaps pure haggadic details survive in the later Carolingian paintings based on a hypothetical Cotton Genesis archetype antedating the actual Cotton Genesis.[113] Perhaps an initial scene of the extraction of Eve fully formed from Adam's side was another of these excised details of incomprehensible midrashic origin, which, nevertheless, did survive in such monuments as Claudius B.iv and the Salerno ivories.

The artist of Claudius B.iv has combined the Creation of Eve at the left on folio 6v with the Prohibition to both Adam and Eve at the right in the same horizontal framed picture space in the top half of the folio. The Creator at the left of the image, with an un-inked-in nimbus that overlaps the top of the frame, either has no facial features drawn in as yet or they have been erased at some later date. All three figures, the Creator, Eve, and Adam, have brilliant blue hair in both scenes. Adam and the Creator both sport full blue beards. The Creator is shown bending slightly at the waist as he grasps Eve on her left shoulder with his right hand while placing his left hand on her upper abdomen, or breasts, as if lifting her up out of the small orifice in Adam's right side in this scene of the first, and last, instance of male parturition. Eve's arms are extended at right angles to her body. Sadly, some later inept hand has given Eve a most unfortunate drawn-over face in both scenes. Adam, as mentioned earlier in the discussion of his creation on folio 4r, exhibits a drawn neckline as if he were wearing a T-shirt in both scenes where he and Eve are meant to be naked. Somewhat like the undulating blue hillocks on which Adam is standing in his creation scene on folio 4r, Adam reclines on a rather uncomfortable-looking outcrop of six or seven gray hillocks. Adam, as mentioned earlier in the discussion of the Creation of Eve scene, turns his head to his right in a somewhat startled, very alert pose and seems to be looking at Eve with some astonishment. Due possibly to some maltreatment or later abrasion, it is not possible to say definitely whether Adam's eyes are meant to be open or not. The exegetical implications of an open-eyed Adam have already been discussed. That Adam's "eye" in this case (there is only one represented) was originally shown "open," again with all that that might suggest exegetically, cannot, however, be totally dismissed.

At the far right of the composition stands a single tree with a blue cloud or waterlike foliage at the top and vigorously intertwined green branches and trunk, several of the branches of which at the trunk have been lopped off as on folios 5r and 6r. As the scene on folio 6v is clearly the Prohibition of Genesis 2:16–17, the tree is presumably the Tree of the Knowledge of Good and Evil, but it does not look like the tree that is represented directly across the opening on folio 7r, which has green diamond-shaped leaves atop blue intertwined branches and trunk below. So it may well be that the tree depicted on folio 6v is not the forbidden tree but perhaps the Tree of Life instead. Adam and Eve both being given the Prohibition, as Kessler has pointed out in other examples as well,[114] contradicts the Bible (Gen.

2:16), where the Prohibition is given only to Adam. But this double prohibition is found in numerous extrabiblical texts and in earlier medieval manuscript images, which, in Kessler's view, is an important piece of evidence pointing to a common link between these medieval examples of the double prohibition and a shared putative early illustrated Pentateuch.

In the Prohibition scene in Claudius B.iv, the Creator holds a tall, framed ocher-colored tablet or closed codex in his left hand as he gestures toward Adam and Eve with his right, the first two fingers of which are extended as in a sign of Christian benediction. To further differentiate this scene from the Creation of Eve at the left, the Creator is shown with different colored garments, a rust-colored himation over a blue full-length tunic instead of the flesh-colored pink himation over a gray tunic at the left.

Chronologically, the prohibition to Adam alone (Gen. 2:16–17) comes before the creation of Eve (Gen. 2:21–25), so the image should be read from right to left; but, in fact, it flows from left to right. Sadly, Eve's face has been smudged here and largely obliterated by a later hand and Adam's feet have been blackened as if he were wearing shoes. Again, Adam is shown with a drawn neckline, as is Eve as well. Both Adam and Eve again have brilliant blue hair. Eve's hair flows in two long tresses, the one on her right falling between her legs and seeming to continue in the undulating curves of the brown snake, the Tempter, that is interestingly interwoven with the vertical blue limbs of the Tree of Knowledge topped by diamond-shaped, shinglelike green leaves.[115] The Temptation scene in Claudius B.iv is closest in many of its details to the same scene on folio 7v of the Carolingian Bamberg Bible,[116] where the snake, as in other Carolingian Bible frontispieces, is entwined in the Tree of Knowledge, although not as complexly as that in Claudius B.iv. In the Carolingian examples, with the exception of the San Paolo Bible, Eve takes the fruit from the mouth of the snake, unlike Eve's action in Claudius B.iv where she plucks it herself from the tree. As in Claudius B.iv, Eve has her arms raised up at her sides in a V-shape in the Bamberg Bible and the Vivian Bible. In both the Grandval Bible and the Vivian Bible Adam is shown holding the fruit up to his mouth, as he does in the San Marco mosaics and the Millstatt Genesis (fol. 26r). The Claudius B.iv image, then, as succinct as it is, is closely related to the Cotton Genesis tradition as seen in the San Marco mosaics and the Carolingian Bibles.

The Bible says that "when they heard the voice of the Lord God walking in paradise at the afternoon air, Adam and his wife hid themselves from the face of the Lord God, amidst the trees of paradise" (Gen. 3:8). God calls for Adam and finds him hiding, and Adam says, "I was afraid, because I was naked; and I hid myself" (Gen. 3:9–10). After Adam confesses that he did indeed eat of the forbidden fruit, which he says Eve gave to him, God inquires of Eve, who says that the serpent beguiled her and made her eat (Gen. 3:13). God then curses the serpent, saying, "Upon thy breast shalt thou go and earth shalt thou eat all the days of thy life" (Gen. 3:14).

The artist of Claudius B.iv illustrates the Expulsion of Adam and Eve from paradise in a most creative two-scene depiction at the bottom of folio 7v. In the left half of the picture space he shows the Creator at the right literally shoving Adam and Eve not only out of paradise itself, pushing on Adam's bent back with his right hand, but also literally out of the frame, which surrounds the entire picture. Eve, dressed in a pea-green garment that covers her body from head to toe, echoes Adam's stooped pose as her head and extended right hand cross the frame at the far left of the composition.

In the right half of the composition, showing Adam and Eve now fully clothed and outside of paradise, is a scene identified some time ago by Otto Pächt as the archangel Michael instructing Adam,[117] and apparently Eve as well as she is shown holding a curved type of pick-axe, in the art of delving the soil, a skill they did not need in their prelapsarian state. Pächt demonstrated that this nonbiblical detail can be found in the apocryphal work known as the *Vita Adae et Evae*.

In the ninth-century Carolingian Bible frontispieces, it is an angel, sometimes wielding a sword, who drives Adam and Eve from paradise.[118] In three of the four examples the angel touches Adam on the shoulder. The Creator himself expels Adam and Eve in the San Marco mosaics as well as in the Millstatt Genesis,[119] so this is clearly a motif associated with the Cotton Genesis tradition. In the Claudius B.iv image, Adam and Eve pass behind the same flesh-colored tree seen in the illustration above of the Calling on folio 7v, only here at the Expulsion the top of the tree, looking more like clouds or water, has regained its blue color.

In scenes of the Labor of Adam and Eve, the majority of works associated with the Cotton Genesis tradition, San Marco among them, show Adam and Eve in gender-appropriate labors, Eve either spinning, as she is at San Marco, or sitting with a child on her lap, as in all four Carolingian frontispieces, and Adam engaged in working the soil with a hoe.[120] There are, however, a number of Italian works, such as the Salerno antependium, which show Eve engaged with Adam in working the soil in some kind of medieval version of equality of the sexes.[121] Whether this is a motif originating in England with a work such as Claudius B.iv and then transplanted to Italy cannot be determined. It is likely that both the Italian examples and the Anglo-Saxon example in Claudius B.iv rely on a common exemplar or model.

The scene of the archangel Michael instructing Adam and Eve is not included in the text of Claudius B.iv and is, therefore, either an addition of the artist/designer or a detail to be found in an exemplar from which the artist/designer was working. The decision to include this scene may have been motivated by Ælfric himself who, on several occasions in his homilies, puts forward the idea that God, in his mercy, "knew, however, that he [Adam] had been seduced, and meditated how he might again be merciful to him and all mankind."[122] Ælfric's text makes no reference to the specifics of the Latin *Vita Adae et Evae*, but the homiletic sentiment that God

takes pity on Adam and Eve may well have inspired the artist/designer to include this scene.

The inclusion of this scene in the Claudius B.iv, then, might be properly described as homiletic rather than exegetical as it serves to illuminate a more down-to-earth theological sentiment than it does to further "explain" some difficult or obscure point of theology implied by the biblical text of Genesis.

THE STORY OF CAIN AND ABEL

The scenes of the Sacrifice of Cain and Abel and Cain Slaying Abel (see fig. 1)[123] are illustrated in the upper half of folio 8v of Claudius B.iv. At the left of this composition the Creator is shown seated at the center on some kind of throne with a reddish-orange draping, nimbed, his left hand resting on an ocher-colored codex, his right raised in a three-fingered benediction or gesture of speech directed at a slightly bowing figure dressed in a short blue tunic with both arms and hands covered by a darker blue cloth. There is nothing visible, however, in the draped hands. To the right is a second figure, also slightly bowing, dressed in a short pink tunic, his arms and hands covered by a blue cloth, again with nothing visible in his draped hands. These two figures are no doubt Cain and Abel offering their respective sacrifices to the Creator as recounted in Genesis 4:3–5. It is not clear in the Claudius B.iv image, however, who is Cain and who is Abel as in the very next scene at the right it is clearly Cain wearing a short blue tunic and sporting mauve-colored hair who is shown in the act of slaying Abel with his distinctive upraised animal jawbone as a murder weapon (Gen. 4:8). In the left-hand composition, the figure at the far left also wears a short blue tunic and has mauve-colored hair. If this figure is Cain, then perhaps the seated Creator is not meant to be understood as blessing him and his sacrifice but instead admonishing him, as in Genesis 4:6: "And the Lord said to him: Why art thou angry? And why is thy countenance fallen?" If the scene at the left is indeed meant to represent the Sacrifice of Cain and Abel, then it is rendered in a manner most unlike the majority of such scenes in Early Christian and earlier medieval art, such as that in the drawing after the lost frescoes of San Paolo fuori le Mura in Rome,[124] where Cain and Abel are shown standing with their respective sacrifices on either side of a smoke-filled altar and with a figure of the Creator in the clouds above blessing with his right hand the figure standing at the left of the altar, who is no doubt meant to be Abel. The Claudius B.iv image does, however, correspond to another lost Early Christian image of the Sacrifice of Cain and Abel, namely, the fifth-century C.E. mosaics on the dome of Santa Costanza in Rome,[125] known also from seventeenth-century drawings in which Cain and Abel are shown presenting their offerings to a figure seated between them who is usually identified

as the Creator. In her study of Cain and Abel in art, Anna Ulrich has suggested that this seated figure was probably originally intended to be understood as Adam instructing his two sons in the necessity of showing gratitude to the Lord through appropriate sacrifice,[126] a theme encountered in a number of originally Jewish apocryphal and extrabiblical literary sources, including the later Syriac Christian text known as "The Cave Treasures" (*Die Schatzhöhle*).[127] Curiously, in her otherwise quite thorough study, Ulrich does not mention the Claudius B.iv image, but she does show that the original conception of the seated figure as Adam instructing his sons in the art of sacrifice reappears on folio 5r of the fourteenth-century English Holkham Bible Picture Book in the British Library (Add. MS 47682).[128] If Ulrich is correct in her assessment of the seated figure between Cain and Abel in a number of Early Christian and early medieval examples of this motif, then it is likely that the artist of Claudius B.iv may have altered the image to represent the seated Creator simply by adding the nimbus and the codex to convert the scene from one of Adam instructing his sons to one meant to be understood as the sacrifice itself. Perhaps the artist felt that the physical presence of the Creator between the two brothers rendered the scene more immediate and morally powerful. It is also possible that the artist was aware of the association of Cain and Abel with the theme of the Last Judgment as explicated by Robert Deshman in connection with the scene of the seated Creator on folio 2v of the tenth-century Anglo-Saxon Galba Psalter (London, British Library Cotton MS Galba A. XVIII),[129] where Cain at the right and Abel at the left proffer their respective offerings with veiled hands at the feet of the enthroned Creator. The presence of Cain and Abel at a Last Judgment is a motif with a number of ramifications, as Deshman has shown, one of which is the theme of the slain Abel as the "first of the just," whose sacrificial death at the hands of his brother was interpreted early on in the development of Christianity as a prophecy of the death of Christ at the hands of the "fratricidal" Jews.[130] This association of the death of Abel with the death of Christ has important exegetical implications for a further understanding of the scene at the right of the actual murder of Abel by Cain in the Claudius B.iv image.

In the right-hand portion of the Claudius B.iv image we see the actual murder scene (see fig. 1). Cain at the left, as described earlier, wearing a short blue tunic, barefoot, and with mauve-colored hair, grasps Abel's right forearm while raising the murder weapon, traditionally described as an animal jawbone, more specifically as the jawbone of an ass, in his upraised right hand. Abel, curiously shown naked, falls to the ground, his left leg plunging below and behind the red outlined frame of the picture, his left hand clutching his head. Surrounding Abel's head are flamelike reddish-orange markings, no doubt indicating blood from his mortal wounds. But, as Charles Wright has perceptively pointed out,[131] Abel's blood seems to water the dark branches of a treelike growth at the right of the picture that Wright has con-

vincingly connected to a number of extrabiblical sources describing the spilled blood of Abel giving rise to some kind of blight or crop of thorns as expressed in an image in the Old English *Genesis A*, which Wright correctly characterizes as a "moralizing expansion of the biblical narrative" of the "branches of sin."[132] As Wright further observes, while this image does not have any impact on the illustration on page 49 of Junius 11, the representation on folio 8v of Claudius B.iv "is as graphic a representation as one could wish."[133] Here is a good example again of how, from time to time, the illustrations in both Junius 11 and, perhaps to a slightly greater degree, Claudius B.iv act as a kind of pictorial exegesis of the biblical text, or, to put it more precisely, especially in the case of Claudius B.iv, a "tropological" moral "homily" on the greater implications of any given biblical event or personage.[134]

As mentioned earlier, Abel is shown naked in this scene of his murder. He also gives evidence of a drawn line at the base of his neck, as noted earlier in the case of the presumably naked Adam and Eve. Here, Abel's nakedness may be meant to emphasize his vulnerability as a sacrificial victim, and it might even be intended as a reference to Christ being stripped of his garments at his crucifixion (Matt. 27:35). Ulrich has noted that the pose of Cain and Abel in other images of Abel's death shows Cain grasping the arm of the fallen Abel much like the standardized image in ancient Egyptian art known as the *Niederschlagen des Feindes*, such as can be seen on the famous palette of Narmer-Menes (ca. 3000–2920 B.C.E.) in the Egyptian Museum, Cairo,[135] where interestingly the fallen foe is shown almost totally naked save for a loincloth.

Cain's murder weapon has fascinated students of the manuscript for some time. Neither the Bible nor the text of Claudius B.iv specifies how or with what instrument Cain succeeded in slaying Abel. Many exegetical traditions, both Jewish and Christian, have specified a number of different possibilities, including stoning, strangulation, and the use of a cudgel or stick, as we see on page 49 of MS Junius 11. In their publication of *Biblical Commentaries from the Canterbury School of Theodore and Hadrian*, Bernhard Bischoff and Michael Lapidge have adduced a passage from this seventh-century manuscript that is the earliest extant explication of Cain's murder weapon as the jawbone of an ass.[136] As the text itself phrases it, "Some say Abel was hanged by Cain, others that he was stoned, others that he was killed *with the jawbone of an ass*."[137] Be that as it may—and it is indeed a most important detail to have emerged only recently in the ongoing debate about the origin of this most distinctive motif in Claudius B.iv that has a long afterlife in Western art and literature—one might still want to ask, why specifically the jawbone of an ass? Henderson has advanced the hypothesis that the jawbone of an ass used by Samson to slay the Philistines may have suggested the same instrument to the Claudius B.iv artist for the slaughter of Abel.[138] Equally appropriate is Barb's perception that actual animal jawbones, or wooden sickles set with animal teeth, were used in ancient

cultures, Egypt among them, to harvest grain and that as Cain was a farmer this would be an appropriate "weapon"[139] for him to wield. In fact, in Prudentius's *Hamartigenia*, a work known to Aldelm, Bede, and Alcuin, Cain is described as killing Abel with a *sickle*.[140] It is worth recalling here as well that the ancient Greek author Hesiod, who was himself a farmer, describes the instrument used by Kronos to castrate his father, Uranos, as a "great long sickle with jagged teeth" (Gk. *harpain charcharodontia*).[141] The instrument, swung over his head by Cain in the Claudius B.iv image, however, is smooth and shows no sign of teeth and looks a bit like the much smaller "pruning" hook carried by the classical figure Sylvanus,[142] who as in a Roman relief standing by an altar might also make an interesting prototype for Cain and his instrument of death.

Further in answer to the question, why the jawbone of an ass?, another interesting possibility arises: the association of the ass, as well as the color red, with the figure of the Egyptian god Set (or Seth), the brother and slayer of Osiris.[143] Set was referred to in Greek as "Typhon" and as Typhon in the Egyptian milieu was associated with the despised ass as well as supposedly "Typhonian" types such as men with red hair. The Jews as a whole were often associated with Typhon as "Typhonians" in late Egyptian literature.[144] In an Egyptian context, then, it would be seen as appropriate to associate Cain, the first murderer, a fratricide, with a "Typhonian" murder weapon, the jawbone of an ass. As Mellinkoff has explored in her studies of the iconography of Cain,[145] he is often represented in later medieval art with red hair, perhaps again a detail reminiscent of this "Typhonian" association.

Of tangential interest but not directly illustrated in Claudius B.iv is the fact that in a late thirteenth-century English manuscript (Cambridge, St. John's College Library MS K. 26, fol. 6v), Cain is represented with two black horns on his head as a representation of the "mark" set upon him by God (Gen. 4:15).[146] In this imagery, horns definitely have a negative connotation.

Whether inspired directly by a written text, such as that of the Canterbury Commentary brought forward by Bischoff and Lapidge, or whether he found such an image already in a model or exemplar from which he was working, the Claudius B.iv artist has presented a striking and memorable image of the first murder that goes beyond its immediate biblical context to provide a number of homiletic/ exegetic possibilities to well-informed reader-viewers who could extrapolate these hidden meanings for themselves[147] or who could have been informed by a lector using the manuscript and its images as a didactic or catechetical tool.[148]

"THERE WERE GIANTS IN THE EARTH IN THOSE DAYS"

On folio 13r of Claudius B.iv illustrating the text of Genesis 6:1–4, the artist has provided a depiction of four of the "giants" referred to in the text, a very rarely il-

lustrated portion of the Genesis cycle.[149] The three figures at the left, all with blue hair and beards, turn and face in profile the fourth figure at the right, also with blue hair and beard, who faces them in profile as if addressing or responding to the other three. While larger than other figures already illustrated in the manuscript (Richard Gameson notes that while other standing figures in the manuscript are 30 mm high, these figures are 70 mm),[150] these "giants" do not at first seem gigantic, in part because there is nothing in their immediate picture plane to compare them to. They also seem remarkably calm and unthreatening. Henderson has compared these figures to the rendering of this same theme on folio 54v of the twelfth-century Seraglio Octateuch (Istanbul, Seraglio Library Cod. G.I.8). In the Octateuch miniature there are five standing figures, bearded, all facing forward in an unframed zone and carrying different kinds of weapons and shields. Of the relationship between these two images, Henderson has stated that the depiction in Claudius B.iv is "strikingly like the picture of the giants" in the Octateuch manuscript.[151] Dodwell, on the other hand, disputing Henderson, has pointed out that the two images are very different— five armed figures in the Octateuch image in contrast to four unarmed figures in Claudius B.iv—noting that what they have in common is only the simple fact that the figures are standing against a neutral background without accompanying figures or background detail.[152] While that may be true at one level, it is uncanny that both images have eschewed any opportunity for narrative drama when in fact depicting the ominous possibilities of potentially violent and dangerous giants would surely have been an interesting prospect, especially when one thinks of classical and Hellenistic artistic representations of the Gigantomachy theme such as the sculptures of the temple of Zeus at Pergamon now in Berlin.[153] However, an intriguing exegetical rationale presents itself in Philo of Alexandria's treatise *De gigantibus*,[154] where the Jewish philosopher and exegete says of the phrase "And there were giants on the earth in those days" (Gen. 6:4), "Perhaps some one may here think, that the lawgiver [Moses] is speaking enigmatically and alluding to the fables handed down by the poets about giants."[155] Quite the contrary, describing Moses as a "man as far removed as possible from any invention of fables,"[156] and, interestingly, remarking that as a corollary to this abhorrence of fables "he has banished from the constitution (i.e. the Law), which he has established[,] . . . those celebrated and beautiful *arts of statuary and painting*, because they, falsely imitating the nature of the truth, contrive conceits and snares."[157] Therefore, "he (Moses) utters no fable whatsoever respecting the giants."[158] Thus, unlike the pagan poets and artists who reveled in depictions of all the hyperbole and drama of the Gigantomachy theme, Moses presents, according to Philo, in this guise of mentioning the giants of old, a thesis about the nature of mankind that there are basically three types of men: those born of the earth who pursue the pleasures of the body; those born of the heavens who are "men of skill and science and devoted to learning"; and those born of God who

are priests and prophets who have risen above the things of this world and have "fixed their views on that world which is perceptible only by the intellect."[159] It might be possible to see the three sober-looking "giants" in the very odd Claudius B.iv illustration, two at the left and one at the right, as representing the three classes of mankind outlined by Philo perhaps being engaged in some kind of dialogue by the more elaborately dressed fourth figure toward the center with both arms upraised and distinguished by a more fulsome pea-green cape.

As for the heavily armed analogue giants on folio 54v of the Seraglio Octateuch, an entirely different philological/exegetical context may be discerned, and that has to do with philological issues related to the word translated as "giants" in various biblical texts, including Genesis 6:4. The Hebrew word *Nephilim* is usually translated as "giants" at Genesis 6:4 and Numbers 13:33. In Ezekiel 32:27, a similar biblical Hebrew word with different vowel sounds is used to refer to dead and fallen Philistine *warriors*.[160] The famous biblical scholar Julius Wellhausen has described Genesis 6:1–4 as a "cracked boulder," while Hermann Gunkel referred to this strange and incomplete passage as "a torso" or "a fragment."[161] In any event, *Targum Neofiti*, the only extant manuscript of the Palestinian Targum to the Pentateuch, thought to date from the first to the fourth centuries C.E., renders the term *Nephilim* as "warriors," so that Genesis 6:4, rather than saying, "Those were the mighty men who were of old, men of renown," says instead, "These were the *warriors* of old, the men of renown."[162] The Octateuchs in general have been shown to reflect in their illustrations a wide range of Jewish extrabiblical texts, *targumim*, *midrashim*, and pseudepigrapha among them, which has led some scholars to posit an illustrated Jewish exemplar incorporating these motifs standing behind the later Christian manuscripts such as the illustrated Byzantine Octateuchs.[163] Other scholars, however, have emphasized how much of this Jewish extrabiblical lore was already known to early Christian writers and theologians.[164] In any event, the somewhat strange illustration of the "giants" on folio 13r of Claudius B.iv does seem to reflect the oddly restrained, antitheatrical allegorization by Philo of this equally strange biblical episode, and it is one of several distinctive scenes in Claudius B.iv that have been most satisfactorily explicated by reference to the exegetical writings of Philo.

THE STORY OF NOAH

At the upper left of the illustration on page 65 of Junius 11, God is shown without a halo and wearing a crown, his right hand raised in a gesture of speech or blessing toward the figure of Noah at the right.[165] Both figures stand on a wavy ground line, and the entire drawing is in brown ink. On folio 13v of Claudius B.iv,[166] God is

shown at the left also carrying a codex, although in his right hand rather than in his left as in the Junius 11 image. The Claudius B.iv figure does not wear a crown, but he also does not have a halo.[167] Noah stands at the right in a pose quite similar to that of the Junius 11 figure.

On the Salerno plaque, God is also shown at the left in human form, an unusual characteristic, as Bergman has pointed out, that the Salerno ivory shares with Junius 11 and the Roda Bible,[168] among others. Noah is shown at the right in a pose similar to that of Noah at San Marco[169] and in the Junius 11 and Claudius B.iv images.

At the bottom of the Junius 11 illustration, Noah is shown working alone on the unfinished hull of the ark. He works with a peculiar axlike cutting instrument identical to that wielded by Tubalcain on page 54, and identical as well to the instrument in Noah's hands on folio 13v of Claudius B.iv. Noah works alone in both Claudius B.iv and Junius 11. This is also true of the drawing on folio 21 of the Millstatt Genesis,[170] in contrast to the Salerno image and the Octateuchs where Noah is shown supervising a group of workmen.[171] As Cope has already suggested,[172] the idea of Noah working alone may be a reference to a haggadic detail known in Christian legend that God commanded Noah to work in secret and to tell no one what he was up to. This detail is not found in the text of Junius 11.

The presence of the Creator in human form ordering Noah to build the ark, as Bergman has indicated,[173] provides an essential link between the Junius 11, Roda Bible, and Salerno representations, which distinguishes them from the Cotton tradition, as we see it at San Marco, and the Byzantine Octateuchs.[174] Bergman does not observe, however, that the presence of God in human form is also to be seen in Claudius B.iv. While the Salerno and San Marco representations of the building of the ark show Noah supervising a group of workmen, with special emphasis on the sawing of a large plank,[175] Bergman does not observe that the shaping of an equally large plank with an ax or adz is, in addition to the sawing of another plank, a prominent feature of the building of the ark as we see it in the drawings after the lost frescoes at San Paolo fuori le Mura in Rome.[176] It would seem that the Junius 11 and Claudius B.iv artists focused on the ax-wielding motif, substituting an instrument of specifically Anglo-Saxon currency, as we see an identical instrument, as pointed out already by Gollancz, represented on the Bayeux Tapestry.[177]

The double drawing on page 65 of the Junius 11 illustration is related, then, to a specific variant of the Cotton Genesis tradition as we see it in the Salerno ivory, with an anthropomorphic Creator figure ordering Noah to build the ark. The planing of a board with an axlike instrument occurs in the Junius 11 image and that on folio 13v of Claudius B.iv, with the addition in both drawings of the ark as a hull-like form.[178]

The Junius 11 drawing shares with Claudius B.iv the depiction of the Ark on folio 14r as a three-tiered structure resting on top of the hull of an animal-prowed

vessel. By contrast, the sixth-century Vienna Genesis,[179] for example, shows the ark as a three-tiered ziggurat-like structure without any reference to a ship's hull. The drawings after the fifth-century fresco cycle at San Paolo fuori le Mura show the ark as a boxlike form (*kibotos*) with a lid.[180] The Junius 11 illustration shares with the San Paolo drawing the detail of the ladder, although the San Paolo image shows the disembarkation rather than the entry into the ark.[181]

While not necessarily the first representation of Noah's Ark as an actual ship,[182] the Junius 11 illustration is certainly one of the most prominent and imaginative in the West before the twelfth century.[183] The relationship of the dragon-head prow of the Junius 11 image to Viking art has been made much of,[184] yet dragon-prowed ships can be seen already in the Utrecht Psalter[185] and other Carolingian manuscripts, as Cope has pointed out. The prominent red dots along the gunwale of the Junius 11 ark may give us a possible source for the animal-prowed ship form. On folio 9v of a ninth-century Carolingian manuscript of Cicero's *Aratea* (London, British Library Harley MS 647),[186] known to have reached Canterbury by the late tenth century,[187] we see the constellation Argo as a large boat with mast and two oars surmounted at the bow by a large, curvilinear prow suggestive of an animal form. In an early eleventh-century Anglo-Saxon representation of the same constellation,[188] based in fact on the Carolingian image in Harley MS 647 (London, British Library Cotton MS Tiberius B.v, fol. 40v), the artist has made the ship not only more architectural by the addition of a small edifice above-decks but also more animated by the elaboration of the prow into a great, horselike animal head with curling tongue, an elaboration suggested in the Carolingian model. In addition, the Anglo-Saxon artist has transformed what appears to be a skimpy pennant on the mast of the Carolingian ship into a rich and elegant draped sail. With a certain relentless pragmatism that characterizes much of the Anglo-Saxon attitude toward representation, the hull of the ship has not only been provided with lapstraking in place of the textured in-fill of the Carolingian image, but each multicolored board of the hull is secured with a neat row of nails along its top edge. The elaborate horse's head with curling tongue and mane is very close indeed to the shape of the prow on the ark of Claudius B.iv on fol. 14r. The prominent red stars along the gunwale of the Tiberius B.v image might be seen as a possible source for the similar red dots along the edge of the gunwale of the Junius 11 vessel.[189]

The drawing of the completed ark, then, on page 66 of the Junius manuscript is an invention of the Anglo-Saxon artist that in the majority of its details probably was not based on any biblical illustration. The drawing as a whole corresponds to the text of the poem on pages 66 and 67. The Junius 11 artist may have based his depiction of the ark as an animal-headed vessel on an image similar to the Argo constellation of Cotton Tiberius B.v, a connection suggested by the prominent red dots along the gunwale of the Junius 11 drawing and the red dots indicating stars

in the Tiberius B.v image. The superstructure of the ark in its three-tier arrangement may reflect the biblical description, while the building as a whole with its weathercocks and tiled roofs may have been intended to suggest the typology of the ark as church. The presence of the two six-winged angels at left and right could also establish a suggestion of the ark as the Ark of the Covenant. The image of the ark as a whole in the Junius 11 illustration has its closest visual parallel with that on folio 14r of Claudius B.iv, suggesting some closer relationship between the two manuscripts at this and other points, perhaps through a shared model or models.

The Junius 11, Claudius B.iv, and Salerno images share with the Cotton Genesis itself[190] and the San Marco mosaics[191] the double depiction of the ark on the waters, thus suggesting something more than a coincidental relationship between these five monuments. That the Junius 11 image of God closing the door of the ark is shared *only* by the Salerno ivory tends to suggest an especially strong relationship between these two monuments probably by means of common sources.

The depiction of the ark afloat on the waters on folio 15r of Claudius B.iv includes an interesting extrabiblical detail in the representation of the raven sent out by Noah in Genesis 8:7, which, according to the Bible, does not return, shown in the illustration perched on a blue-haired and bearded human head, apparently engaged in plucking out the eyes thereof, while the head itself seems to be impaled on a pole that rises up behind the animal-headed prow of the ark. Milton Gatch in his perspicacious 1975 article demonstrates how the so-called *Genesis A* poem included in Junius 11 and the illustration on folio 15r of Claudius B.iv share this curious extrabiblical detail, possibly of Jewish origin, that seeks to explain why the raven does not return to Noah but instead feasts on the drowned corpses created by the Flood.[192]

While Gatch suggests that the impaling of the severed head on a pole may be related to actual Anglo-Saxon battle traditions,[193] viewing the image at the greater magnification afforded by the digital images of the manuscript available on the British Library website suggests that the drawing of two vertical parallel lines creating the supposed "pole" may in fact be later additions, as they seem to extend behind and slightly below the animal-headed prow and do not all together relate smoothly with the prow itself. It may be, then, that the raven and its prey were originally "floating" in space above the ark, as in Gatch's later twelfth-century example of a similar motif on folio 1r of the Avila Bible (fig. 9 in Gatch's article).[194]

The drawing on page 73 of Junius 11, then, has been shown to be related in certain ornamental details to the Cotton Genesis tradition as we see it in the Cotton Genesis itself. At the same time there are even stronger affinities to that branch of the Cotton tradition represented by the Salerno ivory, for example, the diamond pattern on the sides of the ark, the pose of Noah as he leaves the ark, and, most important, the presence of the Creator in human form at the disembarkation, a detail

that both monuments share as well with Claudius B.iv on folio 15v (see fig. 2). And finally, the Junius 11 drawing represents the attempt of a second artist to create a synthesis between the striking innovation of representing the ark as a ship initiated by the first artist and what was apparently a quite different form in the model.

Both Junius 11 and Claudius B.iv display the first extant Western versions of Noah's Ark represented as a ship instead of the traditional *kibotos*. The first extant images we have of Noah's Ark as a ship are Egyptian, for example, from the so-called Chapel of Peace in the necropolis at El-Bagawat of the fourth and fifth centuries C.E. (see fig. 3).[195] The representation of Noah's Ark on folio 15v of Claudius B.iv with its double animal-headed prow and stern is reminiscent as well of the double animal-head prow and stern of Egyptian sacred arks associated with various festivals, as can be seen in a fourth-century B.C.E. wall relief from Karnak (fig. 7),[196] such as that honoring the goddess Isis, called in Roman practice the Navigium Isidis.[197] The late twelfth-century mosaics in the Cathedral of Monreale, Italy, also depict the ark as having two upwardly curved identical prow and stern, much like the ark in the El-Bagawat fresco in Egypt (see fig. 3), with the exception that the Monreale ark does not have the animal-headed prow and stern of the Claudius B.iv image, and the Barque of Amun depicted in the relief from Karnak, also in Egypt (see fig. 7). Western medieval examples of ships with animal-head prows (so-called Viking ships) do not generally have the two animal heads, prow and stern, that we see in Claudius B.iv and the Barque of Amun at Karnak, although there are animal-headed prows and sterns on the representations of some of the ships on the so-called Bayeux tapestry.[198] In addition, as Contessa has shown, the ark on folio 15v of Claudius B.iv (see fig. 2) shares with a number of other Western medieval examples, including the mosaics of San Marco, the curious distinction of representing the ark resting on twin mountain peaks, one called "Qardunia" and the other "Armenia," a detail to be found, according to Contessa,[199] only in the *Pseudo-Jonathan Targum*, an eighth-century C.E. Aramaic translation of the Bible based on second- and third-century sources. In this lively scene in Claudius B.iv showing Noah raising the roof of the topmost portion of the ark while gesturing with his left hand toward the blue-robed figure of the Creator to the right, Noah's sons and their wives, along with pairs of animals and birds, are shown below leaving the open door of the ark. Curiously, just below God's right foot at the top of the scene is a single snake with a curling tail, the only creature shown without a mate!

CONCLUSION

Having surveyed how the artists handled major narrative events from the earlier portion of the Genesis cycle of Claudius B.iv, I can now venture some general con-

clusions about the nature of the task of providing images on such a large scale in this important document of late Anglo-Saxon culture. In the end, it can be said that the relationship of the illustrations in Claudius B.iv to the text they accompany is complex and not subject to any one general principle. Contrary to C. R. Dodwell's opinion that the majority of its illustrations were inspired directly by its Old English text,[200] more recent studies of the manuscript have demonstrated that the illustrations of Claudius B.iv exhibit a not unfamiliar wide-ranging mix of motifs derived in part from various preexisting pictorial models.[201] Some of the latter belong to well-known traditions of Early Christian biblical illustration, such as that associated with the fifth-sixth-century "Cotton Genesis" manuscript now in the British Library (Cotton MS Otho B.vi),[202] while others are derived from sources similar to the eleventh- to twelfth-century Byzantine Octateuchs,[203] and some have also been associated with the seventh-century Ashburnham Pentateuch (Paris, Bibliothèque nationale, nouv. acq. lat. 2334),[204] as well as images that were created de novo for Claudius B.iv, reflecting at times specific idiosyncrasies of the Old English text they accompany.[205] In addition, some motifs in the manuscript's illustrations have been inspired by texts outside of Claudius B.iv, coming instead from extrabiblical, so-called apocryphal texts as well as theological commentaries.[206] A good example of this aspect of the illustrations is the depiction of Jacob's Dream at Bethel (Gen. 28:11–18) on folio 43v, where Carl-Otto Nordström has shown that, while the biblical text says that Jacob used a stone as a pillow, the illustration in Claudius B.iv has Jacob asleep on four stones, which relates the image to a midrashic interpretation that held that Jacob in fact slept on four stones, each one symbolizing three of the twelve tribes of ancient Israel.[207] It is highly unlikely that the monastic artist of Claudius B.iv was familiar with such a text and more likely that the image he drew was based on an earlier, possibly quite ancient illustrated exemplar.

As I demonstrated earlier, the scene of the Creation of Eve on folio 6v of Claudius B.iv is close in its details to the Octateuch-inspired depiction of this event in the lost fifth-century frescoes of the Church of San Paolo fuori le Mura in Rome as represented in a seventeenth-century drawing done from the lost original.[208] This mode of representing a fully formed Eve rising from Adam's side is quite different from that of the Cotton Genesis–inspired rib extraction operation as shown in the later thirteenth-century mosaics of San Marco in Venice.[209] As suggested earlier, the Octateuch-inspired full-body form of the creation at San Paolo may have in turn, in the Octateuchs themselves, been recycled from a motif showing a sleeping Alexander the Great behind whom stand the allegorical figures of the Nemeseis as shown on a third-century C.E. coin from Smyrna.[210]

On the other hand, as Dodwell pointed out in his commentary to the 1974 facsimile of Claudius B.iv, a scene such as that on folio 92v showing Moses's sister Miriam and the Daughters of Zion celebrating the defeat of Pharaoh and his

armies by playing on *harps* as specified by the Old English text, rather than the "timbrels" (*tympana*) of the Vulgate (Exod. 15:20–21),[211] shows how some, but by no means all, of the illustrations reflect specific details of the Old English text they accompany.

Other motifs, such as the striking image of the Fall of Lucifer on folio 2r (see fig. 4) of Claudius B.iv, where Lucifer is shown grasping with both hands his mandorla frame as he plunges into the depths of Hell, have been characterized by previous scholars, myself included, as outstanding examples of Anglo-Saxon artistic inventiveness,[212] but, as suggested earlier, they may well have been inspired by Late Antique pagan iconography, such as depictions of Aion grasping with one or two hands his own zodiacal frame in mosaic examples as well as that on the fourth-fifth-century C.E. Parabiago patera from Milan (see fig. 5).

And finally, there are motifs derived from so-called apocryphal texts such as the *Vita Adae et Evae*, as seen on folio 7v of Claudius B.iv, where a postlapsarian Adam and Eve are shown being instructed by the archangel Michael in the unfamiliar art of delving the soil. In addition, extrabiblical theological texts and commentaries have possibly influenced the illustrations of Claudius B.iv, such as on folio 8v where Cain is depicted for the first time that we know of slaying Abel with an animal jawbone, which we now know, thanks to the work of Bischoff and Lapidge, may have been derived from the biblical commentaries of the Canterbury school of Theodore and Hadrian (Milan, Biblioteca Ambrosiana M. 79).[213]

In the case of Cain and Abel, a number of illustrations in Claudius B.iv show traces of some of the earliest types of Christian biblical imagery, such as the representation of the Sacrifice of Cain and Abel on folio 8v of the manuscript, where the two brothers are shown flanking an enthroned figure of the Creator, as in the lost fifth-century C.E. mosaics in the Church of Santa Costanza in Rome, in contrast to the majority of later medieval representations of this scene showing Cain and Abel either flanking an altar or both standing to one side or another of an altar. As was stated at the beginning of this study, Francis Wormald, speculating on the nature of Claudius B.iv's model, concluded succinctly that "it was ancient and it was exotic."[214]

I have also demonstrated that there are a number of "Egyptianizing" elements in the illustrations of Claudius B.iv, among them the association of Cain with the hated "Typhonian" aspects of the Egyptian god Set, possibly reflected in the specific choice of the jawbone of an ass as his murder weapon; the representation of Noah's Ark as a boat, a motif first encountered in Early Christian Egyptian art; and the representation of the shrouded body of Joseph in a mummylike manner, as noted by Henderson.[215]

As demonstrated in the chapters that follow, the specific representation of Moses himself in Claudius B.iv exhibits as well a number of the most distinctive

"Egyptianizing" motifs in the manuscript as a whole. The very first appearance of Moses in the manuscript, at his birth, at the upper right on folio 75r (fig. 8), is an excellent example of the Egyptianizing element I am speaking of, as well as the appropriation of other striking visual motifs that have no basis in either the Bible or its Old English translation in Claudius B.iv. In an unfinished outline drawing at the upper right of the illustration on folio 75r (fig. 8), the newborn Moses is shown being given his first bath, an extrabiblical motif possibly related to earlier Anglo-Saxon manuscript examples of the first bath given to the Christ child, as seen at the bottom of folio 85r of Oxford, Bodleian Library MS Rawlinson B. 484 (once part of the tenth-century Galba Psalter in London, British Library, Cotton MS Galba A. xviii), an originally Byzantine motif based on accounts of the Nativity in extrabiblical, "apocryphal" writings.[216] The Byzantine motif itself is based on popular visual antecedents showing first bath scenes of pagan divinities and heroic infants such as Dionysus, Achilles, and Alexander.[217] In a mosaic of the fourth century C.E. from the so-called House of Aion at Nea Paphos, Cyprus, for example, a seated figure of Hermes with a winged diadem on his head is shown holding the nimbed figure of the infant Dionysus on his lap while two female figures at the left prepare the infant god's first bath in a cylindrical metal tub.[218] The artist of Claudius B.iv could have derived this motif either from an earlier Anglo-Saxon example of the Nativity of Christ (of whom Moses has been traditionally seen as a forerunner or antetype) or equally from a more ancient exemplar, which had in turn adapted this motif from a "pagan" example such as the Nea Paphos mosaic.

Ernst Kitzinger, in an article on the Hellenistic heritage in Byzantine art, while suggesting that Byzantine depictions of the first bath of the Christ child may have been influenced by secular depictions of the first bath of Byzantine imperial offspring, counters his own argument by observing that this is not likely the case with respect to the cycle of scenes from Genesis in the atrium mosaics of San Marco in Venice, where the first bath motif appears in scenes of the birth of Ishmael and Isaac.[219] Even though these scenes are only partially preserved in the so-called illustrated Cotton Genesis manuscript (London, British Library Cotton MS Otho B.vi) dating to the fourth or fifth century C.E.,[220] on which the iconography of the San Marco mosaics has been shown to be largely dependent,[221] Kitzinger suggests that Old Testament illustrations, such as those in the Cotton manuscript, which have been said by Weitzmann and Kessler possibly to have originated in Alexandria or Antinoë, Egypt,[222] may have been the conduit for "recycled" pagan depictions of the first bath motif of Dionysus, Achilles, Alexander, and others.[223] Kitzinger illustrates a late fourth- or fifth-century C.E. Egyptian textile from Antinoë in the Louvre with the motif of the first bath of Dionysus.[224] To the best of my knowledge, the illustration on folio 75r of Claudius B.iv (see fig. 8) may be the only known depiction of the first bath of Moses in Western medieval art,[225] although it is depicted

in the Byzantine Octateuchs of the eleventh and twelfth centuries,[226] themselves based on much earlier exemplars, and is possibly an important indicator of the antiquity of the putative exemplar on which the eleventh-century Anglo-Saxon artists are relying.

At the bottom left of the illustration on folio 75r of Claudius B.iv (fig. 9), two female figures are shown holding the "basket made of bulrushes" that the Bible (Exod. 2:3) says Moses's mother had made for him and launched him in the "sedges by the river's brink." The Bible says nothing about the specific shape of this "basket" (Heb. *tebah*; Vulg. *fiscella*; OE *windel*). In the mural paintings of the third-century C.E. synagogue at Dura-Europos, and in later early medieval Christian manuscript images, the "basket" is represented as an arklike chest or box (Gk. *kibotos*).[227] The Claudius B.iv image, however, has the distinct double-ended, upward curved prow and stern of a traditional Egyptian papyrus-reed boat such as can be seen, among a number of possible examples, in the famous Nilotic mosaic of the second to first century B.C.E. in the Museo Nazionale Prenestino in Palestrina, Italy,[228] and in the depiction of Noah's Ark from the Chapel of Peace at El-Bagawat, Egypt (see fig. 3). In no other Jewish or medieval Christian example that I know of is Moses's "basket" made to look like this. The two images, then, on folio 75r (fig. 8), the "first bath" of Moses at the upper right[229] and the "basket" of Moses at the lower left (fig. 9), are powerful initial examples of the potential antiquity and specificity of a much earlier exemplar being utilized by the eleventh-century artist(s) of Claudius B.iv, an exemplar exhibiting, on the one hand, adaptations of visual imagery originally relating to "pagan" gods and heroes (e.g., the first bath motif) and, on the other, imagery of a distinctly "Egyptianizing" variety (e.g., Moses's papyrus-reed basket).

"And there arose no more a prophet since in Israel like unto Moses . . ."

The artist or artists of Claudius B.iv have given Moses nine distinctive visual attributes that, coupled with four additional motifs that associate him with major figures of pagan Greco-Roman culture, expand his identity beyond that presented in the Bible.[1] A closer examination of these attributes reveals not only important information about potential pictorial sources being utilized by the artists for their illustrations but also *how* these illustrations function in the manuscript as a kind of visual exegesis that adds important interpretive content amplifying the meanings communicated by the written words they accompany.

Of the nine attributes unique to Claudius B.iv, the two horns on Moses's head on folio 105v are perhaps the most striking (fig. 10). In addition, in the same image Moses holds in his right hand the Tablets of the Law, represented here for the first time that we know of with their familiar rounded tops.[2] Moses is also shown on folio 105v holding in his left hand, rather strangely it would seem, the veil with which the Bible says he covers his face when addressing his people (Exod. 34:33–35).[3] Moreover, in a detail unremarked by previous students of the manuscript, Moses is shown seated at the lower left on folio 136v (fig. 11) displaying on his forehead the priestly frontlet (Heb. *tzitz*, Vulg. *lamina*) described in the Bible at Exodus 28:36–38 but, interestingly, not in the Old English text of Claudius B.iv.[4] Further, Moses is shown on folio 138v (fig. 12) with a curious knotted cloth headband, or diadem, on his forehead at the base of his horns. Moses is also given a snake-headed staff to carry, as we see on folio 78v (fig. 13), where the snake is shown as having *ears*, and which Moses continues to carry throughout the remainder of the manuscript, as Barnhouse has pointed out,[5] despite the fact that the Bible

says at Exodus 3:4 that the "snake" turned back into a stick. We might note here that a later hand, who we now know, thanks to the work of Alger Doane and William Stoneman, is the monk "Normanus,"[6] has added inked-in horns on Moses's head on folio 78v *before* his second trip to Mount Sinai. From folio 105v (see fig. 10) to his final appearance on folio 139v (fig. 14), Moses is shown consistently barefoot like a pagan Isis priest such as we see on a second-century C.E. Roman relief now in the Vatican Museums (see fig. 30). These eight attributes are without extant precedent in earlier medieval art. Two additional attributes of Moses in Claudius B.iv, however, do have earlier extant pictorial precedents: Moses shown as a giant, on folio 139v (fig. 14), similar to the outsized Moses depicted in the third-century C.E. frescoes of Dura-Europos in Syria,[7] and Moses shown seated on a bejeweled "mountain-throne," or rock, at the bottom left on folio 136v (see fig. 11), somewhat similar to an image of Moses seated on what appears to be a rock on folio 216v of the twelfth-century Smyrna Octateuch manuscript,[8] a motif possibly associating Moses with images of the god Apollo sitting on the omphalos at Delphi as on a third-second-century B.C.E. Hellenistic coin (fig. 15).[9]

Three additional motifs in the illustrations of Claudius B.iv associate Moses with major figures of pagan Greco-Roman culture. Moses is shown on folio 124r (fig. 16) with a distinctive vertical rendition of the Brazen Serpent recounted in the Bible (Num. 21:8), lending him the appearance of the healing god Asclepius (fig. 17) with his vertical, snake-entwined *bakteria*.[10] In addition, Moses is shown on folio 75r (see fig. 8) being given his first bath like the pagan god Dionysos and the heroes Achilles and Alexander the Great. And finally, the "basket" in which Moses is placed by his mother at the top of folio 75r (see fig. 9) is represented like a curved, double-ended Egyptian papyrus "bundle raft," unlike the usual box or chest represented in other early medieval renditions of this scene.[11]

Three hypotheses can be adduced to explain the appearance of a horned Moses on folio 105v of Claudius B.iv. The first is Mellinkoff's idea in her pioneering 1970 study, *The Horned Moses in Medieval Art and Thought*, that the image was suggested to the artists by the words of the Old English text before them (fol. 105r) that Moses did not know that he was "gehyrned,"[12] that is, "horned." With specific reference to the Old English text, as noted by Dodwell,[13] it is important to recognize that the text says simply that he was "horned," making no reference to Moses's "face" as in the Vulgate, Exodus 34:29 (*cornuta esset facies sua*). Where, one might ask, would the artists find an appropriate image for the state of being "horned"? And what would the phrase "was horned" mean to an eleventh-century Anglo-Saxon artist or audience? Mellinkoff's suggestion is that positive associations with northern horned helmets, coupled with an Anglo-Saxon literary image of Moses as a military leader and the commander of the Jewish people, would predispose the artists to adapt the horns of such helmets to an image of a horned Moses.

Mellinkoff's association of the horns of Moses in Claudius B.iv with the horns of northern European helmets seems at first to possess an inherent appropriateness, since Moses is often referred to in Old English texts as *se maera heretoga*, the "Great Commander," emphasizing his prowess as a military leader of the Jewish people.[14] And, as Sarah Larratt Keefer has emphasized, Ælfric, in his *Treatise on the Old and New Testament*, refers to Moses as the "Great Commander," even when he is speaking of Moses's writings.[15] Unfortunately, the horns of Moses in Claudius B.iv bear no resemblance to the examples Mellinkoff illustrates.[16]

In the first place, the two double-curved yellow horns atop Moses's head rise up directly in front of what at first looks like a smooth, uncolored caplike hair covering rather than emerging from the sides of a conical, presumably metal, helmet. There are many numismatic examples of metal helmets with double-curved horns emerging from them on the heads of Hellenistic emperors, such as a tetradrachm showing Seleucus I Nicator of the fourth-third century B.C.E. (fig. 19).[17] But the configuration of elements on Moses's head in Claudius B.iv does not exactly resemble this example; there is no visual evidence that Moses's head is actually covered by a horned helmet or headdress, and there is no indication that if there is indeed some kind of head covering or helmet it is meant to be metal, as the space between Moses's horns is not colored in. Moses's "helmet" is also lacking the cheek pieces of the Seleucid example. But perhaps these oversights can be attributed to the Anglo-Saxon artist's lack of skill or lack of knowledge about what he might be looking at in some putative ancient model or exemplar. There are, however, examples of coins minted for Seleucus II (Callinicus, 246–225 B.C.E.) showing the ruler in a frontal view with short, double-curved bull's horns emerging at the sides of his head above a diadem.[18]

The Seleucid examples are appealing primarily from the point of view of the shape of the upright double-curved bull or steer horns associated with a supreme military commander, or *strategos*, as Moses had been characterized by Josephus and other Jewish writers.[19] The Seleucids, successors to Alexander the Great whose depiction with downward-curving ram's horns links him with the Egyptian god Ammon, adopted the upward curving bull's horns as a sign of Alexander-like divine paternity. While she illustrated the better-known numismatic images of Alexander and his downward curving ram's horns as a prime example of the importance of horns as a sign of divinity in the ancient world, Mellinkoff overlooked the visually more apposite upward curving horns of the Seleucids in her search for prototypes of Moses's horns on folio 105v of Claudius B.iv.[20] On the other hand, for a variety of reasons, these horned images of Seleucid rulers, while displaying vertical, double-curved bull's horns, do not precisely resemble the horns of Moses in Claudius B.iv.

The fact that the horns are painted yellow on folio 105v (fig. 10) is probably the result of wanting to connect them with the idea of "radiance" or horns of "light,"

which is how many interpreters, beginning with Pseudo-Philo in the first century C.E.,[21] would like to understand the problematic horns of Exodus 34:29.

A second hypothesis is that the Anglo-Saxon artists found a horned Moses in a no longer extant exemplar, or model, from which they extracted other images to use in their illustrations. If that were the case, what kind of "model" was it, and how do we account for the differences between the way the horns of Moses are represented the first time, on folio 105v (fig. 10), and the last time, on folio 139v (fig. 14)? It is possible that there were two different "models," each showing Moses's horns differently: model A showing Moses with horns and what, at first, seems to be an uncolored-in "coif" or cap as on folio 105v and model B showing Moses's head without the coif, revealing hair between his horns, as well as showing the horns as taller, rather flat, and rising up from behind some kind of headband or diadem as on fol. 139v.

"Models" and "exemplars," of course, belong to a vocabulary based in large part on the methodology of picture criticism articulated by Kurt Weitzmann in his magisterial *Illustrations in Roll and Codex*,[22] a methodology, despite its flaws, that remains a valid approach to understanding medieval book illustration. As mentioned earlier, there are numerous examples in Claudius B.iv demonstrating that the artists turned at times to well-known pictorial prototypes in providing illustrations for their text, some of the images going back to the earliest formulations of Christian iconography. A good example, as mentioned earlier, is the representation of the Sacrifice of Cain and Abel on folio 8v of Claudius B.iv (see fig. 1), where God is shown seated between the two standing brothers in a manner most unlike the majority of later medieval representations of this scene but, as Anna Ulrich has demonstrated, very close indeed to the representation of the same scene, for example, in the lost mosaic cycle of the ceiling of the fifth-century C.E. Church of Santa Costanza in Rome.[23] To the right of the illustration of the Sacrifice of Cain and Abel on folio 8v of Claudius B.iv is the scene of the Slaying of Abel (Gen. 4:8) with what several students of the manuscript have identified as an animal jawbone, specifically, the jawbone of an ass.[24] While the ultimate visual origin of this non-biblically sanctioned motif remains unclear, compelling evidence of a possible Egyptian origin has been proposed.[25] As Ulrich has also noted,[26] Cain's pose with right arm raised holding a sicklelike weapon while grasping the right arm of his fallen victim, Abel, is quite familiar in Egyptian art, going as far back as the famous Stele of Narmer-Menes (ca. 3000–2920 B.C.E.) in the Egyptian Museum, Cairo, showing the triumphant Pharaoh as slayer of Egypt's enemies. These and other Egyptianizing motifs in the illustrations of Claudius B.iv invite us to look to Egyptian sources as a possible origin of the horns of Moses, as horns abound in Egyptian iconography as symbols of divine power and status for both gods and kings. It should be recalled at this point that Kurt Weitzmann and Herbert Kessler, in their 1986 study of the Cotton Genesis (London, British Library Cotton MS Otho B.vi), concluded that

in its iconography Claudius B.iv is a rather conservative member of the Cotton Genesis iconographic tradition, exhibiting, in their opinion, many features quite consistent with that fifth-sixth-century C.E. illustrated Greek manuscript, which, along with its prototype, has been thought to have originated in Christian Egypt, perhaps at Alexandria itself or possibly Antinoë.[27]

The probability and extent of Egyptian or Coptic influence on northern medieval manuscript art in particular is a much debated and still open question.[28] The clouded picture of the arrival of Christianity in Egypt and its early growth there has been a persistent aspect of the problem.[29] Renewed interest in the Egyptian context has been sparked by the discovery and translation of the Gnostic texts at Nag Hammadi.[30] Individual studies, such as Gary Vikan's work with the iconography of Coptic textiles,[31] have called attention to the importance of Christian Egypt as a source of iconographic and stylistic motifs with long afterlives in European medieval art. Recent work by Michelle Brown has revealed numerous iconographic connections between ancient and later Christian (Coptic) Egypt and Insular monastic culture and art.[32] Adelheid Heimann's explication of the late Egyptian and Coptic sources of the *Sphaera Apuleii* drawings of Life (*Vita*) and Death (*Mors*) in the mid-tenth-century Anglo-Saxon Leofric Missal at Oxford (Bodleian Library MS 579),[33] with Death represented on folio 50r (fig. 24) with two double-curved horns on top of his head similar to the double-curved horns on Moses's head on fol. 105v of Claudius B.iv (fig. 10), brings us to the important question of the probability of similar sources lying behind Claudius B.iv.

Alternatively, the eleventh-century Anglo-Saxon artist, or artists, of Claudius Biv might have appropriated the image of Mors directly from the earlier Leofric Missal image itself and adapted it to the needs of the text of Claudius B.iv where Moses is described as "gehyrned."

A number of difficult points are associated with positing a hypothetical Egyptian, or Egyptian-influenced, origin for the image of a horned Moses. One of them is the fact that the illustrations of the Cotton Genesis manuscript accompany a Greek Septuagint text, and, if it ever had an accompanying "Cotton Exodus," which is highly doubtful,[34] there would be no question of horns at Exodus 34:29 as they are specific to the Latin context of Jerome's translation. Philologically speaking, it might also be important to see the depiction of Moses with horns as a pictorial attempt to come closer, as Jerome himself may have thought it did, to the literal *Hebraica veritas*. On the other hand, many Egyptian pictorial motifs, as we shall see, were available in Italy and elsewhere throughout the Late Antique and Early Christian periods.

By focusing in the next chapter on an analysis of Moses's horns as depicted on folio 105v (fig. 10), I hope to demonstrate that they are an integral component of a larger visual construct with several individual elements all working together to communicate an important aspect of the role of Moses as prophet as well as military commander.

"... and he knew not that his face was horned ..."

Depending on which translation of the Bible one reads, something happened to Moses's face after encountering the Lord a second time on Mount Sinai. Exactly what the Hebrew text of the Bible at Exodus 34:29 means by the phrase *wēlō' yāda 'ki qāran' ôr pānāyw* has been the subject of considerable scholarly debate.[1] The phrase has been variously translated into English, for example, as Moses did not know that his "face was horned"[2] or that "the skin of his face shone."[3] St. Jerome's choice of the Latin *cornuta esset* (was horned)[4] for the Hebrew verb *qāran*, often characterized as a mistranslation or a mistake,[5] may have been influenced by Aquila's earlier, more literal *kekeratoto* (horned) as against the *dedoxasthai* (glorified) of the Septuagint.[6] Benjamin Kedar commented on Jerome's use of *cornuta esset*, "This ... is not a haphazard rendering: Jerome could have copied the LXX ('glorified'), had he wanted it. Yet his way of translating is a replica of Aquila's etymologizing rendition and was meant as a glorification of Moses: horns are the insignia of might and majesty."[7] As Mellinkoff points out,[8] in his other writings and commentaries Jerome was clearly aware that the term *horned* was meant to be understood as "glorified," as he says in his *Commentary on Ezekiel*: "Finally after forty-five days the common people with their clouded eyes could not look at Moses's face because it had been 'glorified,' or as it says in the Hebrew, 'horned.'"[9]

While the idea that Moses had actual horns is generally perceived to be a mistake, sometimes even with anti-Semitic overtones, in Jerome's Christian translation of the text of Exodus 34:29, interestingly, a Jewish manuscript from the first half of the thirteenth century C.E. in France (Oxford, Bodleian Library MS OR. 135) contains a midrashic text in Hebrew that reads, "A crown appeared on Moses' head and horns were born on his face." Moses is then described as fighting with the angels, "like a gorging ox."[10]

My goal here is to attempt to discover the origin of the specific visual image of Moses with two horns on his head on folio 105v of Claudius B.iv (fig. 10), which is, nevertheless, inevitably bound up with both the Latin text of Exodus 34:29 and its Old English translation. In the process, although by no means a professional biblical text scholar, I will endeavor to explore aspects of the textual problems as they relate to the visual image itself. It is a given that both the Latin Vulgate text and its Old English translation ("he waes gehyrned") have to do with horns, but exactly *how* and *why* the artist of Claudius B.iv chooses to represent that text the way he does remain to be explored. I begin by considering the image of the horned Moses, but this exploration will in later chapters expand to a consideration of a number of additional unique attributes given to Moses in this remarkable manuscript.

The task at hand is essentially twofold. I want to explore, first, the nature and intent of the Bible text at Exodus 34:29, and various translations of it, most notably Jerome's Latin rendition that Moses did not know that his face had become horned (*cornuta*) from his conversation with the Lord; and second, how that translation was given visual form, for the first extant time that we know of, on folio 105v of Claudius B.iv.

As an educated scholar, Jerome was no doubt aware of the metaphysical association of horns with divinity and power in the ancient world in general and the Greco-Roman world in particular,[11] as in the episode in Ovid's *Metamorphoses* (15.565–621) where Cipus looks at his reflection in a clear stream and sees horns springing from his head. When Cipus and his horns are observed by an Etruscan seer, the seer cries out, "All hail, O King! For to thee, to thee Cipus and to thy horns shall this place and Latium's citadels bow down."[12] Then, of course, there is the famous anecdote told by Jerome himself in his *Letter* 22:30, speaking about his reluctance to give up his library of classic literature, that he was caught up in a dream and dragged before the judgment seat of the Lord where he was asked what he was, and he replied, "I am a Christian. But He who presided said: 'Thou liest, thou art a follower of Cicero and not of Christ.'"[13]

And surely Jerome was aware of the large number of pagan deities described and depicted as horned, for example, Pan, Dionysos Zagreus, Zeus Ammon, and Zeus Olbias.[14] In addition, Jerome may have been aware of the association of horns with Satan, or the Devil,[15] as described by Julius Firmicus Maternus (d. ca. 350 C.E.) in his *De errore profanarum religionum*: "That god whom they bewail [i.e., Tauriform and Bicorn Dionysos], who has seen him wearing horns? What are the horns which he boasts he possesses? Something different are the horns which the prophet mentions at the behest of the Holy Spirit, and which you, *Sir Devil, think you can appropriate for your maculate face?*" Firmicus goes on to say, "But where, Sir, are you going to get yourself adornment and glory in this matter? The horns signify nothing else but the worshipful sign of the cross."[16]

Whatever the reason, or reasons, for Jerome's choice,[17] the authority of his translation as *the* Bible of the Latin Church in the Middle Ages, as Mellinkoff emphasizes, gave his verbal rendering of Moses's special distinction wide currency in the Latin West. Nevertheless, as Mellinkoff observes,[18] while the Jerome translation of the fourth-fifth century C.E. may give us the textual basis for the pictorial motif of a horned Moses, it does not explain why this image of Moses with *two* horns on his head is seen in its specific form in this, the earliest *extant* example on folio 105v of Claudius B.iv.[19]

At the heart of the matter with reference to the visual representation of Jerome's text is the whole question of what an artist is to make of an expression in words, in this case, "and he did not know that his face was horned." What does it mean for a face to become horned? One might more reasonably associate becoming horned with the top or the sides of a head, not the face.[20] If the import of the phrase is understood by the artist to mean that Moses's face became "radiant" or "shone with light" from his interaction with God, as it were, face-to-face, then how is one to represent this visually? What the majority of artists both before and after Claudius B.iv did was to show *rays* emanating generally from behind Moses's head.[21] One might even imagine an artist painting Moses's face a "radiant" or golden color, although we have no known example of such a strategy.[22] In the end, it cannot be assumed that the solution to the visual challenge that we see on folio 105v of Claudius B.iv is necessarily how it must be. One cannot overemphasize that the specific choice of the artist to represent this state of being "horned," that is, to represent Moses with two upright, curved yellow horns on top of his head possibly as some kind of headdress rather than as organic growths coming out of his skull, is just that, a choice. The implications of that choice, the specific shape of the horns and their relationship to Moses's head, are what I propose to investigate.

Mellinkoff makes the observation that in her opinion Moses's horns are not represented by the Anglo-Saxon artist (or artists)[23] on folio 105v and elsewhere in the manuscript as organic growths coming out of Moses's head but rather as part of a special hat or headdress or of some kind.[24] It is Mellinkoff's hypothesis that this horned headgear is the invention of the eleventh-century Anglo-Saxon artists of the manuscript, stimulated in large part by their being able (presumably) to read clearly in the accompanying Old English text copied out in the manuscript before the addition of the pictures that Moses, returning from his second trip to Mount Sinai, did not know that his face was "gehyrned."[25] Mellinkoff quite reasonably concludes that positive associations with horned helmets in Northern European culture in general and Anglo-Saxon culture in particular as signs of power, prestige, and even divinity predisposed the artists of Claudius B.iv to provide Moses with this distinctive horned headgear, a motif with a long and complex afterlife in Western art and thought.[26]

As reasonable as this hypothesis may seem, however, it lacks corroboration. There are no Northern European horned helmets that look exactly like what is depicted on folio 105v. As is now known through more recent research, for example, there were no horned Viking helmets; rather, they seem to be the invention of nineteenth-century Wagnerian romanticism.[27] And while there are examples of horned Celtic helmets, such as those depicted on the famous Gundestrup Cauldron,[28] actual Celtic examples have a distinctively shaped horn that ends in a rounded knob, as can be seen on numerous Roman coins as part of a Roman *tropaeum*, or battle trophy.[29] So, while there are certain kinds of horned helmets in northern European early medieval culture, the horned headgear of Moses in Claudius B.iv, if it is indeed some kind of helmet or headdress, does not resemble the examples Mellinkoff illustrates.[30]

Moses's "horns" in Claudius B.iv are rendered as flat, quite large, and rising vertically directly from Moses's forehead rather than the shorter upwardly curved horns to be seen coming out at the sides of the helmets in Mellinkoff's illustrations. In fact, they are represented differently at different times throughout the cycle of illustrations, curving in a variety of directions and, most important, later in the manuscript rising up at the front of Moses's head from behind a headband or diadem, seemingly tubular or rolled in shape.[31] On folios 105v (fig. 10) and 107v (figs. 20, 25), the horns rise up directly from Moses's forehead in front of what at first might seem like some kind of uncolored-in hair covering or "cap." This "cap" is missing in the later depictions and especially in the case of the images on folios 136v and 139v (figs. 18, 14), where Moses's hair is represented uncovered between the two horns. In none of the examples, however, do these horns curve up from the sides of a helmet such as that illustrated by Mellinkoff in her figure 35. Moses's horns in the Claudius B.iv image are taller and more vertical than those on any horned helmet. And finally, compared to other renderings of horns on horned animals elsewhere in the manuscript, as on folios 48v and 15v (see fig. 2), the horns arising from Moses's head in Claudius B.iv bear no resemblance to them at all.

It is said that one of Aby Warburg's guiding principles was the adage, "God is in the details" (Der liebe Gott steckt im Detail).[32] It has also been said that "the devil is in the details." In the spirit of these two adages, we would do well to examine some specific details relevant to the representation of Moses's horns in Claudius B.iv.[33] First of all, it should be noted that Moses is represented fifty-two times in the manuscript with horns of varying configurations (and colors) by the original eleventh-century artist or artists, as well as five additional times by a later hand of indeterminate date.[34] Moses appears for the first time with horns on folio 105v (fig. 10); here the two horns are depicted as flat, slightly curved, and rising up from Moses's forehead beginning at the bottom edge of what at first sight appears to be an unpainted-in coif or cap that covers Moses's hair. This coif, if indeed that is what

is intended, seems to appear in conjunction with the horns in subsequent images of Moses on folios 107r and 107v (figs. 20, 25), but in the upper left of the illustration on folio 108v, where the yellow colored-in horns rise up from a line drawn across Moses's forehead, this coif seems in fact to be uncolored-in hair since it flows behind Moses's neck onto his shoulder. Then, abruptly, in the second illustration at the bottom right of folio 108v, the horns rise up from *behind*, or *above*, a "roll" (?) of uncolored-in hair that also flows behind Moses's neck, as in the upper image, and do not touch Moses's forehead, as they had done previously on folios 107v, 107r, and 105v. In both illustrations on folio 108v, Moses's horns are painted yellow as they are on folio 105v. At the bottom left of the upper illustration on folio 118v, Moses, with Aaron, is shown prostrating himself before the congregation of Israelites (Num. 14:5). In this image the artist has inexplicably made a single unit out of the "roll" of forehead hair and Moses's horns, with no horizontal line separating the top of the "roll" from the horns and both hair and horns painted in with yellow. At the top of folio 121r, where Aaron is shown protectively hugging Moses as they are confronted by the angry Israelites (Num. 16:41–49), their two unfinished heads are depicted side by side. Aaron has an uncolored-in diadem around his head, as do the priests to the right of the composition, while Moses is shown with the uncolored-in hair "roll" surmounted by two tall yellow horns. At the top of folio 122v, Moses is now shown with an uncolored-in, clearly drawn diadem, with uncolored-in hair flowing down the back of his neck. From behind, or on top, of the diadem rise his two tall yellow painted horns. This same configuration—separately drawn diadem, hair flowing down the back of the neck, and two tall horns drawn above the diadem—is seen even more clearly in the lower illustration on folio 122v, where all of the separate elements are drawn in outline and none is colored in. From here on, the artist, having seemingly come to some kind of resolution or clearer understanding about the relationship of these several elements, continues to draw (1) a separate, horizontal diadem at Moses's forehead, with (2) hair flowing down the back of Moses's neck, and (3) two double-curved horns rising up from either behind or above the diadem. A final image of Moses with this configuration, horns painted yellow, is seen on folio 128r before a run of unillustrated text from folio 128v to folio 136r. Beginning with the image at the top of folio 136v (fig. 18), we see Moses with (1) a separate, beige painted-in diadem across his forehead and (2) brown, curly *hair* between (3) his large beige and reddish-brown painted horns! So from folio 136v to their final appearance on folio 139v (fig. 14), Moses's horns rise up clearly from behind some kind of rolled headband or diadem. In addition, from folio 136v (figs. 11, 18) to folio 139v, the uncolored-in, putative coif or cap, thought to have been seen in the earlier depictions of Moses, has been replaced by visible hair on Moses's head between his horns. Clearly some changes have occurred, either perceptual or conceptual, or both, between the representation of the horns

associated with the putative coif from folio 105v (fig. 10) to the introduction of an intervening, uncolored-in "roll" of hair or a headband of some kind at the bottom of folio 108v to the abandonment of this so-called cranial coif and the appearance of hair on top of Moses's head between the horns at the top of folio 136v (fig. 18)[35] to the final images of Moses on folio 139v (fig. 14). Mellinkoff stresses that in her opinion at all times throughout the manuscript Moses's horns are *always* represented, if sometimes in a somewhat confused manner, as part of some kind of headgear or hat.[36]

Close examination, however, of all the horned images of Moses in Claudius B.iv reveals a high degree of variation, so that, in contrast to Mellinkoff's contention, it cannot be said categorically that *all* representations of Moses's horns are part of some kind of headgear or hat, especially at their initial appearance on folio 105v (fig. 10). It would seem that the artist or artists responsible for the depiction of Moses with horns initially at folio 105v and later at folio 136v—and I believe there is a different, second artist beginning at folio 136v—went through an evolutionary process, seeming to struggle with what exactly it was that they were trying to represent and that the "recognition"—or "invention"—of the separate diadem on folio 122v more or less "resolved" the issue, resulting, going forward, in three clear components of representing Moses's head: the separate horizontal, rolled diadem from which flows hair down the back of Moses's neck[37] and behind which rise up the two double-curved horns, painted in with yellow up through folio 128r, then various shades of reddish-brown, until their final appearance on folio 139v in blue (fig. 14).

What is really difficult to comprehend here is the dramatic difference between the second set of horns on Moses's head at the top of folio 136v (fig. 18) and the first set on folio 105v (fig. 10). Moses's horns on folio 105v, as has been noted a number of times, are double-curved in shape, are painted yellow, and rise up directly from a curved, horizontal line at Moses's forehead without any sign of hair between them, although an outline of hair can be made out in other instances, for example, on folio 107v (figs. 20, 25), falling down behind Moses's neck. What prompted the artist at folio 122v to introduce a rolled, horizontal diadem on Moses's forehead? Did he see it in an earlier exemplar he may have been consulting? Did he introduce it on his own, thinking that it made some kind of visual sense or was more complete? And why is hair so emphatically drawn and colored in beginning at the top of folio 136v, while it is completely absent in *all* of the previous images up to that point? Further, the horns that had been double-curved beginning at folio 105v (fig. 10), similar in shape to those on Egyptian crowns (fig. 21) and Seleucid helmets (fig. 19) and painted yellow, are now much taller at folio 136v (figs. 11, 18), either straight up or curved in a somewhat concave manner, and painted various shades of brown and reddish-brown as in the two images on folio 136v.

My hypothesis with regard to these fundamental questions is that a combination of elements is at work here. By way of explanation of the different shapes and

colors of the horns, I believe, and hope to demonstrate in detail in this chapter, that there are two different prototypes to be discerned. The first is the double-curved horns beginning on folio 105v (fig. 10), as I demonstrate later in this chapter, possibly derived from an image of the Greek god Pan, of a kind seen on a fifth- to seventh-century C.E. fragment of a Coptic Egyptian textile at the Metropolitan Museum of Art, New York (figs. 22, 23), and possibly influenced as well by association with the light of the solar and lunar discs framed by horns on actual ancient and later Hellenistic Egyptian crown types (figs. 21, 27). The second is the idea of misunderstood double feathers emerging from a headband, beginning on folio 136v (figs. 11, 18), in Egyptian and Egypto-Roman examples representing a *hierogrammateus*, or chief lector priest, as in figures 29, 30, and 31. The emphatic *stylistic* differences in the handling of all elements of the images between that beginning at folio 105v and continuing at folio 136v indicate to me two possibly different exemplar images as well as two different artists producing their respective images—one artist from folio 105v on and a different artist beginning at folio 136v. Extending this speculation further, one might imagine that if the two different types of Moses figures, Moses with yellow "horns of light" and Moses with the diadem and feathers of the *hierogrammateus*, were both to be found in a single exemplar, it might not seem too far-fetched to imagine the first artist perhaps looking ahead in this putative exemplar and seeing that the "second" Moses, Moses the high priest and scribe, had his "horns" rising up from behind a rolled diadem and therefore may have decided to include this sensible feature in his images beginning at folio 122v. As noted, Aaron and the other priests are all shown with diadems on folio 122r, although at this point Moses is not. The first artist may have decided that at folio 122v this made sense for Moses as well as he always has a diadem at the base of his "horns" from folio 136v forward to his last appearance on folio 139v (fig. 14), where, inexplicably, his horns are now *blue*. A second factor has to be taken into account, I believe, in trying to understand the various enigmas here, and that is, due to a protocol of working methodology, about which, again, we can only speculate, the first artist responsible for Moses and his horns from folio 105v forward, until the second artist takes over at folio 136v, seems to have first drawn in the outline of the cranial portion between the two horns on Moses's head and then probably intended to come back at a later point to draw and color in the hair between them, as is the case on folio136v (figs. 11, 18), but, for whatever reason, was not able to do so, as many of the illustrations in the manuscript remain unfinished, at various stages of completion. Drawing the horns and painting them yellow seems a primary event in the production of illustrations in Claudius B.iv. Drawing and painting in hair was slated for a later time but, for whatever reason, never got there, hence the illusion that we are seeing some kind of uncolored-in coif, or cap, between Moses's horns beginning at folio 105v.

HORNS OF LIGHT

As Mellinkoff has astutely observed, "The history of religions could almost be written as the history of horned gods and goddesses."[38] The art of the ancient Near East abounds in images of horned deities and rulers, as in the famous stele of Naramsin (ca. 2254–2218 B.C.E.) in the Louvre.[39] Egyptian depictions of horned deities are plentiful as well, although more often than not the horns are part of a headdress of some kind. Horns, often in combination with other symbolic forms, figure prominently in various Egyptian royal crown types such as can be seen in a relief from the first-century C.E. Temple of Dendur now at the Metropolitan Museum of Art in New York, showing Caesar Augustus as Pharaoh at the right,[40] wearing a triple *atef* (or *ḥmḥm*)[41] crown, pouring an offering before the crowned god Osiris, with his consort, Isis, shown at the far left wearing the cow horns of the goddess Hathor. Horizontally projecting ram's horns are prominent features of both Augustus's and Osiris's crowns in this and other depictions.

In addition to such horizontally projecting ram's horns as we see in the Dendur relief, even more elaborate composite versions of the *atef* crown often include a pair of vertical bull or ox horns, usually framing a solar or lunar disc, as in a relief from Karnak (fig. 21) showing the short-lived Hellenistic emperor Philip III Arrhidaeus (ca. 359–317 B.C.E.), an elder half brother of Alexander the Great.[42] Here, in addition to the curving lateral ram's horns rising from the top of a wiglike crown, held in place by a uraeus-wrapped diadem, the two curving upright bull's horns frame a solar disc located in front of the large central element (*hedjet/pschent*) of the crown, which in turn is framed by two large, stylized ostrich feathers at either side. In this late Hellenistic example, the elaborate multiple horn elements rise up from the top of the stylized wig or hair of the figure rather than appearing to be a crown covering the hair/wig in a more conventional manner. Even closer in their disposition but not their size, which is quite small, to the horns of Moses on folio 105v (fig. 10) of Claudius B.iv are the two upright, curved bull's horns (only one of which is actually visible) of the *atef* crown worn by Thutmose III (18th Dynasty, 1479–1425 B.C.E.) in a fragmentary relief from Deir-el-Bahari (fig. 27), now in the Luxor Museum in Egypt. Rather than being placed on top of a wig, as in the image of Philip Arrhidaeus (fig. 21), the bull's horns emerge from the lower border of Thutmose's crown near his forehead, as do the horns of Moses on folio 105v (fig. 10) of Claudius B.iv., with the exception that the much larger yellow horns on Moses begin immediately at his forehead rather than above the edge of a narrow curved band as in the Thutmose III image. This direct contact of the base of the horns in the Claudius B.iv image with Moses's forehead might be seen to reinforce the locution of some translations (such as the Septuagint) of the Exodus 34:29 text that the

"skin of his face shone," or "was glorified," or that the "skin of his face was horned," with "horned" (*cornuta*) being understood as a luminous phenomenon. It should be noted that in both of the images cited, Philip III Arrhidaeus (fig. 21) and Thutmose III (fig. 27), the upright double-curved horns are adjacent to a solar disc—in the Philip III image they actually support the disc—thus linking them with the light of the sun.[43] And finally, while the horns of Moses on folio 105v of Claudius B.iv at first might seem to be associated with a headdress of some kind, they are not emerging from its sides, or from a "headache band" of sorts at the bottom edge of what might at first glance be interpreted as an uncolored-in coif that covers Moses's hair, nor are they rendered as conical in shape but rather as flat against the front surface of this coiflike, uncolored-in cranial area.

THE GMIRKIN HYPOTHESIS I

In a provocative and controversial study, Russell Gmirkin has proposed that, contrary to received scholarly opinion, the Hebrew Pentateuch was composed in its entirety around 273–272 B.C.E. by Jewish scholars in Alexandria, Egypt, who were the same scholars that later traditions credited with the Septuagint translation of the Pentateuch into Greek.[44] This bold hypothesis sees the Pentateuch as Jewish historiography derived from, and in some sense a reaction to, earlier texts to be found in the Great Library of Alexandria, such as Berossus's *Babyloniaca*, written sometime around 290–278 B.C.E. under the patronage of the Seleucid king Antiochus I Soter, and Manetho's *Aegyptiaca*, written sometime in the third century B.C.E. during the reign of Ptolemy I Soter or Ptolemy II Philadelphus.[45] Both of these texts are no longer extant in their entirety but are referred to by later writers such as Josephus and Eusebius of Caesarea.[46] Taking into account a more recent trend in biblical scholarship that sees the Greek Septuagint as more than a mere "translation"—in the words of Anneli Aejmelaeus, "There is now more and more talk about the Septuagint translators having performed a task of interpreting or reinterpreting their Hebrew source text"[47]—it might be possible to see in Gmirkin's hypothesis the extenuating concept that the Septuagint "translation" of Exodus 34:29, that Moses's face "was glorified" (*dedoxasthai*), may have actually been intended as an interpretation of the Hebrew verb *qāran*, with *qāran* meaning what Jerome would later translate as *cornuta esset* (was horned). That is, the Hebrew verb, while literally meaning "was horned," was meant to be understood as "glorified," as "horned" in Jewish Hellenistic Alexandria might have seemed too close to the horned pagan gods and emperors of contemporary Ptolemaic as well as pre-Ptolemaic ancient Egypt. Under this hypothesis, the Septuagint text might be seen as bowdlerizing the more graphic and literal Hebrew locution, which, in a sense,

could then be seen as having been "restored" to its original intention by Jerome's later Latin Vulgate translation. Further possible implications of Gmirkin's hypothesis for my explication of Moses's horns in Claudius B.iv are discussed later in this chapter.

THE NAME "MOSES"

Having invoked the name of Pharaoh Thutmose III, this would be a good place to address an important cognate topic, the origin of the name "Moses" (*Mōšeh*).[48] Apparently there are three reigning hypotheses as to the origin of this distinctive name. The Bible at Exodus 2:10 says, speaking of an unnamed pharaoh's daughter, "And she adopted him for a son, and called him Moses, saying: Because I took him out of the water." So the first hypothesis is that the name "Moses" is related to an Egyptian word for "water," an idea put forward by both Josephus (*Ant.* ii.9.6) and Philo (*Vita Mosis*. i.4).[49] A second hypothesis, one that seems to have achieved wider acceptance among scholars, is that it is derived from the Egyptian *mose*, found in theophorous names such as Ptah-mose, "Ptah is born," or Thutmose, "son of Thut," or Thoth.[50] A third hypothesis, proposed recently by Claire Gottlieb, is that the name "Moses" is derived from a shortened form of an Egyptian cognate, *i my-r mš*, meaning "commander-in-chief."[51] Having no real philological expertise, all I am able to offer in bringing forward these competing hypotheses is the observation that the etymological derivation of the name "Moses" from some aspect of the Egyptian ambit seems inherently logical and of some importance to the larger thesis I am presenting in this study.

MOSES AS PHARAOH

But, one might ask, how could Moses possibly be represented in Claudius B.iv, or anywhere for that matter, with a horned headdress similar to that of the dreaded adversary, the "pagan" pharaoh of Egypt? The potential answer to this question is both a complicated and an interesting one emerging from a rich Hellenistic Jewish apologetic literature, not widely familiar to modern audiences, in which a verbal image of Moses is promulgated presenting him as "god," king, and high priest more ancient, in fact, than all the Egyptian gods and pharaohs.

In his study "Moses as God and King," Wayne Meeks traces the major outlines of an understanding of Moses as "god," king, and high priest as it developed in Hellenistic Jewish Egypt, especially in Philo's *Life of Moses* (*De Vita Mosis*), where Philo, the Alexandrian Jewish philosopher and exegete, says of Moses "he was

named god and king (*theos kai basileus*) of the whole nation."[52] As Meeks points out, Philo takes his reference to Moses as "god" directly from the Bible; in Exodus 7:1 God says to Moses, "Behold I have appointed thee the God of Pharaoh."[53] Similarly, as Meeks demonstrates using other midrashic sources, this same verse has been interpreted to mean that God made Moses a king as well, since "king" is one of the attributes of God.[54]

Later in his study, Meeks refers to the work of Ezekiel, called "the Tragedian,"[55] a writer characterized by Clement of Alexandria as "the Poet of Jewish Tragedies," whose Greek verse drama, the *Exagoge* ("The Leading Out," or Exodus), was written in Egypt, perhaps at Alexandria, sometime in the second century B.C.E.[56] In this poem on the Exodus styled in the manner of a Greek tragedy, Ezekiel describes an apotheosis of Moses in the form of a dream vision, culminating in Moses's enthronement on Mount Sinai. First, Ezekiel describes Moses as seeing a "noble man" (*phos gennaios*) on the peak of Mount Sinai seated on a great throne. This figure, who turns out to be the Deity himself, then gives Moses his own royal diadem, which other sources, as Meeks points out, characterize as a "crown of light,"[57] his "mighty scepter," and, ultimately, the throne itself.[58] The astral, or solar, crown that Moses receives functions as an interpretation of Exodus 34:29 and is, as Meeks also indicates, a widespread motif in the iconography of Eastern as well as Hellenistic kingship.[59]

Thus, in both Philo and Ezekiel the Sinai epiphany is interpreted as an apotheosis of Moses where he is permitted to share in the divine nature and become both "god" and king, or, as a later midrash expresses it, "A 'man' when he ascended on high; 'god' when he descended below."[60]

The idea of Moses as both god and king is given an unexpected twist by the Hellenistic Egyptian Jewish "historian" Artapanus whose work, in Greek, as epitomized by Alexander Polyhistor in his "About the Jews" (*Peri Ioudaion*),[61] equates Moses with the Egyptian god Thoth, identified already by the Greeks as their Hermes through an *interpretatio graeca*.[62]

Certainly the most astonishing of the extant Egyptian Hellenistic Jewish writer-historians,[63] Artapanus, thought to be active in the third to second centuries B.C.E., is known only through fragments of his work cited above, preserved, interestingly enough, in the works of two Christian exegetes, Clement of Alexandria (ca. 150–ca. 215 C.E.), in his *Stromata*, and Eusebius of Caesarea (ca. 263–339 C.E.), in his *Praeparatio evangelica*.[64] To an earlier generation of scholars, Artapanus seemed a bizarre figure indeed, sharply criticized by Emil Shürer, for example, as an individual more concerned with the greater glory of Judaism than with the purity of his religion.[65] John J. Collins, in his recent edition of the Artapanus fragments, has characterized this writer as engaging in what he calls "the competitive historiography" of the Hellenistic age,[66] where individual ethnic-religious enclaves

sought to claim glory for themselves and the history of their people, often in the face of oppression and/or political-cultural domination. Artapanus, then, in this vein states that "Hermes," the Greek equivalent of the Egyptian god Thoth (Dhwtj), is the name given to Moses by the Egyptian priests.[67]

To be precise, Artapanus himself does not actually say that Moses is Hermes/ Thoth but that it is the Egyptian priests who accord him this honor.[68] As the great initiator of all culture, Moses, according to Artapanus, was called by the Greeks themselves "Musaeus," whom Artapanus identifies interestingly, but incorrectly, as the teacher of Orpheus.[69] Artapanus goes on to claim that Moses-Thoth-Hermes divided Egypt into its indigenous regions, or *nomes*, as well as—*incredible dictu*— establishing the individual animal cults of the Egyptian religion.[70] Collins, in discussing the complex sources and implications of Artapanus's seemingly absurd assertions, remarks that they are "part of the general apologetic glorification of Moses, but no other Jewish apologist goes so far."[71]

Particularly noteworthy here, as I mentioned earlier and will return to later, is the fact that what we know of Artapanus and his remarkable thesis that Moses was perceived by the ancient Egyptians as their god of wisdom, writing, and magic, Thoth, who in turn was understood by the Greeks to be the same as their Hermes, is found *only* in extant Christian sources, where this material serves a particular Christian apologetic purpose. And that purpose has to do, in the hands of Christian writers such as Eusebius, with establishing the antiquity of Judaism, and by association, or appropriation, the legitimacy and the "borrowed" antiquity of Christianity itself.[72]

The need to establish this link with a venerable past, that is, ancient Judaism, was an essential *Tendenz* of a certain Christian apologetic in light of the general suspicion in the ancient world of any "new" religion under the principle "older is better" (*presbyteron kreitton*).[73] Christian apologists, then, while understandably not interested in the concept of a deified Moses, were interested in a Moses of great antiquity, predating not only the gods of ancient Egypt and Greece but also revered literary figures such as Homer. Tatian, in his second-century C.E. *Oratio ad Graecos*, for example, states that Moses "is not only older than Homer but is older even than the writers before him" and goes on to list seventeen other ancient authors.[74] Thus an *interpretatio judaica* of Thoth-Hermes as Moses served an important apologetic purpose in establishing the historical priority of Judaism, Christianity's parent, as well as "demythologizing" one of the chief Egyptian deities through a process of "Euhemerism."[75]

While neither Philo nor Artapanus nor Artapanus's Christian appropriators have anything specific to say relative to the question of a Moses with horns, they do establish a context in which Moses is understood as having become "divine" and assuming kingly power by association. In this regard, then, one might see as plausible

a context in which an image of a horned Moses could be imagined displaying the royal horns of various crowns of Egyptian gods and kings. Just such an appropriation of a "pagan" Egyptian deity's distinctive headgear may be seen in the depiction of Joseph wearing the *modius* of the god Serapis on his head in the ivory carvings of the sixth-century C.E. throne of Maximian in Ravenna.[76] Again, by means of an *interpretatio judaica*, the biblical Joseph was understood as the god Serapis, first in a Hellenistic Egyptian Jewish apologetic and taken up by later Christian writers such as Julius Firmicus Maternus, Tertullian, and others.[77]

Having triumphed over Pharaoh, Moses could be seen as being entitled to Pharaoh's crown, particularly in light of two midrashim, one of which is recounted by Josephus in his *De Antiquitates Judaicae* where it is said that when Moses was a small child sitting on Pharaoh's lap, Pharaoh placed his crown on Moses's head only to have the child throw it to the ground, thus prompting Pharaoh's sacred scribe (*hierogrammateus*) to call for the child's death on the spot as his action was seen as an evil omen.[78] Another midrash has the child Moses place Pharaoh's crown on his own head.[79] The horned crown of Pharaoh, who was himself, among many other titles, referred to as the "horned one,"[80] on the head of Moses after having conferred with the deity "face-to-face" (Exod. 33:11; Deut. 34:10) might also be seen as making an important exegetical statement in contrast to the horns of the false god, the golden calf.[81]

Whether the Early Christian artist(s) of the putative original model (or models) that the eleventh-century Anglo-Saxon artists of Claudius B.iv were working from were aware that the fourth-century B.C.E. Macedonian Hellenistic emperor Philip III Arrhidaeus had been depicted, as we see him, in full pharaonic attire at Karnak (fig. 21),[82] or whether the Roman emperor Caesar Augustus had been represented,[83] as we see him on the Temple of Dendur, also in full pharaonic regalia, cannot be known. It is an intriguing possibility, however, that if a Hellenistic emperor, and the great Augustus himself, could be represented in full Egyptian pharaonic attire[84] and horned crown, then why not Moses, who was said by Philo and others to be "god and king" (*theos kai basileus*) of the whole nation?

THE GMIRKIN HYPOTHESIS II: MOSES AS PHARAOH NECTANEBOS II

A further provocative and controversial aspect of Gmirkin's hypothesis about the origin of the Hebrew Pentateuch and its simultaneous Greek translation as the Septuagint is his suggestion that the figure of Moses, in what he refers to as the "Romance of Moses" in the Pentateuch,[85] is based on the figure of Nectanebos II (359–343 B.C.E.), the last indigenous pharaoh of Egypt, who was forced into exile but would return, in some legendary accounts, to deliver his people and who was also

described in these accounts as a magician.[86] In line with this hypothesis is the even more speculative thought that if there had been illustrated Hellenistic Jewish manuscripts of the Septuagint, which is unlikely, like the later illustrated Christian manuscript, the so-called Cotton Genesis, might they have included an image of Moses at Exodus 34:29 modeled on that of Pharaoh Nectanebos,[87] replete with horned pharaonic headdress? There is an interesting Late Antique text, in its earliest version dating not before the second century C.E. and thought to have been written in Egypt, known as the *Life of Aesop* in which Aesop is described as arriving in Memphis and appearing before pharaoh Nectanebos. Nectanebos is described in the text as wearing a robe of pure white linen and a crown with horns on it. Aesop is asked by Nectanebos what his (Nectanebos's) appearance is like, and Aesop replies, "In your horned crown you are . . . like the moon."[88] Perhaps no other topic than that of the influence of Late Antique and/or Egyptian Coptic art on the art of the early medieval British Isles[89] is more fraught with controversy than the idea of illustrated Jewish manuscripts in antiquity. While this is a cherished idea of a number of scholars, Weitzmann chief among them, current scholarly opinion is generally negative in this regard.[90]

On the other hand, suppose that Gmirkin's hypotheses are correct, namely, that the Hebrew Pentateuch was written at Alexandria sometime in the third century B.C.E. after the death of Alexander the Great in 323 and that the figure of Moses in the Bible was modeled on that of the last "native" Egyptian pharaoh, Nectanebos II. In the texts of the Pseudo-Callisthenes *Romance of Alexander*, Nectanebos is said to have impersonated the ram-horned god Ammon and impregnated Alexander's mother in this form, thus becoming the father of Alexander.[91] Is it possible that the characterization of Moses as "horned" in the Hebrew text of Exodus 34:29 was inspired by the ram-horned image of Alexander, as seen on a number of coins minted by Lysimachus, Alexander's successor, around 300 B.C.E.?[92]

FURTHER ON PHARAONIC HORNS

It could reasonably be objected that if Moses's horned appearance in Claudius B.iv might possibly be based in part on horned pharaonic headdresses or crowns, why is Pharaoh himself not depicted in the manuscript in a more Egyptologically correct headdress or crown of his own? In those instances where Pharaoh is represented, either his headgear is missing altogether, as on folios 79v, 80v, 81v, 85r, 89r, and 91v, or it has been rendered, clearly after the fact, in a confused, "bodged up" (to use C. R. Dodwell's locution) manner in a dark black ink "overdrawing," as on folios 68r, 68v, 69v, 71r, 73r, 73v, 76r, 82v, 83r (twice), 83v, 84r, 84v, 86r, 87r, and 87v. In fact, of Pharaoh's twenty-eight appearances in the manuscript, his headdress is shown clearly as a conventional, medieval fleur-de-lis-type coronet or crown only

six times (fols. 58v, 59r, 60r, 60v [twice], 65v). These six instances occur in the Joseph cycle of the manuscript's illustrations. In the unusually numerous cases where the crown is missing altogether or "bodged up," it might be possible that the artists did not understand what Pharaoh was wearing in some more ancient exemplar or model[93] and left the space above a horizontal roll of hair on top of his head blank. Where Pharaoh's crown is shown in a more conventional medieval manner surmounted by fleur-de-lis forms, the artists, as they have done elsewhere in the manuscript, may have chosen to contemporize their own work in contrast to their model or exemplar. However, as I demonstrate in more detail later, I propose to show that Moses's horns in Claudius B.iv, while possibly related in their vertical, double-curved *shape* to the horns on ancient representations of pharaonic headdresses and crowns are in fact *not* part of a headdress or crown but are meant to be understood as symbols of light radiating from Moses's face. That Pharaoh himself should exhibit an archaeologically correct Egyptian-style crown or headdress in his appearances in Claudius B.iv does not necessarily follow from the presence of horns on Moses's head in the same manuscript. And, as I have suggested, the eleventh-century Anglo-Saxon artists of Claudius B.iv may not have understood what Pharaoh was wearing on his head in an earlier exemplar and thus either left his headgear blank above a horizontal hair roll, as they did, quite strangely, several times, or gave him a generic, fleur-de-lis medieval-style crown. It is worth noting that when there is no indication of a crown on Pharaoh's head (as on folios 73r, 79v, 80v, 82v, 84r, 84v, and elsewhere) a later hand has often drawn in some kind of dome-shaped or "bodged up" crownlike element in a darker ink, as if fulfilling the need to provide this missing element. An outstanding example of this situation is the illustration on folio 80v where Pharaoh is seated at the right in the presence of three military figures at the left, all three provided with triangular-shaped helmets as elsewhere in the manuscript, while Pharaoh, with no crown, has only a thin hair roll on top of which a later hand has added a hastily sketched-in dome shape. Even more extraordinary is the situation at the bottom of folio 85v where a later hand has drawn in a darker ink a conical "Judenhut"-shaped headdress on Pharaoh's unadorned head.

From an ancient/Hellenistic point of view where horns and being horned are sure signs of divinity, or association with divinity, Moses, in a sense, *must* have horns, metaphorically or otherwise, in order to be credible. Jerome, as quoted by Mellinkoff, in his *Homily on Psalm 91*, has this to say about horns: "A horn is always set up in a kingdom. Our foes through you we are struck down with the horn. As a matter of fact, no animal is immolated to the Lord in the temple unless it is horned. . . . Unless one has a horn with which to rout his enemies, he is not worthy to be offered to God. That is why, too, the Lord is described as a horn to those who believe in him."[94]

If anything, Moses in his triumph represents a kind of *theos epiphanes* (god made manifest, or revealed), one of the titles of the much despised emperor Antiochus IV

epiphanes,[95] as, according to the Bible, Moses conversed with God "face to face" and is revealing to God's people on folio 105v the fruits of that conversation both in the Tablets of the Law in his right hand and in the radiant horns of light on his head from "speaking with the Lord." From the point of view of the concept of *synkata-basis*,[96] which historians of religion use to describe an accommodation of the "Truth" to the limited capacities of human beings, Moses, in a sense, needed to be "horned" to be understood by the ordinary people as someone important, someone representing divinity having encountered that divinity literally "face-to-face."[97]

Close attention to the specific details of Moses's putative headgear on folio 105v (fig. 10), however, reveals that while it resembles the pharaonic *atef* crown in a general sense, it is by no means an exact version of it. In fact, Moses's headgear in Claudius B.iv, if it is indeed headgear, might best be described as *atef*-like, as it is missing the large central "bowling pin" (*pschent*) element of the *atef* crown as well as the two tall, stylized ostrich feathers on either side.[98] The curving bull or ox horns on Moses's head on folio 105v, however, do resemble the traditional ostrich feathers of actual Egyptian crowns in height. Instead of the central white crown/"bowling pin" element of the traditional *atef* crown, Moses, at first, appears to be wearing a colorless hair covering or coif. An entirely different head covering, without horns, appears on Aaron's head on folio 107v (figs. 20, 25) at the scene of the Consecration of the Priests.

Aaron, Moses's brother, is shown with an uncolored-in head covering on folio 107v of Claudius B.iv in scenes illustrating the consecration of Aaron and his sons as priests (Leviticus 8:12 and 8:23–24).[99] The cloth covering on Aaron's head is no doubt meant to be the miter (*mitznefet*) stipulated by God (Exod. 28:39) for the high priest.[100] Even though Aaron is consecrated high priest by Moses in the Bible (Lev. 8:1–12), Moses is often considered the first high priest in Jewish legend.[101] The seated image of the scribe Ezra on folio Vr of the eighth-century C.E. Northumbrian Codex Amiatinus (Florence, Biblioteca Medicea Laurenziana MS Amiatino 1), itself a copy of the earlier Codex grandior, shows him in the guise of high priest with a white cloth covering on his head,[102] often misidentified as a tallith,[103] clearly representing the priestly *mitznefet* decorated at its center by the golden frontlet (*tzitz*), which is represented in a different manner (to be discussed later) on the forehead of Moses on folio 136v of Claudius B.iv (fig. 18). The way in which the priestly head covering is rendered on Aaron at the bottom left of folio 107v (fig. 25) resembles the baglike Egyptian wig cover called an *afnet*, or *khat*,[104] as seen in figure 28, an example from the fourth to third century B.C.E., more than it does the turbanlike head covering seen on the image of Aaron as high priest on folio 89v of the tenth-century Uta Gospels.[105]

Before discussing Aaron's head covering in more detail, it is worth noting that the complex over-the-shoulder, "interlaced" knotted waistband holding Aaron's

garment closed in the image on folio 107v (fig. 25) resembles the waistbands worn by Isis priests represented in frescoes at Herculaneum and Pompeii. The enlarged knotted belt at Aaron's waist also resembles the interlaced *tjes* knot represented in Egyptian art securing garments worn by various gods as well as appearing in the Egyptian ambit as carved amulets made of various materials.[106]

Aaron's head covering at the bottom left of folio 107v has a short, rolled border where it touches Aaron's forehead, which is rendered differently at the upper right of this tripartite illustration, where it is thicker and more prominent (fig. 20). Also, the first representation of this head covering at the upper right of the illustration appears to have a triangular flap, or overlap, on the top. Mellinkoff maintains that both Moses's hair and Aaron's hair are definitely covered, in contrast to the centrally parted hair visible on figures in the same composition who are "bareheaded," without any headgear, as is Moses himself earlier in the manuscript (e.g., fols. 78v, 79v, 94v, 101v, 104r) and at the upper left of the full folio 105v (fig. 10 is a detail of the lower right portion of this folio) before his descent from the mountain.[107] Nevertheless, the artist may be a bit confused, even on folio 105v, as he seems to have rendered a bit of a curving line that begins at the top edge of Moses's coif and continues down the back of his neck as if rendering long hair, as indeed he does in illustrations earlier in the manuscript (e.g., folios 78v, 79v, 94v). In the depictions of Moses on folio 107v (figs. 20 and 25), this flowing hair at the nape of his neck is quite clearly visible, especially at the upper right, at the left of the middle register, and at the lower right of folio 107v, though in all three instances there is a curved horizontal line crossing Moses's forehead, running from left to right at the base of his horns. At other times in the illustrations, however, the hair flowing down Moses's back flows across his forehead with the horns placed on top of it, as on folio 119r. On folio 118v the horns themselves, as well as this wrap of forehead hair, are all painted with the same yellow pigment, making hair and horns into one continuous entity. It is as if the artist did not quite know what he was doing, as the images in the two examples, folios 118v and 119r, are both missing the domical cranium portion of Moses's head between the horns. On the other hand, both of these images, as are many throughout the manuscript, are not really finished. This unfinished-lack-of-cranium phenomenon occurs frequently elsewhere in the manuscript, especially in cases where Pharaoh is shown, as on folio 22v, with a three-pronged "fleur-de-lis" crown, the forehead band of which is rendered as one continuous unit with a flowing nape-of-the-neck fall of hair. When it finally becomes clear at the top of folio 136v (fig. 18) that Moses's horns are rising up from behind a rolled headband or diadem and his hair appears between them instead of the uncolored-in blank, as on folio 105v (fig. 10), it is still the case that earlier on, as on folio 105v, no indication of the characteristically parted hair on top of Moses's head is present.

ALETHEIA VS. PHANTASIA: WHAT THINGS ARE VS. WHAT THINGS SEEM TO BE

> To repeat: don't think, but look!
> —Ludwig Wittgenstein, *Philosophical Investigations*, Aphorism 66

Here is where we need to invoke Aby Warburg's dictum, "God is in the details." At the beginning of her groundbreaking study, Mellinkoff states that previous researchers failed to note "the highly important detail that in the Ælfric Paraphrase Moses has a hat with horns, rather than horns growing from his head."[108] Close examination of the individual renderings of Moses and Aaron on folio 107v (figs. 20, 25), however, ultimately militates against an interpretation of the uncolored-in cranium portion between the horns of Moses as a cap or coif, because, by comparison, especially with the depiction of the head covering of Aaron at the bottom left of the illustration on folio 107v (fig. 25), Moses clearly has a flow of uncolored-in hair drawn in down the back of his neck, rendered even more clearly on the other three representations of him in this three-tiered illustration. At the lower left of the full illustration, Aaron's head covering, seen at a slightly three-quarter view, clearly gathers up all of his hair inside the cap of the *mitznefet*, in the manner of an Egyptian *afnet* or *khat* (fig. 28), and there is *no* hair visible flowing down the back of his neck or shoulders. The perception that Moses is wearing some kind of coif or cap in front of which his horns rise up must be relinquished.[109] Instead, his horns, like those of Pan on a fifth-sixth-century C.E. Coptic textile in the Metropolitan Museum, New York (figs. 22, 23), rise from his forehead in front of his hair, which, like the hair of Pan, also cascades down the back of his neck and onto his shoulder (fig. 23) but has not been painted in at this point in Claudius B.iv's unfinished state.

HORNS: PRO AND CON

If the Anglo-Saxon artists of Claudius B.iv had only earlier or contemporaneous Anglo-Saxon exemplars to work from in constructing a horned Moses, they might have been able to have utilized an image such as that on folio 50r (fig. 24) of the so-called Leofric Missal (Oxford, Bodleian Library MS 579) depicting a personification of Death (*Mors*) as a figure with Pan-like goat's head and ears and two curved goat's horns emerging from the top of its head.[110] This image occurs in relation to an Anglo-Saxon *prognosticon* based on the so-called *Sphaerae Apuleii*, a diagrammatic aid used to predict the life or death of an ailing patient. The shape of these horns with their double curves is quite similar to that of the image of Moses on folio 105v of Claudius B.iv (fig. 10), with the important difference that Moses's

horns are taller and are depicted rising from a curved horizontal line on his fore-head, not coming out of Moses's head and hair as they do in the Leofric image.

A second prototype that might have been available to the artists of Claudius B.iv through a common intermediary is an image of Moses on folio 83v of the so-called Bury St. Edmunds Psalter of the mid- to later eleventh century (Vatican City, Biblioteca Apostolica MS Reg. Lat. 12).[111] In the illustration from this manuscript later in date than Claudius B.iv, Moses is pointing with his right hand to the two round-topped Tablets of the Law, which he holds in his veiled left hand while around his head are undulating flamelike radiances signifying the transfigured state of his face according to an interpretation of Exodus 34:29 in the work of Pseudo-Philo[112] as a radiating phenomenon of light symbolic of the glory (*doxa*)[113] indicated in the Greek Septuagint translation of the Exodus text. While Propp credits Pseudo-Philo as the first to characterize the glorification of Moses's face as a radiant phenomenon, it should be noted that Philo himself (*De Vita Mosis*) says that a dazzling brightness flashed from him like the rays of the sun.[114]

The relationship of Moses's transformation in Exodus 34:29 to the phenomenon of light has inevitably led some scholars to see a connection between the biblical phenomenon and concepts of a divine light, *melammu* in a Sumerian context and/or its Akkadian equivalent *puluhtu*, generally translated as "radiance" or "splendor."[115] Conservative evangelical Christian scholars, however, have brought forward a number of criticisms to counter this argument, pointing out specific differences between the *melammu* concept and how light figures in the biblical account of Exodus 34:29–35.[116]

The existence of the Bury St. Edmunds image, however, demonstrates that there were in eleventh-century Anglo-Saxon England two distinctly different pictorial traditions of visualizing the text of Exodus 34:29: the literal "horned" tradition exemplified by Claudius B.iv folio 105v and the "radiant/glorified" tradition represented by folio 83v of the Bury Psalter. Both artistic images, of course, co-existed in a mutual biblical environment of the Latin Vulgate text, *quod cornuta esset facies sua*. In possibly choosing the horned image of Mors from the Leofric Missal image, rather than the "radiant" Bury St. Edmunds Psalter alternative, the artist of Claudius B.iv could be seen to be making a specific symbolic point, a visual exegesis of the meaning of Moses and the Law that I shall explore at a later point.

Three major differences, however, separate the tenth-eleventh-century Leofric Mors image (fig. 24) from that of Claudius B.iv. The first is the larger size of the horns in the Claudius image. The second is the fact that the horns on folio 105v (fig. 10) do not emerge from the top of Moses's head but rather from the upper edge of his forehead. The third difference is that the representation of Moses's horns as emerging from a rolled diadem or headband revealing his hair between them, as on folio 139v (fig. 14), is quite unlike that of the Leofric image, where the horns

emerge from the tousled hair on the figure's head. Despite these differences, the representation of Mors on folio 50r of the Leofric Missal may have some connection to the horned Moses on folio 105v of Claudius B.iv.

The ultimate source (or sources) of the Leofric Mors image is unknown, but Adelheid Heimann has associated it with a number of Egyptian and Coptic Christian motifs, both visual and verbal, identifying the six small dragonlike demons emerging from the head of Mors as the "Six Sons of Death" mentioned in an early apocryphal Coptic text, *The Resurrection of Christ*, a text known to the Anglo-Saxons.[117] Curiously, as part of the greater Anglo-Saxon *prognosticon* tradition, these texts include lists of lucky and unlucky days in the year, referred to as "Egyptian Days."[118] Kristine Edmondson Haney, however, has brought forward a number of salient criticisms of Heimann's hypothesis of an ultimately Egyptian origin for the Leofric Mors, suggesting instead Etruscan sources in images of Charun and Tuchulcha, figures associated with Death and the dead, of the fourth century B.C.E.[119] Attractive as this thesis is, with Tuchulcha in Haney's figure 9 (a wall painting from the Orco Tomb in Tarquinia), depicted with tousled hair, wings, and serpents rising from his hair, there is no clear indication of horns, a prominent feature of the Leofric image, on this or other figures of the two demons.

On the other hand, the Pan-like figure of Mors in the Leofric image corresponds in many of its details to St. Jerome's description of the Egyptian St. Anthony's encounter with an apparition of the Devil in his *Life of St. Paul the Hermit* written around 374/375 C.E., where he says that on his way to find the hermit Paul, Anthony encounters a manikin (*homunculus*) "with hooked snout, horned forehead, and extremities like goats' feet."[120] Anthony asks this creature who he is, and the creature replies, "I am a mortal being and one of those inhabitants of the desert whom the Gentiles deluded by various forms of error worship under the names of Fauns, Satyrs, and Incubi."[121]

Jerome's description of this creature corresponds well with Greco-Roman depictions of Pan on various carved marble sarcophagi.[122] The specific double-curved goat's horns on the Leofric figure's head can also be seen on several images of Pan on the fourth-century C.E. silver plates of the so-called Mildenhall Treasure, Roman works excavated in England in the twentieth century, now in the British Museum, London.[123] A particularly appropriate image of Pan, or one of his Satyrs, can be seen on a late fifth- to seventh-century C.E. Coptic textile (figs. 22, 23) now in the Metropolitan Museum of Art, New York.[124] This example has the appealing aspect of showing the two horns as continuous with the skin of the figure's face, as in some later medieval images of a horned Moses,[125] thus suggesting the possibility of serving as an appropriate model in conformity with Jerome's locution that at Exodus 34:29 Moses did not know that his face (*facies*) was "horned" from his conversation with the Lord. In addition, Jerome's description of the creature, especially

its hooked snout (*aduncis naribus*) and horned forehead (*fronte cornibus asperata*) corresponds well with the Pan-like figure of Mors in the Leofric image (fig. 24).

Further in relation to the Pan-like details of the Leofric Mors is a possible connection with the Orphic image of Phanes as seen, for example, on a Roman carved marble relief now in the Royal Museum, Modena.[126] The frontal facing figure of a nude male youth is depicted on this relief with two large wings, crescent horns of the moon on his back but visible at his shoulders, and upward shooting flames on the top of his head from which six rays project laterally, three on each side. A lion's head with furry mane appears at his upper abdomen, while the small head of a horned goat emerges from his right side and an equally small head of a horned ram appears coming out of his left side. He holds a thunderbolt in his right hand and a tall staff in his left. The figure has cloven goat's hooves for feet but is otherwise anthropomorphic. Several features of this image might reasonably be seen as reflected in the Leofric Mors, especially the large wings and the six rays coming out of both sides of his head (associating Phanes with Apollo Helios). Phanes, while often associated with Zeus, was also associated with Pan.[127] The Leofric image has goatlike floppy ears and horns but not the cloven goat's feet of the Phanes figure. While the Phanes figure has the two cusps of a crescent, or horned, moon at its shoulders, it does not have the double-curved goat's horns on its head like the Leofric Mors. One further detail, however, might connect these two images, and that is the furry patch discernible at the solar plexus of the Leofric image (fig. 24) (although the Leofric image has suffered some damage, possibly from water, which has blurred some of its distinctive features), which may be a remnant of the furry lion's head seen at the same spot on the Phanes image. As no other clear source has been adduced for the Leofric Mors, it might seem a credible hypothesis that the Leofric image is an amalgam of details from such an Orphic Phanes image and a more goatlike Pan. The Anglo-Saxon artist of the Leofric Mors may have added the thornlike projections on the figure's knees and elbows,[128] as well as the ragged skirt, much in the same manner as similar details on demonic figures in the Anglo-Saxon copy of the Utrecht Psalter (London, British Library Harley MS 603).[129]

In the larger realm of horned entities as essentially demonic or satanic in the Anglo-Saxon context, it is instructive to recall that in his *Liber Poenitentialis*, Archbishop Theodore of Canterbury (seventh century C.E.) castigates anyone who "at the kalends of January goes about as a stag or a bull; that is making himself into a wild animal and dressing in the skin of a herd animal, and putting on the head of beasts; those who in such wise transform themselves into the appearance of a wild animal, penance for three years because this is devilish."[130] Whether such strictures might still be in the minds and praxis of the Anglo-Saxon artist-monks of Canterbury at the time of the making of Claudius B.iv cannot be accurately assessed but would seem highly probable.

Aligning himself with other earlier Christian apologists, Firmicus Maternus, Minucius Felix, and Tertullian, Eusebius promotes the concept of pagan plagiarism and demonic imitation (*imitatio diabolica*), meaning that the ancient Greek philosophers, Plato foremost among them, stole their ideas from the more ancient teachings of Moses and that pagan gods and liturgical rites are demonically inspired imitations of earlier Judaic ideas as well as future Christian concepts and rites.[131] If, from the point of view of these early Christian apologists, the pagan gods and demons, irrational as it may seem, modeled themselves, their attributes and rites, on—that is, plagiarized or stole those very things from—a preexisting Moses and the attributes and incidents of his life, then that is why Pan has horns, horns said to simulate the glorious radiance of the sun and moon, in imitation of the horns of Moses in Exodus 34:29.

That Jerome may have understood "horned" as a metaphor signifying radiance or light with reference to Pan in a positive manner is corroborated in an interesting way by the fact that Servius (Maurus Servius Honoratus),[132] late fourth to early fifth century C.E., in his commentary on Virgil's *Second Eclogue*, says of Pan that "his horns are like the rays of the sun and the horns of the moon," an idea echoed in Macrobius's early fifth-century C.E. *Saturnalia* (bk. I.22.2–22.7).[133] Servius, like Jerome, had been a student of Virgil's commentator Donatus. So Jerome, no doubt familiar with the idea that "horns" is the equivalent of "light," as in Servius and Macrobius, may easily have translated the Hebrew verb *qāran* of Exodus 34:29 as meaning "was horned," although on the face of it the equating of horns with light does seem a bit odd at first, as one might think that strength, power, and virility would be more appropriate. On the other hand, ideas and images such as the "horns" of the moon might be a possibility. Interestingly, Pan is depicted in a visually intriguing inversion in an early eleventh-century Montecassino manuscript of Hrabanus Maurus with whiskerlike rays coming out of both sides of his head in place of his usual horns.[134] From a visual point of view, then, if there were indeed a non-Hebraic tradition of equating *horns* with *light*, one might imagine an artist choosing to adopt the double-curved upright horns of Pan (of which there are numerous antique examples in a wide variety of media) as an appropriate source for depicting the radiant glow of Moses's face even without the stimulus of Jerome's Vulgate translation at Exodus 34:29 of *qāran* as "was horned." In other words, if in the ancient world horns were widely understood as symbols of light, majesty, power, and divinity, as indeed they seem to have been, then *theoretically* one might not even need Jerome's Vulgate translation in order to choose horns to symbolize the transformation of Moses's face; that is, horns could be used to communicate that idea even *without* use of the word itself. One might want to ask oneself the question, in the words of the Greek Septuagint, if the "skin of Moses's face was glorified [*dedoxasthai*]," then how would an artist represent this visually? Rays coming out of

Moses's head, as indeed many works of art both before and after Claudius B.iv would utilize, might be one solution, but horns, which meant the same thing, would theoretically work as well. Whether this was ever attempted before the image on folio 105v of Claudius B.iv, we do not know. But it should be recognized that Jerome's translation "was horned," that "Moses did not know that his face was *horned* from speaking with the Lord," should not be seen as either irrational or unusual but a legitimate, familiar equation often encountered in representations in the ancient world of gods, kings, and exalted military commanders. In a much later, fifteenth-century painting by Luca Signorelli, called variously the *Court* or *School of Pan*,[135] we see Pan seated at the center of the painting with the radiant horns of the moon emerging from his head.

Because the horns on Moses's head on folio 105v (fig. 10) do *not* emerge directly from his head but rise from his forehead, coupled with the fact that they are painted yellow (surely to indicate their association with light),[136] as are the round-topped Tablets of the Law in his right hand, it would be reasonable to understand their specific representation in Claudius B.iv as itself a *visual* exegesis of Jerome's *cornuta esset facies sua* as horns of *light*, much in the manner of the great Jewish commentator Rashi's later eleventh- to twelfth-century C.E. explication of the "horns" as light taking on the shape of a horn as it radiates from a point outward into space. In other words, they are not literal horns but light with the appearance of horns.

Jerome's translation of Exodus 34:29 (*ignorabat quod cornuta esset facies sua*) specifies that Moses did not know that his *face* was *qāran* ("horned"), where the LXX specifies that the "skin" of his face was "glorified" (*dedoxasthai*).[137] Visual imagery in the ancient and Late Antique worlds offered a limited selection, as far as we know, of possible representations of a "glorified" or "horned" face, if by "glorified" and "horned" something radiant with light is meant. The ancient Near Eastern and Egyptian examples I have brought forward exhibit horns—in the Egyptian examples, often associated with either lunar or solar discs (figs. 21, 27)—that are exclusively connected to helmets or crowns. I am, however, able to bring forward at least one visual example where an ancient Near Eastern deity is depicted with a radiant, sunlike head with triangular pointed rays emerging directly from the figure's circular face.[138] The Hellenistic Seleucid examples I presented feature horns emerging either directly from the individual's head (e.g., Alexander the Great and Demetrios Poliorcetes) or from a helmet on the individual's head (e.g., Seleucus Nicator; fig. 19). Other options for depicting radiance around the head of a deity or royal figure in Hellenistic and Late Antique imagery include a simple circular nimbus, or "halo,"[139] a halo with spiky rays emerging from it or through it,[140] or, generally for rulers, the *corona radiata* with raylike spikes emerging from a circlet on the figure's head.[141] All of these radiant "strategies," however, have to do with the figure's head, or cranium, rather than specifically the figure's *face* as in Jerome's locution of Moses's

face being "horned" rather than his head. Only the double-curved horns emerging from the face of Pan on the Metropolitan Museum dionysiac hanging (fig. 23) actually show the horns as contiguous and continuous with the skin of the figure's forehead, thus providing the most apropos prototype for the horns of Moses on folio 105v of Claudius B.iv (fig. 10), with the exception that the horizontally curved drawn line in the Claudius image at the base of the horns separates the horns themselves from Moses's forehead.

I suggested earlier that this drawn line seems to be the result of the artist's modus operandi of outlining the face, the forehead, and the horns first in a sepia ink and then only later filling in colors such as the yellow of the horns. In one example on folio 107v (fig. 25), the horns almost seem continuous with the skin of Moses's face, but upon closer inspection they too rise from above the curved horizontal sepia line defining the figure's forehead.[142] This yellow infill, as I suggested, is probably meant to represent the light radiating from Moses's face. At the risk of redundancy, it should be remembered that Jerome's text at Exodus 34:29 says nothing about light. Moses's face being radiant with light is an *interpretation* of the circumstances of the text, for example, in Philo and in Pseudo-Philo. As I was able to demonstrate in the case of the writings of Servius and Macrobius, the horns of Pan were understood as the light of the sun and the moon and that in general horns equal light. The horns of Pan, then, as seen on the Metropolitan Museum of Art hanging (fig. 23), or some other analogous visual source, are the best potential prototype for an image of a horned Moses, such as we see on folio 105v of Claudius B.iv (fig. 10), expressing the specific reference in Jerome's Latin text (Exod. 34:29) that Moses did not know that his "face was horned" from his encounter with the Lord on the holy mountain.

While there are much later, especially seventeenth- and eighteenth-century,[143] theological texts equating Pan and his horns with Moses in the manner of other such comparisons to pagan divinities in the works of early Christian apologists and theologians under the aegis of demonic imitation (*imitatio diabolica*), there is no literary example known to me at this time of such an equation of Pan with Moses from the early Christian period.[144]

That a Pan-like creature with goat's ears and horns could be utilized to represent Mors in the Leofric image (fig. 24) is possibly related to another important apologetic trajectory pursued by Eusebius in his *Praeparatio evangelica*, and that is the theme of the mysterious death of Pan,[145] as recounted by Plutarch in his *De defectu oraculorum*, which event is said to have occurred between the years 14 and 37 C.E., at the same time, during the reign of the emperor Tiberius, as the death of Christ on the cross. For Eusebius and Christian apologetics in general, the death of the god Pan is interpreted as the death of *all* pagan gods and demons through Christ's crucifixion by way of a "folk etymology" of Pan's name, as commented on

by Philippe Borgeaud,[146] "Pan" being understood since Plato's time as meaning "All." It is ironic that a supposedly immortal god like Pan should be conceived of as capable of dying, but interestingly, the "manikin" in Jerome's text of the Life of St. Paul tells Anthony, "I am a mortal being."

As there is no known clear iconographic precedent for Death to be represented with Pan-like features in the Leofric Missal image (fig. 24), with horns, long floppy goat's ears, and furry nether quarters, the "Death of Pan" (or "Pan as Death") apologetic in Eusebius as heralding the death of all the pagan gods seems a plausible motivation for these unusual attributes of Death depicted there.

Before coming to a final assessment of its origin and meaning, there are several tangential aspects of the image of a horned Moses that need further exploration. As Mellinkoff has pointed out,[147] the figure of Moses occupies an ambivalent position in Christian culture; exalted as he may be in the original biblical context of his encounter with the Lord, his association with the Law and the "Old" Covenant inevitably places him in a lesser position vis-à-vis the "New" Covenant instituted by Christ's death on the cross. Even in this context, however, Moses is not conceived of as an evil entity per se, yet there is the potential connection between the images of a horned Moses and a horned Satan.[148] As Mellinkoff and others have pointed out, in postclassical Western cultures and art, horns and being horned have an almost exclusively evil connotation.[149] St. Ambrose (d. 397 C.E.), however, in his *Commentary on Psalm XLVI*, recognizes that there are "good" horns (*bona cornua*) as well as "bad" horns and that "Satan has his horns" (*Satanas habet cornua sua*) but Man has no horns with which to protect himself. Christ himself, according to Ambrose, is our "horn" (*cornu nostrum es tu, domine Iesu*).[150] In other of his writings Ambrose expatiates a good deal about horns. For example, in his *De patriarchis* Ambrose has this to say: "He who has exalted the horn of Christ and proclaimed His glory Himself also receives the horns," and later in the same text, "Just so, when horns begin to grow from the head of our soul, as it were, they seem to indicate the advent of a more perfect virtue, and they grow until they are filled out. With this horn the Lord Jesus crushed the nations, to trample on superstition and impart salvation."[151] So clearly, horns, as a metaphor, are ambivalent and in the literary world of the Christian Fathers are not solely the ultimate sign of evil and the satanic.

There is also, on the other hand, the persistent myth, seemingly eternally alive in certain areas of the southern and western United States, as attested by a *New York Times* editorial piece,[152] that Jews have actual horns on their heads (albeit hidden by hair), at times associated as well with cloven hooves, sure signs of a satanic connection. Whether horns on the head had any such resonance in eleventh-century Anglo-Saxon England cannot be demonstrated. In any event, the transformation of horns and being horned from a sign of ultimate divinity and power in the ancient world to a sign of evil and satanic connections, largely during the Christian Middle

Ages, is paralleled, sadly, by a similar transformation at the hands of the German Nazi Party in the twentieth century of the venerable Sanskrit symbol of the swastika into a universally reviled symbol of hate and racial annihilation.[153]

The similarly curved horns on the head of Mors in the Leofric Missal image (fig. 24) may yet be ultimately related to the image of a horned Moses on fol. 105v of Claudius B.iv (Fig. 10). While horns and being horned were the ne plus ultra sign of divinity on both gods and kings in the ancient Near East and Egypt—as mentioned earlier, one of the Egyptian pharaoh's many titles was "the horned one"[154]—and while numerous Hellenistic gods and emperors sported horns on helmets as well as sprouting from tousled locks of hair, often bound by a diadem,[155] none of them looks exactly like the configuration we see on Moses's head on folio 105v of Claudius B.iv. The closest visual analogue we have at present, despite the much larger and taller horns of Moses on folio 105v of Claudius B.iv, is the horned Pan on the fifth- to sixth-century C.E. Egyptian textile hanging at the Metropolitan Museum of Art in New York (figs. 22, 23). One of the most salient features linking the representation of Moses's horns on folio 105v of Claudius B.iv with those of Pan on the Metropolitan Museum hanging is the fact that the horns in both cases rise from their respective foreheads without any indication of a headband or hat. Although, as noted earlier, the inclusion (or invention) of a diadem on Moses's head on folio 122v of Claudius B.iv, and its ongoing representation through to Moses's last appearance in the manuscript on folio 139v (fig. 14), differentiates the two images, it also at the same time links them by virtue of the fact that in both cases the horns are not intended as bony growths emerging from the figure's cranium but rather, as we know explicitly from literary interpretations of the horns of Pan in Servius and Macrobius, are meant to represent a radiance of light and therefore are rendered as flat rather than as conical protrusions rising from farther back on the figure's cranium. Again, as several Jewish and Christian apologetic texts that I have cited claim that Moses antedates *all* pagan gods and heroes, it would follow that his being represented with "horns of light" on his head like Pan on the Coptic textile could be seen as making the image of a horned Pan a "copy" of the original horned Moses.

Before pursuing further the possibility of the horns of Pan as the potential prototype for the horns of Moses in Claudius B.iv, I would like to turn my attention to a closer look at the representation of the peculiar veil of Moses on folio 105v and its relationship to a larger exegesis of Moses's horns.

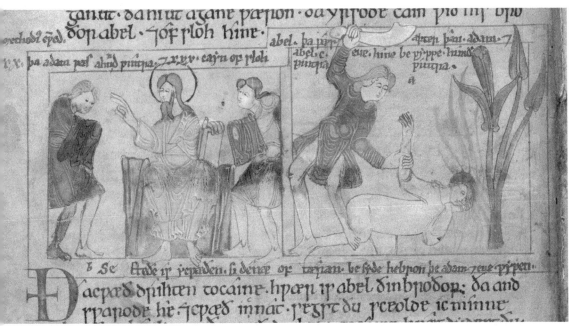

FIG. 1. Claudius B.iv, folio 8v, (left) Sacrifice of Cain and Abel, (right) Cain Slaying Abel (Gen. 4:3–5, 8). Photo: © The British Library Board. All Rights Reserved.

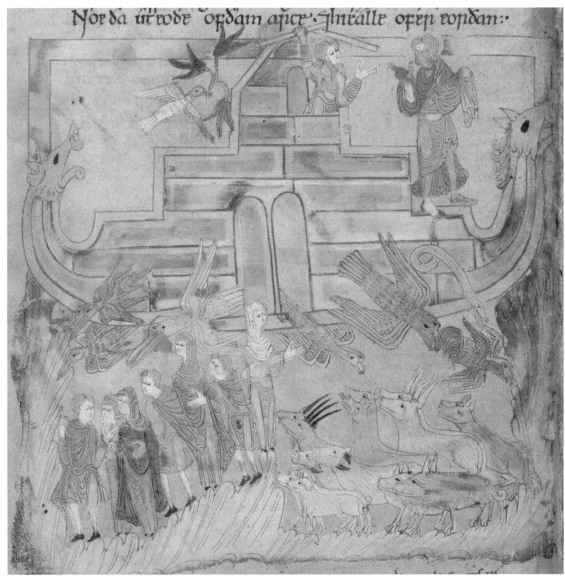

FIG. 2. Claudius B.iv, folio 15v, Disembarkation from the Ark of Noah (Gen. 8:10–19).
Photo: © The British Library Board: All Rights Reserved.

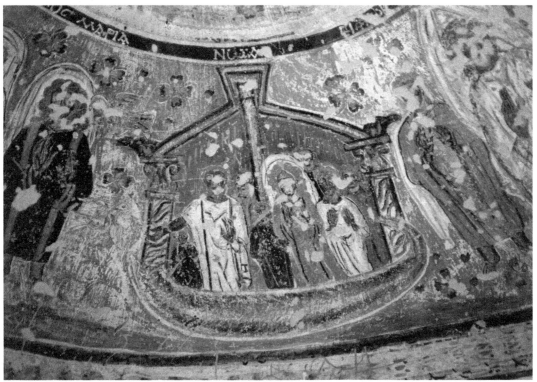

FIG. 3. (Left) Ark of Noah, fresco from the Chapel of Peace, El-Bagawat (El-Kharga Oasis), Egypt. Photo: © DeA Picture Library, Art Resource, New York, ART505915.

FIG. 4. Claudius B.iv, folio 2r, The Fall of Lucifer and the Rebel Angels. Photo: © The British Library Board. All Rights Reserved.

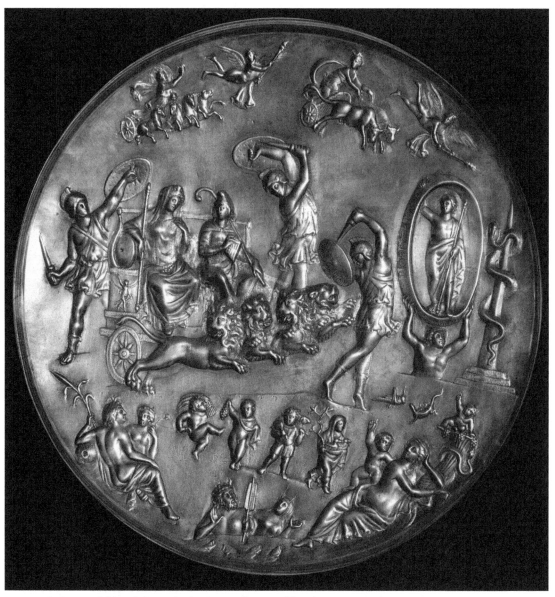

FIG. 5. Milan, Museo Archeologico, Patera of Parabiago, silver, diameter 40 cm, fourth–fifth century C.E. Photo: © Universal Images Group, Art Resource, New York, ART424356.

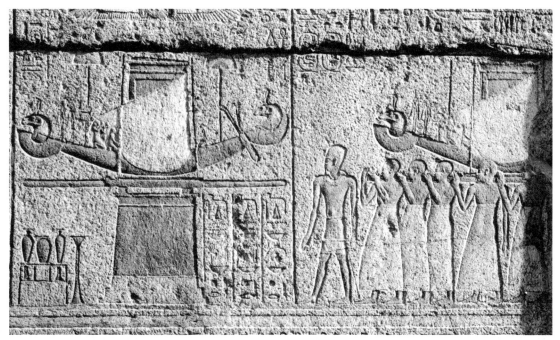

FIG. 7. Double-prowed Barque of Amun, relief sculpture, Karnak, Egypt (Amun District), Granite Chapel, south wall, middle register, ca. 323–317 B.C.E. Photo: © Foto Marburg, Art Resource, New York, ART517077.

FIG. 8. Claudius B.iv, folio 75r, detail (upper right), First Bath of Moses. Photo: © The British Library Board. All Rights Reserved.

FIG. 9. Claudius B.iv, folio 75r, detail (bottom left), Finding of Moses (Exod. 2:5–10). The ark containing Moses is given to the daughter of Pharaoh. Photo: © The British Library Board. All Rights Reserved.

FIG. 10. Claudius B.iv, folio 105v, detail, Moses with the Tablets of the Law and veil in hand speaks to the Israelites gathered before him (Exod. 34:29–35). Photo: © The British Library Board. All Rights Reserved.

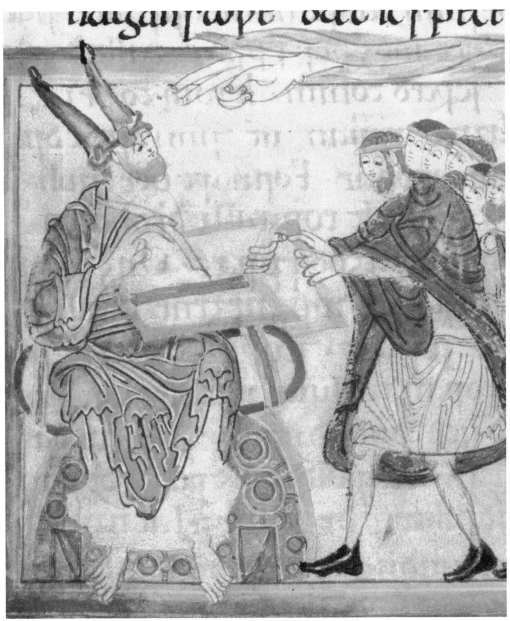

FIG. 11. Claudius B.iv, folio 136v, detail (below), Moses writes down the Law for the priests (Deut. 31:1–8). Photo: © The British Library Board. All Rights Reserved.

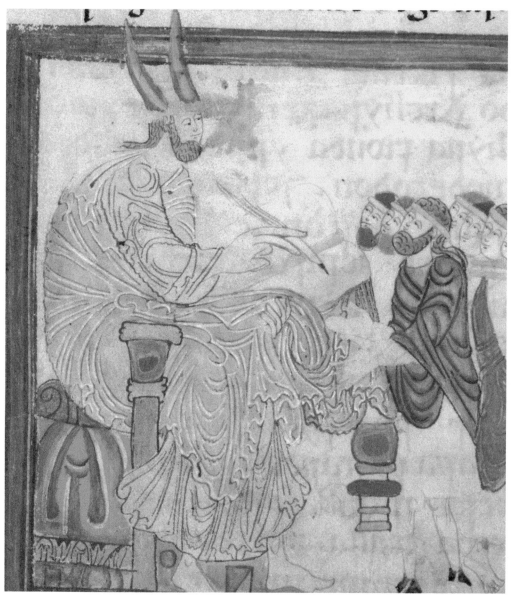

FIG. 12. Claudius B.iv, folio 138v, detail, Moses, seated at the left with a diadem around the base of his horns, writes down the Law and delivers it to the priests at the far right who carry the Ark of the Covenant (Deut. 31:22–32 to 32:47). Photo: © The British Library Board. All Rights Reserved.

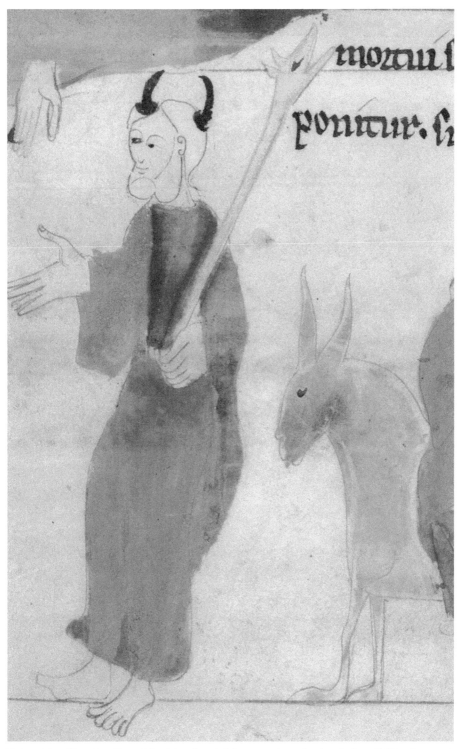

FIG. 13. Claudius B.iv, folio 78v, detail, Moses with snake-headed staff (Exod. 4:3–4).
Photo: © The British Library Board. All Rights Reserved.

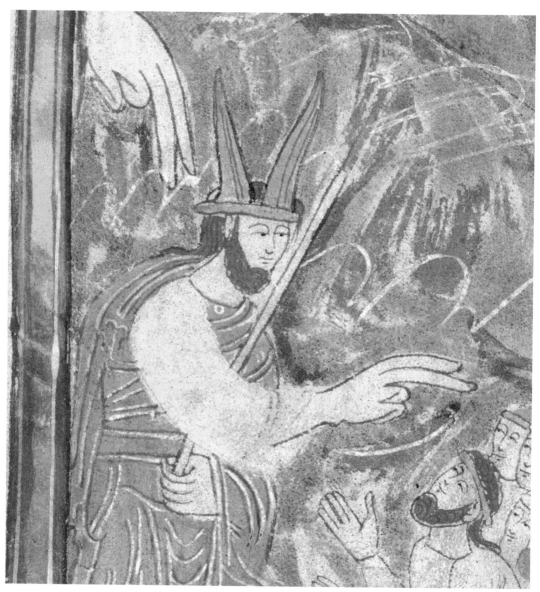

FIG. 14. Claudius B.iv, folio 139v, detail, Moses blesses the tribes of Israel (Deut. 32:48–34:12). Photo: © The British Library Board. All Rights Reserved.

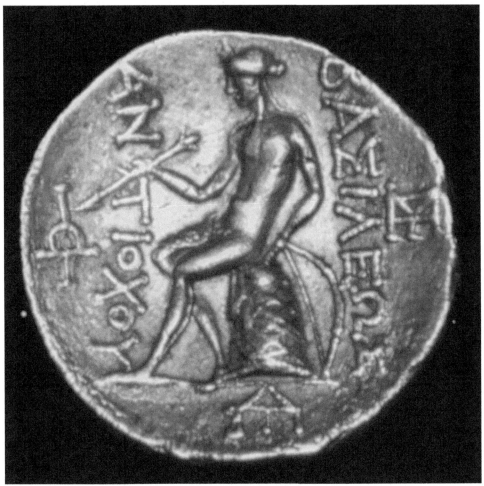

FIG. 15. Silver four drachms of King Antiochus III (ca. 241?–187 B.C.E.), reverse with Apollo Toxotes seated on the omphalos, Delphi. Photo: © HIP, Art Resource, New York, ART9165198.

FIG. 16. Claudius B.iv, folio 124r, detail, Moses raising the Brazen Serpent (Num. 21:8).
Photo: © The British Library Board. All Rights Reserved.

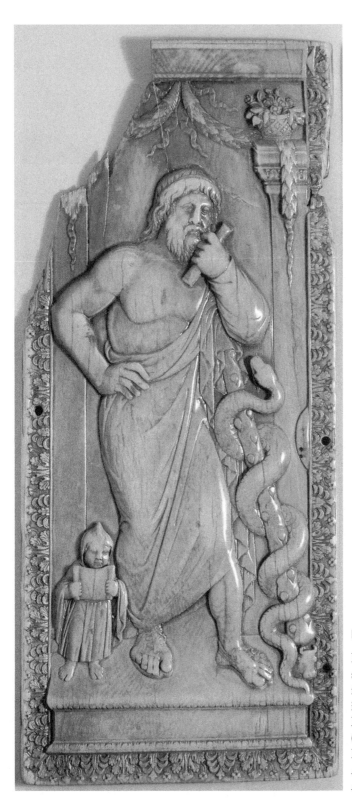

FIG. 18. Claudius B.iv, folio 136v, detail (above), Moses exhorts the Israelites and declares that Joshua will lead them (Deut. 31:1–8). Photo: © The British Library Board. All Rights Reserved.

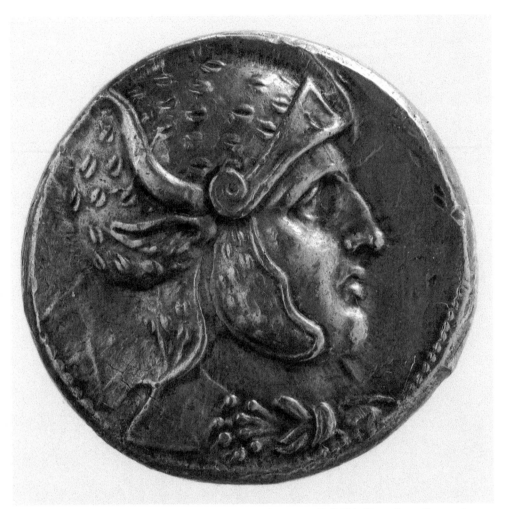

FIG. 19. Tetradrachm of Seleucus I Nicator (300–280 B.C.E.). From Iran, Pasargadae
(Fars Province). Silver, diam. 2.7 cm.; wt. 17 g. Purchase, H. Dunscombe Colt Gift, 1974
(1974.105.9), The Metropolitan Museum of Art, New York. Photo: © The Metropolitan
Museum of Art, New York, Art Resource, New York, ART348738.

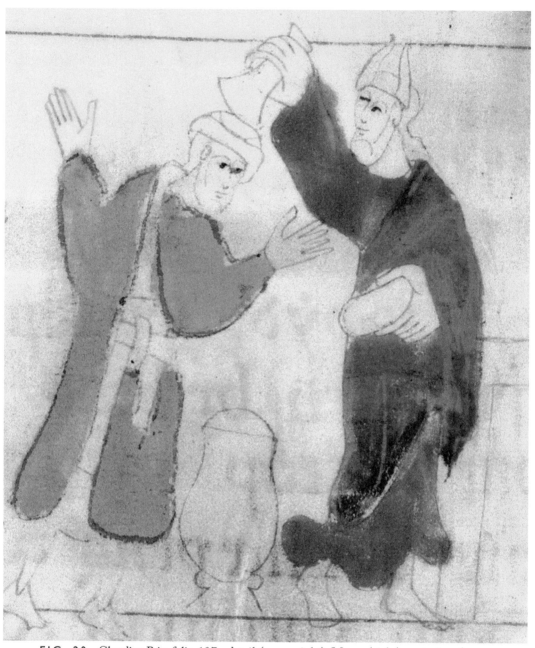

FIG. 20. Claudius B.iv, folio 107v, detail (upper right), Moses (right) anointing Aaron (left) (Lev. 8:6 and 12). Photo: © The British Library Board. All Rights Reserved.

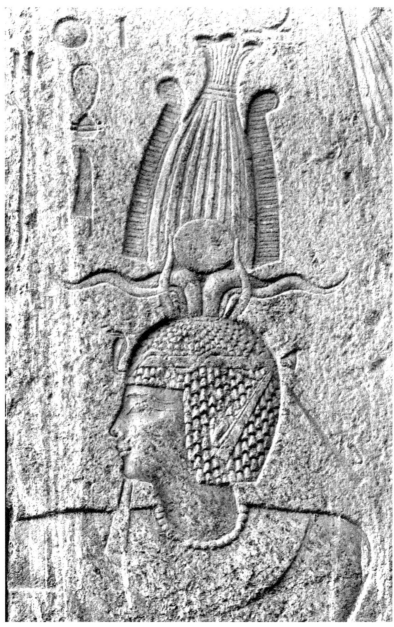

FIG. 21. Detail, head of Philip III Arrhidaeus as Pharaoh (fourth century B.C.E.). From the north wall, outer face, of the Granite Sanctuary, Karnak, Egypt. Photo: © Foto Marburg, Art Resource, New York, ART517079.

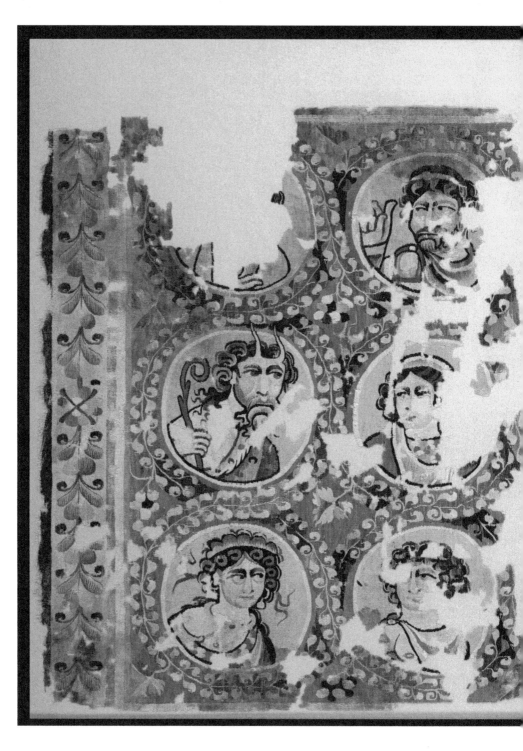

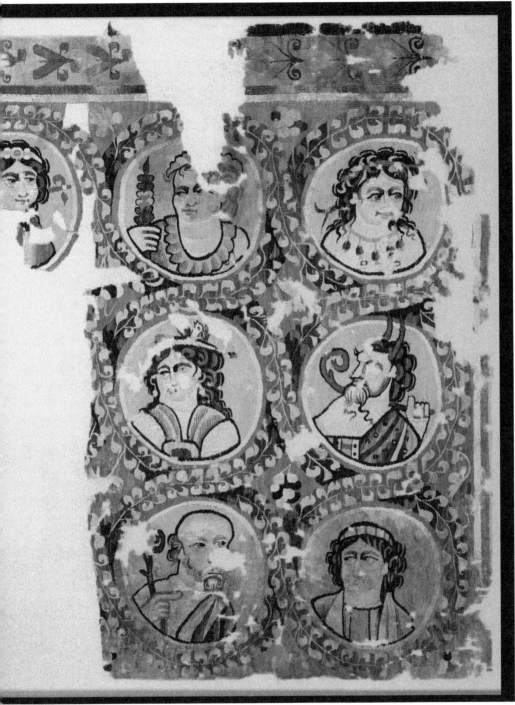

FIG. 22. Fragmentary hanging with Dionysiac Group, Coptic (ca. 400 C.E.). Linen, wool. Height 40.25 in., width 62.25 in. Gift of Edward S. Harkness, 1931. Accession no. 31.9.3. © The Metropolitan Museum of Art, New York. Photo: Art Resource, New York, ART367348.

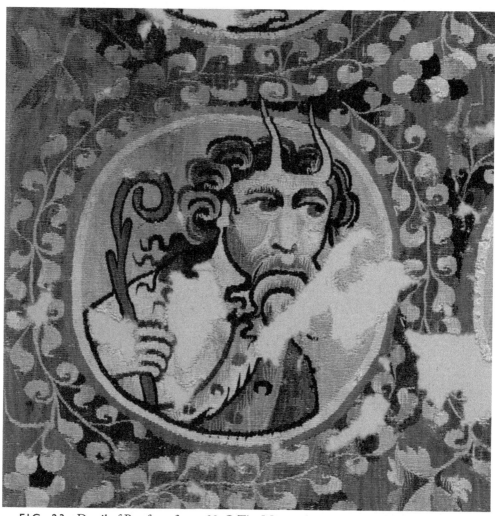

FIG. 23. Detail of Pan from figure 22. © The Metropolitan Museum of Art, New York. Photo: Art Resource, New York, ART367348.

ude p.xxx. &qcdd supauerit reuerteris ad organiolu instra scriptu. & si
1021 conuenerit parti numerus uitalis erit. Si inferiori parte conuenerit

; neguais aut
f. Si dies dnic?
. Si lune. xviii.
iercurius xxv.
neris xv
t

Sic & deom
causis re
fuerit adde
Si martis. xv.
Si iouis. xi.
n. xxvi.

FIG. 24. Oxford, Bod. Lib. MS 579, folio 50r, The Leofric Missal. Detail, *Mors* (Death).
Photo: Courtesy of the Bodleian Library, Oxford.

FIG. 25. Claudius B.iv, folio 107v, detail (lower left), Moses (left) anointing Aaron (right) (Lev. 8:23–24). Photo: © The British Library Board. All Rights Reserved.

FIG. 26. The god Amun. Wall painting from Tomb Maison 21, Tuna el-Gebel, Egypt.
Photo: ©Institut français d'archéologie orientale, Cairo, Egypt.

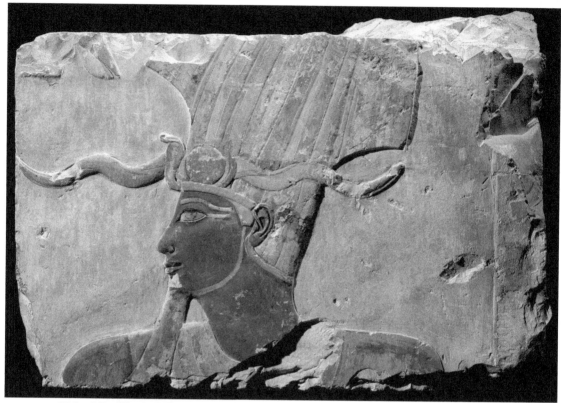

FIG. 27. Head of Thutmose III (1490–1436 B.C.E.). Limestone, painted. H: 58.5 cm.
From Deir el-Bahari, Museum at Luxor. Photo: © Erich Lessing, Art Resource, New York,
ART202756.

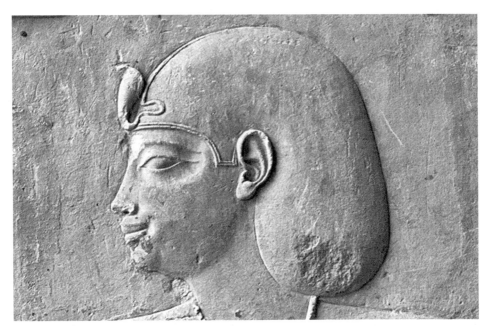

FIG. 28. Detail, head of Ptolemy I with wig-cover (*Afnet/Khat*), Hellenistic (ca. 305–282 B.C.E.). From Kom Abu Billo (Tarrana/Terenuthes), Egypt. Boston, Museum of Fine Arts (#89.559). Photo: Courtesy of the Museum of Fine Arts, Boston.

FIG. 29. Seated Khery-heb priest reading from a scroll, detail. Painted wooden coffin lid of Ankhpakhered (ninth century B.C.E.). Berlin, Staatliche Museen. Photo: © Ägyptisches Museum und Papyrussammlung, Staatliche Museen zu Berlin.

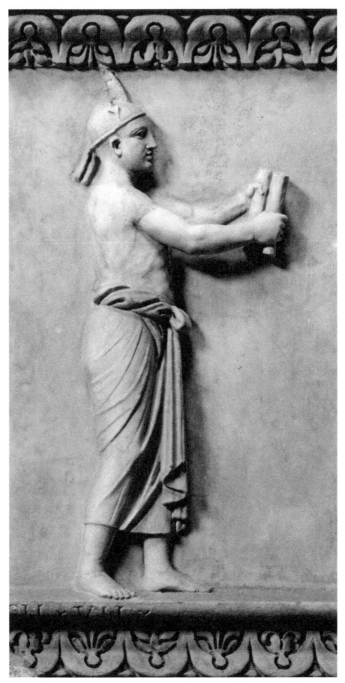

FIG. 30. Isis priest (*hierogrammateus*) reading from a scroll, detail. Sculpted marble relief of an Isiac procession (second century C.E.). Vatican Museums, Vatican City. Photo: ©Alinari/Art Resource, New York, ART186801.

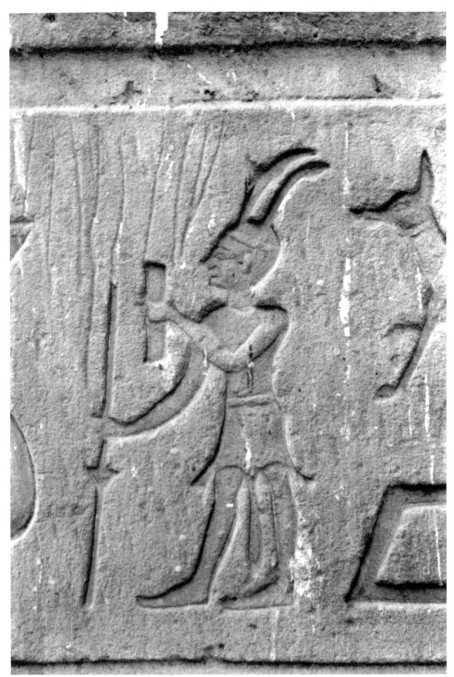

FIG. 31. Detail, carved sunk relief showing Imhotep as a Khery-heb priest, Temple of Horus at Edfu, Egypt (third–first century B.C.E.). Photo: Courtesy of Professor Dr. Dietrich Wildung, Munich.

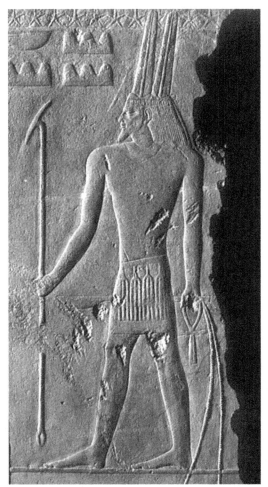

FIG. 32. Relief sculpture from the Mortuary Temple of King Sahurê (ca. 2430 B.C.E.).
Detail showing the god Sopdu ("Lord of the Foreign Lands"). Berlin, Staatliche Museen,
Ägyptische Museum. Photo: Courtesy of the Staatliche Museen, Berlin.

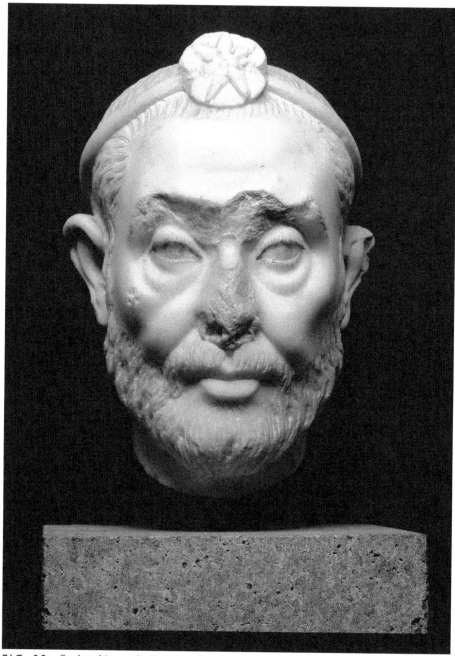

FIG. 33. Sculpted bust of a Serapis priest (ca. 230–240 C.E.). Marble, 28.8 cm. Staatliche Museen, Berlin. Photo: © Ingrid Geske/Art Resource, New York, ART464929.

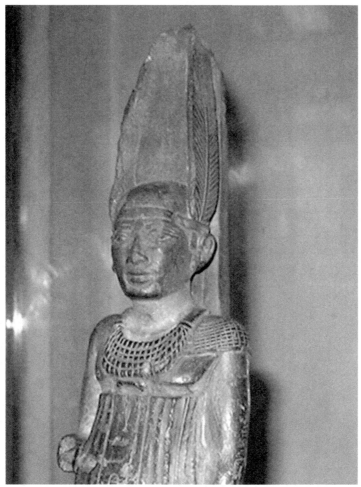

FIG. 34. Detail, head of the Khery-heb priest Pedeamun-Nebnesuttaui (ca. 665 B.C.E.).
Photo: Courtesy of the Museum of Egyptian Antiquities, Cairo.

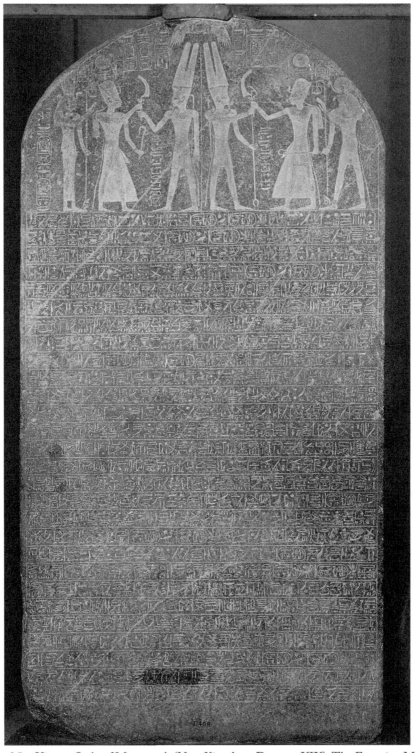

FIG. 35. Victory Stele of Merneptah (New Kingdom, Dynasty XIX). The Egyptian Museum, Cairo. Photo: © DeA Picture Library, Art Resource, New York, ART421478.

The Veil of Moses

The mysterious veil[1] donned by Moses in Exodus 34:33–35 has elicited a certain amount of exegetical commentary but, curiously, very limited expression in the visual arts, although it is a dramatic and essentially *visual* phenomenon.[2] In my article "The Veil of Moses as Exegetical Image in the Illustrated Old English Hexateuch,"[3] I make a case for interpreting the strange device held in Moses's left hand on folio 105v (fig. 10) as a complex visual exegesis of the biblical account of Moses's veil, which one might well imagine as a cloth covering Moses's face more or less as described in the text. In Claudius B.iv, however, it is shown instead as a very peculiar cross-beamed standard from which hang two knotted, pinkish curtains resembling some kind of strange outdoor clothesline or a sail for a boat. To make a complex argument simpler for our purposes here, what I hope I have demonstrated in detail in the article is that this construct is meant to be understood as a proleptic veiled *cross* that Moses is presenting, prophetically, to the Israelites gathered before him in this Christian manuscript, but who, theoretically, cannot see it as such, for as St. Paul says in 2 Corinthians 3:12–16, the Jews are not able to discern salvation in the cross of Christ as "their senses were made dull," and like the veil obscuring Moses's face, the Jews "until this present day" still have "the veil . . . upon their heart" and cannot see the true meaning of the Old Testament, which is, for Christian exegetes, but a shadow of things to come in the life and death of Christ.

As Mellinkoff has observed,[4] St. Paul might justly be styled the first Christian interpreter of Exodus 34:29, the text where Moses is described as not knowing that his face is "horned," when Paul says in 2 Corinthians 3:6–8:

For the letter killeth, but the spirit quickeneth. Now if the ministration of death, engraven with letters upon stones [i.e., the Law written on the stone

tablets Moses brings down from Mount Sinai] was glorious: so that the chil-
dren of Israel could not steadfastly behold the face of Moses, for the glory of
his countenance which is made void: How shall not the ministration of the
spirit be rather in glory?

Commentators on Paul's exegesis here have emphasized that Paul's perception
of the glory (*doxa*) of Moses's countenance is that it is *temporary* and that Moses
covers his face to obscure the fact that this glory is fading.[5] Also, in the never-
ending one-upmanship of early Christian apologetics, a number of exegetes con-
trast the full-body transfiguration of Christ on Mount Tabor with the fact that only
Moses's *face* was made radiant on Mount Sinai.[6] Origen, the famous second-third-
century C.E. Alexandrian Christian exegete, in his *Exodus Homily XII* says of
Moses, "Moses has, therefore, nothing else glorious in the Law except his face. In
the Gospels, however, the whole Moses is glorified anew."[7]

The concept of Moses's veil as "veiling," or preventing, the Israelites from per-
ceiving the cross of Christ has an additional reverberation in Old English poetry.
In the poem *Exodus*, the great cloud that protects and accompanies the Israelites on
their journey out of Egypt is described metaphorically as a sail: "sunnam sithfaet
offertolden/ swa tha maestrapas men ne cuthon/ ne tha seglrode geseon maehton/
eorthbuende ealle craefte" (so that men, dwellers on earth, did not know the mas-
tropes and could not see the sail yard [cross-bar]).[8]

The poet, as Peter J. Lucas points out,[9] has combined the sailyard with the
Rood, the cross of Christ. So, as with St. Paul's diatribe about the Jews who in read-
ing sacred script have their eyes veiled and cannot see the (Christian) Truth, the
Exodus poet suggests that the ancient Israelites could not perceive the cross within
the mighty sail/cloud in the poem. The association of the cross of Christ with the
mast and sailyard of a ship is an early Christian topos, an example of which is to be
found in the *Sentences* of the Coptic holy *synaxarion* counseling the devout Chris-
tian in times of trouble and contrary winds "to raise the Cross like a sail."[10]

In conjunction with the hypothesis presented in chapter 4 that the horns of
Moses that are depicted for the first time in Claudius B.iv on folio 105v might be
seen to be based on an image of the horns of Pan such as that on the Coptic hang-
ing in the Metropolitan Museum of Art in New York (figs. 22, 23), a hypothesis
that I explore in more detail in chapter 6, it is important to note that, contrary to
most modern associations of the goat-horned god Pan with rampant sexuality and
perhaps, thanks to his *syrinx*, or Pan pipes, rustic music making, Pan was a much
more complex deity, especially in the Late Antique period. Among other at first
unlikely associations, Pan was characterized in the so-called Orphic Hymns as a
god in charge of the winds, referred to as the "Sail of the World."[11] Pan was also
perceived as a source of protection against the perils of the sea and seafaring voy-

ages.[12] Even more curious, as indicators of this aspect of the god's purview and as indicators of what some have referred to as the "broadmindedness" of some Egyptian Jews,[13] are two Greek inscriptions in the Temple of Pan at Apollonopolis Magna (Egyptian Edfu) in Upper Egypt (second century C.E.), one of which reads, "Thanks to [the] God, the Jew Theodotos son of Dorion was saved from the sea."[14] In the words of F. Millar in a new edition of Emil Shürer's classic work, "Whether this was Pan or Yahweh seems not to have been of great importance to them."[15] Other scholars have disputed this interpretation.[16] Additional inscriptions record Jewish visits to the Temple of Pan (Egyptian Min) at el-Kanais,[17] but the precise meaning of such inscriptions is also a disputed matter. In any event, the conjunction of possible Pan horns and veil-like sails in the folio 105v image presents a vivid example of image recycling, where specific motifs and elements from seemingly unlikely "pagan" sources have been repurposed to express a complex and totally different set of exegetical ideas.

Related to the recycling of pagan imagery is a painting of the chief Egyptian god Amun on the wall of a late Egypto-Roman tomb (fig. 26), possibly second century C.E. in date, at the site known today as Tuna el-Gebel, one of several necropolises of ancient Khmun (Hermopolis Magna), a city sacred to the god Thoth (Gk. Hermes, ergo Hermopolis).[18] Among other monuments of note, Tuna el-Gebel is the site of one of the boundary stelae of Akhenaten, the "heretic" king, as well as the ca. fourth-century B.C.E. tomb of Petosiris, a chief priest of the scribe god Thoth, and the second-century C.E. tomb of one Isadora, which still contains her intact mummy.[19] This image of Amun, which was not known to me at the time I published my 2011 article on the veil of Moses in Claudius B.iv, presents an important possible visual prototype for the extraordinary rendering of Moses's sail-like "veil" hanging from a cross-shaped "mast" on folio 105v of Claudius B.iv (fig. 10).

The image of Amun is located on the lower painted register of the west wall of Room #1 in a "house" tomb designated "Maison #21" in the necropolis of Tuna el-Gebel, Egypt.[20] Amun is one of four gods represented in this panel, second from the left, with the goddess Nephthys in front of him and the goddess Hathor and the god Thoth behind him. Amun is shown wearing a short kilt with an animal tail visible falling behind. On his head is a multicolored traditional four-feathered crown, the lower part of which consists of the "red crown" of Lower Egypt. Amun's left arm and hand are raised before him, while his raised right hand holds what the literature on the tomb calls a "scepter,"[21] in the form of a cross with two diaphanous curtains, or cloths, perpending from it, the one above shown as smaller than the one below. This striking, cruciform-shaped object is probably meant to represent the hieroglyph "Sail" (*hetau*), which refers to the idea of "breath" or "wind," as Amun is conceived of in Egyptian theology as a lord of air and wind, the source of "the breath of life."[22] In the Book of the Dead, images of the deceased are often

shown with this symbol as an illustration for Spell 38A, "Living by Air in the Realm of the Dead."[23] Amun, then, is characterized as providing the "sweet breath of life" to the deceased.

To a Coptic Christian, the image of Amun (fig. 26) might well be understood as miraculously holding a "proleptic," "prophetic" Christian cross. There are famous examples in the early Christian Egyptian context of the Egyptian Ankh symbol being interpreted as prophetic of the life-giving cross of Christ,[24] and there are many examples of the reuse of Egyptian temples and tombs as places of Christian worship, perhaps most famously the Temple of Isis at Philae where crosses have been carved into the stone reliefs and hieroglyphic inscriptions.[25] Not far from Tuna el-Gebel, at the site known today as Deir el-Bersha, there are several tombs that had been used by Christian monks and have crosses painted over the much older Egyptian dynastic imagery.[26] The Tuna el-Gebel Amun with his veiled "cross" would have made an ideal prototype for a prophetic image of Moses holding a veiled cross before him as we see on folio 105v of Claudius B.iv (fig. 10). But, one might reasonably ask, why should Moses be holding a veiled cross, and what would a veiled cross have to do with the veil described in the Bible as covering Moses's face? As I demonstrated in my article on this strange motif, there are other cognate associations with this peculiar veil that work together in this Christian manuscript to communicate a much larger exegetical concept that relates to a peculiarly Christian understanding of Moses and his veil.

For one thing, on folio 105v of Claudius B.iv, Moses holds an occluded, or veiled, cross in his left hand, much like the famous *labarum* of the first Christian emperor, Constantine,[27] or a military *vexillum* or *tropaeum*[28] of the kind displayed by the Roman military on numerous Roman numismatic examples.[29] Jerome himself refers to this association in his *Homily on Psalm 91*: "That is why, too, the Lord is described as a horn to those who believe in him: and it was with the horns of the cross that he routed his enemies. On the cross he confounded the devil and his entire army."[30] Jerome continues, "To be sure, Christ was crucified in his body, it was he who was crucifying there the devils. *It was not a cross*; it was a symbol of triumph, *a banner of victory*."[31]

In one sense, then, Moses as the "Great Commander" is holding the banner of future victory, the veiled cross of Christ in his left hand, prophetically anticipating the words of the famous sixth-century C.E. hymn of Venantius Fortunatus, *Vexilla Regis Prodeunt* (The Banners of the King Go Forth),[32] with the cross of Christ being likened in the hymn to a Roman military *vexillum*.[33] Moses, then, could be seen in his role as a military commander, a Hellenistic *strategos*, as characterized by Josephus (*Against Apion* 2.157–58).[34] In the writings of Eusebius (*Demonstratio evangelica* III.2.6–30) and others, Moses is also regarded as a prefiguration of Christ and the staff of Moses is understood as a prefiguration of Christ's cross.[35] The cross-shaped staff with its curious veil that Moses holds on folio 105v could well be

understood in light of this comparison. In addition, by holding the round-topped Tablets of the Law in his right hand, "a ministration of death engraven upon stones" according to St. Paul, the figure of Moses on folio 105v stands prophetically between the "ministration of death" through the Law, on the one hand, and the salvation of mankind through the death of Christ on the cross, on the other.

Referring again to Eusebius in his major apologetic work, the *Apodeixis* (comprising the *Praeparatio evangelica* and the *Demonstratio evangelica*), we come across his, by modern standards, curious distinction between the ancient *Hebrews*, who lived before Moses and who, according to Sabrina Inowlocki's assessment, "enjoyed a natural religion . . . free of any obligation," and the *Jews*, who "lead their lives according to the law of Moses, which involves the observance of the Sabbath, various food restrictions, certain purifications and holidays."[36] Oddly enough, as Inowlocki points out, "Eusebius does not hesitate to interpret this passage (Deuteronomy 5:1, e.g., in which Moses tells the people that the covenant on Mount Horeb was made with them, not with their ancestors) as meaning that a superior kind of covenant was made with the ancient Hebrews whose heirs are the Christians. Therefore, the 'true' 'Hebrews'—and consequently the Christians—hardly required laws to lead a life in accordance with God thanks to their true knowledge of the divine."[37] In this light, Moses promulgating the Law to the Israelites on folio 105v of Claudius B.iv could be seen as having a highly negative valence as the Law was seen, in his view, as a necessary propaedeutic/prophylactic function to "cure" the Jews of their illnesses caused by the bad influence of the Egyptians and their idolatry.[38] The Law, of course, in Paul's sense, introduces condemnation, indictment, and punishment.

In another interesting early Christian topos, in his *Paedagogus* (The Instructor), Clement of Alexandria puts forward the idea that the *Logos* teaches Moses to act as an instructor,[39] and that the Law is training for "refractory children." And as Richter and Taylor pointed out in their classic 1904 study of the mosaics of Santa Maria Maggiore in Rome, Clement says that to Christians "Moses is prophet, lawgiver, leader, general, statesman, philosopher."[40]

Thomas Ohlgren has suggested that the parted cloth of Moses's veil on folio 105v of Claudius B.iv might be a reference to the veil of the Holy of Holies in the Jerusalem Temple that is said in the Gospels (Matt. 27:51) to be rent asunder at Christ's crucifixion.[41] Origen was the first to interpret the veil of the Temple as the flesh of Christ himself,[42] an appropriate cognate idea associated with the "veiled" cross seen here in Moses's hand.

The horns on Moses's head, then, may indeed associate him more closely with the horns on the head of Mors in the Leofric Missal image (fig. 24) as an image of Death by virtue of the Law. At this point, it must be said that the cross-beamed representation of Moses's veil on folio 105v (fig. 10) is so peculiar that it must alert us to the possibility that, as a bearer of complex messages in a "visual" exegesis, the illustrations of Claudius B.iv are, to say the very least, most extraordinary.

Horns of Pan/Horns of Light

I have explored a number of potentially appropriate sources for the representation of Moses with horns in Egyptian pharaonic iconography as well as Seleucid Hellenistic horned headgear, with particular reference to the vertical, double-curved shape of Moses's horns depicted on folio 105v of Claudius B.iv. However, the best *visual* analog for the Claudius image (fig. 10) remains the horns of Pan as represented on a fifth- to seventh-century C.E. Coptic textile (figs. 22, 23) in the permanent collection of the Metropolitan Museum of Art in New York primarily because the horns in this work rise from the figure's forehead, *not* from the sides or top of the cranium, and are *not* associated with a helmet or headgear of any kind. Nevertheless, it might at first seem inappropriate that a figure of the pagan god Pan, generally associated with hybrid, half human/half animal, insatiable sexuality, could be a source of inspiration for rendering the spiritual distinction of Moses's face being "horned" from his encounter with the Lord. Before exploring this perceived anomaly in more depth, I would like to turn first to a more detailed account of this striking example of textile art.

According to the Metropolitan Museum's website,[1] this "Fragmentary Hanging with Dionysiac Group" is said to have come from Antinopolis (Antinoë = modern El-Sheikh 'Ibada, or 'Abada) in Egypt.[2] Woven of linen and wool, the hanging measures 40.25 inches in height by 62.25 inches wide, its twelve (originally fifteen) busts framed in leafy circular medallions representing the satyrs, maenads, and others who form the *thiasos* (ecstatic retinue) of the god Dionysus, who may have originally been depicted at the center of the composition as one of the two missing roundels. The Metropolitan Museum website identifies the bearded, bald figure second from the right at the bottom as Dionysus's "tutor" Silenus.[3] The bearded figure second from the left in the top row has been identified as Hercules.

The two bearded figures with horns, both carrying curved shepherds' crooks, or *lagobolon* (originally a curved stick for striking hares, an important iconographic attribute of Pan), at the extreme left and right of the second register are identified as Pan and one of his sons, described in Nonnus of Panopolis's fifth-century C.E. epic poem, the *Dionysiaca*,[4] as assisting Dionysus in his conquest of India. Both Pan figures are bearded, with curly dark hair flowing down the backs of their necks. The figures are differentiated from each other in their poses and the colors of their *lagobolon* and horns. The Pan figure at the left, who is seen from the front, carries a blue *lagobolon*, while his two double-curved horns, which are the same color as his skin, rise up from his forehead, crossing the circular frame of the medallion that encloses him. All of the medallions are linked by leafy tendrils of ivy, a plant sacred to Dionysus. The Pan figure at the right, who might be meant to be seen from the back (*a tergo*) with his head twisted around toward the viewer, holds a reddish *lagobolon* in his hand and has reddish-colored horns that seem to rise more from the temples of his head but that also cross the circular frame of the medallion that encloses him. Servius (late fourth–early fifth century C.E.), in his commentary on Virgil's *Fourth Eclogue*,[5] says that Pan's face "is ruddy, in imitation of the aether; he has a spotted fawn's skin on his breast, in likeness of the stars," and that "he has a crook, i.e. a curved staff, on account of the year, which runs back on itself—because *he is the god of all nature*"[6] As will be discussed later in more detail, this description of Pan as a universal god closely associated with light seems reflected quite well in the details of the Metropolitan Museum hanging. Pan is a protean figure in Greco-Roman mythology, who appears at times in multiples, known as the Paniskoi (little Pans).[7] The mythographer Kerenyi notes the existence of two principal Pans, one the son of Zeus and twin of Arcas and the other a son of Cronus.[8] In Nonnus of Panopolis's *Dionysiaca*, Pan has twelve named sons who come to Dionysus's aid in his war against the Indians. In the Metropolitan Museum hanging, however, it cannot be determined which Pan is which, although it might be ventured that the ruddy color of the horns on the head of the figure farthest to the right seems to correlate more closely with Servius's description of Pan's ruddy face. It might also be possible that the Pan at the right with the ruddy horns was meant to be associated with the sun, while the Pan at the left, with pale skin tone and horns, was meant to relate to the moon. In any event, the salient feature of both figures for our purposes here is the shape of their horns and the physical relationship of the horns to their respective heads. In this connection, the Pan at the far left of the hanging is the most analogous to the configuration of the horns on Moses's head on folio 105v of Claudius B.iv. Three major differences, however, distinguish this figure from the Moses of folio 105v: (1) the greater height of the horns on Moses's head on folio 105v; (2) the fact that the horns of Moses are yellow in color; and (3) the fact that the horns on the hanging are continuous with the skin of the figure's forehead,

whereas the horns on Moses's head on folio 105v are separated from the skin of his forehead by a curved horizontal drawn line that runs unbroken from temple to temple across his forehead. Each of these differences, however, has a reasonable explanation, and it is certainly clear that the Moses of folio 105v is by no means meant to be understood as an exact copy of any specific figure on the Metropolitan Museum hanging. The larger size of the folio 105v horns may be a matter of artistic emphasis, while their yellow color is related again to the idea of their representing the light of the sun signifying the radiance of Moses's face from his encounter with the Lord on the holy mountain. The curved horizontal line separating the horns on Moses's head from continuity with the skin of his face may have to do with how the artist actually went about drawing the head of the figure as a whole. It may well be that the face to the top of the forehead was drawn first as a continuous outline, and then the horns were drawn in as outlines followed by the uncolored-in domical cranial portion of the head between the horns. The horns were then colored in with yellow paint, and the artist may have intended to come back and color in the hair between the horns and down the back of Moses's neck, but, as with many other illustrations in the manuscript, this never happened.

In his poem *The Dunciad Variorum*, the eighteenth-century English poet Alexander Pope, castigating the destruction of major works of pagan antiquity, laments an imaginary statue of Pan now converted into a Moses:

> See, the Cirque falls! Th' unpillar'd Temple nods!
> Streets pav'd with Heroes, Tyber choak'd with Gods!
> Till Peter's Keys some christen's Jove adorn,
> And Pan to Moses lends his Pagan horn;
> See graceless Venus to a Virgin turn'd
> Or Phidias broken, and Apelles burn'd.[9]

Nevertheless, in the syncretistic[10] culture of Late Antique Egypt, or the late Roman Empire in general for that matter, such an association is not unthinkable. In chapter 4, I indicated that Jerome's understanding at Exodus 34:29 of the Hebrew verb *qāran* as "to become horned," that is, to radiate light as a "horn," may have been influenced by the concept in both Servius's commentary on Virgil's *Fourth Eclogue* and Macrobius's *Saturnalia*[11] that the horns of Pan symbolize the light of the sun and the moon.[12] The idea that Pan's horns symbolize the sun and the moon was already a major theme for the neo-Platonic philosopher Porphyry of Tyre (ca. 234–ca. 305 C.E.), who in his treatise *On Images*[13] says that Pan was intended to be the whole (*pan*) of the world and that is why his horns signify the light of the sun and the moon. The earliest attested philosophical speculation on the meaning of Pan's name is said to be the *De natura deorum* of the Roman Stoic philosopher

Lucius Annaeus Cornutus of the first century C.E.[14] The idea, then, that Pan is the "whole of world" and that his horns symbolize the light of the sun and the moon[15] was widespread in the late Greco-Roman world, appearing as well, for example, in a text known as the *Supplementa problematorum* attributed to Alexander of Aphrodisias (also known as Pseudo-Aristotle), a commentator on Aristotle of around 200 C.E.[16] That Pan's horns symbolize the light of the sun and the moon was also known to Isidore of Seville (ca. 560–636 C.E.), who repeats it in his *Etymologiae*.[17] And finally, the seemingly unlikely idea that the horns of Pan were associated quite widely with light is demonstrated for us visually in an image of Pan with whisker-like rays coming out of both sides of his head in place of his usual horns from an eleventh-century Italian illustrated manuscript of Hrabanus Maurus's *De reum naturis*.[18]

The Late Antique[19] milieu that I am positing here for the original conception of a Pan-horned Moses is the world of Hermes Trismegistus,[20] the *Hermetica*, and the "exotic" *Götterdämmerung* cosmos of the fourth- to fifth-century C.E. poet Nonnus of Panopolis (Akhmim), Egypt.[21] In addition to the famous epic poem in Greek, the *Dionysiaca* (the longest surviving poem from antiquity at 20,426 lines, celebrating the life and accomplishments of the god Dionysus, thought to have been written in the fifth century C.E.), Nonnus wrote a paraphrase of the Gospel of St. John, the *Metabole kata Ioannou*.[22] That these two seemingly diametrically opposed works could come from the same author is testimony indeed to a cultural context not easily understood in our time, as modern audiences tend to perceive pagan and Christian themes as mutually exclusive. This seemingly irreconcilable conflict between pagan and Christian themes in two diametrically opposed works by the same author is similar to the seemingly incongruous concept at the center of my hypothesis: that is, that the horned image of the Greek god Pan in the Metropolitan Museum hanging—or something very similar to it—served as a model for a horned Moses in an earlier exemplar on which the eleventh-century Anglo-Saxon artists of Claudius B.iv were basing their illustrations.

More recent scholarship on Nonnus and his cultural milieu has reevaluated this hypothetical conflict between pagan and Christian themes and has brought forward a more complex and nuanced picture of an environment in which these two strands were more often than not intermixed in ways that may still seem surprising, if not shocking, to modern audiences.[23] In an important article by Gianfranco Agosti, the author makes the observation, "When we speak of the 'ambiguity' affecting Nonnian poetry, in expressing either the refined theological reading of the Fourth Gospel or the intoxicating narrative of Dionysus' terrestrial life, we should keep in mind that such an ambiguity was primarily a fact of language, and very common in the everyday life of Egyptian Late Antique elites. The coexistence of Biblical and mythological motifs in everyday art illustrates such a phenomenon well."[24] No better example of this "coexistence" is to be found in two astonishing Coptic textile fragments

now in the Abegg Stiftung in Riggisberg, Switzerland,[25] the larger of the two exhibiting an array of dionysiac figures, including Bacchus himself, shown "tipsy" and posing alluringly nude, along with a syrinx-playing Pan with hairy goat's legs next to several female nudes. According to accounts of its original discovery, this larger Dionysiac fragment was attached to a few other scraps of textile that depict episodes from the New Testament, Joseph as a carpenter, the Annunciation to the Virgin Mary, and the town of Bethlehem.[26] In the words of G. W. Bowersock, "These fragments were reportedly clinging to the Dionysus hanging in such a way as to leave no doubt that they came from the same place, presumably a tomb."[27] Bowersock goes on to say, "Thus the Dionysus hanging and its attached fragments leave us with a problem—or perhaps a solution—very similar to that posed by the *Dionysiaca* epic of Nonnos and the associated paraphrase of the Gospel of St. John. If the textiles both came from the same tomb, we should certainly be prepared to countenance the possibility that the same man wrote those two poems."[28]

In light of the concept of demonic plagiarism (*imitatio diabolica*) discussed earlier (the contention of early Christian apologists that pagan deities and philosophers "stole" or "imitated" concepts and practices of both earlier Judaism and later Christianity), one might even see the horns of Moses on folio 105v of Claudius B.iv as a defiant visual assertion of the primacy of Moses with his biblically sanctioned "horned" face over the plagiarizing demons and horned gods of antiquity. Again, as stated earlier, while there are interpretations in early Christian texts of other pagan gods and heroes as imitators of major figures both Jewish and Christian, there is no textual source that I am familiar with equating Pan and Moses until the sixteenth and seventeenth centuries, where such an equivalency is frequently encountered.[29] While this lacuna of evidence potentially renders my thesis somewhat harder to sustain, the equation of Pan and Moses with respect to bearing horns as symbols of light, at least on a visual level, seems quite apposite and within the tradition of religious *interpretatio*.

While modern sensibilities associate Pan almost exclusively with his identity as an embodiment of natural forces, and especially unbridled sexuality,[30] there was a "second" Pan to be encountered largely in later antique sources who, through a play on his name (although the name Pan is masculine, the word for "Everything" [*pan*] is neuter),[31] was seen as a symbol of the "ALL," the universal Spirit that could well be interpreted as a pagan approximation of Jewish and Christian monotheism—Pan as a symbol of the *hen kai pan* (the One and All).[32] This Late Antique, "cosmic" Pan, referred to in an important article by Hans Brummer as "Pan Platonicus,"[33] in part because of the famous prayer to Pan at the end of Plato's dialogue *Phaedrus*,[34] figures prominently in the Orphic Hymns, where in the eleventh hymn, "To Pan," he is identified with the universe: his body is the sky, the sea, the earth, and fire.[35] Pan is also referred to in this text as "light-bringing lord of the cosmos[,] . . .

cave-loving and wrathful, veritable Zeus with horns."[36] Later in this hymn the text says, "Okeanos who girds the earth with his eddying stream gives way to you [Pan],"[37] an interesting parallel to Moses parting the Red Sea, although I know, at present, of no apologetic or exegetical text making this direct connection. In the thirty-fourth hymn, "To Apollo," it is said, "This is why mortals call you lord and Pan, the two-horned god who sends the whistling wind."[38] In light of these associations, this cosmic Pan, Pan Platonicus, would be an appropriate *Doppelgänger* for Moses, apostle of monotheism.

The idea that the horned Pan, the nymph-chasing, half goat/half human pagan god of the wild might be an appropriate model for Moses, even with his biblically sanctioned horns, seems at first beyond the pale. However, as I have outlined above, there is indeed a historically grounded countercontext in which Pan, the Orphic-inspired symbol of the cosmic "All," with his horns understood in many written sources as the light-bearing sun and moon, was held in the highest esteem in the early fifth-century C.E. Christianized world of Macrobius,[39] and then again in a second flowering in Renaissance Italy of the fifteenth and sixteenth centuries.[40] In addition, there is one known ancient sculptural representation of Alexander the Great with the upright horns of Pan.[41] Given the possible connections in Gmirkin's hypothesis about the origins of the Greek Septuagint text between the literary image of Alexander and that of Moses, there may be an important precedent for a visual connection between the two.

There is yet another possibility linking Pan, a god of shepherds, with Moses, and that is the fact that Moses was himself first a shepherd (Exod. 3:1), leading the flocks of his father-in-law, Jethro (Raguel), the priest of Midian, before he was a leader of men.[42] As Louis Feldman points out, Philo puts a good deal of emphasis on Moses's stint as a shepherd as a fitting preparation for his future role as leader of the Jewish people.[43] In addition, as Feldman remarks, Philo notes (*De Vita Mosis* 1.61) that kings are called "shepherds of their people."[44] As I indicated in chapter 4, much was made in English literature in the sixteenth and seventeenth centuries of the connection between Pan and Christ,[45] unlikely as it may seem. Kathleen Swaim quotes from the E. K. Gloss ("E. K." are the initials of the anonymous author of this text) to Edmund Spenser's sixteenth-century *Shepherd's Calendar*, a source available to John Milton in the seventeenth century, who himself makes much of the Pan-Christ analogy in his poem, *On the Morning of Christ's Nativity*, calling him "mighty Pan" (line 89): "*Great Pan* is Christ, the very God of all shepheards, which calleth himself the greate and good shepherd. The name is most rightly (me thinks) applied to him, for Pan signifieth all or omnipotent, which is onely the Lord Jesus."[46]

Moses, standing as he does on folio 105v (fig. 10) holding the veiled cross of Christ in his left hand, as I suggested in chapter 5, with his Pan-like horns of light in this first appearance, may be meant as well to be understood as prophetic of Christ himself, the Good Shepherd yet to be born. Intriguing as the Pan-Christ

identification is in the later sixteenth- and seventeenth-century literary context outlined above, I know of no early Christian literary or exegetical text that makes this specific identification. Complex and unexpected as this identification is, I doubt that it arose spontaneously only in the sixteenth century.

While it is one thing to find appropriate textual exegeses and assimilations that could be understood to have informed an artist's choice of a specific motif, there remains the essential challenge faced by the artist himself to come up with a *visual* image to express such exegeses/assimilations. And in the case of Exodus 34:29 (*cornuta esset facies sua*), an artist had essentially two choices: either invent something completely new to express this concept or appropriate a preexisting image that, for multiple reasons, both visual and symbolic, would serve. That the horns of Pan were understood as symbols of light might well have occurred to an artist as the perfect solution to his problem of how to bestow on Moses an appropriate visual motif expressing the luminous transformation of his face as stated in the Latin text of the Bible at Exodus 34:29.

In the end, Moses's horns on folio 105v might best be understood as an appropriation of the preexisting horns of Pan on the order of an image similar to the Coptic textile at the Metropolitan Museum of Art, given that, as in the writings of Servius and Macrobius, the horns of Pan were understood in the time of St. Jerome's translation of Exodus 34:29 to be symbols of light. At the same time there is the allusive possibility of associating Moses's horns and the Tablets of the Law, in a Christian context, with Death as seen in the horned image in the Leofric Missal. Overall, the varied attributes given to Moses in the illustrations of Claudius B.iv are a reflection of a visual construct of Moses created in a much earlier exemplar possibly as a Christian answer to the pagan Hermes Trismegistus,[47] presenting Moses as prophet, priest, and scribe, military leader, magician, and divine messenger communicating God's word to man.

Whether this visual construct was to be found in its entirety in an earlier model or exemplar or whether it was constructed de novo by the eleventh-century Anglo-Saxon artist(s) of Claudius B.iv cannot be determined. That Anglo-Saxon artists were capable of creating complex and multilayered visual exegeses is attested by a number of examples.[48] One might venture to say, however, as is the case with other imagery throughout the manuscript, that what we see here is a mixture of preexisting motifs of some antiquity combined with newly created elements on the part of the eleventh-century artist or artists. That some of these elements, in particular the double curved horns of Moses and his round-topped Tablets of the Law, are "Egyptianizing" in appearance is reinforced by a number of other "Egyptianizing" motifs elsewhere in the manuscript.[49]

This construct could have been available in a preexisting model or exemplar; or, equally likely, it could have been created by the artists of Claudius B.iv by appropriation from the image of horned Death on folio 50r of the Leofric Missal with

the goal in mind also of associating Moses and the Old Law with Death, by contrast to Life represented by the veiled cross of Christ held in Moses's left hand. The visual contrast in the Leofric Missal between the image of a horned Mors (Death) and the crowned image of Vita (Life) may reflect a well-known topos embodied in the dramatic opening distinction in the early Christian text the *Didache*, also known as the *Teachings of the Twelve Apostles*,[50] between the "Two Ways," the "Way of Life" and the "Way of Death."

Because the horns on Moses's head on folio 105v (fig. 10) are *flat* and do *not* emerge directly from his head but rise from his forehead, coupled with the fact that they are painted yellow (probably, again, to indicate their association with light), it would be reasonable to understand their specific representation in Claudius B.iv as itself a *visual* exegesis of Jerome's *cornuta esset facies sua* as horns of *light* emerging from Moses's *face*, much in the manner of the great Jewish commentator Rashi's later eleventh- to twelfth-century C.E. explication of the "horns" as light taking on the shape of a horn as it radiates from a point outward into space.[51] In other words, the "horns" on Moses's forehead on folio 105v of Claudius B.iv are not literal horns but light in the shape of horns, the double curved goat's or bull's horns familiar from Egyptian pharaonic crown types, various Seleucid military helmets, and the horns of the sun and the moon associated with the god Pan.

One final thought that might be entertained with respect to the origin of the image of Moses with horns of light, admittedly at the risk of overstepping the bounds of speculation, is that given the literalness of the depiction of actual horns on Moses's head, albeit "horns of light," the closeness of the visual image to the actual words of Jerome's Latin text might suggest that the exemplar from which the later Anglo-Saxon artists were working may have originated in the sixth or seventh centuries C.E., closer in date to the actual completion and dissemination of Jerome's Vulgate text when an association between horns and light may have been a more familiar motif.

Additional Attributes of Moses

MOSES, SCRIBE AND PRIEST

> In his left eye flashes the monocle of Cashel Boyle O'Conner Fitzmaurice Tisdall Farrell. On his head is perched an Egyptian *pschent*. Two quills project over his ears.
>
> —James Joyce, *Ulysses*

> I am most anxious to make it absolutely clear that Moses is not only older than Homer but is older than the writers before him.
>
> —Tatian, *Oratio ad Graecos* (ca. second century C.E.)

Moses's horns take on an entirely different appearance on folio 136v (figs. 11, 18) and after when compared to those on folio 105v (fig. 10). In the top image on folio 136v, Moses instructing the priests (Deut. 34:10), we see a bit of hair between his horns, and the two upright horns seem to rise from behind some kind of rolled headband or diadem.[1] In addition, these horns are much taller and curve in a variety of directions, especially later, on folio 138v (fig. 12), where they sweep upward like two nesting parentheses. Not only are these horns larger and represented as different shapes, in contrast to the two double-curved horns on folio 105v, but they are also in different colors. Before folio 136v, Moses's horns were invariably painted yellow, probably as an indication of their symbolizing light. Beginning at the top of folio 136v, these gigantic horns are painted a reddish-brown, with dark gray centers and a touch of pink toward the top. The equally large horns seen on Moses at the bottom left of folio 136v (fig. 11), so large that they break out of and cross over the frame surrounding the individual illustration, are the same reddish-brown but with

more extensive pinkish centers. What is perhaps most remarkable about these new horns is how tall they are and, in a sense, how unhornlike they appear at first. In some cases before folio 136v, Moses's yellow horns reach almost the same height as can be seen on folio 124r (fig. 16). And finally, Moses's tall, wavy horns on folio 139v (fig. 14) are strangely blue in color in this his final appearance in Claudius B.iv.

Beginning on folio 136v, in a majority of scenes where Moses is shown with this second form of head adornment (horns and diadem), he is seated and presented as a scribe initially writing out and then expounding the Law. This aspect of Moses as lawgiver, scribe, and high priest is fully a part of the Egyptian Jewish Hellenistic apologetic picture of Moses in connection with the concomitant aspects of him as "god" and king. While Moses is characterized in Old English literature and thought as a warrior, lawgiver, miracle worker, and ultimately a type of Christ, he is also represented in Claudius B.iv as a writer and as a reader. As the text of Claudius B.iv says on folio 100r, lines 1–3 (Exod. 24:4–8), "Moses wrote all the judgments of the Lord." In four major images in Claudius B.iv (fols. 95v, 100r, 136v, and 138v), the artists portray Moses as a scribe.[2] Appropriately enough, Moses is the first person described in the Bible as writing, although extrabiblical traditions give this honor to Enoch, as depicted on page 61 of Oxford, Bodleian Library MS Junius 11, the late tenth- or early eleventh-century illustrated collection of poems in Old English based on biblical themes beginning with the Book of Genesis, discussed in chapter 2.[3] Upon reflection, it might be more appropriate to say that Moses is primarily taking dictation, as he is commanded by God (Exod. 34:27): "And the Lord said to Moses: Write thee these words by which I have made a covenant both with thee and with Israel." In Jewish tradition, both Moses and his brother Aaron are styled "sōferīm (scribes) of Israel," as in the Targum Pseudo-Jonathan (Num. 21:19).[4]

Scribes, those who knew how to write, were held in high esteem throughout the ancient world but perhaps especially in ancient Egypt where even the scribe of the gods, Thoth (Dhwtj), was himself a god.[5] Among the various ranks of Egyptian priests recorded on the famous Rosetta stone, now in the British Museum in London,[6] is a "sacred scribe," referred to in Greek and latinized as a hierogrammateus and cited in hieroglyphics as a "Khery-heb" (ḥry-ḥb) or "chief lector priest" formerly transliterated as "Cheriheb" (ḥrj ḥbt).[7] This "lector priest" was also sometimes referred to as a pterophoros" (feather bearer)[8] in reference to the distinctive two-feathered headdress worn by this priestly class.[9] There are numerous representations in Egyptian art of the Khery-heb wearing his distinctive headdress, as can be seen in a relief sculpture in the fourth-century C.E. catacomb of Kom el-Shoqafa in Alexandria, Egypt, showing a hierogrammateus,[10] and on the painted coffin lid of Ankhpakhered, now in the Staatliche Museen, Berlin (fig. 29). The Khery-heb is found in Egypto-Roman art as well, as in a marble relief dating to around the second century C.E. in the Cortile del Belvedere in the Vatican Museums in Rome

(fig. 30) depicting an Isis procession in which the lector priest is shown as the figure second from the right holding a scroll in front of him and wearing a headband from which two feathers extend vertically above him, although the first feather closest to the viewer has been broken off at its base.[11] Ancient Egyptian representations of the Khery-heb often show the figure with a broad sash across his chest and/or a panther skin draped over his shoulder.[12] The Isis priest in this late second-century C.E. Egypto-Roman Vatican relief, however, is depicted without these attributes; he is nude from the waist up. It is worth recalling that active traditional worship is said to have persisted at the temples of Philae in Egypt up through the middle of the fourth century C.E. The temples were officially closed by the emperor Justinian in the sixth century C.E., and various parts of the temple complex had earlier been converted into churches with crosses carved into their relief sculpted walls.[13]

Particularly difficult to read as feathers are the two curved vertical projections rising from a headband on the head of the deified Egyptian architect Imhotep shown in a sunk relief from the third- to first century B.C.E. Temple of Horus at Edfu, but feathers they are (fig. 31). The image is Imhotep's "determinative" in a hieroglyphic inscription on the wall of that temple. It shows Imhotep as a Khery-heb holding in his left hand a scroll or scribe's box of pens.[14] Dietrich Wildung remarks on this image as follows: "The feathers on his head, not otherwise used in Egyptian reliefs, are mentioned by the Christian author, Clement of Alexandria, in his description of an Egyptian temple feast [as] '. . . the *Holy scribe* . . . who has feathers on his head, in his hand a book and a box which contains black ink and a reed to write with it.'"[15] As it turns out, Clement was not describing the deified mortal Imhotep specifically but rather the special type of scribe, the Khery-heb or chief lector priest,[16] sacred to the god of scribes, Thoth, the Egyptian god associated already by the Greeks with their god Hermes through a process known to historians of religion as *interpretatio graeca*. This is the same Thoth/Hermes who is understood in Hellenistic Egyptian Jewish apologetics, specifically in the work of Artapanus, as Moses through the mediation of an *interpretatio judaica*.[17] According to Diodorus Siculus (ca. 90– ca. 30 B.C.E) in his *Bibliotheca historica* (1.15.9–16.2), the Egyptian god Osiris takes Hermes to be his "priestly scribe" and communicates with him on every matter.[18] As Artapanus claims that the Egyptian priests had identified Moses with Hermes,[19] Moses could then be perceived as Osiris's "priestly scribe" as an equivalent to his being the scribe of Yahweh.

In the ancient Egyptian temple hierarchy, the chief lector priest ranked third in importance, with only the phylarch coming between him and the high priest.[20] There were also ordinary lectors (*hryw-hb 'š',w*) beneath the chief lector priest. The Khery-heb or *hierogrammateus* was also understood in ancient Egypt to be a magician.[21] Phonetically rendered as *hartumim*, the term is used in Hebrew to designate the magicians of Pharaoh (*hartummê misrahim*; Exod. 7:9, 22).[22] The idea, then, of

depicting Moses with the two feathers of the Khery-heb in his headband, thus designating him the magician-priest who trumps the magician-priests of Pharaoh, is strikingly appropriate and consistent with the text of Acts 7:22: "And Moses was instructed in all the wisdom of the Egyptians, and was mighty in his words and in his deeds."[23]

In light of the above ideas, an image of Moses as scribe and chief lector priest with two upright feathers in his headband, particularly in a hypothetical Egyptian Christian artistic context where the concept of a "divine" Moses would be unacceptable, has much to recommend it as the ultimate if misunderstood origin of the striking transformation at the hands of an eleventh-century Anglo-Saxon artist into the second type of Moses's horns beginning on folio 136v of Claudius B.iv (fig. 18). As is the case with the various representations of royal and divine crowns on gods and goddesses and kings and queens in late Ptolemaic and Roman Egypt, it is not always easy to distinguish feathers from horns, depending on factors such as artistic medium, stylistic changes, and state of preservation. For example, the tall projecting conical elements rising from the head of the god Amun on the so-called stele of the "Restoration of the Theban Temples," now in the Cairo Museum, are in fact meant to be the two traditional feathers of Amun's distinctive crown.[24] Similarly, the two vertical pointed projections on the head of the god Sopdu, called the god of foreigners and associated with the Sinai region, in a relief (fig. 32), now in Berlin, from the mortuary temple of Sahurê at Abusir (ca. 2430 B.C.E.) are in fact also two large stylized feathers, as the thin rib running up their centers is meant to indicate.[25] While this particular image may not have been visible until it was excavated in the early nineteenth century,[26] there are others like it, of both gods and scribes, in sculpture as well as on papyrus scrolls, that remained visible in the medieval period in Egypt.

There are other examples of confusion between feathers and horns in early medieval art. For example, on folio 33r of an illustrated text of Pseudo-Oppian's *Cynegetica* (ca. eleventh century C.E.), now in Venice (Biblioteca Marciana Cod. gr. 479), the god Hermes is shown with winged feet and two small elements that are supposed to be feathers on his head but that the artist has misrepresented as horns.[27] This is also true of the figure of Mercury shown at the left of a group of gods on folio 234v of the late fifth-century C.E. Roman Virgil (Vatican City, Biblioteca Apostolica MS Vat. Lat. 3867).[28] Conversely, a figure representing Ocean (Mare) at the bottom left of folio 174r of the Bernward Gospels, dating to around 1050 C.E. (Hildesheim, Dom-und-Diözesan-Museum MS 18), is shown with two feathery, or plantlike, extensions springing out of his head rather than the traditional horns of Roman river gods.[29] I am reminded here, of course, of the importance of details as counseled by Erwin Panofsky on the "first level" of his famous tripartite iconological schema. Confusions about the correct identity of "things" at

the first level of interpretation certainly have very real consequences in terms of the ultimate interpretation of the larger meaning of an image.[30]

Withers has recently explored in some detail a number of codicological issues in Claudius B.iv that at certain crucial junctures may have an impact on the iconography of its illustrations.[31] Barnhouse has also studied in detail codicological issues in gathering 18 of Claudius B.iv with important implications for its distinctive depictions of Moses.[32] Perhaps significantly, the depiction of Moses's horns on folio 136v of Claudius B.iv in a style noticeably different from that on folio 105v occurs after a lengthy run of text,[33] possibly indicating the intervention of a different artist utilizing a different exemplar or model. While reflecting the orderly integration of text and image found in the illustrated *Psychomachia*, also from Canterbury (Cambridge, Corpus Christi College MS 23), where picture cycles already existed for this Late Antique text, Withers postulates that "the makers of Claudius B.iv were unlikely to have inherited a cycle of images that fitted the parameters of their recently translated and newly compiled vernacular text."[34] Withers goes on to suggest that the artist (or artists) of Claudius B.iv could not have been working from a completely integrated Late Antique or early medieval exemplar with picture and text already combined since the Old English text of Claudius B.iv is "a reduced version of the Vulgate with many idiosyncratic omissions; moreover, the layout of a Greek or Latin manuscript would simply differ too much from the English text to guide the careful placement of illustrations in the Hexateuch."[35] Withers argues for an original organization of text and image reflected in the *realia* of Claudius B.iv but an originality that does not preclude significant iconographic borrowing from a wide range of sources as well as de novo creations unique to Claudius B.iv.[36]

MOSES *PONTIFEX*

We should recall at this point that the Hellenistic Jewish apologetic depicting Moses as god and king also featured him as priest and scribe. In addition to Artapanus and his image of Moses as the Egyptian god Thoth/Hermes, there was a strong tradition in Greco-Roman Egyptian texts that Moses was in fact an Egyptian priest as attested by the Egyptian writers Manetho, Apion, and Chaeremon, as well as the Greek historian Strabo,[37] an idea taken up by Sigmund Freud in his *Moses and Monotheism* of 1939[38] and subsequently explored in further detail by Jan Assmann in his 1997 study, *Moses the Egyptian*.[39] This verbal picture celebrating Moses's distinctive persona but stopping short of the deification accorded him by some would be equally appealing to both Jewish and Christian audiences who might have been uncomfortable with a "divine" Moses.

The deified mortal Imhotep represented as a Khery-heb (fig. 31) reminds us, as Goodenough points out in his study of Philo, *By Light, Light*, that Philo's portrait

of the "lawgiver in his *Life of Moses* depicts him as a perfect example not only of an ideal Hellenistic god/king, but also as the ideal high priest or '*Hierophant.*'"[40] In the Bible, of course, as mentioned earlier, it is Aaron, Moses's brother, who is commanded by God (Lev. 8:1–12) to be taken by Moses to be consecrated high priest (Vulg. *pontifex*). By implication, however, it is Moses who is the first high priest. He is the first to penetrate the sacred mystery on Mount Sinai, speaking to God himself face-to-face (Exod. 33:11; Deut. 34:10). A curious detail at the lower left on folio 136v of Claudius B.iv (fig. 11) relevant to the representation of Moses with horns but unremarked by previous students of the manuscript is the depiction of Moses seated and writing out the Law for the priests (Deut. 31:9). Between his large and prominent horns, Moses is shown wearing on his forehead at the base of his horns a rounded object threaded on a blue cord, corresponding in its details to the description of the priestly "frontlet" (Heb. *tzitz*; Vulg. *lamina aurea*) in Exodus 28:36–38: "Thou shalt make also a plate of the purest gold: wherein thou shalt grave engraver's work, Holiness to the Lord. And thou shalt tie it on a violet fillet [other translations say a "blue cord"] and it shall be upon the mitre (*mitznefet*)." The large size of the "frontlet" on Moses's forehead in the Claudius B.iv illustration may be related to the depiction of Serapis priests in late Hellenistic Egyptian art with a large circular medallion on a cord on their forehead, often with a star-shaped pattern on it, as in the example illustrated here of ca. 230–40 C.E. (fig. 33), now in the Staatliche Museen, Antikensammlung, Berlin.[41]

The actual words of Exodus 28:36–38, interestingly enough, are not included in the Old English text of Claudius B.iv. The priestly *tzitz/lamina* on the forehead of Moses in the illustration, then, cannot be said to be inspired by the Old English text alone but is no doubt, as in the case of the same object, represented differently, on the forehead of the scribe Ezra on folio Vr of the early eighth-century C.E. Northumbrian Codex Amiatinus (Florence, Biblioteca Medicea Laurenziana MS Amiatino 1), a copy of the earlier sixth-century Codex grandior from Vivarium, where the seated figure represented was Cassiodorus himself, although Paul Meyvaert has suggested that the priestly frontlet on Ezra's forehead was based on the description of this item in Josephus's *Antiquitates Judaicae*.[42] The smooth, white head covering or coif on the head of the Ezra figure in the Codex Amiatinus, often incorrectly described as a tallith,[43] is more likely the cloth turban or miter (*mitznefet*) of the biblical high priest.[44]

While Meyvaert has plausibly argued that Bede may have had a hand in personally executing the image of Ezra on folio Vr of the Codex Amiatinus as *pontifex*,[45] complete with the golden frontlet (*lamina aurea*) described in the Bible, but in an even more elaborate and complicated manner by Josephus in his *Antiquitates*, his argument might not be appropriate for the creation of the same detail in the image of Moses on folio 136v of Claudius B.iv. In the first place, the priestly front-

let is represented in an entirely different manner in the Claudius B.iv image, bean-like and threaded on a blue lace as described in the Bible (Exod. 28:36–38). It would seem more likely that the frontlet had already appeared in an exemplar or model from which the artist of Claudius B.iv was working, as the motif itself is not bibli-cally appropriate to Moses, who was technically not a high priest, and the particular concern of Bede with Ezra, as characterized by Meyvaert with reference to Bede's writings on him, as an exemplary leader and model for the faithful and as a symbol for the leadership of bishops in the church,[46] may have been at too distant a chrono-logical remove to be a source of inspiration for an eleventh-century monastic artist at Canterbury to create on his own. Moreover, the Codex Amiatinus, with its "un-orthodox," unique image of Ezra in the guise of the high priest, had long been in Italy at the time that Claudius B.iv was being illustrated and could not have served as a source of immediate inspiration. And finally, while Bede was able to find refer-ences to Ezra as *pontifex* in the text of 3 Ezra, as Meyvaert has pointed out, the artists of Claudius B.iv are most unlikely to have had access to the kind of texts (Manetho, Chaeremon, Strabo, et al.) characterizing Moses as a hierophant, or high priest.

Moses shown in the act of writing out the Law for the priests a second time (Deut. 31:9), on folio 138v of the manuscript (fig. 12), puts emphasis on an under-standing of Moses not only as scribe[47] but also as priest.[48] It is important to note at this juncture that in the depiction of Moses in the separately framed illustration at the top of folio 136v (fig. 18) and elsewhere in the manuscript, the horns rise from behind a rolled headband or diadem, revealing between them, as elsewhere, a bit of curly hair. Likewise, the priests assembled before Moses in both pictures on folio 136v are shown with similar yellowish rolled diadems or headbands. Mellinkoff proposed that these headbands are in fact "cap-shaped" hats and are the earliest ex-tant representations of a distinctive Jewish head covering, the *kippah*, that was to be superseded in later medieval art by the pointed *Judenhut*.[49] Referring to the repre-sentations on folio 136v and elsewhere in the manuscript, Mellinkoff observes that "the hats have been rather bizarrely painted so that the crowns look like curly hair."[50] On the contrary, rather than being "bizarrely painted," it is clear that these head "coverings" are not coverings at all but are instead meant to be understood as diadems, fillets, or headbands. In ancient art, particularly in Ptolemaic Egypt, such diadems can be understood as signifying priestly rank, as shown on a second-century C.E. sculpted bust in Berlin (Staatliche Museen) representing a priest of the god Serapis (fig. 33).[51] Appropriately, then, the figures of the priests on folio 136v are shown with such diadems, although, interestingly, not biblically sanc-tioned, further evidence of an Egyptianizing/Hellenistic element in such a specific detail. What appears often, then, in unfinished drawings in MS Claudius B.iv, even when not specifically depicting a priestly group, is a diadem of a priestly kind

perhaps alluding to the concept of the Jewish people as a whole as a "nation of priests" (Exod. 19:6).

My hypothesis that Moses, with his tall featherlike horns, depicted seated and reading the Law to the priests gathered before him on folio 136v might be modeled on an Egyptian chief lector priest engaged in a similar task has an interesting potential parallel in an image from the painted sarcophagus of Ankhpakhered (ninth century B.C.E.) in Egypt (fig. 29), now in the Staatliche Museum, Berlin, where just such a befeathered lector priest with headband is shown holding up a large rectangular tablet from which he is reading to the mourners assembled before him.[52] It is worth noting at this point how tall the feathers are on the head of the lector priest in the Egyptian painted image (fig. 29), as well as on the head of Sopdu (fig. 32) and on the head of Moses on folios 136v (figs. 11, 18) and 139v (fig. 14), much taller than the double-curved horns on folio 105v (fig. 10) or any of the other actual animal horns illustrated elsewhere in the manuscript (e.g., fig. 2). Moses's "horns" even break out of the frame, crossing its upper horizontal border, in both images on folio 136v as well as on folio 138v (fig. 12). There would appear to be no rationale for the great size of these "horns," but they do seem similar in this respect to the tall feathers of the Egyptian examples previously cited.

Returning momentarily to the image of Imhotep (fig. 31) from the temple of Edfu, it is worth noting that the inscription refers to him as the "chief lector priest, the scribe of the book of god." The beginning of the inscription indicates that the temple of Edfu itself was constructed according to principles first enunciated by Imhotep, the great architect of the Step Pyramid of King Djoser at Saqqara.[53] In this way Moses is like Imhotep in that he communicates Yahweh's instructions for constructing the sacred Tabernacle on earth according to a heavenly plan. Thoth, who was equated with Hermes/Moses, was also identified with Imhotep (called Imuthes by the Greeks) at Saqqara.[54] The equating of Thoth/Hermes/Imuthes with Moses through a process of *interpretatio judaica* in Hellenistic Egyptian Judaism, then, may have prepared the way for a later Judeo-Christian image of Moses as scribe/chief lector priest whose large vertical feathers were at some time, possibly for the first time in Claudius B.iv, transformed into horns.

If one were to accept the hypothesis that the eleventh-century Anglo-Saxon artists were consulting some kind of model, or models, for some of their illustrations, I would posit further that one of their exemplars may have had two images of Moses with two distinctive types of horns. The first corresponds to the double-curved type emerging from the forehead, as found on the figure of Pan from the Metropolitan Museum Coptic hanging (fig. 23), seen initially on folio 105v (fig. 10). The second, perhaps not as well understood configuration emphasizes Moses's role as priest and scribe by showing him wearing the two-feather headdress with diadem of the Egyptian Khery-heb. Not understanding the tall vertical elements of the Khery-heb as *feathers*, the Anglo-Saxon artist may have tried to make them look

more hornlike by shading them and coloring them brown, as on folio 136v and else-where later in the manuscript. The final image of Moses on folio 139v (fig. 14), however, with its two vertical blue "horns" rising from behind a headband, reveals its true origin, I believe, by virtue of the two thin vertical "ribs" through the middle of the horns that so closely resemble the centrally located vertical "ribs" of the styl-ized feathers rising from the headband of the Egyptian god Sopdu on the relief now in Berlin (fig. 32). The great height of the "horns" on Moses's head on folio 139v (fig. 14) is matched in the statue of the Khery-heb Pedeamun-Nebnesuttaui of around 665 B.C.E., now in the Egyptian Museum, Cairo (fig. 34).[55]

This assessment of the image of a second type of horned Moses in Claudius B.iv is based in part on Mellinkoff's original assertion that the horns of Moses in that manuscript are not organic growths coming out of Moses's head but rather rep-resent some type of headgear or helmet. As I demonstrated earlier, however, the horns on Moses's head on folio 105v (fig. 10) are not part of a helmet or headdress but rise from Moses's forehead as a visual approximation of the idea of Moses's face emitting hornlike rays of light. The second type of Moses's horns, as seen for the first time on folio 136v (figs. 11, 18), does represent some type of headdress as the "horns," which I have interpreted as originally feathers, do indeed rise from behind, or out of, some kind of diadem or headband but not a helmet. In the end, as prob-lematic as a "divine" or "royal" Moses may have been in Hellenistic Judaism, the first of these two aspects of Philo's verbal picture of Moses would have held no at-traction for early Christianity whose exclusive focus was the divinity and kingship of Jesus. But the image of Moses as high priest, albeit superseded by a greater high priest, Christ himself (Heb. 8:1–2), who is both priest and victim, would have been attractive to Christians on a number of accounts. In that sense, this idea would have made the Christian audience all the more attentive to a pictorial image of Moses as scribe-priest. The two upright feathers of the Khery-heb were still in evidence in Alexandria in the fourth century of the Christian era,[56] as seen in the Kom el-Shoqafa catacomb relief sculpture, and the practice of Christian monks taking over pagan Egyptian temples and at times incorporating or painting over preexisting wall paintings and reliefs is well known.[57] The opportunity, then, of constructing a "horned" Moses in early Christian Egypt as a modified image of a Khery-heb along the lines of an image of Imhotep from Edfu (fig. 31) emerges as a credible possibility.

Josephus (37–ca. 100 C.E.) in his *Contra Apionem* (bk. 1.32) refers to Moses and Joseph as scribes, calling Joseph specifically a *hierogrammateus*.[58] Furthermore, late Hellenistic non-Jewish Egyptian authors such as Apion, Chaeremon, and Manetho[59] all refer to Moses as holding Egyptian priestly rank, Chaeremon (him-self a *hierogrammateus*) calling him specifically a *hierogrammateus*.[60] This distinction, then, rather than the more radical and specifically Jewish understanding of Moses as king or even "god," would be the more appealing to a Christian audience as a way of featuring Moses's special distinction vis-à-vis God and his sacred word without compromising the exclusive divinity of Christ himself.

In this connection as scribe-priest, the figure of Moses in Claudius B.iv could be seen as analogous to the mysterious Egyptian scribe-priest Hermes Trismegistus of the writings referred to collectively as the *Hermetica*, a collection of pagan spiritual texts that, until the celebrated seventeenth-century scholar Isaac Casaubon (1559–1614) dated them to the post-Christian period,[61] were thought to be of great antiquity, predating Christianity and that Hermes Trismegistus was a contemporary of Moses. To early Christian writers such as Lactantius (ca. 250–ca. 325), these writings were of great utility in a polemic that was directed at educated Gentiles attempting to demonstrate that pre-Christian sages, such as Trismegistus, had foretold the coming of ideas that would ultimately be revealed in Christianity itself.[62] As Josephus in his *Against Apion* (2.154–155) and Augustine (*De civ. Dei.*, bk. XVIII.38)[63] both claim that Moses is older than any of the ancient philosophers and sages including Hermes Trismegistus, representing Moses in Claudius B.iv in the guise of a prophet-scribe like Trismegistus would be an important corollary to the ideas about the antiquity of Moses presented by Artapanus and others as retold by Clement of Alexandria and Eusebius in their project to establish the greater antiquity of Judaism and its offshoot Christianity.[64]

MOSES AS "APOLLO," THE "SACRED INTERPRETER"

Clement of Alexandria refers to Moses as the "Sacred Interpreter,"[65] and this idea, that in addition to being the bearer of the Law Moses was its interpreter, would, by extension, mean to Clement and his Christian audience that Moses would be thought of as interpreting the law as a "shadow" or forerunner of the revelation in Christ. It is of interest to note here that the child Moses is shown in the mid-fifth century C.E. mosaics in the nave of Santa Maria Maggiore in Rome either being "instructed in all the wisdom of the Egyptians," as noted in Acts 7:22, or, like a young Christ teaching the Doctors in the Temple (Luke 2:46), perhaps instructing the elders seated around him like philosophers on a *synthronon*.[66]

Brenk identifies the scene as Moses and the pagan philosophers at Pharaoh's court, a scene with no direct biblical source but one that is recounted in Philo's *Vita Mosis*.[67] Another implied subtext to representing Moses as a lector priest, even a chief lector priest, or *hierogrammateus*, is the slightly "subordinate" aspect of the scribe, even the Sacred Scribe, being a kind of secretary, or simple *grammateus*, taking down God's word as dictation.[68] In its way, the two-feathered headdress of Moses as *hierogrammateus* is a singularly appropriate attribute, giving Moses a "historical" distinction that shores up two major Christian apologetic agendas and at the same time puts Moses "in his place" as God's amanuensis, an appropriate forerunner of the four Evangelists themselves.[69] Thus the unique image of Moses as befeathered lector priest might in fact have seemed more appropriate for a poten-

tially Egyptian Christian audience than a radiantly beaming, aureoled figure look-
ing like an Apollo/Helios with light beams surrounding his head, as he is some-
times depicted in later Byzantine art.[70]

Speaking of Apollo, in a famous passage from book 4 (427) of Plato's *Republic*[71]
Socrates, replying to the question, "What . . . is still remaining to us of the work of
legislation?," says that in matters of religion he is ignorant and that trusting such
matters to "any interpreter but our ancestral deity" would be unwise. And who is
this ancestral deity? Socrates replies, "He is the god who sits in the center, on the
navel of the earth, and he is the interpreter of religion to all mankind." That god,
of course, as Socrates had indicated earlier in this passage, is none other than
"Apollo, the god of Delphi." Apollo as exegete is often represented in classical art,
especially on coins of the Hellenistic Seleucid emperors shown seated on the rounded
sacred stone, or *betyl*, at Delphi called the omphalos,[72] or navel, of the world. Apollo
is shown on these coins holding a bow as Apollo Toxotes. The omphalos in art is
often covered by a netlike overall pattern looking at times like bumps or faceted
polyhedrons, or like small stones in many numismatic examples, such as on the re-
verse of a silver four drachms of Antiochus III (ca. 241?–187 B.C.E.) (fig. 15).[73]

Moses, of course, had been characterized by Philo and others as the interpreter
of God, so that an image of Moses seated on the omphalos, in place of Apollo, such
as we see at the bottom of folio 136v of Claudius B.iv (fig. 11), by virtue of an au-
dacious *interpretatio judaica* of this well-known motif, might not seem entirely im-
probable; there was a well-established Jewish tradition, as recounted in *Midrash
Tanhuma*,[74] that saw Jerusalem as the "true" navel of the world and the navel stone
there at the site of the Temple called "Shettija."[75] There was also an actual later
Christian omphalos in the Church of the Holy Sepulcher in Jerusalem.[76] Although
there is no literary reference that I know of to such an image of Moses as Apollo
Exegetes, the concept would not seem entirely improbable given the characteriza-
tions in the work of Artapanus and others of Moses as "Hermes" and, even more
significantly in this instance, of Moses as the oracle Musaeus.[77] It is worth recall-
ing again that Eusebius's recounting in his *Praeparatio evangelica* of the tale of the
death of Pan from Plutarch's *De defectu oraculorum*[78] introduces the apologetic idea
that with the death of Christ on the cross all pagan oracles are silenced and that
Moses, in promulgating the Law, is seen as an earlier adumbration of the ultimate
replacement of Apollo by Christ. This kind of "supercessionism" is also to be seen
in the famous line of Numenius of Apamea, "What is Plato but Moses speaking
Attic Greek."[79]

MOSES SEATED ON A JEWELED "MOUNTAIN-THRONE"

While I have characterized the strange half-round object that Moses sits on at the
bottom left of folio 136v of Claudius B.iv (fig. 11) as a possible reference to the

omphalos of Delphic Apollo, there are other possible associations that would seem equally appropriate to the meaning of this scene. The half-round object itself looks like some kind of bejeweled mountain throne. Stylized, round, jewel-like forms cover the surface of the blue-tinted semicircle on which Moses sits, while two small rectangular window or doorlike apertures are to be discerned at the lower left and right of the semicircle.

Barnhouse has noted that Moses is shown seated on what appears to be a rock on folio 214 of the twelfth-century Smyrna Octateuch (Smyrna [*olim*], Evangelical School Library Codex A.1) with a small book on his lap, his arm stretched out toward a group of Levites.[80] At the bottom left of folio 140v of Claudius B.iv, Joshua is shown seated on a similar but not identical jeweled mountain throne.

Several rabbinic legends associate Moses and the Tablets of the Law with gem quarries and gemstones. One haggadic tradition says that the Tablets themselves were made of a sapphirelike stone.[81] Another tradition says that Moses got the second set of Tablets from a diamond quarry, according to Louis Ginzberg,[82] and that the chips that fell from the precious stones during the process made Moses a rich man! Another source says that God himself showed Moses a sapphire quarry under his throne.[83] This detail may have been inspired by the description in the Bible where it says that Moses and seventy of the elders of Israel "saw the God of Israel: and under his feet as it were a work of sapphire stone" (Exod. 24:10).[84] It should also be recalled that in the *Exagoge* of the Jewish poet Ezekiel the Tragedian, referred to by Eusebius in his *Praeparatio evangelica*, Moses has a dream vision of the exalted Throne of Heaven on which God himself invites Moses to sit.[85]

The Sinai region, at Serabit el-Khadim in Egypt, was prized by the Egyptians as a source of precious blue turquoise and was associated with the horned Egyptian goddess Hathor and the god Sopdu (fig. 32),[86] who, as mentioned earlier, was represented with tall, hornlike feathers emerging from his diadem-wrapped head. But perhaps the most compelling explication of the blue, jewel-encrusted mountain throne on which Moses sits on folio 136v of Claudius B.iv is to be found in the seventh-century biblical commentaries from the Canterbury school of Theodore and Hadrian discovered by Bernhard Bischoff in the Biblioteca Ambrosiana in Milan (MS M.79), where, commenting on the great epiphany at Sinai, the text says, "They say it took place on the *sapphire summit of Mt. Sinai*, with Moses sitting on a rock, so that his conversation could take place through its tiniest crack."[87] Hadrian, a native of North Africa, and his colleague, Theodore of Tarsus, archbishop of Canterbury, originally from Tarsus in Cilicia, brought to their commentaries a broad background not only in Christian patristics (both Greek and Latin) but also in Jewish midrashic and haggadic exegetical traditions that were especially available in the Syriac Christian cultural ambit from which Theodore originated.[88] This description of the blue sapphire summit of Mount Sinai is the second motif in the illustrations

of Claudius B.iv that I have discussed that may have its direct origin in this impor-
tant body of Canterbury exegetical literature. Earlier I cited the statement from the
Canterbury Commentaries concerning the identity of Cain's murder weapon as the
jawbone of an ass.[89] As Claudius B.iv has been traditionally associated with St. Au-
gustine's Abbey at Canterbury where Hadrian himself was abbot, it is not surpris-
ing that we should find such connections between the illustrations in Claudius B.iv
and theological/exegetical texts such as the *Canterbury Commentaries*.

THE SERPENT-HEADED ROD OF MOSES

In her 1994 PhD dissertation, Barnhouse noted that Moses carries a snake-headed
rod *after* Exodus 4:3, when, the Bible reports, God changes the rod into a snake.
But, as Barnhouse goes on to observe, although the snake becomes a rod again in
the biblical text at Exodus 4:4, the artist of Claudius B.iv represents the rod with a
snakelike head and with *ears* throughout the rest of Exodus until chapter 34:29,
where Moses receives his horns, at which point the artist ceases to include the eared,
serpent-headed rod in his remaining illustrations of Moses.[90]

The manner in which the serpent rod with its peculiar ears is represented on
folio 78v (fig. 13) of Claudius B.iv resembles the more stylized eared animal-headed
staff, or *was* scepter,[91] carried by numerous Egyptian royal and divine figures, as
shown on a relief sculpture from the first-century C.E. Temple of Dendur, now in
New York at the Metropolitan Museum of Art.[92] The god Thoth, as with many of
the gods, is also frequently shown carrying a *was* scepter. The main difference in
the Claudius B.iv image is that the serpent rod of Moses does not have the dis-
tinctive inverted crescent shape at its base like the *was* held by the god Sopdu in
figure 32. The intriguing feature for us here is the distinctive *eared* aspect of both
the *was* scepter and Moses's rod in Claudius B.iv. There is absolutely no reason that
a serpent-headed scepter in Moses's possession in an eleventh-century Anglo-
Saxon manuscript should have ears. Moses's eared scepter in Claudius B.iv bears a
superficial resemblance to an eared Celtic battle horn called a *carynx*,[93] but putting
a horn in Moses's hand, even as "se maera heretoga," the Great Commander, pos-
sesses little internal logic to recommend it as an interpretation of the distinctive
appearance of his staff in Claudius B.iv.

Returning to the text of Artapanus as recounted by Eusebius in his *Praeparatio
evangelica*, a good deal of emphasis is placed on Moses's rod, about which Artapa-
nus has this to say: "Again Moses by his rod brought up frogs and besides them lo-
custs and lice. And for this reason the Egyptians dedicate the rod *in every temple*,
and to Isis likewise, because the earth is Isis, and sent up these wonders when smit-
ten by the rod."[94] This *interpretatio judaica* on the part of Artapanus of a ubiquitous

symbol to be found in every Egyptian temple is quite an astonishing tour de force in the realm of religious syncretism and *interpretatio* strategies in general. The specific detail of ears on the head of the serpent rod of Moses provides an especially interesting possible connection between the Claudius B.iv image and the Egyptian *was* scepter. The relationship of this detail to the Artapanus text is particularly compelling in terms of understanding not only the physical appearance of Moses's rod in Claudius B.iv but also the importance attached to it indicated by its multiple appearances.

THE ROUND-TOPPED TABLETS OF THE LAW

An additional important and distinctive attribute of Moses in Claudius B.iv, as noted in Mellinkoff's study of the motif,[95] is the round-topped shape of the Tablets of the Law, as seen twice in Moses's hands on folio 105v (fig. 10). Without exception, before Claudius B.iv the Tablets of the Law, both in Western and Byzantine art, were represented as rectangular in shape with flat tops or sometimes as a scroll.[96] However, in a 1990 exhibition of treasures from the Monastery of St. Catherine, Sinai, a pair of early thirteenth-century C.E. painted Byzantine sanctuary doors were included depicting a standing figure of Moses on the left-hand panel holding two round-topped Tablets of the Law with simulated marbleized texture on their surface meant to indicate stone.[97] It is not clear whether the round-topped form of the Tablets is a result of contact with Western sources, although work by Michelle Brown at the Monastery of St. Catherine has indicated the presence of Latin and other Western manuscripts in its great library collections.[98]

The Bible indicates that there are two Tablets of the Law,[99] made of stone (Exod. 24:12), and that on both sides of each (Exod. 32:15–16) the words were written "with the finger of God" (Exod. 31:18). But the text says nothing about their shape. As Mellinkoff has noted,[100] the Claudius B.iv image again seems to be the first extant appearance of this well-known, and, surprisingly, little-explored motif, which ironically has achieved almost canonical status as a symbol of Judaism itself, ironically because its first documented appearance seems to be in a Christian medieval manuscript.

Again, appealing to the Old English text of Claudius B.iv, Mellinkoff suggests that medieval writing tablets may have served as the model for the Tablets of the Law. But the specific choice of Old English words in Claudius B.iv does not explain, as Mellinkoff puts it, "the choice of the unique round-topped shape."[101] While there are numerous depictions of round-topped, hinged diptych writing tablets in medieval manuscript art as well as actual preserved examples,[102] it is again possibly ancient Egypt that might be seen as providing an alternative explanation. A round-topped carved stone stele, like the famous Merneptah Stele in the Mu-

seum of Egyptian Antiquities, Cairo (fig. 35), thought to be the earliest recorded mention of the name "Israel" outside of the Bible,[103] is encountered frequently in ancient and Late Antique Egypt.

Round-topped stelae also occur in a wide range of cultures in the ancient Near East and the Mediterranean. Mellinkoff, for example, illustrates both the round-topped Stele of Naram-Sin (ca. 2340 B.C.E.) and a portion of the Stele of Hammurabi (ca. 1792 B.C.E.), both Mesopotamian examples, in her study of the horned Moses but does not make any connection.[104] Of particular interest in the ancient world are the round-topped pair of stelae, or *betyls*, seen on coins from the Phoenecian site of Tyre of the third and fourth centuries C.E. associated with the aniconic cult of the god Melqart, a god associated with Hercules through a widespread *interpretatio graeca* resulting in Melqart-Hercules. The two round-topped *betyls* are often represented side by side on a horizontal base, giving them an appearance very much like that of the often depicted double round-topped Tablets of the Law.[105] Furthermore, many important inscriptions in ancient Rome, and elsewhere in the empire, are found on a round-topped stone stele type called a *cippus*.[106]

The round-topped form, however, is more frequently found in Egypt, where the rounded top is understood to represent the curve of the vault of the heavens.[107] The cosmic significance of the round-topped stone stele would seem to accord well with the heavenly origin of the first tables of stone given by God to Moses on Mount Sinai (Exod. 31:18). The Bible specifies that the two stone tablets of "testimony" were written by the finger of God but, as noted earlier, says nothing about their shape. Interestingly, at the end of the text on the Ptolemaic temple wall at Edfu, where the representation of Imhotep has two tall feathers projecting hornlike above his head (fig. 21), it is inscribed that the book with the order of the temple itself is said to have fallen directly from Heaven, north of Memphis, a miraculous event associated directly with the deified mortal Imhotep.[108] The fact that the Tablets of the Law on folio 105v of Claudius B.iv (fig. 10) are painted yellow, as are the horns of Moses, relates well to descriptions of the chief lector priest in Egyptian Isis processions carrying "a tablet of gold and electron"[109] with the ritual texts in honor of the goddess.

The cosmic association of the round-topped Egyptian stele is seen as well in Egyptian depictions of the cosmos as a round-topped rectangle, such as in the famous Papyrus of Ani.[110] This way of depicting the cosmos is remarkably similar to one of the cosmic diagrams in the ninth-century C.E. illustrated version of a sixth-century C.E. work by Cosmas Indicopleustes known as the *Christian Topography*. Wanda Wolska-Conus points out that Cosmas's diagram of the universe bears a close resemblance to depictions of the Ark of the Covenant in all three illustrated versions of the *Topography* as well as in the two Vatican Octateuchs, such as on folio 231r of Codex Graecus 746.[111] This resemblance between the shape of the universe in the work of the Alexandrian Christian merchant and traveler, Cosmas, and the

shape of the Ark of the Covenant, which had been interpreted by that other Alexandrian exegete, Philo, as a reflection of the universe as a whole, may ultimately go back to Egyptian images of the universe such as we have in the Papyrus of Ani image mentioned earlier. In his *Stromata*, Clement of Alexandria says that the Tablets of the Law were "written by the finger of God[,] . . . for by the 'finger of God' is understood the power of God, by which the creation of heaven and earth is accomplished; *of both of which the tables will be understood to be symbols.*" Later in the same text he says, "And the Decalogue, *viewed as an image of heaven*, embraces sun and moon, stars, clouds, light, wind, water, air, darkness, fire."[112] Clement continues his exegesis of the two tablets by suggesting, "And perhaps the two tables themselves may be the prophecy of the two covenants."[113]

Mellinkoff cites a later text from Isidore of Seville (ca. 560–636 C.E.) from his *Quaestiones in Vetus Testamentum* where Isidore equates the glorified face of Moses in Exodus 34:29, covered by a veil, with hidden knowledge, the glory of knowledge, which is "the horns of the two Testaments, armed with which it goes forth against the dogmas of falsehood."[114] Mellinkoff goes on to show how this interpretation may have influenced Durandus in his thirteenth-century text of a prayer for the imposition of the miter at the consecration of a bishop, where Durandus refers to "the helmet of defense and of salvation, so that with comely face and with his head armed with the horns of either Testament he may appear terrible to the opponents of truth."[115]

George Henderson, in his 1972 book, *Early Medieval*, comments on how "puzzling and extraordinary"[116] is the picture on folio 143r of Claudius B.iv illustrating the events of Joshua 4:9 where Joshua sets up twelve stones in the midst of the river Jordan to commemorate where the feet of the priests who had borne the Ark of the Covenant had stood. The Bible text says, "and they are there unto this day." Henderson remarks that unlike other representations of this scene in the tenth-century Byzantine "Joshua Roll" (Vatican City, Biblioteca Apostolica Vaticana MS Palatinus Graecus 431) and related Octateuch manuscripts, where the stones are shown as horizontal slabs placed one on top of the other, "the Anglo-Saxon artist shows Joshua completing a row of standing stones, varying in height and girth, just like the irregularly sized menhirs in prehistoric Gezer!"[117] The round-topped vertical stone stelae at Gezer and elsewhere in modern Israel are referred to by their biblical name *masseboth* (Exod. 24:4–8). *Masseboth* have both negative and positive connotations throughout the Old Testament.[118] What seemed remarkable to Henderson was the "archeological" accuracy of these vertical menhirs. Henderson, however, does not mention that the Claudius B.iv stones have rounded tops like the Tablets of the Law held in Moses's hand on folio 105v (fig. 10).

A round-topped stone stele of the kind seen frequently in ancient and Late Antique Egypt would no doubt make an appropriate image for the stone "Tables of Testimony" cited in the Bible. The suggestion put forward by Mellinkoff, and

more recently Withers,[119] that medieval writing tablets may have served as models for the particular depiction seen in Claudius B.iv might also seem inappropriate to the occasion in that those examples that are preserved are wood or leather hollowed out to hold wax in which the letters were actually written, hardly an appropriate medium for the immutable words of the Lord written with the finger of God.[120]

MOSES WITH *VITTAE*, PRIEST AND VICTIM

Moses is shown seated at the bottom left on folio 138v of Claudius B.iv (fig. 12) with a curious knotted cloth headband or diadem on his forehead, at the base of his large horns. There is no clear raison d'être for the presence of such a cloth, binding at their base the two tall horns rising from behind it. This cloth, however, bears a striking resemblance to the knotted cloth binding the head of Christ on folio 14r of the mid-eleventh-century Cotton Psalter (London, British Library Cotton MS Tiberius C.vi),[121] where it may be a reference to Christ's burial raiment as he is shown in this image as the not yet resurrected Christ bending down to retrieve the souls of the Patriarchs from Limbo, standing at the broken gates of Hell with Satan bound and defeated at his feet. A similar cloth is seen binding the head of a thirteenth-century Gothic sculpture referred to as the "Mainzer Kopf mit der Binde,"[122] whose identity remains a matter of dispute. Some would see the figure as representing Adam, while others have associated it with the anointing of the head of kings with chrism in the medieval coronation *ordo*.

In ancient Roman religious ritual, priests offering sacrifice wore bands of white wool called *vittae* (in ancient Greece associated with the terms *diadema*, *lemniscus*, and *mitra*) on their heads,[123] sometimes twisted around *infulae*,[124] another form of headband, also traditionally made of white wool. The *vittae* with *infulae* were often tied around the head of the sacrificial victim as well as that of the sacrificiant.[125] If the victim were a cow or an ox, its horns would often be gilded (*taurus auratus et bos femina aurata*).[126] In the entry for *Vitta* in Daremberg-Saglio, *Dictionnaire des antiquités grecques et romaines*, this "bandelette" is said to be "par excellence, un signe sacerdotal."[127] In Roman use these bands were called *vittae sacerdotis*.[128] In the Vatican Museums in Rome, Galleria dei Candelabri,[129] is a fragmentary carved columnar base whose exact origin and date are unknown but thought perhaps to come from Alexandria, where two enigmatic sacerdotal figures are represented carved in relief with their hair bound by some kind of rolled diadem from which protrude upward curved, hornlike forms, perhaps meant to represent feathers as in the carved relief showing a lector priest of Isis, also in the Vatican collections (fig. 30).

In the case of the Moses figure on folio 138v of Claudius B.iv (fig. 12), it would seem that some kind of reference to Moses as a sacerdotal figure is being made here with the binding of his horns, a further commentary on his role as priest, with perhaps reference as well to a horned Moses himself as a sacrificial victim,[130] alluding,

in this Christian manuscript, to the concept put forward by St. Paul in Hebrews (7:24–27) of Christ as both priest and victim. In any event, based on prior experience with this extraordinary manuscript, one has rightfully come to expect that so specific a motif as the cloth binding Moses's forehead cannot be dismissed as some superfluous decorative detail of no importance.

MOSES AS "ASCLEPIUS" THE HEALER

Moses is shown at the far left of the framed illustration at the top of folio 124r of Claudius B.iv (fig. 16) in a partially colored-in outline drawing grasping with his right hand a portion of a large pythonlike twisted form no doubt meant to represent the "Brazen Serpent" commanded by God to be raised up by Moses in the wilderness to heal the afflicted Israelites (Num. 21:8). At the same time, with the very large index finger of his left hand Moses points at his yet to be drawn-in eye, as if to say that the afflicted Israelites must "look" upon the Brazen Serpent to be healed as indicated in the biblical text. Enigmatic enough as a biblical narrative, where God seemingly orders Moses to break, as it were, the Second Commandment about not making "graven" images of things in heaven above or in the earth beneath (Exod. 20:1–17/ Deut. 5:4–21), this motif is generally represented in later medieval art as a horizontal snakelike form raised up vertically either on a forked stick, as on the so-called Bury St. Edmunds ivory cross in the Cloisters Collection of the Metropolitan Museum of Art, New York, of the twelfth century C.E.,[131] or as a curled-up snake atop a column, as in the so-called anagogical stained-glass window of Abbot Suger at St. Denis, Paris, also of the twelfth century.[132] Philo of Alexandria, in his *Allegorical Interpretation* (2.79),[133] equates the serpent in general with sensual pleasure and says that a serpent was needed to combat the serpent of sensual pleasure in the Garden of Eden, thus relating the Brazen Serpent episode to the temptation of Eve by a serpent. Interestingly, the Brazen Serpent on folio 125r of Claudius B.iv, intertwined with some kind of vertical tree or pole, echoes the serpent of the temptation of Eve on folio 7v, where the snake is "interlaced" in the Tree of the Knowledge of Good and Evil. From a purely rationalistic and pragmatic point of view, it is difficult to understand how the Anglo-Saxon artist of Claudius B.iv would imagine a "serpent of brass" being represented as a sinuous, pythonlike creature making its way vertically up a tree or a pole, looping itself, even in the unfinished drawing, over the top edge of the frame since earlier in the manuscript, on folio 81v, the snakes of the Egyptian magicians had twined themselves around the bottom of the framed illustration.[134]

The large size of the snake in the Claudius B.iv image and its sinuous vertical movement are reminiscent of depictions of the healing god Asclepius with his snake-entwined *bakteria*, or staff, as in the Late Antique carved ivory diptych from

the Joseph Mayer collection, now in the Liverpool Museum, England (fig. 17).[135] Other Greco-Roman depictions of the healing god show him with a very large, snake-entwined vertically held staff, as in a second-century C.E. example from the Ny Carlsberg Glyptotek, Copenhagen,[136] or a standing second-century C.E. example in the Cyprus Museum, Nicosia.[137] Asclepius, without his snake-entwined staff, appears on folio 19r of an eleventh–century Anglo-Saxon illustrated herbal (London, British Library Cotton MS Vitellius C. III).[138] Voights, commenting on this striking image of the "pagan" figure of Asclepius in the center flanked by Apuleius Platonicus at the left and the centaur Chiron at the right, notes that while there is no known specific model for these images, nonetheless, "we have here a representation faithful to a late antique exemplar."[139]

Assimilating Moses to Asclepius as a healer would make sense given the apologetic trajectory of Artapanus, and others later in the Christian ambit, to see all the pagan gods and demigods as plagiarized versions based on earlier Hebraic figures such as the prophet Moses. Justin Martyr, in his *Dialogue with Trypho*, introduces the example of demonic imitation (*imitatio diabolica*) with reference to Asclepius "imitating" Christ when he says, "And when he [the devil] brings forward Asculapius as the raiser of the dead and healer of all diseases, may I not say in this matter likewise *he has imitated the prophecies about Christ?*"[140] As mentioned above, Moses had already been assimilated to the deified mortal Imhotep,[141] whom the Greeks had in turn associated with their god Hermes and was referred to by them as Imuthes. Linking Moses as Imuthes with Asclepius would seem a reasonable development. As appealing as this concept is, no text has as yet been found, to my knowledge, linking Moses with Asclepius,[142] but that need not discourage us from seeing a purely visual appropriation of this motif as suitable for picturing the healing role of Moses in his raising of the Brazen Serpent. In the logocentric world of traditional iconographic interpretation, it is important to recognize that images, too, can serve as iconographic precedents not always connected with written texts.

MOSES "GIGAS," OR MOSES THE GIANT

One final distinguishing attribute of Moses in the Claudius B.iv illustrations is that he is often depicted physically as a giant among his contemporaries. This is especially true in the illustration on folio 138v (fig. 12), where the seated Moses is so large that the frame around the illustration cannot contain him. If Moses were to stand up in this illustration, he would tower above the Israelites gathered before him. And tower he does on folio 139v (fig. 14), where he is represented standing at the lower left of the picture.[143] The idea of Moses having the stature of a giant has its origin in Jewish legend and, as noted already by Kraeling, appears in the depiction of Moses in the third-century C.E. paintings from the Synagogue at

Dura-Europos.[144] It should be kept in mind, however, that many such extrabiblical details of Jewish origin were well known to Christian exegetes, especially in the Syriac ambit.

Kraeling, in his explication of the image of Moses as a giant in the Dura-Europos synagogue paintings, refers to an aggadah that states that Moses's height was ten cubits, approximately fifteen feet.[145] In the Harrowing of Hell image from the Anglo-Saxon Cotton Psalter mentioned earlier, Christ is also shown as a giant, stooping down to pull up the figures of the Patriarchs. The *Christus gigas* is a well-known exegetical image based in part on Psalm 19:5, which was interpreted to refer to Christ, the Heavenly Bridegroom, "strong as a giant to run his race."[146] Moses the giant, then, as a type of Christ, communicates this association visually in the Claudius B.iv illustrations.

One final note: in the image of Moses in his last earthly appearance on folio 139v (fig. 14) he is shown barefoot, as he has been since his encounter with the Lord on Mount Horeb/Sinai on folio 105v (Fig. 10) of Claudius B.iv.[147] This fact is of course significant in the biblical context of the Horeb/Sinai epiphany where God famously commands Moses to remove his sandals as he is standing on holy ground (Exod. 3:5), but it is doubly significant that not only did the Jewish high priest officiate barefoot, but so did Isis priests (e.g., fig. 30), a small but important additional piece of evidence that Moses is being represented in Claudius B.iv in his role as both priest and prophet. Origen, the second-third-century C.E. Alexandrian theologian, made an exegetical contrast in his second *Homily on Exodus* between Abraham and Isaac, who did not have to take off their shoes as they climbed Mount Moriah, and Moses, who, "nevertheless coming from Egypt," had to remove his sandals as he had "fetters of mortality . . . bound to his feet."[148]

It is also in this final image of Moses (fig. 14) that we see how bizarre his "horns" are: tall, flat, slightly wavy, and *blue*,[149] rising from behind some kind of headband or diadem with a central ridge running up the middle. As I pointed out earlier, these central ridges are similar to the central ridge running up the middle of the two stylized feathers rising up from behind a diadem on the head of the god Sopdu depicted on the relief from the Egyptian mortuary temple of King Sahurê at Abusir (fig. 32). To my eye at least, this is the strongest piece of evidence that these "horns" are in fact the misunderstood twin feathers of the *hierogrammateus*: Moses in the guise of a barefoot Isis lector priest, the Khery-heb of ancient Egypt, but the servant/amanuensis of Yahweh, "instructed in all the wisdom of the Egyptians, and . . . mighty in his words and his deeds" (Acts 7:22). The image of Moses on folio 139v is directly related to his blessing of the tribes of Israel, where, in Deuteronomy 33:17, Moses says of Joseph, "His beauty as of the firstling of a bullock, his horns as the horns of a rhinoceros: with them shall he push the nations even to the ends of the earth."

Conclusion

All Horns/No Hats

What began some years ago as an attempt to understand the origin(s) of the representation of Moses with horns on folio 105v (fig. 10) of Claudius B.iv soon took on a much wider scope, resulting in the realization that Moses was presented in this extraordinary manuscript with a large number of additional related attributes that also called for explication. In the process of attempting to understand the single visual motif of the two yellow horns on Moses's head, I have brought forward, I hope, a number of useful perceptions in terms of understanding the original biblical text at Exodus 34:29 and how it might have been understood by Jerome in his famous Latin translation characterizing Moses's altered state after his conversation with the Lord as being horned. Working with Russell Gmirkin's hypothesis that the Hebrew Pentateuch was actually written in Alexandria in the third century B.C.E. by the same Jews who produced its Greek translation as the Septuagint, I have suggested that, as recent scholarship has proposed that the Septuagint itself is at times an explication of its text, the LXX translation of the skin of Moses's face as *dedoxasthai* (glorified) at Exodus 34:29 might have been intended as an "explication" of the original Hebrew verb *qāran*, which Jerome rendered as "was horned" (*cornuta esset*) in his Vulgate translation (see ch. 4). I also suggested that, under the Gmirkin hypothesis of a third-century B.C.E. date for the Hebrew Pentateuch, the Hebrew verb *qāran*, meaning "horned" to Aquila and later Jerome, may have been influenced by the image of the Ammon horns of Alexander the Great signifying his divine status. In addition, I have advanced the well-known concept that being "horned" in the ancient world, especially in the ancient Near East and Egypt, was a widely acknowledged topos signifying divinity, or divine honor, no doubt known to Jerome,

a scholar, and that the specific association of horns with light, as found in Servius and Macrobius's explication of the horns of Pan as symbols of the light of the sun and the moon, may also have influenced Jerome's choice of "horned" at Exodus 34:29 to describe the state of Moses's face after his encounter with the Lord. However, attempting to understand the sense of the biblical text and its translations is one thing; understanding why the horns on Moses's head on folio 105v of Claudius B.iv look specifically the way they do is an entirely different matter, which I pursued in conjunction with explicating the remaining distinctive visual attributes of Moses in this extraordinary manuscript.

Having identified the extrabiblical motif of the First Bath of Moses on folio 75r (fig. 8), our initial encounter with the figure of Moses in Claudius B.iv, as a possible borrowing of a Late Antique theme associated with "pagan" deities and heroes (although possibly filtered through later parallel uses of the First Bath motif in the context of the birth of the Virgin and scenes of the nativity of Christ where the same motif occurs),[1] of the nine distinctive attributes of the mature Moses in Claudius B.iv, I have isolated six as Egyptianizing:

(1) his horned countenance, as shown initially on folio 105v (fig. 10), possibly based on an image of a horned Pan such as can be seen on the Metropolitan Museum Coptic hanging (figs. 22, 23) as well as the possibly Egyptian-inspired horned image of Death, or Mors, found on folio 50r (fig. 24) of the tenth-century Anglo-Saxon Leofric Missal (see ch. 4);

(2) his alternate two-horned representation beginning on folio 136v (figs. 11, 18), where the large "horns" rising from behind a headband or diadem I have characterized as an alteration, most likely based on ignorance of the meaning of the original image, of the two feathers and headband of a barefoot Egyptian Isiac lector priest (fig. 30) (see ch. 7);

(3) the round-topped Tablets of the Law (fig. 10) carried by Moses on folio 105v, similar to the round-topped stelae so prevalent in Egyptian art (fig. 35) (see ch. 7);

(4) his Egyptian *was*-like eared snake rod first seen on folio 78v (fig. 13) through Moses's last appearance on folio 139v (fig. 14) (see ch. 7);

(5) his peculiar "veil" depicted on folio 105v (fig. 10), possibly derived from a depiction of the Egyptian god Amun holding a draped sail before him on a cross-shaped staff, a symbol of the "breath of life" as seen in the second-century C.E. Egyptian painting on the wall of a tomb at Tuna el-Gebel (fig. 26) (see ch. 5); and

(6) the blue color of Moses's horns on folio 139v (fig. 14), which is not a haphazard artistic whim but an attribute associated in several ways with a number of Egyptian gods, Amun chief among them (see ch. 7).

These six specific Egyptianizing attributes of Moses must be seen in the context of three additional Egyptianizing motifs in Claudius B.iv as a whole. They are

(1) the representation of Joseph's corpse on folio 72v, as pointed out by George Henderson, encased in a mummylike wrapping (see introd.);
(2) the representation of Noah's Ark on folio 15v (fig. 2) as a ship, a motif first seen in Early Christian Egypt (fig. 3), with double-headed animal prow and stern as seen in ancient Egyptian examples of the sacred barque of Amun (fig. 7) (see ch. 2); and
(3) the representation on folio 75r of the "basket" in which the infant Moses was found (fig. 9) as an upward double-curved Egyptian-style papyrus "bundle raft" (see ch. 2).

The sum total of these nine distinctive features would seem to point to an exemplar or model of some antiquity, Egyptianizing in tone, that far surpasses the creative ingenuity of the eleventh-century Anglo-Saxon artists responsible for the illustrations in Claudius B.iv and is much too specific for them to have invented on their own based solely on the Old English text before them as some have maintained.

With specific reference to the representation of Moses, I have demonstrated that, in addition to his role as the Great Commander, a Hellenistic *strategos* shown with his distinctive draped *vexillum* on folio 105v (fig. 10), his multiple identities as prophet, priest, scribe, and healer are communicated through several specific attributes in the illustrations of Claudius B.iv that are unique to this manuscript and that, with the exception of his horns and the round-topped Tablets of the Law, make no further appearance in later medieval or Renaissance art. These are

(1) the "veiled" cross of Christ held by Moses on folio 105v (fig. 10), signifying his role as prophet and prefiguring the future sacrifice of Christ on the cross (see ch. 5);
(2) Moses's characterization not only as a prophet in the biblical sense but also as a sacred interpreter in the manner of the god Apollo by representing him on folio 136v (fig. 11) seated on a blue, jeweled mountain throne that may reflect, simultaneously, the description in the *Canterbury Commentaries* of the Sinai epiphany taking place with Moses seated on the sapphire top of the sacred mountain, as well as the sacred omphalos upon which the god Apollo is often represented (Fig. 15) (see ch. 7);
(3) the presence of the priestly *tzitz* (*lamina*), or frontlet, represented on Moses's forehead in the illustration on folio 136v (fig. 11), signifying Moses's role as a biblical high priest (*Cohen ha-gadol*) (see ch. 7);

(4) Moses represented on folio 138v (fig. 12) with a knotted cloth or diadem on his forehead at the base of his horns, possibly related to the cloth bands, or *vittae*, worn by Roman sacrificial priests (see ch. 7);

(5) Moses shown several times in the manuscript as a scribe in the act of writing, perhaps originally as an Egyptian *hierogrammateus* with his two distinctive feathers rising from behind a headband or diadem (figs. 29–31, 34) most likely misunderstood by the Anglo-Saxon artist as the "he was horned" (*he waes gehyrned*) description of Moses in the Old English text of Exodus 34:29 (see ch. 7);

(6) Moses assimilated to the pagan god of healing, Asclepius, through a visual *interpretatio judaica* of the image of the healing god with his snake-entwined staff as a representation of the Brazen Serpent (figs. 16, 17) Moses is commanded by God to raise up in the wilderness to heal the afflicted Israelites (see ch. 7); and

(7) Moses represented as a giant on folio 139r (fig. 14), his last appearance in Claudius B.iv, where his gigantic stature, originating in Jewish legendary sources, may be intended as a prophetic reference to *Christus gigas*, Christ as a giant securing the salvation of mankind (see ch. 7).

I have been able to elucidate many of these images with reference to some of the earliest Christian exegetical texts by writers such as Julius Firmicus Maternus, Justin Martyr, Eusebius of Caesarea, Clement of Alexandria, and St. Ambrose. In addition, Jewish sources in extrabiblical midrashic texts as well as the writings of Philo of Alexandria have proven useful. Indeed, as I demonstrated earlier, some details, such as particular aspects of the representation of the Rivers of Paradise on folio 5v (fig. 6), the presence of an uninked-in angel in the scene of Balaam's dream on folio 125v, and the unusual representation of the Giants on folio 13r could *only* be understood by direct reference to Philo. The entire enterprise of equating figures from both Judaic and Christian traditions to major figures and ideas of pagan culture plays a central role in Hellenistic religious apologetic, both earlier Jewish and later Christian. The distinctive attributes of Moses in Claudius B.iv, his assimilation to major pagan divinities, such as Apollo and Hermes/Thoth, and his characterization as an Egyptian *hierogrammateus*/chief lector priest belong to this Judeo-Christian Hellenistic apologetic atmosphere and point strongly to their origin in a manuscript model, or models, of a much earlier date than early eleventh-century Anglo-Saxon England. It is also questionable whether the Anglo-Saxon artists, or their audience, really recognized or understood the original intent or meaning of some of the visual details carried over into the illustrations of Claudius B.iv.

Having invoked the name of Philo, there is one remaining aspect of his work that calls for consideration here. That is Philo's description of the divine pretensions

of the Roman emperor Gaius Caligula in his text *On the Embassy to Gaius* (*Legatio ad Gaium*), where he records his experiences as the leader of a delegation of prominent Alexandrian Jews to Rome in 40 C.E. in an effort to reverse Caligula's attempt to have the Jews acknowledge his divinity.[2] With not so subtle scorn, Philo describes the antics of Caligula, saying, "Then, as in a theatre, he assumed different costumes at different times, sometimes the lion skin and club, both overlaid with gold, to adorn himself as Hercules." Philo goes on to say, "Then when it pleased him he would strip them off and change his figure and dress in Apollo's, his head encircled with garlands of the sun's rays."[3] In characterizing Caligula as a "counterfeit" god, Philo summarizes the position of the Jews that such a deification would be "judged to be the most grievous impiety, since no sooner could G-d change into a man than a man into G-d."[4] So, one might ask, what would Philo have thought of the characterization of Moses I have put forward here as a military general brandishing a *vexillum*, or a sacred scribe with the feathers and diadem of an Isaic lector priest? The answer, of course, is that Philo is no art historian, and having said that Moses "has banished from the constitution, which he has established, those celebrated and beautiful arts of statuary and painting" (*De gigantibus*, 12.59),[5] he would not have been concerned with *any* pictorial representation of Moses. As mentioned earlier, Philo has nothing specific to say about the details of Moses's situation as "glorified" at Exodus 34:29. But it must be remembered that the claims of Artapanus about Moses being revered as Hermes/Thoth, or Ezekiel the Tragedian's description of an enthroned Moses with scepter and astral crown, are preserved *only* in the writings of Christian apologists such as Clement of Alexandria and Eusebius of Caesarea[6] as part of their larger project of establishing the antiquity and legitimacy of Judaism from which Christianity is descended. Even in that context, the attributes I have concentrated on, his horns, are, at least in the instance of folio 105v, stipulated by a sacred text, the Hebrew Bible, *if*, at Exodus 34:29, St. Jerome has correctly translated *cornuta*, unlike Gaius Caligula and the Seleucid emperors who appropriated for themselves the attributes of divinities. And I am proposing that, while based in part on Judaic texts preserved as excerpts in later Christian writings, the original *visual* construct of Moses as general, king, prophet, priest, and scribe that we see in the illustrations of Claudius B.iv was a Christian creation. It should also be kept in mind that early Christian exegetes, particularly in the Alexandrian and Syriac ambits, were in possession of extensive, originally Jewish extrabiblical and exegetical material, often not freely admitted to or cited as such in Christian theological literature.

Because the depiction of Moses in Claudius B.iv in the guise of a barefoot Isis lector priest and scribe is so deeply rooted in a particular early Christian apologetic milieu that borrowed heavily from a preexisting Jewish Hellenistic construct, the likelihood is much greater that the early eleventh-century Anglo-Saxon artists of

Claudius B.iv are borrowing from a pictorial model, or models, of some antiquity, despite the fact that there are only a limited number of extant earlier images to corroborate this hypothesis.[7] It is also highly likely that the artists may not have fully comprehended what it is that they were borrowing. It is debatable, for instance, whether an Anglo-Saxon Christian artist of the eleventh century knew enough on his own, or cared enough, to create a depiction of the priestly frontlet (*tzitz/lamina*) on a blue cord on Moses's forehead, as in the image on folio 136v (fig. 11), especially as this detail is not only, strictly speaking, not appropriate for Moses as Aaron is the first high priest; it is also not mentioned in the accompanying Old English text, even though it had been depicted in a different form on the head of Ezra on folio Vr of the Codex Amiatinus.[8] That this and other details of this image, such as the diadem and the two feathers as "horns," are "traces" of a much earlier manuscript exemplar or model, perhaps even unwittingly incorporated in the eleventh-century artist's work, presents itself as a credible possibility. It might also be suggested that the "prestige" and antiquity of a model or exemplar may have induced the later eleventh-century artists to include in Claudius B.iv specific visual details they observed in their model, even if they did not fully comprehend their significance. Specifically in the case of the horns of Moses, the fact that the Old English text in front of them, which read "he waes gehyrned" (he was horned), coincided with an image they could see may have confirmed in their minds the appropriateness, even the necessity, of including such in their own depiction of Moses.

The Hellenistic Jewish Egyptian apologetic that may originally have inspired this imagery associated with Moses, an apologetic that had been appropriated by early Christian polemicists such as Eusebius and Clement in their missionary project to demonstrate, first, the antiquity of Judaism and its principal hero, Moses, and second, the "appropriated" legitimacy, therefore, of Christianity and its "second" Moses, Christ, may not actually have been needed any longer in eleventh-century Anglo-Saxon England. Moreover, to the best of my knowledge, the central texts presenting these aspects of Moses's persona drawn from Hellenistic Jewish sources, Clement's *Stromata* and Eusebius's *Praeparatio evangelica*, do not seem to have been known in Anglo-Saxon England, and were themselves translated from Greek into Latin only at a much later date.[9] It is possible, of course, that their contents were known to individuals such as Theodore and Hadrian and may have been incorporated in their teaching at Canterbury.[10] That these attributes and motifs associated with these texts should appear in the depictions of Moses in Claudius B.iv is further testimony to the antiquity and "exoticism" of the exemplars or models referred to by the artists responsible for Claudius B.iv. In a review of Michael Lapidge's *Archbishop Theodore: Commemorative Studies of His Life and Influence*, W. Trent Foley reminds us:

As a crucible of cultures, the early Anglo-Saxon church played host to Irish missionaries in the north, Roman missionaries in the south, and British ecclesiastics in the west and northwest. . . . As if this picture of the early English church were not complex enough, Michael Lapidge and friends remind us that to it we must add the influence of Syriac and Byzantine Christian culture as they were transmitted by Theodore of Tarsus, a native of Cilicia in Asia Minor whom Pope Vitalian dispatched to England in 668 to succeed the deceased Deusdedit as archbishop of Canterbury.[11]

It is against this background that it might be possible to speculate that Theodore and his North African companion Hadrian brought with them illustrated manuscripts[12] that served the eleventh-century Canterbury artists as exemplars from which to extract individual illustrations and motifs that preserved their unique, "exotic" qualities while at the same time being altered or enhanced to meet the specific interests of the artists and their Old English text and audience.

It cannot be overemphasized that the Egyptianizing details to be found in the illustrations of Claudius B.iv, especially with reference to the depiction of Moses, are not mere "historicizing" flourishes, attempts on the part of the eleventh-century Anglo-Saxon artists to provide an appropriate "historical" context for the presence of Moses in Egypt. They are instead fundamental visualizations of the original Egyptian Jewish Hellenistic apologetic, adopted by Christian polemicists for their own missionary purposes, that Moses, and with him, Judaism itself, was more ancient than all the Egyptian gods and pharaohs and that, in the extraordinary case of Artapanus, the Egyptian religious cult itself had in fact been established by Moses. This interpretation of the visual evidence answers the hypothetical question, Why was Moses represented in Claudius B.iv with various Egyptianizing attributes?

In the end, it is ironic that the Egyptian Jewish Hellenistic apologetic that featured a verbal picture of Moses as prophet, priest, and scribe (and in Philo, and others, an image of Moses as "god" and king) should find, perhaps, its sole extant visual expression in an early eleventh-century Anglo-Saxon Christian manuscript, MS Claudius B.iv.[13]

While I have posited an Egyptianizing milieu, both literary and pictorial, as a place of ultimate origin for the rendering of a number of distinctive motifs in Claudius B.iv, it is by no means certain that its artists were working from an exemplar of direct Egyptian provenance. Any number of originally Egyptian motifs could be seen, for example, in Italy throughout the Late Antique–Early Christian period,[14] as the sculpted relief in the Vatican Museum in Rome (fig. 30) and the Nilotic mosaic from Palestrina, among many other possible examples, demonstrate.

There was extensive Egyptian imagery to be seen in a variety of sites through-out Italy in the Late Antique and early medieval periods, even discounting the chronological unavailability of numerous Egyptian motifs in the art of Pompeii.[15] As Robert Bergman has shown, there are strong iconographic links between images in Claudius B.iv and the eleventh-century carved ivory plaques of the so-called Salerno antependium in Italy.[16] In addition, there are stylistic aspects of a group of Italian Amalfitan ivories that share numerous features with the distinctive, some say "crude," figure and hairstyle of the Claudius B.iv illustrations that would benefit from further study.[17] In the matter of style, the illustrations of Claudius B.iv also share a number of characteristics with the so-called *Vergilius romanus* (Vatican City, Biblioteca Apostolica Cod. Vat. Lat. 3867), a fifth-century C.E. manuscript whose origin is unknown.[18]

While the distinctive iconographic features I have focused on in Claudius B.iv, with specific reference to the horns of Moses, may ultimately have an Egyptian origin (meaning that these motifs occurred originally in a Late Period/Coptic en-vironment), it is equally possible, and perhaps even more probable, that the Anglo-Saxon artists were consulting an intermediary exemplar, perhaps of Italian origin via Rome. As is well known, the original mission of St. Augustine to Canterbury in the sixth century C.E. brought from Rome a number of important manuscripts, many of which no longer survive.[19] It is also of note, as I have indicated, that Abbot Hadrian, originally from Carthage in North Africa, and Theodore of Tarsus, from Cilicia, certainly must have brought with them to seventh-century Canterbury numerous manuscripts, some of them no doubt containing pictures reflecting the "exotic" Mediterranean milieux from which they both came.[20] It is also important to recall at this point that Kurt Weitzmann and Herbert Kessler, in citing Claudius B.iv as an important "tertiary witness" to the so-called Cotton Genesis iconographic tradition in the West, have indicated for the Cotton manuscript itself (British Li-brary Cotton MS Otho B.vi) a likely Egyptian origin, either at Alexandria or pos-sibly Antinöe, and that Kessler, especially, has brought forward important new Egyptian comparanda in further illuminating the iconographic origins of this im-portant work of art.

What I hope to have demonstrated is a plausible hypothesis as to the creation of a multifaceted image of Moses in Claudius B.iv that may have been based on pu-tative earlier, no longer extant exemplars or models of unknown date and prove-nance but exhibiting unique Egyptianizing motifs. The attention paid to details has led me, in the spirit of Anthony Grafton's title *Bring Out Your Dead*,[21] to follow the precepts of Erwin Panofsky's tripartite iconographic schema,[22] as well as Kurt Weitzmann's methodological concept of model, copy, and migrating images.

A possible useful analogy to what the artists of Claudius B.iv and its putative exemplar(s) have succeeded in doing in the visual realm may be had in the literary

concept of bricolage,[23] the assembly of diverse elements into an aesthetic whole, or, perhaps even more appropriate to the Late Antique–Early Christian milieu I have posited is the literary genre of the *cento*,[24] a poem composed entirely of lines taken from other authors and arranged in a new form or order. The *cento* genre apparently originated in the late second or third century C.E. The first known *cento* is thought to be the *Medea* by Hosidius Geta, composed, according to Tertullian, entirely from rearranged lines from Virgil.[25] Irenaeus, in his late second-century C.E. work *Adversus Haereses*, composed a *cento* to demonstrate how heretical Christians often modify texts from the canonical Gospels by arranging them in a different order.[26] Clement of Alexandria's *Stromata*, or *Miscellanies*, actually fragments "stitched" together, a "patchwork," is another example of a theological bricolage where extracts of varied works by other authors are stitched together to form an exegetical whole.[27] It might be instructive to see the persona of Moses in Claudius B.iv as a kind of visual *cento*, with attributes and elements from a variety of visual resources knitted together to present a multifaceted image of the great leader as prophet, priest, king, military general, and inspired scribe.

Some may claim that I have created a vast, coincidental fiction here along the lines of the much-criticized early twentieth-century German biblical scholar Daniel Völter, whose studies attempted to show direct relations between distinctive features of ancient Judaism and Egyptian religion.[28] Mindful of Gameson's warnings in the field of Anglo-Saxon iconographic studies about "improbable theories and misleading speculations,"[29] I would argue that too many of the details I have brought forward—listed above—are too specific and in their eleventh-century Anglo-Saxon Christian context too inexplicable to be simply "coincidences."[30] I submit that what we see in the depiction of Moses and his nine distinctive attributes in Claudius B.iv are traces of an ancient and, to quote Francis Wormald once again, "exotic" exemplar available to the manuscript's artists in the cosmopolitan milieu of eleventh-century Canterbury.

One additional aspect of my thesis needs to be addressed here. In characterizing various aspects of the depiction of Moses in Claudius B.iv as "Egyptianizing," I have adduced a number of *comparanda* from ancient Egyptian art of widely ranging dates that may appear far too wide-ranging in my attempt to bolster my argument. In answer to that potential objection, I would venture to say that, on the whole, Egyptian art, unlike other historical stylistic developments, is remarkably consistent and conservative over a very long span of time. In addition, almost all of the works I have referred to, even of the most ancient dates, theoretically could still be observed during the Late Antique and Early Christian periods. This statement, of course, is highly speculative, but with the second-century C.E. sculpted relief of the Isiac *hierogrammateus* from the Vatican Museums (fig. 30), the *hierogrammateus* depicted in the relief sculpture of the second-century C.E. catacombs of Kom

el-Shoqafa, the fragmentary Coptic hanging from the Metropolitan Museum of Art (figs. 22, 23) with dionysiac themes of the fifth to sixth century C.E., and the second-century C.E. depiction of Amun with his sail-like symbol of the "breath of life" in the wall painting from Tuna el-Gebel (fig. 26), I have brought forward a good number of examples that are not too far from a sixth- or seventh-century C.E. date for a putative model, or models, from which the eleventh-century Canterbury artists were working.

Whatever its ultimate origin, the depiction of Moses in Claudius B.iv with these nine distinctive attributes, foremost among them perhaps his horns, as seen later in so famous an example as Michelangelo's Moses in Rome,[31] is powerful testimony to the role that images play in medieval art as a legitimate exegetical vehicle, the equal of, if not surpassing, the written word itself. In the end, it is remarkable that only *one* of the nine distinctive attributes given to Moses is even remotely related to the Old English text of Claudius B.iv—and that is that Moses was *gehyrned*, horned from speaking with the Lord (whatever that may have meant in eleventh-century Anglo-Saxon England). Unless they are all pure inventions of the Anglo-Saxon artists, which is unlikely, the remaining eight attributes, and perhaps even the horns themselves, would therefore have to have been derived from a *visual* model, a model perhaps with an entirely different text, an excellent example, again, of Weitzmann's fundamental concept of "migrating images," images originally created for one textual milieu that have been brought over to an entirely different context. While certain specific details of the illustrations of Claudius B.iv, as C. R. Dodwell has shown, are a mirror of contemporary eleventh-century Anglo-Saxon life, other aspects of the illustrations are a window into the lost world of a far more ancient prototype.

Many valuable lessons have been relearned on this journey. One of the most important of them has to do with the "first level" of Panofsky's tripartite iconographic paradigm, the "pre-iconographical," or primary, description, that in Panofsky's original telling had to do with his famous "acquaintance who greets me on the street by removing his hat."[32] If there is error at this primary level of observation, if a hat is not really a hat, then the whole iconographic enterprise, as Panofsky demonstrated, may be totally askew. Panofsky cites the following example: "If the knife that enables us to identify a St. Bartholomew is not a knife but a corkscrew, the figure is not a St. Bartholomew."[33] So, by following at the outset Warburg's dictum "God is in the details" and Wittgenstein's advice to "just look," it became apparent that Moses's horns on folio 105v (fig. 10) of Claudius B.iv were *not* part of some headdress or helmet as had been asserted in Mellinkoff's groundbreaking study and that, in addition, many other details relating to the depiction of Moses in this extraordinary manuscript were not the product, as Dodwell maintained, of the artists simply reading the Old English text before them but were instead telltale signs of an exemplar rooted in a milieu of some of the earliest Christian art.

And finally, if the horns of Moses were to be associated with the horns of Mors as in the Leofric Missal (fig. 24), as I have suggested, then the image on folio 105v of Claudius B.iv stands at the threshold of a total revolution of the *image* of a horned individual as the complete opposite of what horns and "being horned" had meant in antiquity; rather than the ultimate symbol of divinity, power, and light it became the ultimate symbol of Satanic darkness and death. This revolution had already taken place in the writings of the early Church Fathers and theologians, as I have indicated earlier, but whether it had surfaced in visual form before the tenth-century Leofric Missal image is not known. Sadly, from Claudius B.iv forward in time, the horns of Moses as a negative sign in medieval and Renaissance art came to be something of a commonplace, but as with the figure of Moses himself in Christianity as a whole, a figure imbued with complex ambivalence, vacillating in almost equal parts between the positive and the negative, between exaltation and execration,[34] these horns remain a highly charged cultural sign.

Some writers on the horned Moses motif of Jerome's translation of Exodus 34:29 have posited an anti-Semitic motivation on Jerome's part in choosing "was *horned*" over the "was *glorified*" of the Septuagint.[35] Horns and "hornedness," however, are ambivalent throughout ancient cultures and in the Bible itself. In chapter 4, I explored a number of literary sources that are in general positive in their equation of horns with divinity, power, and light that may well have been known to Jerome and may have influenced his choice. That horns and "being horned" in the later Middle Ages and Renaissance *became* the ultimate symbol of evil and are associated in a negative sense with the Jews is not in dispute.[36] It may well be, as suggested above, that the association of Moses's horns on folio 105v of Claudius B.iv with the horns of Mors in the Anglo-Saxon Leofric Missal and with the Law as Death "engraven upon stones" in fact represents a turning point in the *visual* association of horns and "hornedness" with evil and with the Jews in general as somehow in league with the Devil himself. Unfortunate as this may be, and we have no way of knowing if this was indeed the case, if it is true it is a dramatic example of the power of images and the transformative nature of cultural context that can alter completely the meaning of a visual symbol, investing it with a diametrically opposite meaning.[37]

One final intriguing question is suggested by a detail in the biblical account of Moses's early days, and that is in Exodus 2:19 where the daughters of the Midian priest Jethro (Raguel) return to their father after encountering Moses in the famous incident at the well (Exod. 2:17) when he defends them from a group of shepherds who had chased them away as they were trying to fetch water for their father's sheep. Their father asks them why they have returned sooner than usual. They respond, "A man of Egypt delivered us from the hands of the shepherds: and he drew water also with us, and gave the sheep to drink" (Exod. 2:19). The question comes to mind, how did the daughters recognize Moses as "as a man of Egypt"? The Bible,

as is so often the case, does not say why or how. Somewhat disappointingly, the figure of Moses in this scene on folios 76r and 76v of Claudius B.iv is not depicted in any distinctive way. But we might imagine from the biblical text that he was dressed in some fashion or other that would have led Jethro's daughters to recognize him as an Egyptian. This biblical text may well be the first time that the figure of Moses the "Egyptian" was recognized as such, that same Moses whom we see again with Egyptian attributes in the illustrations of MS Claudius B.iv, the Illustrated Old English Hexateuch.[38]

In the end, while the various attributes of Moses in Claudius B.iv I have brought forward here and have characterized as "Egyptianizing" create a multifaceted image of his multiple roles as military leader, prophet, priest, and scribe, it is his identity as scribe, as a writer of sacred text,[39] that would seem to dominate. This is seen in the number of images of Moses writing and the distinctiveness of the befeathered headband of an Egyptian sacred scribe meant to be understood as "horns."

NOTES

Introduction

The epigraph quoting Philo of Alexandria is from Colson, *Philo: De Vita Mosis* 1 (158), 474. This statement of Philo's has been the center of considerable scholarly debate, with conservative scholars, such as Feldman, *Philo's Portrayal*, 331–54, maintaining that Philo's intention was to see the words of Exodus 7:1 as indicating that Moses would seem like a god to Pharaoh, or that in comparison to Pharaoh, who was considered a living god, Moses would appear as an even mightier god. Other scholars, such as Crispin Fletcher-Louis, "A Discourse on the Sinai Tradition," 236–52, have interpreted this statement to indicate Philo's understanding of the actual "divinization" of Moses.

I capitalize "Early Christian" and "Late Antique" when referring specifically to art-historical styles.

1. Assmann, *Moses the Egyptian*, 8–9. On memory and Moses, see also Ben Zvi, "Exploring the Memory," 335–65.

2. The traditional separation of disciplines between word and image can lead to distortions of the cultural record. A recent example in the Anglo-Saxon realm is the conclusions of Gernot Wieland in "*Legifer, Dux, Scriptor*," 208–9: "The Anglo-Saxons never did seem to make the typological connection I posited between Moses and God. In all the texts I examined, Moses is so strongly associated with the Old Testament Law, and hence is so strongly identified as Jewish, that—despite the respect shown to him—he is not allowed entry into the New Testament through the doorway of typology." I show in chapter 5 of the present work that that is precisely what the illustration on folio 105v of Claudius B.iv (fig. 10) accomplishes, a typological image of the veil of Moses as the veiled cross of Christ. In all fairness, Wieland's project is an analysis of Anglo-Saxon texts *only*, and his conclusions are certainly correct. But what illustrations, such as that on folio 105v of Claudius B.iv, can achieve is precisely this kind of expanded exegetical enhancement of a text. See my remarks in Broderick, "Veil of Moses," and Broderick, "Metatexuality." On the larger concept of image as exegesis, see O'Kane, "Interpreting the Bible," 388–409. Gameson, "Book Decoration," 291, suggests the term *visual theology* for this important role that images are often called on to play in Anglo-Saxon and other early medieval manuscript illustrations.

3. On the idea of Moses as a Hellenistic king, see Borgen, "Moses, Jesus, and the Roman Emperor," 146 and notes 5 and 6; and esp. Fiorenza, *Aspects of Religious Propaganda*.

4. On the theme of Moses as a military leader, see Feldman, "Josephus' Portrait," pt. 2, 83 (1992): 13–28; also Feldman, *Jew and Gentile*, 269–73.

5. For a comprehensive bibliography of the manuscript (although a few art historical references are missing from this otherwise extraordinary publication), see Gneuss and Lapidge, *Anglo-Saxon Manuscripts*, 243–45. See in addition my entry on Claudius B.iv for the online *Oxford Bibliographies* (www.oxfordbibliographies.com). For a full account of the manuscript and scholarship on its text and illustrations, see most recently Withers, *Hexateuch*. Withers's text is accompanied by a full-color CD-ROM of the entire manuscript published by the British Library. In addition, the British Library has made available on its website the entire manuscript in full color. Specific images in Claudius B.iv can be accessed on this site, and readers are encouraged throughout the present study to avail themselves of this stunning resource, which permits magnification of individual images for in-depth views of specific details. The manuscript has also been published in facsimile with extensive commentary and notes by Dodwell and Clemoes, *Hexateuch*. For an analysis of the Old English texts of Claudius B.iv, see Marsden, *Text of the Old Testament*, 402–41. See Withers, *Hexateuch*, 4 n. 8, regarding what the manuscript should rightly be called. I concur in referring to the illustrated manuscript in the British Library collection as "Claudius B.iv."

6. Withers, *Hexateuch*, 21 n. 9, following Wormald and Dodwell and Clemoes, posits two scribes and one artist as responsible for the creation of Claudius B.iv. Others have suggested the manuscript is the work of more than one artist; see Mellinkoff, *Horned Moses*, 15 n. 18; and Barnhouse, "Text and Image," 176–83, 236–37. I am inclined to agree that there is more than one artist at work in Claudius B.iv, as the illustrations themselves show striking stylistic differences.

7. I have published a preliminary version of this thesis in an article titled "Visualizing Moses," 145–69. Some of the central hypotheses about the representation of Moses's horns in that article have been superseded in the present study.

8. Henderson, *Early Medieval Art*, 178. In an abstract of a paper delivered at the Ninth Annual Byzantine Studies Conference (4–6 November 1983 at Duke University, Durham, NC), "The Lost *Biblia Gregoriana* of St. Augustine's Abbey, Canterbury," Mildred Budny made perspicacious remarks about Claudius B.iv, namely, that some of its numerous illustrations show "distinct traces of a late antique cycle of Bible illustrations which belongs to no otherwise known recension and displays marked Greek characteristics." Referring to Claudius B.iv later in her paper, Budny invokes the term "eastern Mediterranean *symptoms*" to describe specific aspects of Claudius B.iv's illustrations.

9. James, "Illustrations of the Old Testament"; Pächt, "Giottesque Episode," 64–65.

10. Wormald, "Continental Influence," in Alexander, *Francis Wormald: Collected Writings* 2, 10 (emphasis mine); see also Wormald's remarks in "Late Anglo-Saxon Art," in *Collected Writings* 1, 106: "One has only to think of that immense set of Old Testament pictures in the illuminated Pentateuch preserved in Ælfric's Old English Heptateuch . . . to realize that the Anglo-Saxon artists had access to rare things and appreciated eccentric imagery for their themes." Remarking on its large number of illustrations, some exhibiting connections with known iconographic traditions and others seeming to be "ad hoc inventions," John Lowden, "Illustration," 479, describes Claudius B.iv as a "book without close parallels."

11. Dodwell and Clemoes, *Hexateuch*, 65–73; also Kauffmann, *Biblical Imagery*, 68. In a perspicacious review of the Dodwell and Clemoes *Hexateuch*, Milton Gatch observed,

Speculum 52 (1977): 368, "Granted that the pictures of Claudius B.IV display remarkable attention to the letter of a special text and remarkable iconographic inventiveness, the artist can hardly be regarded as an absolute sport in the history of medieval art. That he knew biblical cycles and that he recalled at least one such cycle as he worked on these illustrations seems an unavoidable conclusion." See also the remarks of Kessler, "Traces," 178 n. 6: "Dodwell greatly over-estimates the inventiveness of the Ælfric [Claudius B.iv] illustrations." In a pair of individual articles in 1971 and 1976 (curiously, written in French), Dodwell first proposed, and then continued to promote, the idea that the illustrations of Claudius B.iv were directly inspired by the Old English text of the manuscript and contained numerous reflections of contemporary Anglo-Saxon life; see Dodwell, "L'originalité iconographique," 319–28; and Dodwell, "La miniature Anglo-Saxonne," 56–63.

12. Beginning with the important groundbreaking work of George Henderson, "Late-Antique Influences," 172-98; and Henderson, "Joshua Cycle," 38–59, both republished in Henderson, *Studies*, 1, 76–110 and 184–215, respectively. Through the generosity of Florentine Mütherich of the Zentralinstitut für Kunstgeschichte in Munich, I was permitted access to the unpublished 1976 master's thesis of Roland Thomas at the Ludwig-Maximilians-Universität, Munich, "Die Illustrationen des Ælfric-Hexateuch (London, British Library Cotton Claudius B.IV) und ihre Vorlagen," which traces numerous parallels between the illustrations of Claudius B.iv and a wide range of Early Christian, Byzantine, and early medieval works of art. Schubert, "Egyptian Bondage," 31–42, has proposed connections between Claudius B.iv and the so-called Ashburnham Pentateuch (Paris, Bibliothèque nationale, nouv. acq. lat. 2334) from the seventh century. See most recently the important and detailed article by Barnhouse, "Pictorial Responses," 67–87; also Withers, *Hexateuch*, 86–132; and Kogman-Appel, "Rylands Haggadah," 8 n. 34 passim.

13. Henderson, *Studies*, 1, 76–110, indicates important connections to the so-called Cotton Genesis of the fifth-sixth centuries C.E. (London, British Library Cotton MS Otho B.vi); and Henderson, *Studies*, 1, 184–215, demonstrates connections with the Byzantine, post-iconoclastic illustrated Octateuch manuscripts. See also the observations on Claudius B.iv in Weitzmann and Kessler, *Cotton Genesis*, 25, where Claudius B.iv is described as an important "tertiary" witness to the Cotton Genesis iconographic tradition originating in the so-called Cotton Genesis manuscript itself, thought by Weitzmann and Kessler to have been created somewhere in early Christian Egypt, possibly Alexandria or Antinoë. Kessler has recently adduced further evidence of an Egyptian origin for the Cotton manuscript; see Kessler, "The Cotton Genesis and Creation," 17–32. Brenk, *Die Frühchristlichen Mosaiken*, 131, says of the artists of Claudius B.iv, "Sicher waren die Miniatoren der Handschrift keine slavischen Kopisten." And he goes on to say that, despite certain shared iconographic points here and there, "dennoch können wir keine enge ikonographische Beziehung zwischen SMM und dem Aelfric sehen" (131). Kogman-Appel, "Rylands Haggadah," 8, 11, 12, passim, has pointed out a number of important connections between the Old Testament cycles of these later medieval Jewish manuscripts and the illustrations in Claudius B.iv.

14. Such as the scene of Adam and Eve at the bottom right of folio 7v being instructed by an angel to the far right in the art of delving the soil, an extrabiblical detail noted by Pächt, "English Frescoes in Spain," 169, as coming from the apocryphal text known as the *Vita Adae et Evae*. Further, Biggs and Hall, "Traditions concerning Jamnes and Mambres,"

77–79, discuss the possible impact on some of the illustrations in Claudius B.iv of an *apocryphon* concerning the Egyptian magicians Jamnes and Mambres.

15. All biblical quotations in English in subsequent chapters are from the 1899 edition of the *Holy Bible* (*Douay Rheims*) (Rockford, IL: Tan Books and Publishers, 1971).

16. For the earlier literature on this motif, see Bischoff and Lapidge, *Biblical Commentaries*, 499, where the authors are now able to state that the earliest explanation in the context of the British Isles that Cain's murder weapon was the jawbone of an ass is to be found in the seventh-century glosses from Canterbury discovered by Bischoff in Milan.

17. See Ulrich, *Kain und Abel*, 41–50. For a reproduction in color of the sixteenth-century watercolor by Francesco d'Ollanda of this lost mosaic, see fig. 74 in Spier, *Picturing the Bible*.

18. A detail that Claudius B.iv shares with the earlier (end of the tenth- or early eleventh-century) Oxford, Bodleian Library MS Junius 11 (the so-called Caedmon Manuscript). On this manuscript, see most recently Karkov, *Text and Picture*. On the specific issue of the representation of the ark as a ship in Junius 11, see Broderick, "Iconographic and Compositional Sources," 320.

19. See Lezzi, "L'Arche de Noé," 319–24.

20. Henderson, *Early Medieval*, 178; see also Heimann, "Moses-Darstellungen," 8.

21. Dodwell, in Dodwell and Clemoes, *Hexateuch*, 66.

22. See de Gruneisen, *Les caractéristiques de l'art copte*, pl. XIII, fig. 2, for a good example of this square grid pattern on a mummy wrapping.

23. Henderson, *Early Medieval*, 178.

24. Crawford, *Old English Version*, 21, 315.

25. Withers, "Secret and Feverish," 53–71. Karkov, *Text and Picture*, 16, 36, passim, suggests such a function for the illustrations in MS Junius 11 (Oxford, Bodleian Library MS Junius 11) and, by extension, other illustrated Anglo-Saxon manuscripts, but in the process she has overlooked the possible relationship of a number of individual images in the manuscript to previous exemplars or models from which these images may have been derived, albeit altered and expanded on by their Anglo-Saxon appropriators to serve different narrative and exegetical needs. See my critique of this argument in Broderick, "Metatexuality," 384–401. See also Kessler, "Pictures as Scripture," 17–31.

26. As in works such as Meeks, "Moses as God and King," 354–55; Gager, *Moses in Greco-Roman Paganism*; Droge, *Homer or Moses?*; Feldman, "Josephus's Portrait of Moses,"; Feldman, "Abraham the Greek Philosopher," 143–56; Collins, *Jewish Cult and Hellenistic Culture*; Bloch, *Moses und der Mythos*; Borgeaud et al., eds., *Interprétations de Moïse*; Barclay, "Manipulating Moses," 28–46, among others. See also the recent articles on Moses in the *Reallexikon für Antike und Christentum*, 25, Lehnhardt, "Mose I (literarisch)," 58–102, and Heydasch-Lehmann, "Mose II (Ikonographie)," 102–15.

27. Litwa, *Iesus Deus*, esp. 18–19: "In an effort to balance the one-sidedness of current scholarship on early Christology, this book proposes that early Christians did in fact use and adapt widespread Hellenistic conceptions about divinity in order to understand and depict the divine status of Jesus."

28. Matthews, *Clash of Gods*. For a general overview of critical reactions to Matthews's work, see Poilpré, "Bilan d'une décennie," 377–85. See more recently the remarks of Kinney, "Instances of Appropriation," 14, esp. n. 54.

29. Damgaard, *Recasting Moses*, 1, 164.

30. Gmirkin, *Berossus*, 215–21.

31. Goodenough, *Jewish Symbols*, 10, 119–25. See also the remarks of Neusner, "Judaism at Dura-Europos," 89-91. Feldman, *Jew and Gentile*, 69, invokes the "knobby club of Hercules" at Dura as evidence of a limited Jewish assimilation of pagan iconography. Kessler, in Weitzmann and Kessler, *Frescoes of the Dura Synagogue*, 43, questions Goodenough's relying solely on the attribute of the "knobby" club to connect Moses with Hercules but ends up saying, "So Goodenough may be right, after all, that a Hercules figure is involved, although not because of his attribute alone and its far reaching symbolism, but more concretely because a similar action is involved." Interestingly, Martin Luther, in his *Table Talk*, makes a reference to Moses wielding the club of Hercules but in a negative, punitive context. See Foster, "Types and Shadows," 371.

32. Goodenough, "Greek Garments," 221–27; see also the remarks of Schapiro in Fine, "Symposium on the Dura-Europos Synagogue," 136–39.

33. Marsden, *Old English Heptateuch*, xxxviii, notes that "dimensions of pages and written areas are approximate."

34. Withers, *Hexateuch*, 18.

35. See Barker-Benfield, *St. Augustine's Abbey*, I, 405–6; III, 2034. See also Budny, "The Biblia Gregoriana," 237–84, where the author suggests that the artist responsible for the illustrations on folios 68v–69v of Claudius B.iv was possibly the same artist who added an evangelist Mark portrait to folio 30v of the so-called Royal Bible (London, British Library MS Royal 1 E. vi), an Anglo-Saxon illustrated Bible fragment of ca. 815–45, thought to be based in part on the lost *Biblia Gregoriana* of St. Augustine's Abbey, Canterbury.

36. Marsden, *Text of the Old Testament*, 406: "Nevertheless, it must be stressed that almost all of Genesis . . . and most of the rendered portions of the other books . . . are directly translated, not paraphrased or summarized." See also Marsden's remarks in his article "The Biblical Manuscripts," 429.

37. See Godden, "Ælfric of Eynsham (c. 950–c. 1010)," in *Oxford Dictionary of National Biography*, online at www.oxforddnb.com/view/article/187.

38. Dodwell and Clemoes, *Hexateuch*, 13–17, 42–73.

39. Withers, *Hexateuch*, 17–85.

40. Marsden, *Old English Heptateuch*, xlv–l. Among other informative details, Marsden states, xlv, n. 32, that "in 2006, the manuscript was disbound at the BL, to facilitate digital filming, and then rebound in-house in dark green calfskin."

41. Marsden, "The Bible in English," 223.

42. Withers, *Hexateuch*, 21 n. 9. Marsden, *Old English Heptateuch*, xlvii, states that the illustrations are "by several different artists."

43. With respect to Moses in particular, see Mellinkoff, *Horned Moses*, pt. 2, 18–21, "Eleventh-Century England: A Place of Originality."

44. Assmann, *Moses the Egyptian*, 11, addresses this issue directly, saying of his own work, "I have given the name 'Moses the Egyptian' to this vertical line of memory which I am investigating from the times of Akhenaten up to the twentieth century. I shall not even ask the question—let alone, answer it—whether Moses was an Egyptian, or a Hebrew, or a Midianite. This question concerns the historical Moses and thus pertains to history. I am

concerned with Moses as a figure of memory." On this issue, see also Jánosi, "Die Ägyptologie," 29–61.

ONE Ways and Means: Methodology

1. In celebration of its second century of publication, Kirk Ambrose, editor of the *Art Bulletin*, has commissioned a series of articles by contemporary art historians titled "Whither Art History?" The first of these essays, by Griselda Pollock, appeared in *Art Bulletin* 96.1 (March 2014): 9–23.

2. For a full account of the manuscript and the history of scholarship on its text and illustrations, see most recently Karkov, *Text and Picture*. For a detailed iconographic study of each of the manuscript's illustrations, see my unpublished 1978 Columbia University PhD dissertation, "Iconographic and Compositional Sources." See also the entry on MS Junius 11 in Gneuss and Lapidge, *Anglo-Saxon Manuscripts*, 491–93. On the question of the manuscript's date, see Lockett, "An Integrated Re-Examination," 141–73. The manuscript has been published in facsimile by Sir Israel Gollancz, *Caedmon Manuscript*. High-quality images of all pages of the manuscript are available on the Bodleian Library website: http: image.ox.ac.uk/show?collection=bodleian+manuscript=msjunius11. In addition there is an excellent CD-ROM of the entire manuscript with commentary and bibliography created for the Bodleian Library by Muir (ed.) and Kennedy (software), *A Digital Facsimile*.

3. Withers, *Hexateuch*, 62–85; for Junius 11, see Karkov, *Text and Picture*, 19–44.

4. Both manuscripts have been a focus of intense study for their texts as well as their illustrations. Studies of these renowned manuscripts tend to focus on one or the other aspects of both works. The Oxford Online Bibliographies for Medieval Studies provide extensive bibliographic resources for the study of both text and illustration. On the poetic texts of MS Junius 11, see most recently Anlezark, *Old Testament Narratives*.

5. Karkov, *Text and Picture*, 1–18; cf. my remarks in Broderick, "Metatexuality," 384-401 (Mittman and Kim, "Locating the Devil," 21–22, have responded directly to my critique of Karkov's approach in *Text and Picture*). Withers, *Hexateuch*, 86–90, 132.

6. On the continuing importance of source study in Old English literary studies, see the remarks of Wright, "Old English Homilies," 15–66, esp. 16: "Source study (like every approach) has limitations, but it supports many fundamental concerns of Old English scholarship." Wright goes on to say, "Source identification resolves the discrete voices, words, and works that a homilist has compiled and appropriated (whether overtly or covertly), enabling us to observe how they have been *transformed* in the process" (59; emphasis mine).

7. See Broderick, "Metatexuality," 392 n. 99, 396 nn. 147, 148. Karkov, "Manuscript Art," 212, has nuanced some of her earlier views, writing, "Most medieval art was based on older models and some scholars direct their work to tracking the influences, direct and indirect." On the interaction of tradition and innovation in medieval manuscript culture, see Brown, *The Book*. See also Alexander, "Facsimiles," 61–72. The extended discussion, "The Illustration of Texts," with specific reference to the Anglo-Saxon ambit, in Gameson, *Role of Art*, especially the section "Inherited Illustrations," 9–19, makes an excellent case for a balanced approach in assessing the complex relationship between "tradition" and "innova-

tion." As Gameson points out, "Pre-existing images and traditions of illustration were of considerable importance in determining the Anglo-Saxon illustrator's approach to his task and in defining his visual vocabulary" (9). On the other hand, the author observes, "Yet, even when following exemplars which provided complete models for both text and illustration, Anglo-Saxons, like other artists, can be seen altering the images they had inherited, and this is exactly what we should expect" (11). Similarly, David Flusser makes the observation in his introduction to Schreckenberg et al., *Jewish Historiography*, that "during the Middle Ages illustrations were more dependent on their exemplars than in other periods" and goes on to say, "Of course, the illustrations were not slavishly copied in most cases during this period" (xiii).

8. Grafton, *Bring Out Your Dead*, 293.

9. Interest in Panofsky and his philosophy of interpretation as one of the "founding fathers" of modern art history as a discipline reached an all-time high toward the end of the last century. See Holly, *Panofsky*. The most trenchant criticism of Panofsky's methodology is to be found in the publications of Keith Moxey; see, in particular, "Politics of Iconology," 27–31; and "Semiotics," 985–99; see also Lang, "Chaos and Cosmos."

10. See the important remarks by Richard Gameson, "Study of Early British Books," 719, on some aspects of current scholarship on the iconography of Anglo-Saxon manuscripts such as Claudius B.iv and Junius 11.

11. Stahl, "Iconographic Sources," 245.

12. Bernabò, in Weitzmann and Bernabò, *Byzantine Octateuques*, 311.

13. Weitzmann, *Illustrations in Roll and Codex*, esp. 130–53. Today Weitzmann and his methodology seem to be in somewhat the same situation as the famous literary aphorism attributed to André Gide, who, when asked, "Who is the most famous French poet?," is said to have answered, "Victor Hugo, hélas!" Most recently, aspects of Weitzmann's methods have been critiqued by Lowden, *Octateuchs*; Lowden, "Concerning the Cotton Genesis," 40–53, esp. 40 n. 5; and Cutler, "End of Antiquity," 401–9. See also Wright, "The School of Princeton," 6–8. See the important review in *Burlington Magazine* 142 (2000): 503–4 by C. M. Kauffmann of *Imagining the Early Medieval Bible*, edited by John Williams, for critical details of the Weitzmann approach but also a reasoned concession that "the comparison of illustrations with earlier treatments of the same scene can still lead to interesting results"; and the review by John Lowden of Weitzmann and Bernabò's *Byzantine Octateuchs*, *Burlington Magazine* 142 (2000): 502–3. For additional views on the Weitzmann-Bernabò approach to manuscript studies, see Dolezal, "The Elusive Quest," 128–41. On the continued utility of the Weitzmann "method," see Bernabò, *Pseudoepigraphical*, esp. 7; and Kessler's remarks in the introduction to Büchsel et al., *Atrium of St. Marco*, 16–17.

14. Judge, "Antike und Christentum," 5.

15. See below ch. 2, nn. 62, 102, 103, 165, 174, 200, and 208. The relationship of these extrabiblical Jewish interpretive texts to pictorial iconography, especially in Christian art, is a complex subject that has generated considerable scholarly controversy. I tend to agree with the position of Bernabò, *Pseudepigraphical Images*, 11: "The debt of Christian iconography to Jewish midrashim can be explained by means of oral or written traditions known to the Christians; and the presence of Jewish interpretations in Christian works of art asserts only that Jewish traditions were amply known in the Christian world."

16. On the issue of the "originality" and "creativity" of early medieval artists, see Nees, "Originality of Early Medieval Artists," 77–109. See also the remarks of Noel, *The Harley Psalter*, 6–9, where among other important observations, Noel makes the following statement about the nature of the Harley Psalter as a "copy" of its exemplar, the Carolingian Utrecht Psalter, which was in England sometime before the year 1000: "Much is hidden in the familiar phrase that the Harley Psalter is the first English copy of the Utrecht Psalter. The phrase itself is the result of an accident of survival. Most books of this period were 'copies' of other books, but normally their exemplars have disappeared." See also Kessler, *Studies*, 1: "Many scholars doubt altogether that images communicate meaning: others apply a romantic notion of license to the medieval 'artist.'"

17. Alexander, *Medieval Illuminators*, 72–94.

18. On the role of memory in medieval culture in general, see Carruthers, *Book of Memory*. On the role of memory with direct reference to the relationship of the Cotton Genesis to the mosaics of San Marco, see Kessler, "Memory and Models," 463–75.

19. See Karkov, *Text and Picture*, 7–16 passim. See also my remarks in Broderick, "Metatexuality," 392.

20. See Kinney, "Instances of Appropriation," 1–22, on "appropriation" in late Roman and Early Christian art.

21. Weitzmann and Kessler, *Cotton Genesis*.

22. Weitzmann and Bernabò, *Octateuchs*.

23. Bernabò, *Pseudepigraphical Images*. Among many important findings in this groundbreaking work, Bernabò emphasizes that a great deal of extrabiblical lore, much of it Jewish in origin, was known to early Christian writers and exegetes. This all-important perception has lead Bernabò to the conclusion, expressed in his portion of Weitzmann and Bernabò, *Byzantine Octateuchs*, 1, 322, that "a Jewish origin of the core of the cycle [referring to the later Octateuch manuscripts] should be consequently excluded."

24. Kessler, *Bibles from Tours*.

25. von Erffa, *Genesis*.

26. See Gameson, *Role of Art*, index, 302–3, for numerous references to Claudius B.iv. See also Gameson, *Cambridge History of the Book*, 249–93, for general remarks on Claudius B.iv and Junius 11, as well an extensive bibliography.

27. Karkov, *Text and Picture*.

28. Withers, *Hexateuch*.

29. Brown, *The Book and the Transformation*.

30. On Muir's exemplary digital project, see my remarks in Broderick, "Metatexuality," 384, 397.

31. This CD-ROM comes with Withers's book, *Hexateuch*.

32. Henderson, *Studies* 1, 76–10, 184–215.

33. See Gombrich, *Aby Warburg*, 13–14 n. 1.

TWO Traces of a Late Antique Exemplar in MS Claudius B.iv: The Book of Genesis

1. Henderson, "Joshua Cycle," in *Studies*, 1, 184–215.

2. Withers, *Hexateuch*, 223-64.

3. Readers should consult the British Library, London, website for all images discussed in this chapter that are not illustrated here in this book. Similarly, readers should consult the Bodleian Library, Oxford, website for complete illustrations from MS Junius 11.

4. Traditionally, this scene is referred to as "The Fall of Lucifer and the Rebel (or Evil) Angels." Withers, "Satan's Mandorla," 247, says that the illustration on folio 2r should be more correctly called "The Origin of Satan." For the sake of consistency, I shall continue to refer to it as the Fall of Lucifer and the Rebel Angels, as the scene does show both Lucifer, now transformed into Satan, and his cohort of evil angels falling.

5. Withers, "Secret and Feverish Genesis," 53–71; see also Withers, *Hexateuch*, 32, 128, 188; Withers, "Satan's Mandorla," 247–70.

6. Withers, "Secret and Feverish Genesis," 56.

7. Zahlten, *Creatio*, 119–27; von Erffa, *Ikonologie*, 59–70. On this extrabiblical theme as inaugurating the illustrations of Claudius B.iv and forming an example of the illustrations playing an important role enhancing or expanding the contents of the texts they accompany, see Gameson, *Role of Art*, 43.

8. von Erffa, *Ikonologie*, 1, 66–70.

9. See my discussion of the potential sources of this drawing in Broderick, "Observations," 165–69. Karkov, "Exiles," 209–10, observes a number of important differences between the images of the Fall of Satan and the Rebel Angels in Claudius B.iv and Junius 11, noting that Satan's rebellion involves a claim to both land and power and that while this is emphasized both in the Junius 11 illustration and its poetic text, there is no indication of this aspect in the Claudius B.iv image or its text. For a more recent interpretation of the drawing in Junius 11, see Mittman and Kim, "Locating the Devil," 3–25.

10. See Gameson's observations on the expressive aspects of the composition of this image in Gameson, *Role of Art*, 130, 162, 188 n. 176.

11. As in the Utrecht Psalter, see Tselos, "English," fig. 5.

12. Blue hair occurs from time to time in earlier Insular and Anglo-Saxon manuscript art as on the head of the bearded figure (Moses?) peeking out at the right from behind a curtain on folio 17v of the so-called Copenhagen Gospels (Copenhagen, Royal Library G.K.S. 10,20) of ca. 1000 as well as on the heads of the seated evangelist St. Matthew and the bearded head, also peeking out at the right from behind a drawn aside curtain, on folio 25v of the earlier eighth-century Lindisfarne Gospels (London, British Library Cotton MS Nero D.iv). For both images, see Brown, *Manuscripts*, color pl. 118 and frontispiece. The monk on the right of the dedication page, folio 11v, in the mid-eleventh-century Old English Herbal (London, British Library Cotton MS Vitellus C.iii) is shown with blue hair: see Voights, "A New Look," 54 and fig. 2. Some of the Celtic tribes in Britain were known to have painted or tattooed their bodies with a blue dye made from woad: see Allen, *Celtic Warrior*, 20; also Carr, "Woad, Tattooing and Identity," 273–89. See chapter 7 below for further discussion of the possible significance of this choice of blue for Moses's horns on folio 139v of Claudius B.iv (see fig. 14).

13. "Spiky" or "flaming" hair is often a sign in later medieval art of the demonic in general, as can be seen, for example, on a twelfth-century capital from the nave of La Madeleine, Vézelay, depicting a flame-haired demon dancing on top of the Golden Calf. See Gerlach and Paul, "Kalb," in Kirschbaum, *Lexikon*, pl. 266, fig. 84; and Ackerman and

Gisler, *Lexicon Iconographicum*. Similar "flaming" hair can be seen on a sculpted Roman plaque representing Aias in the Villa Borghese, Rome, in Kirschbaum, *Lexikon*, 2, 481.

14. See my remarks on this image in Broderick, "Attitudes toward the Frame," 32–35.

15. Illustrated as fig. 9 in Curschmann, "Oral Tradition," 177–206. The creature in Claudius B.iv is also similar to the classical "Cetus" seen in many works of medieval art, e.g., folio 147v of the ninth-century Stuttgart Psalter (see the complete manuscript at www .wib-stuttgart.de/index.php?id).

16. See von Dassow, *Egyptian Book of the Dead*, pl. 3. While the creature in the Claudius B.iv image is biting, there is an earlier image on a ninth-century Carolingian ivory in the Victoria and Albert Museum, London, showing a Hell Mouth ingesting the upper body of one of the damned in this scene of the Last Judgment, illustrated as fig. 2 in Kemp, "Seelen," in Kirschbaum, *Lexikon*, 4, 140.

17. Kemp, "Seelen," in Kirschbaum, *Lexikon*, 4, 143; see also Perry, "On the Psychostasis," 94–97, 100–105.

18. Illustrated in Kessler, *Bibles*, fig. 129; for other images of Aion, see Ackerman and Gisler, *Lexicon*, 1/2, "Aion," pl. 313, figs. 11–20.

19. See Ackerman and Gisler, *Lexicon*, 1/2, "Aion," pl. 313, fig. 16, from a Roman mosaic in Carthage.

20. See Weitzmann, "Survival of Mythological Representation," 45–65; Weitzmann, *Age of Spirituality*, 402; also Büchsel, "Theologie," 102 and Abb. 2, where the author brings forward the example of the sleeping Eros as a prototype for the sleeping Adam in the San Marco mosaics and other medieval examples.

21. See the description of this kind of visual "chiasmus" discussed by Schapiro, *Language of Forms*, 24–27, 58; see also Broderick, "Attitudes toward the Frame," 32. On the "foliate" aspect of the frame on folio 2r of Claudius B.iv, see Gameson, *Role of Art*, 207, 212.

22. See Bacher, "Targum," 1, 634–35.

23. On the possible function(s) of and audiences for illustrated vernacular Anglo-Saxon manuscripts, such as Junius 11 and Claudius B.iv, see the remarks of Richard Gameson, *Role of Art*, 9, 54, and esp. 57, where the author remarks, "Of the surviving late Anglo-Saxon manuscripts with illustrations, only the Old English Hexateuch seems particularly suitable for use with an illiterate, possibly lay, beholder."

24. On the concept of performativity, see the introduction to Suydam and Ziegler, eds., *Performance and Transformation*, 1–26. Withers, *Hexateuch*, 176 passim, suggests a number of putative scenarios for the use of Claudius B.iv.

25. On the work of the six days in medieval art in general, see von Erffa, *Ikonologie*, 70–74. On the work of the second day specifically and the *Kosmoskugel*, see Zahlten, *Creatio Mundi*, 157–64.

26. See Bergman, *Salerno*, 16–17, 18, fig. 3.

27. See Kessler, *Studies*, 502–5 and fig. 2.

28. See fig. 5 in Broderick, "Northern Light," 216, a coin from the Roman Imperial period (ca. 141–61 C.E.) on the reverse showing Aeternitas seated on a starry globe.

29. See Kessler, "Memory and Models," 463, where the winged figures identified by D'Alverny as "angel-days" in the San Marco mosaics as well as the Cotton Genesis itself are

described as Late Antique personifications of days rather than as angels. A convenient source of excellent color reproductions of the San Marco mosaics is found in Büchsel, "Theologie," pls. 1–58.

30. See Wallace, *Michelangelo*, pl. 161.

31. Crawford, *Exameron Anglice*, 20.

32. Ibid., 9–10.

33. See Blum, "Cryptic Creation," 217–19.

34. On medieval representation of the work of the third day, see von Erffa, *Ikonologie*, 1, 70–74; also, Zahlten, *Creatio Mundi*, 164–67.

35. See the representation of the cross of Christ on folio 1v of the Anglo-Saxon Gospels of Judith of Flanders (New York, Pierpont Morgan Library MS 709) in Temple, *Anglo-Saxon Manuscripts*, color pl., fig. 289.

36. See Broderick, "Northern Light," pl. 7.

37. On medieval representation of the work of the fourth day, see von Erffa, *Ikonologie*, 1, 70–74; also, Zahlten, *Creatio Mundi*, 174–84.

38. See Wallace, *Michelangelo*, pls. 142–47. On the incarnational associations of the color pink in earlier Carolingian manuscripts with Christ's Passion and his bloodied flesh, see Kessler, "*Hoc Visibile*," 297–302.

39. See my remarks in Broderick, "Some Attitudes," 31–42.

40. Illustrated in Calkins, *Illuminated Books*, pl. 45.

41. Illustrated in Kessler, *Bibles*, fig. 129.

42. See Böhlig and Labib, *Die koptisch-gnostiche Schrift*, 96.

43. Illustrated in color pl. IV in Backhouse, *Golden Age*.

44. See the remarks on the upraised arms pose in Henderson, *Studies*, 1, 111. On the Berlin plaque, where the Creator is seated on the circular *gyrus terrae* in the scene of the fourth day but reaching up with both arms to place the sun and the moon in the heavens, see Kessler, *Studies*, 497 and fig. 2.

45. Kessler, "Cotton Genesis and Creation," 18.

46. Weitzmann and Kessler, *Cotton Genesis*, 52–53.

47. See the commentary by Mütherich in Bischoff and Mütherich et al., *Der Stuttgarter Bilderpsalter*, 174.

48. Bamberg, Staatsbibliothek, Misc., Class Bibl. 1, folio 7v; see Kessler, *Illustrated Bibles*, 15 and fig. 2.

49. See Büchsel, "Die Schöpfungdmosaiken," 70–71.

50. Ibid.

51. Anderson, "2 (Slavic Apocalypse of) Enoch," in Charlesworth, *Pseudepigrapha*, 1, 170–71; see also Bunta, "One Man in Heaven," 139–65.

52. Philo, *De Opificio Mundi*, 46 (135); Colson, 107.

53. Theophilus of Antioch, *Apologia ad Autolycum*, bk. 2; translated by M. Dods (www .logoslibrary.org/theophilus/autolycus/218.html).

54. On Irenaeus's theology of creation, see Nielsen, *Adam and Christ*, 16–19.

55. See Agaësse and Solignac, trans., *La genèse*, 474–75; see also the remarks of von Erffa, *Ikonologie*, 1, 79.

56. Crawford, *Ælfric's Treatise*, 20; emphasis mine.

57. Kessler, "Cotton Genesis and Creation," 24, figs. 12, 13.

58. See Quispel, "Original Doctrine," 327–52.

59. Siemens, *Christology of Theodore*, 85.

60. Ibid., 86. See also Brown, "Bearded Sages," 278–90. Mellinkoff, *Mark of Cain*, 58, mentions that in the twelfth-century Irish *Book of the Taking of Ireland* (*Lebor Gabála*), which contains numerous apocryphal details, Adam is presumed to have been created with his beard.

61. Broderick, "A Note on the Garments," 250–54; see also von Erffa, *Ikonologie*, 1, 237–38.

62. Ginzberg, *Legends*, 1, 177, V, 199, 276.

63. von Erffa, *Ikonologie*, 1, 80–81.

64. See fig. 53 in Zahlten, *Creatio Mundi*.

65. Zahlten, *Creatio Mundi*, figs. 2, 39, 386, etc.

66. Barnhouse, "Text and Image," 218–31. Interestingly enough, however, Wright, "Old English Homilies," 46, remarks, "After the Bible and the apocrypha, one might expect the most influential writings to have been patristic texts," and goes on to say, "In stunning contrast . . . ," however, "not a single direct borrowing from a genuine work by Jerome or Ambrose has been identified in the entire corpus of anonymous homilies," which suggests that this Ambrose "borrowing" may have occurred in an earlier model or exemplar and is *not* the work of the artist(s) or designer of the cycle of illustrations in Claudius B.iv.

67. In the words of Lucchesi, *L'usage de Philon*, 7, "Ambroise est le plus grand usager de Philon, parmi les Pères de l'Eglise."

68. Barnhouse, "Text and Image," 229–30.

69. Ibid., 221.

70. Ibid.

71. Ibid., 227.

72. Ibid.

73. Marcus, *Philo, Quaestiones et Solutiones in Genesin*, 1, 8–9; emphasis mine.

74. Barnhouse, "Text and Image," 228.

75. Savage, *Saint Ambrose*, 298.

76. Dodwell and Clemoes, *Hexateuch*, 18.

77. Barnhouse, "Text and Image," 228.

78. Colson, *Philo*, 6, *De Vita Mosis*, 1 (49), 274.

79. Barnhouse, "Text and Image," 228.

80. Savage, *Saint Ambrose: Hexameron*, 298.

81. On these later inscriptions, see Doane and Stoneman, *Purloined Letters*, 1–12.

82. See Withers, "Secret and Feverish," 56.

83. Withers, *Hexateuch*, 94–104.

84. Ibid., 98.

85. Colson, *Philo, De Vita Mosis* 1, 484–85; see the discussion of Philo's substitution of an angel for references to God himself in Num. 22:38 and 23:5 in Levison, "The Prophetic Spirit as an Angel," 191.

86. Henderson, *Studies*, 1, 76; see also Green, "Hortus," fig. 3f.

87. Bergman, *Salerno*, fig. 5.

88. Green, "Hortus," fig. 1c, 8.

89. Ibid., 347.

90. Cook, *Zeus*, 1, 279, fig. 205. Similarly, Büchsel, "Theologie," 102, fig. 2, has suggested figures of a sleeping Eros as a model for the sleeping Adam in the rib-removing operation as seen in the San Marco mosaics, Büchsel, "Theologie," pl. 17.

91. Kessler, "Plaque," fig. 2.

92. Ibid., fig. 22, 88–89. Kessler states that the figure of Eve rising from the side of Adam on the Berlin plaque is not a borrowing from an Eastern, Byzantine cycle but is rather a conflation of two separate scenes, the drawing of the rib and the shaping of Eve, as preserved at San Marco. See Bergman, *Salerno*, 20 and fig. 5, for a different explanation.

93. Smyrna Octateuch, fol. 12v, see Weitzmann and Bernabò, *Octateuchs*, fig. 77; Seraglio Octateuch, fol. 42v, see Weitzmann and Bernabò, *Octateuchs*, fig. 80.

94. Waetzoldt, *Kopien*, fig. 330, cat. no. 592; see also Büchsel, "Theologie," 121.

95. Dodwell and Clemoes, *Hexateuch*, fol. 6v.

96. Neuss, *Katalanische*, fig. 2 (fol. 6r).

97. London, British Library Egerton MS 1894, fol. 1v, reproduced as pl. IV in Joslin and Watson, *Egerton Genesis*, 35–36.

98. Weitzmann and Bernabò, *Octateuchs*, 31–33; Karkov, *Text and Picture*, 57.

99. Weitzmann and Bernabò, *Octateuchs*, 32 n. 2.

100. On this theme, see Schade, "Adam und Eva," 1, 52; see also von Erffa, *Ikonologie*, 1, 147–48.

101. Broderick, "Metatexuality," 393 n. 117.

102. Freedman and Simon, *Midrash Genesis Rabbah*, 1, 137: "A (Roman) lady asked R. Jose why (was woman created) by a theft? Replied he, 'a man depositing an ounce of silver with you in secret, and you return him a litra [= 12 oz.] of silver openly; is that theft?' 'Yet why in secret?' she pursued. 'At first He created her for him and he saw her full of discharge and blood; thereupon He removed her from him and created her a second time.' 'I can corroborate your words,' she observed. 'It had been arranged that I should be married to my mother's brother, but because I was brought up with him in the same home I became plain in his eyes and he went and married another woman, who is not as beautiful as I'"; see also Ginzberg, *Legends*, 5, 87 n. 40. Ginzberg, *Die Haggada*, 60 n. 3, suggests that Augustine in "*Contr. Advers.*, Liber primo homini duas crease mulieres," rather than confirming the existence of a midrash on a twofold creation of Eve, had another haggadic detail in mind, and that is the legend that before the birth of Seth Adam consorted with devils who gave birth to a series of demonic offspring. This is confirmed, in Ginzberg's opinion, by the remainder of the quotation cited above from St. Augustine, "ex quibus texunt genealogias . . . infinitas."

103. Mirsky, "On the Sources," 386, notes that the Bible text (Gen. 2:21) speaks only of a "deep sleep" and that the Old English text adds the words "and softe" (line 179). According to Mirsky, "This addition we find also in Jose ben Jose, a Hebrew poet who lived in Palestine presumably in the fifth century. In the epic poem 'Azkir geburoth eloah' (= "I shall

relate the mighty deeds of God"), describing the creation of Eve, we read in verse 43: 'God put Adam into a sweet sleep, lifted up his bone and built from it a maid.'" Murdoch, *Fall of Man*, 3, says the following: "A detailed (although perhaps somewhat overdone) modern study by A. Mirsky of the Old English *Genesis* and *Exodus* poems adduced a large number of potential rabbinic parallels in those texts."

104. Freedman and Simon, *Midrash Genesis*, 1, 142.

105. Schade, "Hinweise," 375–92; for the *Bible moralisée* image, see fig. 43 in Schade, "Das Paradies," 79–182. See also Haussherr, "Sensus litteralis," 358, fig. 59.

106. Cf. Kessler, "*Bibles*," 17 n. 19: "Actually, it appears to us that even in R (San Paolo Bible), this element [Adam's open eyes] is of stylistic rather than theological origin for even in the scenes of the creation of Adam and the forming of Eve, Adam's eyes are shown open."

107. On the *Annales Colbazenses* (Berlin, Staatsbibliothek MS Theol. Lat. folio 149), a Danish manuscript of ca. 1100, see Wrangel, *Lunds Domkyrkas*, 91–103, figs. 58–62.

108. Green, "Hortus," fig. 8; cf. remarks by Henderson, *Studies*, 1, 80 n. 22, that Weitzmann, in connecting the Millstatt Genesis with the Cotton Genesis tradition, "has to strip the Millstatt version of all its positive features"; but Weitzmann himself, in *Illustrations of Roll and Codex*, 157ff., already presents a theoretical basis for dealing with additions, omissions, and changes in a basic pictorial tradition.

109. Green, "Hortus," fig. 1c.

110. Ibid., fig. 3g.

111. Reproduced in color as pl. 6 in Brown, *Holkham Bible*; see also James, "An English Bible-Picture Book," 1–27. Both Hassall, *The Holkham Bible Picture Book*, 61, and James, 7, describe the scene at the upper right as the creation of Adam.

112. Bergman, *Salerno*, 42–47; Mütherich, "Die Stellung der Bilder," 175, indicates the existence of both Early Christian cycles in the West at least in the ninth century; Gaehde, "Carolingian Interpretations," 351–84, has suggested an illustrated Early Christian Octateuch as one of the sources of the ninth-century San Paolo Bible; Bergman, *Salerno*, 41–47, posits a mixed Octateuch–Cotton Genesis recension, containing details not found in later descendants of either recension, in existence in Rome in the fifth century C.E.; Kötzsche-Breitenbruch, *Die neue Katakombe*, also argues for an early combination of details in the West from the two perhaps not so separate traditions; see also the remarks of Stahl, "Iconographic Sources," 20, 138 passim.

113. Kessler, *Bibles*, 25–28.

114. See Kessler, "Traces," 187.

115. See the discussion of the Temptation in Troje, *Adam und Zōē*. Troje was one of the first scholars to explore many extrabiblical details in the context of the Early Christian Genesis scenes in the wall paintings of the El-Bagawat Necropolis, El-Kharga Oasis, Egypt. Karkov, "Exiles," 217 n. 100, observes that the Serpent in this scene winds between and around Eve's legs, potentially suggesting the sexual nature of the sin of Adam and Eve.

116. Kessler, "Traces," 144–45.

117. Pächt, "Cycle of English Frescoes," 169, fig. 13.

118. Kessler, "Traces," 144.

119. Ibid., 145–46.

120. See von Erffa, "Arbeit," in *Ikonologie*, 1, 342–46.

121. Ibid., 344.

122. Clemoes and Godden, *Ælfric's Catholic Homilies*, 184/160–61; English translation, Thorpe, *The Homilies of the Anglo-Saxon Church; The Sermones Catholici*, I, *De Initio Creaturae*.

123. On this theme and its history, see von Erffa, *Ikonologie*, 1, 346–51; also Schrenk, "Kain und Abel," 19, 943–72.

124. Kessler, *Bibles*, fig. 39.

125. See Stern, "Les mosaiques,"172–73.

126. Ulrich, *Kain und Abel*, 41–50. Interestingly, on a carved ivory panel of fifth-century C.E. date in Milan (Museo del Tesoro del Duomo), part of a five-panel diptych currently arranged as if meant to be the cover of a codex, a small panel to the right shows Christ seated on a "starry" globe handing wreath-crowns to two figures who stand with covered hands to his left and right, the entire composition looking very similar to the triad seated God/Christ with Cain and Abel at left and right in the Santa Costanza and Hexateuch images. See Frantová, "Milan Five-Part Diptych," 11, fig. 2.

127. Ulrich, *Kain und Abel*, 47, nn. 167, 168.

128. Ibid., 117, fig. 152; see also Brown, *Holkham Bible*.

129. Deshman, *Eye and Mind*, 44–45, fig. 57. Interestingly, the figures in Claudius B.iv seem to have nothing visible in their veiled hands. Perhaps the artist has not completed the image, as there are many unfinished illustrations throughout the manuscript. Perhaps there is some subtle exegetical point here that God alone knows which offering he will favor for reasons the Bible itself does not indicate.

130. See Schrenk, "Kain und Abel," 953–63.

131. Wright, "Blood of Abel," 7–20.

132. Ibid., 7.

133. Ibid., 17.

134. See my remarks on the exegetical role of images in Anglo-Saxon illustrated manuscripts, Broderick, "Metatexuality," 387–89.

135. Ulrich, *Kain und Abel*, 96, fig. 102.

136. Bischoff and Lapidge, *Biblical Commentaries*, 499.

137. Ibid.; emphasis mine.

138. Henderson, *Studies*, 1, 216–28.

139. Barb, "Cain's Murder-Weapon," 386–89.

140. See Wright, "Blood of Abel," 9.

141. See Schwartz, "Theogony 175," 177–80.

142. Ackerman and Gisler, *Lexicon Iconographicum*, 7/2, 553. See also a depiction of Silvanus holding a distinctive "jawbone"-shaped sickle or pruning instrument in a second-century C.E. mosaic from the *mithraeum* in Ostia, illustrated as fig. 120 in Deckers, "Constantin und Christus," 279.

143. See Mellinkoff, *Outcasts*, 1, 149–50.

144. See van Henten and Abusch, "The Depiction of Jews," 271–310; Frankfurter, *Religion in Roman Egypt*, 112–14; see also Schäfer, *Judeophobia*, 56–62; and Borgeaud, "Moïse, son Âne et les Typhoniens," 121–24.

145. See Mellinkoff, *Outcasts*, 1, 47, 145–57.

146. See Mellinkoff, *Outcasts*, 1, 134 n. 84, 2, fig. VI.50; also Mellinkoff, *Mark of Cain*, 57–80.

147. See Broderick, "Metatexuality," 389, 391.

148. On the catechetical possibilities, see Day, "Influence of the Catechetical *Narratio*," 51–62; see also Hall, "The Old English Epic," 185–208. In personal correspondence on this topic, Michelle Brown has suggested that the instrument of Abel's murder may have been associated in the minds of the monks of Canterbury, where Claudius B.iv was likely created, with the martyrdom in 1012 of St. Alphege (Ælfheah), archbishop of Canterbury, who was pelted to death with "bones and the heads of cattle" (Swanton, *The Anglo-Saxon Chronicle* [E version], 142) by a band of marauding Vikings angry at Ælfheah's refusal to pay ransom for himself and some other captives.

149. See von Erffa, *Ikonologie*, 1, 429–31. On the concept of giants in general in the medieval realm, see Cohen, *Of Giants*. With specific reference to the representation of the giants in Claudius B.iv, see Mittman, "'In those days,'" 237–61.

150. Gameson, *Role of Art*, 170.

151. See Henderson, *Studies*, 1, 79.

152. Dodwell and Clemoes, *Hexateuch*, 66.

153. See Kerenyi, *Gods of the Greeks*, 28–30.

154. Colson and Whitaker, *Philo*, 2, *De gigantibus* (13, 58–61), 475; See also Philo's remarks in Marcus, *Philo Supplement*, 1, *Questions and Answers on Genesis* (1, 92), 60–61.

155. Colson and Whitaker, *Philo*, 2, *De gigantibus* (1, 58–61), 475.

156. Ibid.

157. Ibid.; emphasis mine.

158. Ibid.

159. Ibid.

160. See Newman, "Ancient Exegesis," 24–25.

161. See Hendel, "Of Demigods," 14.

162. Newman, "Ancient Exegesis," 24.

163. See Weitzmann and Bernabò, *Byzantine Octateuchs*, 321–22; see also Bernabò, *Pseudepigraphical Images*, 8–12.

164. See, among others, Stichel, "Ausserkanonische Elemente," 159–81.

165. Described by Gollancz, *Caedmon Manuscript*, xlv; Ohlgren, "Guide," 139. On the theme of the importance of Noah in Anglo-Saxon literature and cultural history, see Anlezark, *Water and Fire*.

166. Ohlgren, "Guide," 139, notes the similarity between the two images.

167. Halos are frequently missing in the drawings of Claudius B.iv, an oversight of the artist, possibly meant to be filled in later; cf. fol. 14r.

168. Bergman, *Salerno*, 34; fol. 9r of the Roda Bible, Paris, Bibl. nat. lat. 6, cf. Neuss, *Katalanische*, fig. 8.

169. Bettini, *Mosaici*, pl. LVII.

170. Kracher, *Millstätter Genesis*, fol. 21; Al-Hamdani, "Genesis Scenes," 190.

171. Noah working alone in Junius 11 and Millstatt: Bergman, *Salerno*, fig. 8; Smyrna, fol. 19r; fig. 31 in Seraglio; fol. 57v, fig. 36 in Weitzmann and Bernabò, *Byzantine Octateuchs*.

172. Cope, "Caedmon Manuscript," 35 and n. 72.

173. Bergman, *Salerno*, 34.

174. Ibid., 33, nn. 56 and 57.

175. Ibid., 34 and n. 62; for San Marco, see Bettini, *Mosaici*, fig. LVIII.

176. Waetzoldt, *Kopien*, fig. 339.

177. Gollancz, *Caedmon Manuscript*, xlv; for the Bayeux image, see Stenton, *Bayeux Tapestry*, pl. 38.

178. Cope, "Caedmon Manuscript," 21, notes that on folio 57v of the Seraglio Octateuch the ark is shown as a ship's hull at the left but in the more traditional Early Christian form as a box at the right.

179. Vienna, Öst. Nat. Bibl. Cod. Vindob. theol. graec. 31, fol. 2; reproduced as pl. 4 in Gerstinger, *Wiener Genesis.*

180. Waetzoldt, *Kopien*, fig. 340.

181. The disembarkation in the mosaic cycle in the Capella Palatina in Palermo shows a ladder. For a convenient illustration, see fig. 5 in Gatch, "Noah's Raven"; Demus, *Mosaics of Norman Sicily*, pl. 31.

182. Al-Hamdani, "Genesis Scenes," 190 n. 30, cites the fifth- to sixth-century C.E. painting of the ark as a ship in the church of El-Bawit, Egypt. See also Lezzi, "L'Arche de Noé," 301–24.

183. Cope, "Caedmon Manuscript," 32. Among the twelfth-century examples are the ark in the mosaic cycle at Monreale, the Capella Palatina in Palermo, and the frescoes in the Abbey Church of Saint-Savin sur Gartempe, France.

184. Kendrick, *Late Saxon*, 105.

185. Cope, "Caedmon Manuscript," 11 and note 36; these dragon-headed vessels appear also in the first English copy of the Utrecht Psalter, London, British Library Harley MS 603, fols. 27v, 82v, 156v, 166.

186. Saxl, *Catalogue*, pl. LXVI, fig. 166.

187. Temple, *Anglo-Saxon Manuscripts*, 104.

188. Saxl, *Catalogue*, pl. LXVI. fig. 165.

189. I would like to thank John Plummer, formerly of the Pierpont Morgan Library, New York, for originally suggesting this idea to me.

190. Weitzmann, *Studies*, 46–48.

191. Bettini, *Mosaici*, pl. LVI.

192. Gatch, "Noah's Raven," 5–6.

193. Ibid., 11.

194. Ibid.

195. See Lezzi, "L'Arche de Noé," 301–24.

196. Illustrated as fig. 31 in Lesko, *Great Goddess*, 232. See also the double animal-prowed barque of Ammon from the Temple of Sethos I, Abydos (ca. 1300 B.C.E.), illustrated as fig. 176 in Teichmann, *Der Mensch*, 262.

197. As a pagan Roman festival, the Navigium Isidis survived into the fourth century C.E. and is recorded in the Calendar of Philocalus of 354. See Alföldi, "A Festival of Isis."

198. As remarked on by Gatch, "Noah's Raven," 9, nn. 44–46.

199. Contessa, "Noah's Ark," 257–70.

200. Dodwell and Clemoes, *Hexateuch*, 65–73; also Kauffmann, *Biblical Imagery*, 68.

201. Beginning with the groundbreaking studies of George Henderson, "Late-Antique Influences in Some English Medieval Illustrations of Genesis," *Journal of the Warburg and Courtauld Institutes* 25 (1962): 172–98; and "The Joshua Cycle in B.M. Cotton MS Claudius B.iv," *Journal of the British Archaeological Association*, 31 (1968): 38–39, reprinted in Henderson, *Studies*, 1, 76–110 and 184–215, respectively. In addition, the many relations between other Early Christian, Byzantine, and earlier medieval works brought forward by Thomas in his unpublished M.A. thesis, "Illustrationen," should be taken into account, as well as, most recently, Barnhouse, "Pictorial Responses," 87; also Withers, *Hexateuch*, 86–132. Particularly appropriate in this endeavor to discern sources, see Stahl, "Iconographic Sources," 245: "The utility of these manuscripts (meaning *comparanda*) to any discussion of models depends upon one's ability to read the contemporary style and to discount the artist's updating or mannerisms or the impact of other models." See also Stahl, *Picturing Kingship*, 89, 189. Speaking of the evolution of the illustrated Byzantine Octateuchs with respect to their relationship to earlier models, Massimo Bernabò, in Weitzmann and Bernabò, *Byzantine Octateuchs*, 311, remarks, "Over the course of the centuries the changes accumulated so considerably that it becomes impossible to get a clear picture of the archetype. *One can perceive it only at a distance, as if through a veil*" (emphasis mine). The so-called new art history does not like the concept of exemplar and copy, arising largely from fear of an overly literal, exaggerated image of the medieval artist as "servile" copyist. See, e.g., the remarks of Karkov, *Text and Picture*, 6–10, and esp. 16. See further my remarks on this issue in Broderick, "Metatextuality," 384–401.

202. See Weitzmann and Kessler, *Cotton Genesis*; see also Schubert, "Jüdische Vorlage," 1–10; Schubert, "Die Vertreibung," 174–80.

203. See Weitzmann and Bernabò, *Byzantine Octateuchs*, 32.

204. Schubert, "Egyptian Bondage," 31, 33, 36, 38, 42.

205. Dodwell and Clemoes, *Illustrated Hexateuch*, 65–73.

206. Ibid. On the importance of extrabiblical, "apocryphal" texts in Anglo-Saxon literary and homiletic culture, see Wright, "Old English Homilies," 43, where the author notes, "The recently revised and updated *SASLC* entries for the Apocrypha show just how liberally Anglo-Saxon authors availed themselves of these non-canonical writings."

207. Nordström, "Rabbinic Features," 187–90.

208. See Büchsel, "Die Schöpfungsmosaiken," 53–55, fig. 31.

209. Ibid.

210. See n. 89 above.

211. Dodwell and Clemoes, *Illustrated Hexateuch*, 70.

212. See my earlier remarks on this image and in particular the observation of Lucifer grasping his own mandorla from *inside* the frame in Broderick, "Some Attitudes," 31–42. More recently, see Withers, "Satan's Mandorla," 93–108.

213. See n. 138 above.

214. See Introduction, n. 10.

215. See Introduction, n. 20.

216. On the origin of this motif in the Oxford nativity, see Deshman, "Anglo-Saxon Art after Alfred," reprinted in Deshman, *Eye and Mind*, 19–20.

217. On this aspect of the motif, see Hermann, "Das Erste Bad," in n. 45 of Deshman, "Anglo-Saxon Art after Alfred," reprinted in Deshman, *Eye and Mind*.

218. For a full-color reproduction of the mosaic, see Bowersock, *Mosaics as History*, fig. 2.8 and pp. 39–40. On Bowersock's observation, 41, that the scene of Hermes holding the child Dionysus on his lap resembles the Christian image of the Virgin seated with the Christ Child on her lap, see Fossum, "Myth of the Eternal," 313–14 n. 33, where the author points out that the Paphos mosaic is fourth century C.E. in date and that it precedes any Christian images of the seated Virgin and Child. The implication is that the Christian image might have been modeled on this and other similar pagan images.

219. Kitzinger, "Hellenistic Heritage," 101–3.

220. Ibid., 102 n. 28. Here Kitzinger notes that a defective fragment of the Cotton Genesis illustrates the birth of Isaac, but that the miniature depicting the birth of Ishmael is lost altogether.

221. On the San Marco mosaics and various iconographic connections, including the Cotton Genesis, among others, see most recently, Büchsel et al., *Atrium of San Marco*.

222. See chapter 3, note 28, below.

223. Kitzinger, "Hellenistic Heritage," 102.

224. Ibid., fig. 4.

225. An earlier "First Bath" motif occurs on folio 57r of Claudius B.iv associated with the birth of Tamar's twin sons, Pharez and Zarah (Gen. 38:27–30).

226. See Weitzmann and Bernabò, *Byzantine Octateuchs*, 1, 144–45, 2, figs. 596–98. Although Bernabò, *Byzantine Octateuchs*, 1, 307–8, has suggested that the motif of the first bath is possibly Christian derived from representations of the birth of the Virgin and may have been introduced only in the later examples. See also Bernabò, *Byzantine Octateuchs*, 1, 3, on the date of the putative exemplar: "But other manuscripts whose miniatures are connected with the Octateuch recension strongly indicate that the Octateuch cycle existed before the eleventh century, the period in which the oldest Octateuchs, Vat. 747 (Vatican City, Biblioteca Apostolica Vaticana, Vat. Gr. 747) and Florence (Florence, Biblioteca Medicea Laurenziana, *Plut. VI.5*) were produced."

227. On the Dura-Europos and later Christian medieval images, see Gutmann, "Dura Europos Synagogue Paintings," 25–27, figs. 1 and 2, where the "basket" is rendered as a box-shaped chest.

228. For Egyptian "bundle rafts" made of papyrus stalks bound together, see McGrail, *Boats of the World*, 16, 20–22, and fig. 2.8, a drawing after a wall painting showing a figure tightening the lashings of a bundle raft bound at the prow and stern as in the Claudius B.iv image (fol. 75r). For the Palestrina mosaic, see Meyboom, *Nile Mosaic of Palestrina*; also La Malfa, "Reassessing the Renaissance," 267–72.

229. Interestingly, the pictorial narrative of the two scenes at the top of folio 75r progresses from right to left with the scene of Moses's first bath at the right followed by Moses's mother, Jochebed, placing him in a very confusingly drawn "basket" at the left. The narrative resumes at the bottom of the folio running from left to right. Pharaoh's daughter

who discovers Moses in his basket is not named in the Bible, but Jewish legend (known to Josephus and others) had given her the name "Thermuth" or "Thermuthis." On the subject of her name, see Flusser, "The Goddess Thermuthis," 217–33. On the inscription of the name "Thermuth" on folio 75r by a later twelfth-century commentator, see Doane and Stoneman, *Purloined Letters*, 116.

THREE "And there arose no more a prophet since in Israel like unto Moses . . ."

The chapter title is a quotation from Deuteronomy 34:10.

1. The bibliography on the figure of Moses is, of course, enormous. Of notable interest among a number of more recent studies are Feldman, *Philo's Portrayal*; Borgeaud et al., eds., *Interprétations de Moïse*; Graupner and Wolter, eds., *Moses*; Otto and Assmann, eds., *Moses: Ägypten und das Alte Testament*; Assmann, *Moses the Egyptian*; Bloch, *Moses und der Mythos*; Römer, "Moses Outside the Torah"; Römer, "Moses the Royal Lawgiver"; and Römer, *La construction*. See also Ehrlich, "'Noughty' Moses: A Decade of Moses Scholarship 2000–2010," 93–110; Beal, ed., *Illuminating Moses*. In the specific realm of Anglo-Saxon studies, see Scheil, *Footsteps of Israel*; Zacher, *Rewriting the Old Testament*; Zacher, ed., *Imagining the Jew*. The continued contemporary popular interest in the figure of Moses and the Exodus story is indicated by the appeal of recent movies such as Ridley Scott's *Exodus: Gods and Kings* (2014). For a general, wide-ranging account of the history of the visualization of Moses, see Spronk, "Picture of Moses," 253–64.

2. Mellinkoff, "Round-Topped Tablets," 155–65.

3. On this motif, see Broderick, "Veil of Moses," 271–85. This image is discussed in more detail in chapter 5.

4. This image is discussed in more detail in chapter 7.

5. Barnhouse, "Text and Image," 201–3.

6. Doane and Stoneman, *Purloined Letters*, 351–58.

7. Both Heimann, "Moses-Darstellungen," 10–17, and Gameson, *Role of Art*, 104, 172, note Moses's great size in these images.

8. Barnhouse "Text and Image," 153–58.

9. Discussed in chapter 7.

10. Discussed in chapter 7.

11. See chapter 2 for a discussion of the "first bath" motif and the shape of Moses's basket.

12. For the text in question, see Crawford, *Heptateuch*, 285.

13. Dodwell and Clemoes, *Illustrated Hexateuch*, 73. Dodwell remarks on Moses's horns, "This is a device which could have been derived more easily from the Old English than from the Latin: the Vulgate (Exodus 34:29) says that when Moses came down from Mount Sinai his *face* was horned—a concept not easy to express visually; the Old English says nothing of his face but simply that he was horned ('he waes gehyrned')."

14. Mellinkoff, *Horned Moses*, 55–57; see also Feldman, "Moses the General," 1–17.

15. Keefer, "Assessing," esp. 114–21; see also Wyly, *Figures of Authority*, 219–71.

16. Mellinkoff, *Horned Moses*, e.g., figs. 28, 31, 32, 35.

17. See Hadley, "Royal Propaganda," 56, where the author notes, "This possibility is further suggested by the panther skin and bull's horn and ear which adorn the helmet on Seleucus' coins. These are unmistakable symbols of Dionysus, who, even before Alexander's lifetime was famed as the conqueror of Asia as far as India"; for more on horns and their Dionysian connections, see Smith, *Hellenistic Royal Portraits*, 40, 41 passim, esp. 41 n. 78, where the author lists various Greek epithets for Dionysus involving the Greek word *keras* (horn): "*Kerasphoros, dikeros, taurokeros*," etc. The Jews were often mistaken in the ancient world for followers of Dionysus; see van Kooten, "Moses/Musaeus/Mochos," 133–35; see also Seaford, *Dionysos*, 120–22.

18. An example from a private collection in Washington, DC, appears in Houghton, *Seleucid Coins*, pt. 1, vol. 2, pl. 82, #767.

19. Josephus, *Antiquities*, 3.329 passim. See also Feldman, *Jew and Gentile*, 269–85. On Moses the "warrior," see Feldman, *Philo's Portrayal*, 163–64, 242–43, 286; see also Römer, "Moses Outside the Torah," 9–11. Seidel, in her review of Mellinkoff's *Horned Moses*, 79–80, emphasizes Mellinkoff's association of Ælfric's use of the word *heretoga* to describe Moses as being appropriate to a "secular chieftain rather than a royal leader," thus reinforcing Mellinkoff's hypothesis that a horned helmet worn by "pagan warriors" in the Anglo-Saxon milieu would be a natural association for the artist of Claudius B.iv as an attribute of Moses. Neither Mellinkoff nor Seidel, however, seems aware that this idea of Moses as a military general (*strategos*) is not unique to Ælfric but is a major motif in the apologetics of Josephus and other Jewish writers who have been referred to here.

20. Mellinkoff, *Horned Moses*, 3, fig. 1.

21. According to Propp, "Skin of Moses' Face," 375–76 n. 1, the earliest source that interprets the Hebrew verb *qāran* in Exodus 34:29 to refer specifically to some kind of radiance of light, rather than "to become horned," is Pseudo-Philo (Hebrew original, first century C.E.); see Kisch, *Pseudo-Philo's Liber*, 147.

22. See Weitzmann, *Illustrations in Roll and Codex*. On the role of exemplar and copy in medieval art in general, see Kessler, "On the State of Medieval Art," 166–87. For an important counterargument, see Nees, "Originality of Early Medieval Artists," 77–110. See also the remarks of Alexander, *Medieval Illuminators*, 52 passim. In a review of Weitzmann's *Miniatures of the Sacra Parallela* titled "The School of Princeton and the Seventh Day of Creation," *University Publishing* (Summer 1980): 7–8, David Wright has this to say about an overly rigid and literalist understanding of Weitzmann's concepts: "The fault lies not with Weitzmann, but with some of his pupils, who have attempted to codify a doctrine and have baptized it with his name" (7). For a summary of recent critiques of Weitzmann's methodology, see Evangelatou, "Word and Image," 113–216, esp. 114 n., 117 nn. 29, 30.

23. Ulrich, *Kain und Abel*, 95–96.

24. See Breeze, "Cain's Jawbone," 433–36; also Kramer, "Les armes de Caïn," 165–87. Bischoff and Lapidge, *Biblical Commentaries*, state, "As matters stand, therefore, the present gloss (Milan, Biblioteca Ambrosiana, M. 79 sup.) preserving Anglo-Saxon biblical commentaries from the mid-seventh to mid-eighth centuries is the earliest explanation as yet discovered of the notion that Cain's murder-weapon was the jawbone of an ass" (388–89; see also 499).

25. Barb, "Cain's Murder-Weapon," 386–89.

26. Ulrich, *Kain und Abel*, 95–96. See also the article by Wildung, "Erschlagen der Feinde," cols. 14–17.

27. See Weitzmann and Kessler, *Cotton Genesis*, 25, 30–34. On the other hand, Büchsel, "Die Schöpfungsmosaiken," 51–57, has proposed a Latin/Roman milieu for the origin of the manuscript. For a critique of Büchsel's thesis of a Roman origin, see Bernabò's forthcoming review of Büchsel, Kessler, and Müller, *Das Atrium von San Marco*, to be published in *Byzantinistica: Rivista di studi bizantini e slavi*.

28. Few questions in the study of the history of art are as controversial as that concerning the possibility of direct connections between the art of Coptic Christian Egypt and that of early medieval northern Europe, especially the British Isles. See the remarks of Alexander, *Insular Manuscripts*, 18 n. 20. Opinions on this topic range from complete denial of any connections by scholars, such as du Bourguet "Art, Coptic, and Irish," 251–54, to specific affirmations of direct influence by scholars, such as Paulson, "Koptische und irische Kunst," 149–87; Bober, "Illumination of the Glazier Codex," 31–41; Ritner, "Egyptians in Ireland," 65–87; and especially a number of important articles by Martin Werner, most recently, "On the Origin of the Form," 98–110. In support of Coptic connections with Insular art, see also Brown, *Lindisfarne Gospels*, 273, 277, 287, 320–21; "Eastwardness of Things"; and "Imagining, Imaging and Experiencing," 49–86. Brown's very important recent research in the libraries of the Monastery of St. Catherine, Sinai, will demonstrate ongoing relations between the monastery and England into the eleventh century and beyond. Additional support for Coptic connections has also been advanced by Cramp, "Early Northumbrian Sculpture," 25, where, among other observations, she remarks, "The whole of Western Christendom was strongly influenced by East Christian culture in the early eighth century, and as has often been pointed out, England had a Cilician archbishop, Theodore of Tarsus, from 668 to 690." Literary connections between Coptic Egypt and early medieval Ireland have been explored by a number of scholars, among them, Dando, "Les Gnostiques," 3–34; Stevenson, "Ascent through the Heavens," 21–35; and, more recently, Carey, "The Sun's Night Journey," 14–34, where the author suggests that Spain may have been the conduit for much of Ireland's early apocryphal literature, an idea advanced earlier by Dumville, "Biblical Apocrypha," 299–338.

29. See Doresse, *Secret Books*; Doresse, *Des hiéroglyphs*; see also Robinson, *Nag Hammadi Library*. Birger A. Pearson begins his essay, "Earliest Christianity in Egypt: Some Observations," 132, with the following statement: "'The obscurity that veils the early history of the Church in Egypt that does not lift until the beginning of the third century constitutes a conspicuous challenge to the historian of primitive Christianity. . . .' [W]ith these words, Colin H. Roberts, one of the most prominent papyrologists of our time, opens a groundbreaking study of early Christianity in Egypt, *Manuscript, Society, and Belief in Early Christian Egypt*.

30. Robinson, *Nag Hammadi Library*.

31. Vikan, "Joseph Iconography," 99–108.

32. See Brown, "The Eastwardness of Things"; and Brown, "Imagining, Imaging and Experiencing."

33. Heimann, "Three Illustrations," 39–59.

34. Büchsel, "Schöpfungmosaiken," 29–80, proposes that the so-called Cotton Genesis manuscript (London, British Library Cotton MS Otho B.vi), with its Greek Septuagint text, was actually created in Rome rather than the Greek/Egyptian milieu proposed most famously by Weitzmann and Kessler. See his more recent remarks in Büchsel, "Theologie," 95–130. On this question, see Kessler, "Traces," 189–90. See also Lowden, "Concerning the Cotton Genesis," 40–53, regarding the nature of the tradition of an illustrated text of Genesis alone.

FOUR "...and he knew not that his face was horned..."

The chapter title quotation is from Exodus 34:29 (Douay-Rheims).

1. For the most recent summary of the debate and its relevant literature, see Dozeman, "Masking Moses," 21–45; see also Sanders, "Old Light," 400–406; Süring, *Horn-Motif*, 422–32; and especially Medjuck, "Exodus 34:29–35." In the large body of literature on the subject of Moses and his putative "horns," opinions, as might be expected, are often quite divergent and sometimes follow sectarian lines in that, in general, many "modern" students of the subject are uncomfortable with the generally negative associations with horned figures in medieval, Renaissance, and modern Western culture. So there is a tendency in some of the literature to play down, explain away, or characterize as a mistake Jerome's choice of the word *cornuta* (horned) to describe the condition of Moses's face at Exodus 34:29. On the other hand, some scholars of religious studies, such as Crispin H. T. Fletcher-Louis, following the lead of ancient Near East scholars, are quite emphatic about accepting that Jerome's understanding of the text to mean "horned" is correct. In his study, *All the Glory of Adam*, 6, Fletcher-Louis states that "upon his descent from Sinai Moses' face has received the horns that mark him out as a divine being in the iconography of the ancient Near East." In a footnote to this statement (p. 6, n. 6), Fletcher-Louis refers to the work of Nicholas Wyatt, "Degrees of Divinity," and remarks about Moses receiving "horns" that "here Wyatt 1999, 871–73, states what should have been obvious long ago." Other scholars have also emphasized the ancient Near Eastern context of the relationships of horns to divinity and royal power. See, e.g., Niehaus, *God at Sinai*, 325–27; Mathews, *Royal Motifs*.

Nevertheless, as Philo makes no mention of horns with respect to Exodus 34:29, Louis Feldman, the foremost contemporary Philo scholar, passes over the issue in his magisterial study, *Philo's Portrayal of Moses*. Thomas Römer, on the other hand, in his inaugural lecture at the Collège de France in 2009 (available at www.college-de-france.fr/site/en-news /Thomas-Romer-s-Inaugural-Lecture.htm), asserts, "It therefore seems that Jerome's translation was right and that it ought to be rehabilitated, to the detriment of the Greek and Syriac versions, and of the traditional Jewish and Christian interpretations." Nonetheless, one still encounters statements, such as that by Harvey, "Vulgate and Other Latin Translations," 454, who writes of Jerome, "Occasionally, moreover, his less than perfect knowledge of Hebrew produced curiosities. Famously, at Exodus 34:29–35, Moses' face is described as 'radiant.' Jerome misunderstood the verb *qāran* (to radiate light) as the noun *qeren* (horn). Jerome's Moses is thus *cornuta*, 'horned.'"

2. See *The Holy Bible*, translated from the Latin Vulgate, diligently compared with the Hebrew, Greek, and other editions in diverse languages, the Old Testament, first published by the English College at Douay, 1609 (Baltimore, MD, 1899); Exodus 34.29, 100.

3. See *The Holy Bible*, containing the Old and New Testaments, Authorized King James Version (New York, 1909); Exod. 34:29, 117.

4. See *Biblia Sacra iuxta Latinam Vulgatam Versionem ad codicum fidem*, iussu Pii PP.XI, cura et studio monachorum Sancti Benedicti Commissionis, pontificae a Pio PP.X institutae sodalium praeside Aidan Gasquet, S.R.E. Cardinale edita, Rome, 1926, et seq., vol. 2 (Exodus and Leviticus), 1929, Exodus 34.29, 259. See also *Biblia sacra: Iuxta vulgatam versionem*, ed. Robert Weber and Roger Gryson et al. (Stuttgart: Deutsche Bibelgesellschaft, 2007); and *Nova Vulgata Bibliorum Sacrorum* edition (Vatican City: Libreria editrice vaticana, 1979).

5. With special reference to Claudius B.iv, see Marsden, "Wrestling with the Bible," 76–77. As Marsden presents the clearest explanation of the philological problem for the nonspecialist, I quote it here in its entirety:

> Characteristic of Semitic languages is the trilateral root, three consonants, which is the basis of most words. Onto this framework are added the appropriate vowels or affixes to form specific words (just as, on a rather simpler level, the consonantal structure R D in English can generate RiDe, RoDe, RiDer, RiD, ReD, RoD, RuDe, and so on). The problem is that, in Jerome's day, the vowels were not marked in scriptural manuscripts, the reader being left to supply the appropriate ones. In Exodus 34:29, Jerome will have been faced with a word written as the consonants QRN. This ought to have been read as QaRaN, 'ray', a derivative of a rare verb meaning 'to shine', but in fact it appears to have been read as QeRen, meaning 'horn'—hence Latin *cornuta*. However, Jerome was no fool and we know that he supplemented his own knowledge of Hebrew with guidance from rabbis. He had a great fondness for ingenious etymologizing, and in this case his interpretative rendering echoes one given by Aquila (an Italian converted first to Christianity and then to Judaism), c. 140, in a literal Greek version of scripture that he had made from the Hebrew. It is intended to glorify Moses, for horns were seen as 'the insignia of might and majesty.'

On the other hand, Alter, *Five Books of Moses*, 512, notes that the Hebrew verb *qāran* appears only once in the Bible (Exod. 34:29–35) and that the Aquila/Jerome translation of Moses's face being horned would be "a virtually impossible reading because horns grow from the head, not from the skin of the face." He goes on to say, "The notion of divine radiance enveloping the head or face of a god, a king or a priest appears in numerous Mesopotamian texts, and so would probably have been a familiar idea to the ancient Hebrew audience." For an example in Mesopotamian art of a deity with rays of fiery light radiating from the skin of his face, see Frankfort, *Ancient Orient*, 113, fig. 122, a terra-cotta relief from the Iraq Museum, Baghdad; Kugel, *Traditions*, 727–29, presents a broader view. Sasson, "Bovine Symbolism," 380–87, stresses the understanding of *qāran* as "to be (or become) horned."

6. Aquila, a second-century C.E. proselyte to Judaism, produced an extremely literal translation of the Jewish scriptures into Greek in contrast to the earlier Septuagint (LXX) of the third century B.C.E., which had been utilized by Christians. On Aquila and his

translation, see Medjuck, "Exodus 34:29–35," 79–85, where a number of difficulties with respect to the text of Aquila at Exodus 34:29 are discussed. See also de Lange, "Jewish Greek Bible," 56–68.

7. Kedar, "Latin Translations," 317. On Jerome as a translator and his methods, see Kamesar, "Jerome," 653–75. As Medjuck, "Exodus 34:29–35," 90, points out, there is currently no Old Latin (i.e., *Vetus Latina*) version of Exodus 34:29–35 available. As Medjuck, 89, also notes, the *Vetus Latina* versions, of which there are several, are translations made from the Septuagint and not from the Hebrew Bible itself.

8. Mellinkoff, *Horned Moses*; see also Mellinkoff, "More about the Horned Moses," 184–98. Of earlier writers cited by Mellinkoff in her bibliography, Cohn, "Horns of Moses," 220–26, stands out as particularly perspicacious in terms of possible sources and analogues.

9. Quoted in Mellinkoff, *Horned Moses*, 77–78: S. Hieronymi Presbyteri Opera, *Commentariorum in Hiezechielem*, in *Corpus Christianorum*, Series Latina, 75, Turnholti 1964, 557, lines 262–64. Propp, "Skin of Moses' Face," 383, calls attention to the fact that "the Bible speaks of the *skin* of Moses' *face*, while we would rather expect the *head* or *forehead* to sprout horns" (original emphasis).

10. See Kasher, "Mythological Figure of Moses," 25.

11. See the comprehensive article by Korol, "Horn I," cols. 524–73.

12. Ibid., col. 548. English translation from Miller, *Ovid in Six Volumes*, 4, 405–9; see also Galinsky, "The Cipus Episode," 181–91.

13. *Letter 22:30—To Eustochium*, in Page and Capps, *Select Letters*, 126.

14. On "tauroform" Dionysos, see the article by Waser, "Tauros," cols 145–47; for "tauroform" Zeus, see cols 148–49. On Dionysos Zagreus, see the relevant article in Wissowa et al., *Paulys Realencyclopädie*, 18, cols. 2244–46; on Dionysos Zagreus in particular, see Rouse, *Nonnos: Dionysiaca*, 1: xv–xvi, 229; and 6, 225; 9, 305; see also the article by Dubois, "Zagreus," in Daremberg and Saglio, *Dictionnaire*, 5, 1034–37; for images of *Dionysos tauromorphos*, see Ackerman and Gisler, *Lexicon Iconographicum*, 3/1, 440–41, fig. 158a. See also Palmer, "Horns of Moses," 284–85, for Apollo Karnaios, who was "the horned, *i.e.* rayed, sun-god; the hind of Keryneia with golden horns was the dawn." The Ptolemies, beginning with Alexander the Great shown posthumously with the downward curving ram's horns of Zeus Ammon, also adopted horns as an emblem of sacral kingship; see an illustration of coins issued by Lysimachus, ca. 300 B.C.E., in Mellinkoff, *Horned Moses*, fig. 1. See Wheeler, "Moses or Alexander?," 191–215. On horns in the ancient Greco-Roman tradition in general and their relationship to ancient Judaism, see also Goodenough, *Jewish Symbols*, 7, 14–28. For an overview of various understandings of horns in a biblical context among early Christian writers, including Jerome, St. Ambrose, and Verecundus Iuncensis, see Nosarti, "Some Remarks," 47–48.

15. On the general concept in Western Christian tradition that the Devil has hooves and horns, see Kulik, "How the Devil Got His Hooves," 195–229.

16. Translation by Forbes, *Firmicus Maternus*, 90–92 (emphasis mine); see the Latin text edited by Ziegler, *De errore profanarum*, 68–69. It is interesting in this connection that Firmicus seems to equate horns with glory as he rhetorically addresses the Devil asking him where he is going to get such "adornment" and "glory" for his "maculate" face.

17. See, e.g., the reason advanced by Tsevat, "Skin of His Face" (in Hebrew), 257 (English summary): "The second appendix asks why Jerome, against his better knowledge and against 2 Cor. 3.7, sided with Aquila, who introduced the image of the horned Moses. A possible answer is that Jerome's opposition, as a translator of the Bible, to St. Augustine made him choose a non-septuagintal interpretation, be its authenticity ever so shaky."

18. Mellinkoff, *Horned Moses*, 2.

19. The reference to *two* "horns" on Moses's head in Claudius B.iv as being the first extant example of this motif is by way of differentiation, as an image of Moses with *one* horn emerging from his forehead is seen at the lower left of folio 89v of the *earlier* tenth-century Uta Codex (Munich, Bayerische Staatsbibliothek MS Clm 13601), as noted by Cohen, *Uta Codex*, 126–28. This example, however, had been noted already by Mellinkoff, "More about Horned Moses," 186, fig. 4. An interesting possible explanation for this unique one-horned Moses might be related to the understanding of Artapanus's equation of Moses with the Egyptian god Thoth/Hermes, discussed above; there are a number of visual examples of late Egypto-Roman bronze sculptures depicting Hermes with a single, hornlike projection on his head referred to as the "plume of Thoth." See fig. 13 in Bugarski-Mesdjian, "Traces d'Égypte," 311.

20. See Propp, "Skin of Moses' Face," 383; also Alter, *Five Books of Moses*, 512.

21. Mellinkoff, *Horned Moses*, 6 and fig. 7. These medieval images, for example, fig. 6 showing Moses receiving the Law in a sixth-century C.E. mosaic in the Church of San Vitale, Ravenna, could generally be said to be derived ultimately from earlier "pagan" images of a radiant Apollo Helios. This imagery had already been adopted for certain Egyptian deities in Roman Egypt, as seen on a carved stone relief representing the god Sobek in human form with solar rays and a halo behind his head, now in the Egyptian Museum, Cairo; fig. 26.5 in Riggs, *Oxford Handbook of Roman Egypt*, 451. For a good example of a radiant Apollo Helios depicted with a *Strahlenkranz*, see the second- to third-century C.E. relief in the Louvre illustrated as fig. 142.2 in Beck and Bol, *Spätantike*, 536. Dionysos is depicted with rays emerging from his forehead on an Egyptian textile of the fifth to sixth century C.E. in the Museum of Fine Arts, Boston; item 123 in Weitzmann, *Age of Spirituality*, 144. The multiplicity of rays in these images brings up an interesting theoretical question: if the Vulgate text states at Exodus 34:29 that Moses did not know that his *face* "was horned" (*cornuta esset*), while the Septuagint version of the same passage states that the *skin* of his face was "glorified" (Medjuck, *Exodus*, 77–78), how do we know how many of these "horns" there were? The later images of a two-horned Moses, such as that on folio 105v of Claudius B.iv, have induced us to think unquestioningly that that is what was meant by the phrase "was horned." In fact, there might have been multiple "horns," like the creatures described in the Book of Daniel or the Apocalypse. The minds of a more pious age than ours came up with a similar query. In "Horns of Moses," *Congregational Magazine*, n.s., 9 (1845): 25, the author quotes Adam Clark, author of a well-known biblical commentary of the day, "'But we might naturally ask,' says Dr. Adam Clarke, 'while they were indulging themselves in such fancies (speaking of Jerome's Vulgate), why only *two* horns? For it is very likely that there were *hundreds* of these radiations proceeding at once from the face of Moses." This perception only confirms that the specific *visual* choice of two horns of a specific shape on the head of

Moses on folio 105v of Claudius B.iv is in fact that, a choice that was either an original creation of the Anglo-Saxon artist of the manuscript or taken over from some earlier exemplar or model the creator or creators of which had themselves chosen this specific type of two-horned representation, itself based on an understanding that *horns* are in fact what is being described in the Vulgate text.

22. See Beard, "Triumph of the Absurd," 27, where the author describes a triumphant Roman general (the *triumphator*) riding in a procession, "dressed, more or less, in the costume of the cult image of Jupiter Optimus Maximus, his *face painted red* [emphasis mine] just like the statue." Wheeler, "Moses or Alexander?," 212 n. 82, states that several manuscript sources of the Septuagint say that the skin of Moses's face, rather than "shining," changed colors.

23. While Mellinkoff, *Horned Moses*, 15 n. 18, and others have suggested that Claudius B.iv is the work of several artists, Withers, *Hexateuch*, 21 n. 9, suggests that the illustrations are the work of a single artist.

24. Mellinkoff, *Horned Moses*, 13, 17, 57 passim.

25. Ibid., 26–27.

26. Ibid., 26–27, 56–57, 138–40.

27. See Frank, "Invention of the Viking Horned Helmet," 199ff.; Graham-Campbell, *Viking Artefacts*, #271, reproducing "the most complete Viking Period helmet."

28. Illustrated in Mellinkoff, *Horned Moses*, fig. 31.

29. See an example illustrated as fig. 7 in Broderick, "Veil of Moses," 279.

30. Mellinkoff, *Horned Moses*, figs. 28, 29, 32, 35.

31. Moses's horns are depicted in a variety of ways on folios 105v, 107r, 107v, 108v, 110v, 111r, 111v, 112r, 113v, 115r, 115v, 116v, 117r, 118v, 119v, 120r, 121r, 121v, 122r, 122v, 123r, 123v, 124r, 124v, 125r, 128r, 136v, 137r, 138v, 139v.

32. See Gombrich, *Aby Warburg*, 13–14 n. 1.

33. For this portion of the discussion, see especially the full-color illustrations of Claudius B.iv on the British Library website, http://www.bl.uk/manuscripts/. Or simply Google Claudius B.iv. The high-definition images can be greatly enlarged, enabling one to view specific details of the drawings.

34. These horns are drawn without benefit of a headband, as if they were actually growing out of Moses's head, on folios 78v, 79r, and 79v, before Moses is actually said to have become "horned" on folio 105r. These later "doodles," which are found elsewhere in the manuscript, are described by Dodwell and Clemoes, *Illustrated Hexateuch*, 61, as the work of a person "more meddlesome than artistic" who succeeded "by his childish efforts . . . to bodge up the pictures," leaving "his unhappy mark on almost all the folios between 70v and 128r." In addition to the principal original Anglo-Saxon artist(s) of Claudius B.iv, another, very gifted Anglo-Saxon artist identified as Artist "G" by Withers, *Hexateuch*, 74–76, and noted earlier by Dodwell and Clemoes, *Illustrated Hexateuch*, 60, has "overdrawn" in a stylish manner some of the unfinished images in Claudius B.iv, including a major image of the horned Moses on fol. 113v.

35. The image of Moses with the second type of horns (i.e., with hair between them and the horns rising from behind a headband) on folio 136v (figs. 11, 18) appears to be the

work of a different artist when compared to the image on folio 105v, where the first type of horns appears, an artist whose style seems more emphatic, indeed almost "sculptural" in its emphasis on mass and coloristic "modeling." The two images of Moses on folio 136v occur after a solid run of text, from folios 128v to 136r. On this phenomenon of large chunks of unillustrated text, see Withers, *Hexateuch*, 32–33. Perhaps this large break at folio 128v and the different configuration of Moses's horns at the end of it (fol. 136v) might indicate a change in the exemplar that the different artist was consulting. Also, Heimann, in her review of Mellinkoff, *Horned Moses*, 285, remarks on the erratic and often confused renderings in the manuscript as a whole that make definitive assessments of what is being represented quite difficult: "aber die Illustrationen in diesem Manuskript sind so uneinheitlich, so flüchtig gezeichnet und so grob und sorglos koloriert worden, dass sich keine sicheren Schlüsse ziehen lassen."

36. Mellinkoff, *Horned Moses*, 17.

37. Another distinctive feature of the representation of Moses in Claudius B.iv is that he is shown having long hair, in this instance and others, flowing down the back of his neck. The majority of medieval representations of Moses show him with short cropped hair. Two exceptions to this convention are the representations of Moses on folio 6v of the so-called Farfa Bible (Vatican City, Biblioteca Apostolica Vat. Lat. 5729) and on folio 49v of the Bible of San Paolo fuori le Mura, both illustrated in Mellinkoff, *Horned Moses*, figs. 11 and 25. Denis, "Le portrait," 62, remarks how Artapanus describes Moses as being "plein de dignité" and as having "une longue chevelure."

38. Mellinkoff, *Horned Moses*, 3.

39. Ibid., fig. 2.

40. Aldred, *Temple of Dendur*, fig. 16.

41. On the *atef* and other crown types, see Strauss, "Kronen," 3, cols. 811–16.

42. See Myśliwiec, *Royal Portraiture*, pl. XCVIII, d. passim, an excellent overview with numerous illustrations of a broad range of late dynastic crown types. For clear outline drawings of numerous late Egyptian crowns, see Vassilka, "The Pronaos," 948–51.

43. On the solar disc in Egyptian iconography, see Wildung, "Flügelsonne," in *Lexikon*, 2, 277–79. For the moon, see Helck, "Mond," in *Lexikon*, 4, 192–96.

44. Gmirkin, *Berossus*, 1–21. For criticism of some aspects of this theory, see the reviews by Wood, 28; Hillmer, 773–74; van Seters, 212–14; and Cook, 64, who emphasizes that the biblical narratives in Gmirkin's view must be seen in light of the events of the third century B.C.E., especially those of Alexander and his successors, the Ptolemies.

45. Gmirkin, *Berossus*, 240–56.

46. Ibid., 170–91.

47. Aejmelaeus, *On the Trail*, 295 passim. See also Joosten, "Interpretation," 52–62.

48. See Cazelles, "Mōšeh," 26–43.

49. On the issue in general, see Dozeman, *Commentary on Exodus*, 81–82; Cassuto, *Commentary on Exodus*, 20–21.

50. Griffiths, "Egyptian Derivation," 225–31; see also Edelman, "Taking the Torah," 17–20.

51. Gottlieb, "Will the Real Moses," 130.

52. Meeks, "Moses as God and King," 354–55. Philo also calls Moses a "divine man" (*theios aner*). On problematic aspects of this term, see Georgi, *Die Gegner des Paulus*, 147–51; also Holladay, *Theios Aner*, 190–232. Fletcher-Louis, *All the Glory of Adam*, esp. 6–8, makes a strong case for the "angelomorphism" of Moses. See also Litwa, "The Deification of Moses," 1–27. For another view of the "divinity" of Moses issue in Philo, see Feldman, *Philo's Portrayal*, 331–58.

53. Also Exodus 4:16, where God says to Moses, speaking of his brother Aaron, "thou (Moses) shalt be to him instead of God."

54. Meeks, "Moses as God and King," 355–57.

55. Ibid., 359; for text, translation, and commentary, see Holladay, *Fragments*, 2 [Poets]; see most recently Allen, "Ezekiel the Tragedian," 3–19; also van de Water, "Moses' Exaltation," questioning the traditional idea that Ezekiel's *Exagoge* is a pre-Christian example of Moses's ascension-exaltation; and Whitmarsh, "Pharaonic Alexandria," 41–48.

56. See the introduction and translation by Robertson in Charlesworth, *Old Testament Pseudepigrapha*, 2, 803–19. On Ezekiel and Philo, see Sterling, "From the Thick Marshes," 115–33.

57. Meeks, "Moses as God and King," 357–85, 361–64.

58. Ibid., 359. See also Charlesworth, *Old Testament Pseudepigrapha*, 83–85.

59. Meeks, "Moses as God and King," 361–62.

60. Ibid., 357 and n. 1.

61. See the introduction and translation by Collins in Charlesworth, *Old Testament Pseudepigrapha* 2, 889–903. In addition to the selected bibliography provided by Collins, see also on Artapanus, Holladay, *Fragments*, 1 [Historians]; Droge, *Homer or Moses?*, 25–35; Koskenniemi, "Greeks, Egyptians and Jews," 17–31; also Flusser and Amorai-Stark, "The Goddess Thermuthis," 217–33; and Kugler, "Hearing the Story," 67–80. Further on Polyhistor's work, see Hadas, *Hellenistic Culture*, 93–94; and more recently Adler, "Alexander Polyhistor's *Peri Ioudaiōn*," 225–40.

62. Humorously enough, Paul and Barnabas, as recounted in Acts 14:8–15, are subjected to a personal *interpretatio graeca*, when, having healed a lame man at Lystra, they are thought by the people to be gods, who call Barnabas Zeus (Jupiter) and Paul, Hermes (Mercury), "because he was the chief speaker." See Martin, "Gods or Ambassadors of God?," 152–56. And, of course, words such as *hermetic* and *hermeneutic* are derived from the Greek god Hermes, as an interpreter (*logon hermeneutikon*), and, in the case of Hermes Trismegistus, a master of occult knowledge. On the hermetic tradition in Egypt, see Fowden, *Egyptian Hermes*. On Moses as scribe and connections with Hermes in Artapanus, see Deutsch, *Guardians of the Gate*, 166–67.

63. See Gruen, *Heritage and Hellenism*, 156–57, for a current assessment of what to call Artapanus and his work. Of critical importance is Feldman, "Reshaping of Biblical Narrative," 60–79, where the author questions whether Artapanus and other writers in the Hellenistic ambit were actually Jewish at all (75). See also Tcherikover, *Hellenistic Civilization*, 527 n. 38, on the idea that not all Alexandrian Jewish literature is "apologetic." Gruen, *Diaspora*, takes a novel approach to the Artapanus "problem" by suggesting that Artapanus's extraordinary assertions about the Jewish origins of "sacrosanct" Egyptian institutions such

as *zoolatry* are in reality almost a kind of Groucho Marx–like tongue-in-cheek humor. Gruen, *Diaspora*, 212, concludes, "If these constructs afford a clue to the receptivity of diaspora readers, they suggest self-assurance and comfort in the Greek-speaking lands of the Mediterranean, and a secure confidence in their own traditions that allowed for manipulation, merriment, and mockery." Inowlocki, "Möise en Égypte," 5–16, provides further perspectives on the Artapanus "problem." See also Collins, "Artapanus Revisited," 59–68.

64. Collins, in Charlesworth, *Old Testament Pseudepigrapha* 2, 889.

65. Ibid., 892 n. 30. Speaking of Artapanus's work, Dalbert, in *Die Theologie*, 44, says "während bei Artapanus nichts anders zu finden ist als ein Gemisch von Historie, Legende, Glaubensüberlieferung und Phantasie."

66. Collins, in Charlesworth, *Old Testament Pseudepigrapha* 2, 891–92.

67. Ibid., 899. On Thoth and Thoth/Hermes, see Kurth, "Thoth."

68. See Holladay, *Theios Aner*, 229–32.

69. See Collins, in Charlesworth, *Old Testament Pseudepigrapha* 2, 898, and n.h & i, see Mussies, *"Interpretatio Judaica,"* 94–96, for an explanation of the relationship, based first of all on the similarity between the two names "Musaeus" and "Moyos." Tiede, *Charismatic Figure*, 152, refers to an Orphic tradition in which *Mousaios* is identified as the teacher of Orpheus, although normally the relationship is presented as the reverse. See Droge, *Homer or Moses?*, 17–19, for the substitution of the name "Moses" (Gk. Μωυσης) for the early Egyptian pharaoh "Mneves" (Μυευης) in the work of the third-century C.E. Christian apologist Pseudo-Justin. Later theological writers, such as Hugo Grotius in the seventeenth century, who associated Mneves with the horned Egyptian bull god Mnevis (*Annotationes in Vetus Testamentum* [Halle, 1775–76]), pursued a similar trajectory based on an orthographic resemblance between the two names. Thus Moses was associated with Mneves and by extension the horned solar bull deity Mnevis (= Egyptian Mer-wer). Grotius explains (*Caput* XXXIV) that rays of light coming from Moses's face at Exodus 34:29 rise in the shape of horns like the horns of the god Mnevis, quoting Ibn Ezra, the twelfth-century rabbi and exegete, as well as Pseudo-Justin, saying that this Mnevis is Mneves the pharaoh, who is actually Moses.

70. Collins, in Charlesworth, *Old Testament Pseudepigrapha* 2, 899.

71. Ibid., 893.

72. See the general introduction with notes on Alexander Polyhistor by Strugnell in Charlesworth, *Old Testament Pseuepigrapha* 2, 777–79; also Droge, *Homer*, 8–11 passim; Feldman, "Origen's *Contra Celsum*," 105–35; Bonnefoy, *Mythologies*, 2, 658–65. With specific reference to Moses in this regard, see Gager, *Moses in Greco-Roman Paganism*, 76–79 passim.

73. On this concept, see Pilhoffer, *Presbyteron Kreitton*, 2, 39. See Inowlocki, "Eusebius's Appropriation," 240–55; and Inowlocki, "Eusebius' Construction," 199, where the author describes Eusebius's work as a "performance of erudition." Grafton, *Christianity and the Transformation*, devotes a chapter to the topic "Eusebius at Caesarea: A Christian Impresario of the Codex" (178–232).

74. As quoted in Whittaker, *Tatian*, 73. The list includes Orpheus and Musaeus among this cohort. St. Augustine in the fourth to fifth century (*De civitate dei* XVIII, ch.

37, 39) says that Moses is more ancient than Orpheus, Linus, and Hermes/Trismegistus/ Thoth.

75. In his *Holy Treatise* or *Sacred Record* (*Hiera Anagraphe*), Euhemerus (ca. 300 B.C.E.) presented the concept of a number of supreme deities, such as Zeus, as deified human kings. See Droge, *Homer or Moses?*, 127–28; Mussies, "*Interpretatio Judaica*," 91; also Bonnefoy, *Mythologies*, 2, 666–68. On the importance of Euhemerism for early Christian apologetics, see the remarks of Forbes, *Firmicus Maternus*, 27–28. See also Cooke, "Euhemerism," 396–410.

76. Schapiro, *Late Antique*, 40–43, casts doubt on whether the biblical patriarch Joseph as depicted on the throne is actually meant to be understood as wearing the *modius*, the basket crown of the Alexandrian god Serapis, as a sign of his intervention on behalf of the Egyptians in averting famine, even though several early Christian writers, such as Firmicus Maternus and Tertullian, describe Joseph as such. Schapiro asks rhetorically, "Yet is it likely that Christians in the sixth century would have illustrated the conversion of an Old Testament patriarch into a pagan god?" (40). Such an objection, however, hardly seems valid in light of the appropriation of several pagan iconographies, such as those of Orpheus, Apollo Helios, or Hermes Criophoros for the image of Christ. See Matthews, *Clash of Gods;* and Finney, *Invisible God*, among other sources on this issue. Mussies, "Interpretatio Judaica of Sarapis," 196–97, is in agreement with Schapiro's interpretation that the object on Joseph's head on the Ravenna ivory throne is the imperial *modiolus* crown and not the *modius* of Serapis, even though no extant image of such a crown exists.

77. Firmicus Maternus, in his *De errore profanarum religionum* (Forbes, *Firmicus*), says, "After his (Joseph's) death the Egyptians reared temples to him . . . and they represented him with his head bearing the measure (*kalathos/modius*)." Tertullian (ca. 160–220) says in his *Ad Nationes*, in Roberts and Donaldson, *Ante-Nicene Fathers*, 3, 137: "They (the Egyptians) called him Serapis, from the turban which adorned his head. The peck-like shape of this turban marks the memory of his corn-provisioning; whilst evidence is given that the care of the supplies was all on his head." See also Höpfner, "*Fontes Historiae*," 2, 873. According to Lightfoot, "Apology of Ps.-Meliton," 85, this text, "a short work, extant only in Syriac, in a sixth- or seventh-century manuscript," is the earliest testimonium to the equation of Serapis and Joseph. It is worth recalling that Archbishop Theodore came from Cilicia and utilized Syriac sources in his exegetical commentaries; see Bischoff and Lapidge, *Biblical Commentaries*, 190–242.

78. See Thackery, *Jewish Antiquities*, 267.

79. In *Midrash Wayōshā* of the eleventh or twelfth century C.E., as cited by Hamilton, "La source d'un épisode," 130–31.

80. See Brunner-Traut, "Horn (als Symbol und Metaphor)," 3, cols. 9 and 10, "Götter (Horus, Osiris, Amun u.a.) werden zum 'Herrn' (oder 'Ersten') der Hörner, auch der König (als Stier) gilt als 'gehörnt' (*bwtj*)." See in this connection also Scolnic, "Moses and the Horns of Power," 575–76.

81. While the golden calf of Exodus 31:4 is illustrated on folio 102r of Claudius B.iv with horns, (1) the image itself looks as if it has been drawn over by someone at a later date (the Canterbury "doodler"), rendering it unreliable; (2) it is debatable whether a calf would

have such large horns; and (3) the horns of the calf as they are now do not look like those of Moses as represented on folio 105v (fig. 10). The way the calf in the Claudius B.iv illustration is positioned on a substantial podium facing in profile to the left looks very similar to a depiction of the standing Apis bull in a late Roman "Egyptianizing" fresco of the Main Tomb of the Great Catacomb at Kom el-Shoqafa, Alexandria, Egypt; see Venit, *Monumental Tombs*, figs. 114, 118. Nonetheless, there may be an exegetical idea in Moses being horned to emphasize his association with true divinity by his being "horned" with light, in contrast to the earthly, golden horns of the calf, an idea developed in some detail by Scolnic, "Moses," 577–78. This idea is also suggested by Sarna, *Exodus*, 221; see as well Gottlieb, "Will the Real Moses," 129–30. On the biblical motif of the Golden Calf, see Janzen, "The Character of the Calf," 597–609.

82. On this concept, see Stanwick, *Portraits of the Ptolomies*.

83. On the relationship of Augustus to the Egyptian pharaonic role and its visual representation, see Dundas, "Augustus and the Kingship of Egypt," 433–48.

84. Another important example of this phenomenon is the representation in numerous sculptural examples of Antinous, the favorite of the Roman Emperor Hadrian, in Egyptian attire, especially with the pharaonic *nemes* head covering—see the examples in Opper, *Hadrian*. Of particular interest is the janiform head of an Egyptianized Antinous and the Apis bull originally from the Serapaeum of Hadrian's Villa at Tivoli of the second century C.E., now in the Vatican, Museo Gregoriano Egizio (cf. www.museivaticani.va).

85. Gmirkin, *Berossus*, 217; see also Gmirkin, "Greek Evidence," 56–88; and in the same volume, Thompson and Wajdenbaum, "Introduction: Making Room for Japheth," 1–18. Römer, "Hebrew Bible and Greek Philosophy," 185–203, has brought forward some cautionary observations relative to the theory of Greek influences on the Hebrew Bible.

86. Gmirkin, *Berossus*, 215–21.

87. A statue of the falcon god Horus with a miniature Nectanebos II standing between his protective legs in the collection of the Metropolitan Museum of Art, New York (apparently only the second inscribed sculpture depicting the pharaoh's face), shows the figure wearing the traditional *nemes* headdress but without any horns. Interestingly, in various later versions of the so-called *Romance of Alexander* by Pseudo-Callisthenes, Nectanebos is described, for example, in a fifth-century C.E. Armenian version of the third-century Greek text as impersonating the Egyptian ram-horned god Ammon by donning the fleece of a ram, "together with the horns from its head," and subsequently mating with Olympias, wife of Philip of Macedon, thus fathering the future Alexander the Great, himself depicted in coins minted after his death with the downward-curving horns of Ammon. See Wolohajian, *Romance of Alexander*, 28.

88. For earlier scholarship on this text and its significance, see Dillery, "Aesop, Isis, and the Heliconian Muses," 268–80. For an English translation of the *Life*, see Daly, *Aesop without Morals*.

89. For an earlier general assessment of various aspects of this issue, see Kozodoy, "Origin of Early Christian," 34–35; Gutmann, *Illustrated Midrash*; Gutmann, "Dura Europos," 25–29; also Weitzmann and Kessler, *Frescoes of the Dura Synagogue*; Weitzmann and Bernabò, *Byzantine Octateuchs*, I.

90. See especially Weitzmann, "Zur Frage des Einflusses Jüdischer Bilderquellen auf die Illustrationen des Altes Testamentes," 401–15, reprinted in Weitzmann, *Studies in Classical.*

91. Gmirkin, *Berossus*, 217–21. Hadas, *Hellenistic Culture*, 84–98, compares the Jewish Hellenistic literature on Moses by Artapanus and others to the legends surrounding Alexander the Great in works like the Pseudo-Callisthenes so-called *Romance of Alexander.*

92. Mellinkoff, *Horned Moses*, pl. 1. Alexander the Great has also been represented, although in very few works, with the upright, but short, horns of Pan; see Fulińska, "The God Alexander," 132.

93. There is a flat-topped headdress in ancient Egyptian art of a type to be seen, for example, on the head of the striding figure at the center of the relief from Karnak illustrated here (fig. 7) and on the head of Amun in the painting from Tuna el-Gebel (fig. 26), although without the curl at the top and the tall stylized falcon feathers in this example, somewhat like the so-called red crown of Lower Egypt but without the vertical extension at the back of the red crown that is worn occasionally by royal and divine figures (King Tutankhamen wears such a headdress on a carved wooden image from his royal burial trove now in Cairo). Pharaoh might possibly have worn such a headdress, not to be confused with the blue, sometimes scaly *khepresh* military helmet/crown worn by various pharaohs, including Tutankhamen, in an exemplar that the artists of Claudius B.iv may have been consulting but not understanding the shape of which, may have left the space above their depictions of Pharaoh's head blank, or, as I suggested above, giving him a conventional medieval fleur-de-lis-type crown from time to time.

94. Mellinkoff, *Horned Moses*, 79.

95. See Gafni, "Antiochus IV Epiphanes," 203. Antiochus IV has often been associated, not without some dispute, in biblical exegesis with the "little horn" of Daniel 8:9. Interestingly, the Syriac (*Peshitta*) text of the Bible indeed inserts the actual name "Antiochus IV" in its text of Daniel 8:9.

96. On the concept of *synkatabasis*, see Dreyfus, "Divine Condescendence," 74–86.

97. See the remarks of Claire Gottlieb in her article "Will the Real Moses," esp. 129–30, "Now, since the people were so impressed with the horned deity represented by the golden calf, Yahweh had given him the one remaining characteristic by which his unique position would be recognized and respected not only by Pharaoh and by Aaron, but by the Israelites who still considered him only a man. He gave the man whom he spoke with "face-to-face" the horns of divinity, visual proof of Moses' singular status, making him equal in rank to a king or god in the eyes of all who beheld him."

98. See Strauss, "Kronen," 3, cols. 811–16. On the various meanings of the feathers on pharaonic crowns, see Nilsson, *Crown of Arsinoë II*, 24–30.

99. This head covering is discussed by Mellinkoff in "Round Cap-Shaped Hats," 155–65.

100. It is, of course, not known what the biblical priestly miter actually looked like as there is no visual record and various ancient verbal descriptions are contradictory. It is often generally assumed that the high priest's miter was in the form of some kind of wound turban. Mellinkoff, *Horned Moses*, 103, briefly discusses the biblical reference to a miter stipulated

for Aaron as high priest but does not discuss its representation on folio 107v of Claudius B.iv. In her later, 1973 article, "The Round Cap-Shaped Hats," Mellinkoff mentions Aaron's distinctive head covering but does not refer to it as a priestly miter. On the priestly miter, see Eisenstein,"Miter," 622–23; see also Revel-Neher, "Problèmes d'iconographie," 50–65. In a separate chapter on the development of the Christian bishop's miter with its "horns," Mellinkoff, *Horned Moses*, 94–106, explores a number of possible literary, exegetical connections of these "horns" with the horns of Moses, but these connections do not seem to predate the early twelfth century. McCulloch's review, 47, makes the interesting observation that in the Latin *Physiologus* (Greek original, possibly third-fourth century C.E.) the two horns of the antelope (or ibex) are already interpreted as the two Testaments (Old and New), which predates Isidore of Seville's (seventh century C.E.) association of the two Testaments with horns in his *Quaestiones in Vetus Testamentum*. Both St. Ambrose and Verecundus Iuncensis had interpreted horns as symbols of the Old and New Testaments; see Nosarti, "Some Remarks," 47. See also Brown, "Paten and Purpose," 162–67, on the two horns of the ibex in the *Physiologus*. Mellinkoff, *Horned Moses*, 83, suggested that "Isidore's reference to the horns of the two Testaments was an obtuse, if awkward, allusion to the horned face of Moses in the Vulgate text."

101. Moses is the first to penetrate the sacred mystery on Mount Sinai, speaking to God himself "face-to-face" (Exod. 33:11; Deut. 34:10). On the priesthood of Moses, see Lierman, *New Testament Moses*, 65–76; see most recently, Feldman, *Philo's Portrayal*, 291–96.

102. Chazelle, "Ceolfrid's Gift," 135 and fig. 4 refers to fol. 4/Vr. See Bruce-Mitford, "Art of the *Codex Amiatinus*," 1–25, pls A–D, I–XX, where the author mentions the "tallith" cloth and jeweled breastplate. Further on Amiatinus, see Corsano, "First Quire," 3–34; Fischer, "Codex Amiatinus," 57ff. On the Ezra image, see Marsden, "Job in His Place," 3–15; O'Reilly, "Library of Scripture," 4–6, 18–26; Meyvaert, "Bede, Cassiodorus," 827–83; and most recently Meyvaert, "The Date of Bede's *In Ezram*," 1123–25.

103. Bruce-Mitford, "Art of the *Codex Amiatinus*," 13; also Alexander, *Insular Manuscripts*, 33.

104. See Müller, "Kopftuch," 3, cols. 693–94. A good example of the *khat* head covering can be seen on the head of a standing figure of the deceased from the Great Catacomb of Kom el-Shoqafa in Alexandria, Egypt. See Venit, *Monumental Tombs*, 138, fig. 116.

105. See Cohen, *Uta Codex*, fig. 27.

106. For an example of such an amulet, see Roehrig, *Hatshepsut*, 145; and the Metropolitan Museum of Art, New York, website. A third-century B.C.E. Greek marble statuette of Dionysos in the collection of the Metropolitan Museum of Art (Acc. no. 59.11.2) shows the god wearing a panther skin secured by a knotted sash identifying him, along with his goatskin cape, as Dionysos Melanaigis ("of the Black Goatskin"), also illustrated on the Metropolitan Museum website.

107. Mellinkoff, *Horned Moses*, 33–34, with a hand-drawn illustration of this centrally parted hairstyle. Mellinkoff also notes that Moses himself in the upper portion of the illustration on folio 105v, before coming down from the mountain to address the Israelites gathered before him, also displays this conventionalized hairstyle.

108. Mellinkoff, *Horned Moses*, 13, and later, p. 33: "First, and most important, as noted earlier, although the horns of Moses vary to some extent in their design throughout the manuscript, they are always represented as horns on a kind of hat or headdress and not as organic growths."

109. While the configuration of elements around Moses's head in Claudius B.iv, beginning on folio 105v (fig. 10), can no longer be understood as horns on some kind of coif or cap, interestingly, the only image of a horned cap, or miter, even remotely resembling what is to be seen on Moses's head on folio 105v is to be found on the head of the Nubian eparch, or king, in a fragmentary painting on the wall of the so-called Rivergate Church at Faras, Nubia, possibly of twelfth-century C.E. or earlier date. See Griffith, "Oxford Excavations," 77–79, pl. LXI. See also Clarke, *Christian Antiquities*, 44, where the author, describing a fragment of a wall painting at Old Dongola, Nubia, of uncertain date, says, "On the wall of the centre chamber, nearest to the stairs, has been found beneath the plaster a piece of a painting which may be intended for Moses as a pair of horns project from the head." This representation, however, might also be of the Nubian eparch.

110. See Temple, *Anglo-Saxon Manuscripts*, 44–45. On this important manuscript and its origins, see most recently Orchard, *Leofric Missal.*

111. Temple, *Anglo-Saxon Manuscripts*, 100–101. For a detailed discussion of the Moses image, see Harris, "Marginal Drawings," 427–34.

112. According to Propp, "Skin of Moses' Face," 375–76 n. 1, the earliest source that interprets the Hebrew verb *qāran* in Exodus 34:29, 30, and 35 to refer specifically to some kind of radiance of light, rather than "to become horned," is Pseudo-Philo (Hebrew original, first century C.E.); see Kisch, *Pseudo-Philo's Liber*, 147. A "radiant" or "shining" face is attributed to a number of biblical figures, especially Noah, in particular in extrabiblical, so-called apocryphal sources. See Orlov, "Noah's Younger Brother," 16; and Fletcher-Louis, *All the Glory of Adam*, 33ff. In the Egyptian Book of the Dead, the scribe/god Thoth is described as "whose head is shining, he is the phallus of Osiris[,] . . . he is the phallus of Re"; see von Dassow, *Egyptian Book of the Dead*, 102.

113. For further visual implications of the word *doxa* only briefly referring to its use in the Septuagint at Exodus 34:29, see Loerke, "Observations," 15–22.

114. Medjuck, "Exodus 34:29," 47.

115. See Haran, "Shining of Moses' Face," 169 n.7. See also Matthews, *Royal Motifs*, for discussion of the relationship of the biblical depiction of Moses to ancient Near Eastern sources.

116. See Philpot, "Shining Face of Moses," 95–98.

117. Heimann, "Three Illustrations," 39–43, 50, pl. 7a, 7c. Jordan, "Demonic Elements," 293, suggested that Heimann's interpretation of the six dragonlike demons emerging from the head of Mors as the six sons of Death mentioned in the early apocryphal Coptic text, *The Resurrection of Christ*, was not possible as, in his opinion, there is no evidence that the work was ever known in the West. This has now been refuted by evidence presented by Wright in Biggs, *Sources*, 28–29. Deshman, *Eye and Mind*, 73–74, had previously agreed with Heimann's suggestion of possible Egyptian sources for the Leofric Mors.

118. Liuzza, *Anglo-Saxon Prognostics*, 1; see also Chardonnens, *Anglo-Saxon Prognostics*, 330–40, and esp. 333, where it is suggested that the term *Egyptian Days*, whose exact origin remains unclear, refers to days on which the people of Egypt are cursed together with Pharaoh.

119. Haney, "Death and the Devil," 11–26.

120. As cited in Coleiro, "St. Jerome's Lives," 172. See also Harvey, "Saints and Satyrs," 35–56. It is important to note here that Jerome describes the creature as having a "horned" forehead in contrast to his description of Moses at Exod. 34:29 as having a horned "face."

121. Coleiro, "St. Jerome's Lives," 172.

122. An excellent example showing Pan with very similar double-curved horns is to be seen on a third-century C.E. carved marble sarcophagus now in the Getty Museum collection, illustrated as no. 218, p. 269, in Ackerman, *Lexicon Iconographicum*, 8/1, 2.

123. Illustrated as fig. 5 in Hobbs, "Platters"; see also the entry on the Mildenhall treasure in Weitzmann, *Age of Spirituality*, 151–52.

124. The textile is from Antinoë, Egypt. Illustrated as no. 71, p. 618, in Ackerman, *Lexicon Iconographicum*, 8/1, 2.

125. As illustrated in Mellinkoff, *Horned Moses*, figs. 55, 64, 74.

126. Illustrated as fig. 909 in Cook, *Zeus*, 2, Appendix G, 1051–52.

127. Cook, *Zeus*, 2, Appendix G, 1051.

128. See my remarks in "Some Attitudes," 40, about similar thornlike projections on portions of the frame on p. 28 (fig. 8) of MS Junius 11.

129. On the demonic attributes of demons in Harley MS 603, see Jordan, "Demonic Elements," 283–317.

130. As quoted in Summers, *History of Witchcraft*, 134.

131. As discussed in Bonnefoy, *Mythologies*, 2, 658–62. See also Weltin, "Quid Athenae," 153–61, who discusses this concept in detail, where he says, among other important perceptions, on p. 154, "The device mainly, but not exclusively, employed to account for the many unwelcome theological similarities was daemonology." See also Smith, "Adde Parvum," 70; also Ridings, *The Attic Moses*; and Borgeaud, "Silent Entrails," 80–95. Justin Martyr in *The First Apology*, ch. 60, "Plato's doctrine of the cross," in the *Timaeus* of Plato, where he says, "He placed him crosswise in the universe," he borrowed in like manner from Moses." Roberts and Donaldson, *Ante-Nicene Fathers*, 1, 183.

132. See McLellan, "Great God Pan," 76 n. 7.

133. See Kaster, *Macrobius, Saturnalia*, 1–2 (bk. 1), 22.2, 293. Macrobius also relates the horns of Jupiter Ammon to the radiant sun in *Saturnalia*, 1.21.19: "Hammonem quem Deum solem occidentem Lybies existimant, arietinis cornibus fingunt, quibus id animal valet, sicut radiis sol." See also bk. 1.20.287, where Macrobius discusses the Egyptian Mnevis and Apis bulls and their relation to the sun; Servius, *Commentary on Virgil, Ecl. II.* Sir Thomas Browne (1605–82), the renowned English polymath, in his *Pseudodoxia epidemica* (6th ed., 1672), ch. 9, 286–88, refers to Macrobius's invocation of the horns of Jupiter Hammon in his discussion of the horns of Moses, insisting that such an association of Jupiter with Moses will "vilify the mystery of the irradiation [of Moses's face]." Browne goes on to say that such an association would also bring up other inappropriate pagan analogies such as Pan and Bacchus; see Hughes, *Pseudodoxia*.

134. Illustrated as pl. XLII, fig. 71, in Panofsky, *Studies in Iconology.* The illustration is from bk. 15, ch. 6 (*De diis gentium*) in Hrabanus Maurus's *De rerum naturis* (Montecassino, Biblioteca Abbaziale MS 132, fol. 391).

135. Unfortunately destroyed during World War II. Illustrated as fig. 1 in Boardman, *Great God Pan.*

136. A June 25, 2012, *New York Times* article reported that noninvasive spectrometry readings on the sculpture of the temple menorah depicted on the inner wall of the first-century C.E. Arch of Titus in Rome revealed that it was originally painted a rich yellow to give it the appearance of gold as described in the Bible (Exod. 25:31–40). Dodwell, *Anglo-Saxon Art*, 175, notes that headbands on various female figures throughout Claudius B.iv are painted yellow to represent gold.

137. Medjuck, "Exodus 34:29," 47, where the author emphasizes that the verb *qāran* is unique to the text of the Hebrew Bible and its three occurrences in Exodus 34:29–35.

138. See n. 5 above. The most apropos image of the concept of a radiant face in a theological context from the post-ancient/medieval world might be said to be the representation of the resurrected Christ in Grünewald's sixteenth-century Isenheim altar, where Christ's radiant face merges subtly with the large sun-nimbus behind his head. See Baldwin, "Anguish, Healing and Redemption," 90. In a print by Albrecht Dürer, also from the sixteenth century, an apocalyptic Christ with small triangular flames encircling his eyes is shown seated on a lion. See Olszewski, "Naturalism: the Rare and the Ephemeral," 28 n. 16.

139. As can be seen, for example, behind the head of the emperor Theodosius on the so-called Missorium of Theodosius of the late fourth century C.E., now in the Real Academia de la Historia in Madrid, Spain. See Kiilerich, "Representing an Emperor," 273–80 and pl. 1. On the larger question of imperial radiant imagery in the Hellenistic and later Roman periods, see the detailed and important study by Bergmann, *Die Strahlen der Herrscher.*

140. Seen, for example, behind the head of Apollo Helios on a carved metope from the temple of Athena at Illion (Troy) of the early fourth century B.C.E. now in the Antikensammlung of the Pergamon Museum, Berlin, illustrated in Bergmann, *Die Strahlen*, pl. 6, no. 3.

141. See Bergmann, *Die Strahlen*, pl. 9, no. 3—a gold octadrachm of the third century B.C.E. depicting Ptolemy III Euergetes wearing the *corona radiata*. Amedick, "'Iesus Nazarenus,'" 60–66, advances the striking observation that the crown of thorns placed on Jesus's head at his mocking by the Roman soldiers might be seen as an ad hoc *corona radiata*.

142. Again, readers are encouraged at all times to access the clear digital images of the manuscript that can be enlarged to see detail on the British Library website.

143. See Merivale, *Pan*; also Krailsheimer, "Significance of the Pan Legend," 13–23. The major proponent of the Pan-Moses connection was the divine, Bishop Pierre Daniel Huet, in his *Demonstratio evangelica* of 1679. On Bishop Huet, see also Stroumsa, *A New Science*, 56. Merivale, *Pan*, 42, reviews Huet's reasons for equating Moses with Pan, seemingly unaware that early Christian writers had demonstrated pagan parallels to other biblical figures (although not specifically Pan), and notes Huetius's "traditional Plutarchan" identification of Pan with Christ but concludes, "Even so, there seems no reason to dispute Knoblauch's judgment (1794) of Huetius's Pan-Moses identification that 'seine Argumente

dafür kann man ohne Lachen kaum lessen [one can hardly read his arguments for it without laughing],'" a judgment that may yet prove short-sighted. Nathan Bailey in his entry on Pan in his classic *New Universal Etymological English Dictionary* (1756), says, "It is pretended, that the heathens have taken many circumstances of the life of Moses and applied them to the god Pan. He was represented with horns like Moses, and carrying a wand in his hand." Concerted efforts by early Christian apologists to present pagan gods and stories about them as diabolical imitations of things biblical has continued up to the present day but abounded in the seventeenth and nineteenth centuries, one example of which in the nineteenth century is Edward Stillingfleet's *Origines Sacrae: or a Rational Account of the Grounds of Natural and Revealed Religion* (Oxford: Clarendon Press, 1817), where in ch. 5, "Of the Origin of the Heathen Mythology," 156, the author begins, "Many things concerning Moses are preserved in the story of Bacchus." Conversely, numerous modern authors of varying degrees of scholarly credibility have endeavored to show how the biblical figures and narratives of Moses and others are modeled on pagan antecedents. A good example of this speculative trajectory is D. M. Murdock (who also publishes under the name "Acharya S"), *Did Moses Exist? The Myth of the Israelite Lawgiver* (Seattle: Stellar House Publishing, 2014); another is Ahmed Osman, *Moses: Pharaoh of Egypt* (London: Grafton Books, 1990), which promotes the thesis that the heretical pharaoh Akhenaten and Moses were the same individual.

144. Although there is an intriguing image of a two-horned Pan (clearly labeled as such) pointing to the gathered Israelites as they are about to enter the desert wilderness in Psalm 77 on folio 93v of the ninth-century Stuttgart Psalter (Stuttgart, Württembergische Landesbibliothek, MS Biblia Folia 23) that in its bearded fully human form could be mistaken for a horned Moses; illustrated as fig. 2 in Boardman, *Great God Pan*. See also Panofsky, *Renaissance and Renascences*, 93 and fig. 63. On the concept of *imitatio diabolica*, see Borgeaud, "Religion romaine," 126–27.

145. See Irwin, "Survival of Pan," 159; also Schoff, "Tammuz, Pan and Christ," 527.

146. Borgeaud, "Death of the Great Pan," 266; Wicker, "De defectu oraculorum," 131–80. See also Droge, *Homer or Moses*, 184.

147. See Mellinkoff, *Horned Moses*, 131–36.

148. Ibid., 1–2, 138–40, and fig. 130, where the author reproduces the cover of an advertising brochure of Mount Sinai Memorial Park and Mortuary in Los Angeles, California, where the "offending" horns have been airbrushed out of a reproduction of the head of Michelangelo's famous statue of Moses in Rome.

149. On the origins of the image of the horned Satan, see the comprehensive article by Korol, "Horn I," cols. 561–62. See also Kulik, "How the Devil Got His Hooves and Horns," 195–229.

150. Ambrose, *Explanatio psalmorum, XLV*, in Petschenig, *Sancti Ambrosii*. For a discussion of the variable meanings of horns and light in the early Christian poetry of Dracontius (Blossius Aemillus Dracontius, ca. 455–ca. 505 C.E.), the *Hymn to Light*, see Nosarti, "Some Remarks," 47–49.

151. See McHugh, trans., *Saint Ambrose*, 272–73. Works by St. Ambrose known in Anglo-Saxon England, including *De patriarchis*, have been surveyed as an online reference by Bankert et al. as part of the *Sources of Anglo-Saxon Literary Culture* project (www.mun.ca/Ansaxdat/ambrose/pref.html).

152. Auslander, "Grabbing Life by the Horns," *New York Times*, December 16, 2011. See also Cohn, "Horns of Moses," 224. Examples of the horn as a symbol of evil abound in contemporary popular as well as "highbrow" culture.

153. On the origins and transformation of the swastika, see Gardner, "Multiple Meanings," 35–37.

154. See Brunner-Traut, "Horn," 3, cols. 9–10. See also in this connection, Scolnic, "Moses and the Horns of Power," 575–76.

155. See Smith, *Hellenistic Royal Portraits*, for numerous examples. As the author observes, horns as royal symbols in the Hellenistic era generally associated the rulers with the god Dionysos. The downward-curving ram's horns of the Egyptian god Ammon on numismatic images of Alexander the Great are perhaps the most widely known. Alexander is often associated with the mysterious *Dhu al-Qarnayn* ("Two-horned") in the Quran (18:83–101). It should be said that not all scholars are in agreement that *Dhu al-Qarnayn* was always understood to be Alexander: see Wheeler, *Moses in the Quran*, 16–17. On the horns of Alexander, see the classic essay by Anderson, "Alexander's Horns," 100–122. In an article concerning the horns of Alexander, Polignac, "L'Homme aux deux cornes," 49, notes that the Jewish protagonist in the famous Arabic collection of tales, *The Thousand and One Nights*, swears on "the sacred horns of our lord Moses." Pollitt, *Art in the Hellenistic Age*, 32, specifically notes that the horns of Zeus Ammon were applied to Alexander only after his death. Demetrios Poliorcetes and Seleucus I, according to Pollitt, 32, "did not hesitate to have themselves represented with the horns of divinity while they were active, mortal, fallible men." Specifically on the Seleucid emperors, see Hadley, "Royal Propaganda," 56. Erickson, "Seleucus I," 122–23, observes regarding the horned Seleucid helmet that "the best interpretation of the helmet may be of the heroic Babylonian king or god, which the helmet most closely emulates." He goes on to say, "Images of humans with horns (either directly attached or attached to helmets) was a common iconographic trope in Persian, Babylonian and Greek cultures and would have been immediately recognizable as a symbol either of divinity or of heroised kingship." Iossif, "Les 'cornes' des Séleucides," deals extensively with various important implications of this imagery.

FIVE The Veil of Moses

1. Eilberg-Schwartz, *God's Phallus*, 143–47 n. 18, points out that the Hebrew word used in the text, *masweh*, is a *hapax legomenon*. Riemer, "Veil over Moses' Face," 237–52, surveys the motif in patristic interpretation. For a study of the *doxa* tradition in St. Paul's account of Moses's veil, see Belleville, *Reflections of Glory*. For a recent interpretation of Moses's veil using "affect theory," see Koosed, "Moses: The Face of Fear," 414–29.

2. As observed by Britt, "Concealment," 228. Feldman, *Philo's Portrayal*, presumably because Philo himself does not deal with it in any significant way, does not mention it at all. See Philpot, "Shining Face of Moses," 91–100, for a conservative theological interpretation of the veil motif as well as comprehensive relevant bibliography. While a majority of modern scholars have rejected the idea first introduced in 1913 by Hugo Gressman, *Moses und seine Zeit*, 249–51, that the veil was a kind of mask, possibly with horns (but see Jirku, "Die

Gesichtsmaske des Mose," 43–45), art historical evidence lends some support in an image on folio 6v of the early eleventh-century C.E. so-called Farfa Bible (Vatican City, Biblioteca Apostolica MS Lat. 5729) illustrated in Mellinkoff, *Horned Moses*, fig. 11, 7–8, where the seated figure of Moses at the left does indeed seem to sport a sort of "Phantom of the Opera" half-face mask!

3. Broderick, "Veil of Moses," 271–86.

4. Mellinkoff, *Horned Moses*, 79; see also van Kooten, "Why Did Paul," 149–81.

5. Beginning with Origen in the third century C.E., Christ's full-bodied glorification at the Transfiguration has been contrasted with the partial glorification only of Moses's *face* in the Old Testament. On this exegesis, see Mellinkoff, *Horned Moses*, 80–81 nn. 19, 20. See also Belleville, *Reflections*.

6. See Lucas, "Cross in Exodus," 202–3.

7. See Heine, trans., *Origen: Homilies*, 370.

8. Lucas, "Cross in Exodus," 202–3.

9. Ibid.

10. Miquel, *Déserts chrétiens*, 172. For details and earlier bibliography on the association of the cross of Christ with the mast of a ship, see Karkov, "Tracing the Anglo-Saxons," 133–44.

11. On this aspect of Pan and connections to the *Orphic Hymns*, see Brummer, "Pan Platonicus," 58, esp. nn. 12, 13. See also Most, "Pindar, Fr. 94b.19–20 Sn.-M," 33–38. The goddess Isis is also sometimes regarded as "mistress of the winds, protector of sailors, and inventor of navigation and of the sail," and as such was referred to as Isis Pelagia and Isis Pharia, in conjunction with the famous Pharos, or lighthouse, of ancient Alexandria. See Williams, "Isis Pelagia," 111.

12. See Patai, *Children of Noah*, 92–93.

13. See Millar, in Schürer, *History of the Jewish People*, 3.1, 58.

14. Patai, *Children of Noah*, 92.

15. See Millar in Schürer, *History of the Jewish People*, 3.1, 58. On the meaning of these inscriptions, see also Feldman, *Jew and Gentile*, 67: "such inscriptions would seem to indicate a real compromise with Jewish monotheism."

16. See Goldenberg, *The Nations That Know Thee Not*, 64.

17. See Kerkeslager, "Jewish Pilgrimage," 218–19.

18. See Kaplan, *Grabmalerei*, 162–65 and fig. 83b.

19. See Gabra, *Rapport*, 1–45.

20. Ibid., 41–45.

21. Kaplan, *Grabmalerei*, 131. Gabra, *Rapport*, 41, refers to this object as "un fillet."

22. See the article by Otto, "Amun," col. 245.

23. Moore, "Any as an Element," 152 and n. 167.

24. On the Ankh adopted as a Christian symbol, see De Zwann, "Another Strain of Symbolism," 332–33. For more recent issues associated with this assimilation, see Hurtado, *Earliest Christian Artifacts*, 135–54.

25. On the reuse of ancient sites for Christian purposes, see Westerfeld, "Saints in the Caesareum," 59–86.

26. On Deir el-Bersha, see Newberry, *El Bersheh*. For images of the later Christian overpaintings of crosses in the Tomb of Djehutihotep, see www.egyptopia.com/Visit -Tomb-of-Djehutihotep-30-1167-498001737-en.html.

27. On the *labarum* of Constantine, see the article by Lipinsky, "Labarum," 3, cols. 1, 2.

28. See Dinkler von Schubert, "Tropaion," 3, cols. 361–63. On the relationship of the Roman *tropaeum* and the victorious cross of Christ, see Storch, "Trophy and the Cross," 105–18. On this important motif, see further Dinkler von Schubert, "Bemerkungen zum Kreuz als TPOΠAION," 71–78.

29. See fig. 5 in Broderick, "Veil of Moses," 278.

30. Mellinkoff, *Horned Moses*, 79.

31. Ewald, *Homilies of St. Jerome*, 1, 170–71; emphasis mine. Justin Martyr in *The First Apology*, ch. 55 ("Symbols of the Cross"), also compares the cross of Christ to "vexilla"; Roberts and Donaldson, *Ante-Nicene Fathers*, 1, 182.

32. On the hymn itself, see Rousseau, "Vexilla Regis." On Fortunatus, Venantius Honorius Clementianus, its author, see Skeabeck, "Fortunatus." Interestingly, Bede says that St. Augustine and his companions came before Ethelbert "carrying a silver cross for a standard" (*veniebant crucem pro vexillo ferentes argenteam*); see Sherley-Price, *A History*, 69. For the Latin text, see Plummer, *Venerabilis Baedae*, 45–46.

33. The *vexillum*, a square piece of decorated cloth attached to a pole and carried by a *vexillarius*, was an important Roman military insignia; see Rostovtzeff, "Vexillum and Victory," 93. The twelve Elders of Israel, according to Kraeling, *The Synagogue*, 84, are shown carrying *vexillum*-like placards on poles in the scene of Moses parting the Red Sea in the paintings of the synagogue of Dura-Europos of ca. 250 C.E. Kraeling, *The Synagogue*, 84 n. 254, refers to the interpretive text, *Numbers Rabbah* 2, 2, 7, which suggests that "the nations (Romans) derived their use of the vexillum from Israel's 'standards,' referred to in Numbers 1:52." The "standard" at Dura, as Kraeling notes, 83 and fig. 23, is pink. On the incarnational aspects of the color pink in the context of medieval Christian art, see the discussion in Broderick, "Veil of Moses," 279–80 and n. 38. The curtains on Moses's "staff" on folio 105v of Claudius B.iv are also pink. Dura, interestingly, was founded by Seleucus Nikator ca. 300 B.C.E. See Weisman, "Militarism," 15–16, fig. 7. An intriguing visual analog here is a second-century B.C.E. coin (tetradrachm) of the Seleucid king Antiochus VIII Epiphanes (Grypos) with an image of Zeus Ouranios on its reverse shown standing holding a tall staff in his left hand with either a star or the sun in his right hand and above his head, touching his hair, the horns of a crescent moon (illustrated at www.cngcoins.com/).

34. See Feldman, *Jew and Gentile*, 269–70.

35. On this theme, see Rapp, "Imperial Ideology," 693–94, where the author cites that, according to Georgius Codinus, the staff of Moses was brought to Constantinople by the emperor Constantine who placed it in the newly constructed church of the Theotokos of the Rhabdos (i.e., the Rod of Moses).

36. Inowlocki, *Eusebius and the Jewish Authors*, 112; on this curious concept, see the classic study by Marcel Simon, *Verus Israel*. On Eusebius's strange distinction between the original "Hebrews" and the later "Jews," see Johnson, *Ethnicity and Argument*. Droge, *Homer or Moses*, 185–93, also discusses this concept in Eusebius.

37. Inowlocki, *Eusebius and the Jewish Authors*, 112–13.

38. Ibid., 113.

39. See Kovacs, "Divine Pedagogy," 3–25.

40. Richter and Taylor, *Classic Christian Art*, 149.

41. Ohlgren, *Insular and Anglo-Saxon*, 239 (item 307). Moses appears to the left of the parted curtains of the Tabernacle of Testimony (Deut. 31:14) on folio 137r of Claudius B.iv. Interestingly, the pink "curtains"/veil on folio 105v are parted in two separate sections. For a detailed discussion of the mysterious figure whose head emerges from behind a curtain at the right in the depiction of the evangelist St. Matthew on folio 25v of the seventh- to eighth-century Lindisfarne Gospels (London, British Library Cotton MS Nero D.IV), who I believe is meant to represent Moses, see Broderick "Veil of Moses," 274 n. 18. A further possible confirmation of the identity of the figure as Moses may be provided by the miniature illustrating a seated St. Matthew on fol. 17v of the so-called Copenhagen Gospels (Copenhagen, Kongelige Bibliotek MS Gl. Kgl. Sml. 10, 2°) of late tenth or early eleventh century date, where, in a fashion similar to the Lindisfarne image on folio 25v on which it is modeled, a nimbed, bearded head is shown peering out from behind a partially pulled aside curtain. The figure is generally described as holding a "book" (see Karkov, *Art of Anglo-Saxon England*, 41 and fig. 9), but the "book" appears to have a rounded top and may be intended to represent the Tablets of the Law, if indeed the figure is meant to be understood as Moses.

42. See Sieger, "Visual Metaphor," 85 n. 29; also Borret, *Origène*, IX, 1, *Sources chrétiennes*, 321, 280–81.

SIX Horns of Pan/Horns of Light

1. www.metmuseum.org/coptictextiles.

2. For further references to this work, see most recently Thomas, "Material Meaning," 21–53, fig. 1-1.1. Also, Stauffer, *Textiles of Late Antiquity*, no. 45, 47; Friedman, *Beyond the Pharaohs*, 132–33; and Weitzmann, *Age of Spirituality*, cat. no. 129, 150–55. The work is illustrated in color as Pl. X and discussed briefly in Török, *Transfigurations*, 231–32. On related aspects of Coptic textiles, see Friedländer, *Documents of Dying Paganism*; Lenzen, *Triumph of Dionysos*; Thomas, *Textiles from Medieval Egypt*. See also Ackerman and Gisler, *Lexicon Iconographicum*, Supplementum 8/1, #71, 927; 8/2 #17, 618.

3. On dionysiac imagery in Coptic textiles in general, see Allen, "Dionysiac Imagery," 11–24.

4. See Rouse, *Nonnos; Dionysiaca*, bk. 13.

5. See ch. 4 above.

6. *In Virg. Eclog. Ii*, McLellen, "Great God Pan," 76 n. 7; emphasis mine.

7. See Ruck and Staples, *World of Classical Myth*, 132.

8. Kerenyi, *Gods of the Greeks*, 174.

9. Butt, ed., *Poems of Alexander Pope*, bk. 3, 406–7, lines 99–104.

10. Frankfurter, "Syncretism and the Holy Man," 340–44, seeking to redefine this term as used in history of religion studies, remarks, "'Syncretism' has been largely abandoned for such terms as 'hybridity,' 'heterogeneity,' and 'cultural synthesis,' as historians and anthropologists try to encompass that truly interesting phenomenon, the mixture of traditions, with more critically astute sensibilities about power, discourse, and identity, and the realization that 'mixture' is normative to religions, 'purity' rare and often invented."

11. On these writers, especially Macrobius and the celebration of pagan culture and *vetustas*, see Cameron, *Last Pagans*; Cameron, *Greek Mythography*.

12. See ch. 4 above. Herren, "Transmission and Reception," 89, notes that Latin poetry was important in the curriculum of the Canterbury school conducted by Theodore and Hadrian and, 91, states that Servius's commentary on the works of Virgil would have been available in England by ca. 700, so that the idea of Pan's horns symbolizing light may well have already been known in the Canterbury ambit.

13. Barnes, *Porphyry's Introduction*, ix, notes, "For a thousand years and more, Porphyry's *Introduction* was every student's first text in philosophy. St. Jerome learned his logic from it." Unfortunately, Porphyry's treatise *About Images* exists only in fragments, which can be found in Bidez, *Vie de Porphyre*. On this text, see Magny, *Porphyry in Fragments;* and Simmons, *Universal Salvation*, 349 n. 128.

14. Stambaugh, *Sarapis*, 86 n. 7, cites von Wilamowitz-Moellendorff, who maintains that the pantheistic conception of Pan did not appear until Cornutus's *De natura deorum*, 27, but earlier, 86, states that the phrase "the god of all things" is invoked by Plato, *Cratylus*, 408c. See also Palmer, "Studies of the Northern Campus Martius," 38–41, for a detailed discussion of the transmission of the idea of Pan as "All God."

15. The idea of personifying the moon, often as a female figure with horns, is to be found in Late Antique and early medieval art. Speaking of a sixth-century ivory in Berlin depicting the sun and the moon as, respectively, a young male figure with rays and a young female figure with horns, Kiilerich, "Symmachus, Boethius," 214 (n. 80), quotes the famous early sixth-century C.E. philosopher, "There is one Father of all things. . . . He gave the sun his rays and he gave the moon her horns."

16. See Kapetenaki, *Supplementa problematorum*, 113 (bk 1, 17), "Hear also concerning Pan, that they intend him to be the whole (*pan*) of the world. For they place two horns on his head because of the double nature of the whole. For the whole has been established as male and female in its parts, like the sun and the moon." In note 197, the author connects this idea with Orphic Hymn 11.1, in Quandt, *Orphei hymni*, 12–13, 27–28. For text, translation, and commentary, see also Holladay, *Fragments*, 4 [*Orphica*]. Connections of Pan to Orphism and the so-called Orphic Hymns, short religious poems composed either in the late Hellenistic period (ca. third or second century B.C.E. or the early Roman period (ca. first to second century C.E.) are complex and intriguing as is the vast, yet mysterious realm of "Orphism" itself. On the question of Orphism, see most recently Edmonds, *Redefining ancient Orphism*. With specific reference to Pan himself and the notion of a "cosmic" Pan, see the commentary by Athanassakis and Wolkow, *Orphic Hymns*, 94–96, as well as the notes to Fayant, *Hymnes orphiques*, 120–22 and 300–302 (Pan in connection with Apollo). With specific reference to Moses, it is important to recall that Artapanus (see ch. 4) of the

third-second century B.C.E. in the fragments of his text epitomized by Alexander Polyhistor in his "About the Jews" (*Peri Ioudaion*) embedded in Clement of Alexandria's later *Stromata* and Eusebius of Caesarea's *Praeparatio Evangelica* had asserted that the Greeks had called Moses "Musaeus" and had claimed that Musaeus had been the teacher of Orpheus, thus reversing the traditional student-teacher relationship. Remarking on this reversal, see Torjussen, "Metamorphoses," 19. In an apocryphal text called the *Testament* (*Diatheke*) *of Orpheus*, Orpheus, who is said to have traveled in Egypt and had learned of monotheism from Moses himself, calls Musaeus "son of the light-bearing moon" and instructs him in the monotheistic message of "the one born of water" (i.e., Moses). The text of this *Testament* is embedded in Eusebius's *Praeparatio* as part of a fragment of Aristobolos's (an Alexandrian Jewish writer, ca. second century B.C.E.) *Explanation of the Mosaic Law*. On the *Testament*, see Friedman, *Orpheus in the Middle Ages*, 13–37. Moses is thus brought into the Orphic realm as a hierophant and indeed the originator of the Orphic theology.

17. See MacFarlane, "Isidore of Seville," (*Origines* VIII.11), 3–40. Herren, "Transmission and Reception," 88, states, "There is good evidence to suggest that this text was already circulating in Ireland well before the end of the seventh century" (see also p. 90).

18. See ch. 4, n. 132.

19. The term *Late Antique* and its implications have continued to evolve in scholarly discourse. See preliminary remarks by Brilliant, "Forwards and Backwards," 7–24: also Brilliant, "Late Antiquity," 29–56; and Marcone, "A Long Late Antiquity?," 4–19.

20. On the complex subject of Hermes Trismegistus and the *Hermetica*, see Fowden, *The Egyptian Hermes*, esp. 23, where he makes a brief reference to Artapanus who, he says, "wrote an account of the life of Moses in which he assimilated his hero (i.e. Moses) to 'Hermes' (i.e. Thoth), making him responsible for introducing the Egyptians to ships, machines, weapons and philosophy." Hermes Trismegistus was considered by some early Christian writers, Lactantius and Augustine among them, to be a contemporary of Moses and the creator of a *prisca theologia* paralleling the monotheism of Moses, an idea taken up in the fifteenth and sixteenth centuries by a number of influential Italian Renaissance writers, such as Marsilio Ficino, Giovanni Pico della Mirandola, and Giordano Bruno. Until the seventeenth century, when the scholar Isaac Casaubon demonstrated that the texts attributed to Hermes Trismegistus, the so-called *Hermetica*, were no earlier in date than the second or third century C.E., they were considered the work of an all-wise ancient Egyptian priest. Hermes Trismegistus is represented in the late fifteenth-century inlaid floor of Siena Cathedral. From the quite extensive literature on this subject, see, among others, Walker, "Orpheus the Theologian," 103–7; Heiser, *Prisci Theologi and the Hermetic Reformation*; Yates, *Giordano Bruno and the Hermetic Tradition*.

21. The Egyptian city of Akhmim, where Nonnus came from, was called Panopolis by the Greeks, and a cult of Pan (identified by the Greeks with the ithyphallic Egyptian god Min) was a feature of Late Antique Greco-Egyptian religion. Contrary to the comment of W. H. D. Rouse in his translation of the *Dionysiaca* for the Loeb Classical Library, 20, that "the interest which classicists of the English-speaking world have taken during the last century and a half in the *Dionysiaca* of Nonnos of Panopolis has shown an inverse ratio to the astonishing bulk of the poem," studies of both the poem and its author continue to

proliferate at a healthy pace. The following works are but a small sample of this rapidly growing field of study: Hopkinson, *Studies in the Dionysiaca*; Spanoudakis, ed., *Nonnus of Panopolis in Context*; Hernández de la Fuente, *Bakkhos anax*; and Shorrock, *The Myth of Paganism*.

22. On this remarkable text, see Livrea, *Towards a New Edition of Nonnus' Paraphrase*; Whitby, "The Bible Hellenized," 195–232; Hernández de la Fuente, "Nonnus' Paraphrase," 169–90; Hernández de la Fuente, "Parallels between Dionysos and Christ," 464–87. For an idiosyncratic, contemporary English translation of the Greek text, see Prost, *Nonnos of Panopolis: Paraphrase of the Gospel*.

23. In addition to Shorrock, *Myth of Paganism*, see the earlier work of Liebeschütz, "Pagan Mythology in the Christian Empire," 193–208; Brown, *The World of Late Antiquity*; Bowersock, *Hellenism in Late Antiquity*; Bowersock, *Mosaics as History*; Bowersock et al., *Late Antiquity: A Guide*; Bagnall, *Egypt in Late Antiquity*; and Hernández de la Fuente, *New Perspectives on Late Antiquity*. Thomas, *Late Antique Egyptian*, xvii–xxv, addresses various aspects of the difficulties involved in the interpretation of pagan mythological themes in Christian Coptic art, referring to the seminal 1969 study by Torp, *Leda Christiana*. On the possibility of a "double reading" of pagan and Christian themes in Coptic art, see Török, *Transfigurations of Hellenism*, 262–80. Further on the problem of "double reading," pagan themes that have sometimes been given incorrect Judeo-Christian meanings, see Durand, "David Lyricus," 51–74. On Nonnus specifically, see Bowersock, "Dionysus as Epic Hero," 158: "There are plenty of parallels for a deep interest in pagan mythology among Hellenised Christians of the period. The *Dionysiaca* need not have been the work of a polytheist."

24. Agosti, "Contextualizing Nonnus's Visual World," 149. See also Cavero, "The Appearance of the Gods," 557–83.

25. Discussed by Bowersock, *Hellenism*, 52–53, color pls. 10, 11; also Bowersock, *Mosaics as History*, 42, color figs. 2.10, 2.11. See the more recent study by Flury-Lemberg et al., *Der Dionysos-Behang*; also Kessler, "The Word Made Flesh," fig. 82 (color).

26. Bowersock, *Hellenism*, 53.

27. Ibid.

28. Ibid.

29. See ch. 4, n. 131. It is truly remarkable how widespread the perception is in seventeenth- and eighteenth-century sources that Pan in many ways "plagiarizes" salient features of Moses, especially his horns. Even the great eighteenth-century American Congregational divine, the Rev. Jonathan Edwards, best known for his famous jeremiad *Sinners in the Hands of an Angry God*, in his *Notes on the Bible*, reissued by Edward Hickman, *The Works of Jonathan Edwards, A.M.*, 2 vols. (London: William Ball, 1839), 725, compares the power of Pan to strike up "astonishing fears" in the enemies of Bacchus, just as the God of Israel whose shepherd (Moses) "brought up the children of Israel out of Egypt, with which he terrified the Egyptians and Israel themselves and all nations." Where this topos originated I cannot locate, as I have not been able to find a single Hellenistic Jewish or early Christian text that makes a direct connection between Pan and Moses. Of course it could be argued, especially with reference to the horns of Moses, that theological commentators before Jerome and his rendering of Exodus 34:29 may not have had any reason to concern

themselves with Pan's horns as the Septuagint concept of Moses's face being "glorified" would not have necessitated any thought of Pan and his horns. So the "Ante-Nicene" fathers, Clement of Alexandria, Justin Martyr, Pseudo-Justin, and others, who do speak of "demonic" plagiarism and the imitation of Jewish and Christian personae by pagan gods would have no real reason to pursue that line of explication. For the present, it seems that possibly the visual connection between the horns of Pan and the horns of Moses is our only source, an ostensibly uncomfortable conclusion as so often the traditional modus operandi of iconographic research is to connect image with text in order to legitimize an interpretation. Rarely does an image alone perform this function; although in theory this should not be a problem, traditionally text has been "privileged" in this enterprise.

30. On the original goatlike Arcadian Aegipan manifestation of Pan, see Borgeaud, *Cult of Pan.*

31. See the remarks of Feldman on this important distinction in *Judaism and Hellenism,* 137.

32. On the concept of *to hen kai pan,* which is not the same as the biblical view claiming that God is one but not identifiable with the all, see Assmann, "Mono-, Pan-, and Cosmotheism," 130–49; and Assmann, *Moses the Egyptian,* 80, 81, 139–43.

33. Brummer, "Pan Platonicus," 55–67.

34. Ibid., 61–62. See also Rosenmeyer, "Plato's Prayer," 34–44.

35. Athanassakis and Wolkow, *Orphic Hymns,* 13–14; see also notes 94 and 95 where the authors note that Silenus, a figure closely associated with Pan, sings a song of creation in Virgil, *Eclogues* 6.31ff., an interesting parallel to Moses's *Genesis.* Silenus is potentially depicted at the lower right of the Metropolitan Museum dionysiac hanging (pl. 7); also Brummer, "Pan Platonicus," 58.

36. Athanassakis and Wolkow, *Orphic Hymns,* 97: "As noted in the introduction to this hymn, Zeus is called Pan in *Orphic fragment* 86. Another fragment calls Zeus 'the god of all and the mixer of all' (*Orphic* fragment 414): the Greek words for 'mixer' and 'horned' are the same ('*kerates*') except they are accented differently."

37. Ibid., 14.

38. Ibid., 31.

39. There has been considerable scholarly controversy as to Macrobius's religious identity; see Cameron, "Date and Identity of Macrobius," 25–38. More recently, Jones, *Between Pagan and Christian,* 152, has assessed the situation as follows: "Alan Cameron, who has done more than anyone to advance understanding of Macrobius and *Saturnalia* in recent decades, firmly rejected the thesis of Macrobius's Christianity in 1967 and again in 1977, but now has modified his earlier position: '[Macrobius is] surely not a pagan,' 'if a pagan, . . . not writing with a specifically pagan agenda.'" In his new Loeb text of the *Saturnalia,* Robert Kaster, *Macrobius, Saturnalia,* xxi–xxii, has called him "probably a Christian and certainly writing for an audience assumed to be Christian."

40. See Bremmer, "Pan Platonicus," 58–67.

41. See Fulińska, "The God Alexander," 132, a small marble sculpture from Pella. As the author notes, 132, Pan appears on the coins of the Antigonids, successors to Alexander.

42. Weitzmann and Ševčenko, "Moses Cross," 388, note that Moses is represented as a shepherd in a short tunic in the ninth-century C.E. Byzantine *Topographia christiana* of Cosmas Indicopleustes. See ch. 7, n. 111.

43. Feldman, *Philo's Portrayal*, 73.

44. Ibid.

45. See ch. 4, n. 131. For more on Pan as shepherd and his connection with Hermes, see Eckerman, "Thyrsis' Arcadian Shepherds," 670–71.

46. Swaim, "Mighty Pan," 487. Swaim notes, 487 n. 7, that a Latin etymology of Pan's name, *pa-sco*, the "feeder," links the pagan and Christian *pastors* (i.e., Christ, the "pastor" = "shepherd" of the sheep). Further on Pan's link to Christ in Rabelais and the idea, put forward by Eusebius in his *Praeparatio*, that the death of Pan recounted by Plutarch in his *De defectu* signified the death of the whole pagan pantheon, see Screech, "The Death of Pan," 37, 44.

47. See Fowden, *Egyptian Hermes*, 27 n. 86, quoting Cyril of Alexandria observing that Hermes was of like mind with Moses, "though he was not correct and above reproach in everything."

48. See, e.g., the recent studies O'Reilly, "St. John the Evangelist," 189–218; and Rosenthal, "Image in the Arenberg Gospels," 229–46.

49. Henderson, *Early Medieval Art*, 178, made the intriguing observation that the shrouded body of the dead Joseph on folio 72v of Claudius B.iv resembles an ancient Egyptian mummy case. Other illustrations in Claudius B.iv exhibit distinctive "Egyptianizing" characteristics, as mentioned in chapter 2. By using the term *Egyptianizing*, however, I am not suggesting that the model or models employed in part by the artists of Claudius B.iv must necessarily have originated in Egypt itself, as Egyptian motifs were widespread throughout the Roman Empire. See, e.g., Bricault et al., *Nile into Tiber*.

50. See Holmes, ed., *Apostolic Fathers*, chs. 1–6.

51. On Rashi's explication of Exodus 34:29, see Sonsino, *Did Moses Really Have Horns?*: "Rashi notes that *keren* is like *Karnayim* (in Habbakuk 3:4) because light radiates and protrudes like a type of horn."

SEVEN Additional Attributes of Moses

1. Strangely, these large horns look at first like giant *rabbit* ears. In a coda to her book *Anglo-Saxon Art: A New History*, Leslie Webster, 237, commenting on the "afterlife" of Anglo-Saxon art in the modern world, reproduces one of Tenniel's illustrations for Lewis Carroll's *Through the Looking Glass, and What Alice Found There* (1871) showing the messenger called Haigha, who is described by the King as "an Anglo-Saxon Messenger," whose strange gestures and gait Alice had commented on earlier as "curious attitudes." The King further replies, "Those are Anglo-Saxon attitudes. He only does them when he's happy." This Haigha is dressed in a short tunic, wearing a cowl-like coif on his head that, like a strange vertical glove, covers his erect, tall rabbit ears. On his feet are black "ballet" shoes with an opening over the top instep, looking quite like the black soft shoes on many of the

male figures in Claudius B.iv (see, e.g., fig. 6). Webster comments that Lewis Carroll makes several references to things Anglo-Saxon in *Alice in Wonderland* and *Alice Through the Looking Glass* and seems to be knowledgeable at some level about Anglo-Saxon literature and art.

2. See Withers, *Hexateuch*, 144–58. Gameson, *Role of Art*, 212 n. 134, remarks on the elaborate foliate frame surrounding the image of Moses writing on folio 100r, in contrast to the "plain" frames used in the narrative illustrations throughout the rest of the manuscript. Oakes, "Moses in Paul," 250, notes that St. Paul states that Moses *writes* (Rom. 10:5–6), repeating a tradition that occurs several times in the Pentateuch itself.

3. On MS Junius 11, see Karkov, *Text and Picture*, 9–10. See also the discussion of this image in Broderick, "Iconographic and Compositional Sources," 290–93.

4. See Seligson, "Scribes." See also Macho, *Neophyti I*, 1, 570, where the words of this targum also refer to Moses as the "scribe of Israel."

5. On Thoth, see Bleeker, *Hathor and Thoth*; also Jasnow and Zauzich, *Ancient Egyptian Book of Thoth*, 1, 9–12, 65–74. It is this same Thoth who is referred to in later Greek Hermetic literature as *wr wr wr* = Trismegistus = Mercurius ter Maximus = "Thrice Great."

6. See Budge, *Rosetta Stone*, 54, 67.

7. See Otto, "Cheriheb," 1, cols 940–43. See also Sauneron, *Priests of Ancient Egypt*, 63–64. On the survival of these sacerdotal ranks into the Roman period, Frankfurter, *Religion in Roman Egypt*, 73 n. 126, 145, 213 n. 60, 227–88, 239. See also Edelman, "Of Priests and Prophets," 103–12. For a detailed account of the role of scribes in the cultures of the ancient Near East in general as well as a detailed account of the status of the lector priests in Egypt, see van der Toorn, *Scribal Culture*, esp. 67–73.

8. See Zauzich, "Hierogrammat," 2, cols. 1199–201. The lector priests were also referred to in Greek as *pterophores* on account of the feathers worn on their head. They are mentioned in the Greek text in line 4 of the Stele of Canopus (238 B.C.E.) and in line 7 of the Rosetta stone (196 B.C.E.). According to Jitse Dijkstra, "Religious Encounters," 68, "On 24 August 394 (C.E.) another Smet, surnamed Akhom, dedicated the last hieroglyphic/demotic inscription of Egypt as *hierogrammateus*."

9. Diodorus Siculus, a Greek historian of the first century B.C.E., writes in his monumental universal history, the *Bibliotheca historica*, that the feathers of the *hierogrammateus* refer to the "days of old" when a hawk brought to the priests of Thebes a book encircled by a band of purple, which is why the scribes wear a purple cord on their heads and a hawk's feathers. See Murphy, *Antiquities of Egypt*, 110.

10. See, e.g., Bakry, "A Statue of Pedeamūn-Nebnesuttaui," pls. I–IV, VII, VIII; see also Rowe, "New Excavations at Kôm-el-Shukafa," figs. 7, 8 and pl. VII; Venit, *Monumental Tombs*, 138 and fig. 117; Venit, "Tomb from Tigrane Pasha," 725–28; and Parker, *A Saite Oracle Papyrus*, pl. I. I would like to thank Richard Fazzini, chairman emeritus of Egyptian, Classical, and Ancient Middle Eastern Art at the Brooklyn Museum, for his generous help with these references.

11. Illustrated in Witt, *Isis*, fig. 30; and Merkelbach, *Isis Regina*, fig. 145. See also Amelung, *Die Sculpturen*, 142–45 (#55); also Malaise, *Inventaire*, 234–35 (#441) and frontispiece; cf. a similar representation of an Isaic priest on a second-century C.E. ivory plaque from Egypt in the Dumbarton Oaks Collection in Washington, DC, discussed by Weitzmann, *Catalogue*, 5–7 and pl. I.

12. Although late Egypto-Roman depictions of the Khery-heb, as in the Kom el-Shuqafa Main Tomb, are also shown with a spotted animal skin over their shoulder; see Venit, *Monumental Tombs*, 138, fig. 116; and 139, fig. 117.

13. On Philae, see Kockelmann, "Philae," 8–9.

14. Wildung, *Egyptian Saints*, 67–70. I am especially grateful to Professor Wildung for his generous permission to publish these photographs from his book.

15. Ibid., 69. The description is from Clement of Alexandria, *Stromata*, 6, 4; see Stählin, *Clemens Alexandrinus*.

16. See Otto, "Cheriheb."

17. On the concept of *interpretatio* in general as well as the specific *interpretatio judaica* of Thoth-Hermes, see Mussies, "*Interpretatio Judaica*"; see also Griffith, "Interpretatio graeca."

18. See Oldfather, *The Library of History*, 55. On the connection with Hermes, see Burton, *Diodorus*, 276.

19. On Artapanus and his equation of Moses with Hermes, see ch. 4 above; see also Feldman, *Philo's Portrayal*, 291 and n. 67; and Droge, *Homer or Moses*, 25–27.

20. See Blackman, *Gods, Priests and Men*, 138–39.

21. See Ritner, *Mechanics*, 220–23; see also Kilcher, "Moses of Sinai," 148–70; and Noegel, "Moses and Magic," 45–59. Eusebius in his *Praeparatio evangelica* (see Gifford, *Eusebii Pamphili Evangelicae praeparationis*, ch. 8) quotes Numenius as saying that the two Egyptian magicians chosen to challenge Moses, Jannes and Jambres, were themselves "sacred scribes."

22. See van der Toorn, *Scribal Culture*, 70–71; see also Redford, *Study of the Biblical Story*, 203–4, with the interesting quote on p. 204 from the wisdom of Onkhsheshonqy, "when Re is angry with a land, he makes its washermen into *hry-tme*," a concept that might be extended to the elevation of Moses to that rank.

23. On this topic, see Hilhorst, "And Moses Was Instructed," 153–76.

24. See Otto, "Amun," 1, col. 238.

25. For a description of the relief and relevant bibliography, see Vandersleyen, *Das Alte Ägypten*, 286 (#244). On the god Sopdu, see Gïveon, "Sopdu"; Schumacher, *Der Gott Sopdu*. See also Petrie's article "Egyptian Religion," in Hastings, ed., *Encyclopedia*, 5, 249, where he notes that "*Sopdu* was identified with the cone of light of the zodiacal glow which is very clearly seen in Egypt. He represented the light before the rising sun, and was specially worshipped in the eastern desert, at Goshen and Serabit in Sinai."

26. I am grateful to Dietrich Wildung for pointing this out to me in personal correspondence. For an additional image of a Khery-heb with double-ribbed feathers emerging from a headband, see the example from a manuscript in the British Museum, London, illustrated online at www.ancient-egypt-priests.com/AE-Life-english.htm.

27. See Weitzmann, *Greek Mythology*, 123 and fig. 143.

28. See Wright, *Roman Vergil*, 40. Interestingly, there are images of the god Mercury (Gk. Hermes) in various parts of northern Europe where his usual head wings are replaced by horns; see Green, *Symbol and Image*, 96–98.

29. See Cohen, *Uta Codex*, 124, fig. 33.

30. Panofsky, "Iconography," 40–41.

31. Withers, *Hexateuch*, 17–52 and esp. 106–32.

32. Barnhouse, "Text and Image," 176–88.

33. Ibid. Barnhouse notes a run of five pages of text without any pictures.

34. Withers, *Hexateuch*, 86.

35. Ibid., 105.

36. Ibid., 90; see also the conclusions of Barnhouse, "Pictorial Responses," 67, 83.

37. See Gager, *Moses*, 40 passim.

38. See Bernstein, *Freud and the Legacy of Moses*, for a discussion of this important work of Freud's and its implications. Other studies of Freud's interest in Moses and possible connections with the horned Pan comprise a separate bibliography. An important example of this genre is Rosenfeld, "The Pan-Headed Moses," 83–93.

39. Assmann, *Moses the Egyptian*, 8–9, where the author discusses his concept of mnemohistory, which, "unlike history itself . . . is concerned not with that past as such, but only with the past as it is remembered." Visual images and the study of history of "art" are an important corollary to the project of mnemohistory not directly addressed by Assmann in his study. See also Lehmann, *Moses: Der Mann*; and Otto, *Moses: Ägypten und das Alte Testament*.

40. See Goodenough, *Symbols*, 12, 171; see also Goodenough, *Light*, 181–87. Feldman, *Jew and Gentile*, 66–67, says, "Even the great Philo (*De sobrietate* 4.20) refers to Moses as a hierophant (the term that designates the highest officer of the heathen mysteries)." The Greek historian Strabo says in his *Geography*, 16.2.35, that Moses was an Egyptian priest; see Jones, *Geography of Strabo*, 7, 283. On the priesthood of Moses, see Lierman, *New Testament Moses*, esp. 65–76; see most recently Feldman, *Philo's Portrayal of Moses*, 291–96.

41. On this work, see Fluck et al., *Egypt: Faith*, 69, fig. 69. For an additional example, see item #12 in the exhibition catalog edited by Volbach, *Koptische Kunst*.

42. Chazelle, "Ceolfrid's Gift," 138, fig. 4, cites the folio on which the image of Ezra appears as 4/Vr. See Bruce-Mitford, "Art of the *Codex Amiatinus*," 1–25, pls A–D, I–XX, where the author mentions the "tallith" cloth and jeweled breastplate. See also O'Reilly, "Library of Scripture," 4–39; Corsano, "First Quire," 3–34; Fischer, "Codex Amiatinus," 57ff.; Marsden, "Job in His Place," 3–15; Meyvaert, "Bede, Cassiodorus and the Codex Amiatinus," 827–83; and Meyvaert, "Date of Bede's *In Ezram*," 1123–25, esp. 1125, where the author remarks on Bede's description of the high priest's distinctive garments at the time of performing sacrifice, and goes on to say, "but the high priest could hardly do so when sitting down to write a book!" Interestingly, however, this is precisely how the artist of Claudius B.iv has represented Moses on folio 136v.

43. Bruce-Mitford, "Art of the *Codex Amiatinus*," 13; see also Alexander, *Insular Manuscripts*, 33.

44. Exodus 38:4; 39; 39:31. On the priestly miter, see Eisenstein, "Miter"; see also Revel-Neher, "Problèmes d'iconographie," 50–65. However, in her 1992 book, *The Image of the Jew*, 61, Revel-Neher says that in the Ezra image from the Codex Amiatinus "the *tefillin*, here, took the place of the High Priest's headdress, the mitre *miznefet* which gave way to them." (The author, p. 60, describes the Ezra figure as having "a small cube beneath his hair like a bulge. Though seldom recognized as such, this little cube is the *tefilla shel rosh*, the frontlet phylactery worn on the forehead.") Revel-Neher brings forward evidence from the

Babylonian Talmud and the later Maimonides that the biblical high priest wore the *tefilla shel rosh* on his forehead *between* the *mitznefet* and the priestly frontlet (*tzitz*) (54, 56). According to Joseph Gutmann in a letter to me in 1976, no biblical high priest wore the *tefilla shel rosh*. Revel-Neher (color pl. VIII) illustrates the Vatican Octateuch, gr. 746, folio 242v, where Aaron and his sons as priests are depicted with all three items on their heads, the *tzitz* represented as a small circle of pearl-like jewels. Bede has a complicated description of the priestly miter and its frontlet in his treatise *De Tabernaculo*, based largely on Josephus, who goes into greater detail about these two items than the Bible itself; see Thackery, *Jewish Antiquities* 4, 399–403.

45. Meyvaert, "Date of Bede's *In Ezram*," 1112–13; see also Pakkala, *Ezra the Scribe*. See Blenkinsopp, "Mission of Udjahorresnet," 409–21, where the author compares Ezra to an Egyptian author as both priest and scribe. Foley, *Bede*, 102 n. 3, states that neither the Vulgate nor any other patristic writer refers to Ezra as "high priest" (*pontifex*). Further on Ezra as priest and scribe, see Kratz, "Ezra—Priest and Scribe," 168–88.

46. Meyvaert, "Date of Bede's *In Ezram*," 1127–28. See also the discussion of Meyvaert's thesis in conjunction with a puzzling object from the so-called Staffordshire Hoard, bearing some intriguing visual connections with the *lamina aurea* as represented on Ezra's head in the Codex Amiatinus, in Webster, "Imagining Identities," 44–48. Webster suggests "the possibility of an Anglo-Saxon interest in and visualization of the high priest's insignia" (47). Wright, "Jewish Magic," 174–75, presents further observations on the representation of the high priestly insignia on the head of Ezra in the Amiatinus image.

47. Again, this emphasis on Moses as being the first person mentioned in the Bible as *writing* is an important impetus to an understanding of Moses as scribe. See Mussies, "*Interpretatio Judaica*," 100; "and the Lord said to Moses, write this for a memorial in a book" (Exod. 17:14). Cf. the depiction of a seated Khery-heb with two feathers projecting upward from a diadem on his forehead; the figure holds up a very large codex or tablet as painted on the wooden sarcophagus of Ankhpakhered (fig. 19), illustrated as fig. 6 in Leipoldt and Morenz, *Heilige Schriften*.

48. Mussies, "*Interpretatio Judaica*," 98 n. 32. See also Goodenough, *Jewish Symbols*, West Wall, 5, and 13, on Moses as a Philonic hierophant, 110–23. Goodenough quotes the prayer of Philo to Moses, which begins "Oh thou hierophant"; Goodenough illustrates this Isaic *Hierophant* (fig. 99) reading from a sacred scroll (*hieros logos*). See the representation of Moses in a Greek himation in the third-century C.E. wall paintings of the synagogue at Dura-Europos, illustrated in Goodenough, *Jewish Symbols*, 11, 164–65.

49. Mellinkoff, "Round, Cap-Shaped Hats," 155–65.

50. Ibid., 157 n. 4.

51. See n. 37 above.

52. As discussed in Leipoldt and Morenz, *Heilige Schriften*, 89 nn. 4, 5; and figs. 5, 6. See also Assmann, *Tod und Jenseits*, 193.

53. Wildung, *Saints*, 70.

54. Ibid., 32–33, 67.

55. Illustrated in Bakry, "A Statue of Pedeamūn-Nebnesuttaui," 15–25. I would especially like to thank Wendy Doremus and Kamal Tamraz for their help obtaining a photograph of this statue from the Museum of Egyptian Antiquities, Cairo, Egypt.

56. See Rowe, "New Excavations," 2, 21–22, fig. 1; also Venit, *Monumental Tombs*, 138, fig. 117.

57. See Badawy, *Coptic Art*, 247. For a color photograph of a sixth-century C.E. carving on the interior of the Isis temple at Philae in Egypt, see Capuanni, *Christian Egypt*, 250. See Trombley, *Hellenistic Religion*, 227–28 n. 112, for evidence of the office of *pterophoros* existing through 435 C.E.

58. *Contra Apionem*, Thackery, 1, 288–90. More exactly, Josephus says that Chaeremon calls them "sacred scribes." On Josephus's use of the term *hierogrammateus*, see Castastini, "'Hierogrammateus,'" 133–37. See also Feldman, *Jew and Gentile*, 239–40.

59. Further on the importance of Manetho and his *Aegyptiaca*, see Moyer, *Egypt and the Limits of Hellenism*, 84–141.

60. See Gager, *Moses*, 120–22. See also van der Horst, *Chaeremon*, 8–10 passim. For a comprehensive overview of ideas about Moses in the Greco-Roman/early Christian, Jewish, and non-Jewish literary and iconographic sources, see Lehnhardt, "Mose I (literarisch)," 58–102; and Heydasch-Lehmann, "Mose II (Ikonographie)," 102–15. Neusner, "Judaism at Dura-Europos," 93, quotes at length from Goodenough's description of Moses in the paintings on the west wall of the third-century C.E. Dura synagogue, where he says of Moses (*Jewish Symbols in the Greco-Roman Period*, X, 137–38), "He reads the mystic law like the priest of Isis alongside the closed Temple and the all-conquering Ark."

61. On the *Hermetica* in general, see Fowden, *Egyptian Hermes*.

62. Ibid., esp. 205–11. Further on the *Hermetica*, Casaubon, and Lactantius, see Yates, *Giordano Bruno*, 399–404.

63. See Bettenson, *The City of God*, 812–13.

64. On the apologetic project of Tatian and others that Moses antedates all the pagan gods and philosophers, see Young, "Greek Apologists," 81–104.

65. Clement, in "The Exhortation to the Greeks," Butterworth, *Clement of Alexandria*, 50–51, refers to Moses as the "sacred interpreter" ("hierophant"). Further on Clement's understanding of Moses, see Ashwin-Siejkowski, *Clement of Alexandria*, 45–48 passim. Philo refers to Moses as the "interpreter of the sacred laws" (*hermēneos nomōn hierōn*); see Meeks, *Prophet-King*, 107; also Feldman, *Philo's Portrayal*, 297–307. Further on the idea of Moses as "interpreter," see Wieder, "The 'Law Interpreter,'" 158–75. Clement, who utilized Philo to a large extent as a source in the *Stromata* (see van Den Hoek, *Clement*), says of Moses (*Stromata*, 23), "He was a theologian and a prophet, and as some say, an interpreter of sacred laws." Mercury (Hermes) was called by Virgil an interpreter of the gods (*interpres divum*). Plato in *The Republic*, Ferrari, ed., bk. 4, refers to Apollo as "the interpreter of religion to all mankind." Holladay, "Portrait of Moses," 10, demonstrates that in Ezekiel's *Exagoge*, 452, "Sinai replaces Delphi . . . [and] . . . Moses replaces Apollo" as the "spokesman for God"; van der Horst, "Moses' Throne Vision," 28, referring to Holladay's paper, says, "Here Moses is modeled on Apollo, Zeus' spokesman sitting on a mantic throne."

66. On the mosaics of S. M. Maggiore, see Brenk, *Die frühchristlichen Mosaiken*. Brenk, *Mosaiken*, 79, concurs with Richter and Cameron, *Classic Christian Art*, 159, that this scene and the scene of the Adoption of Moses in the Santa Maria Maggiore mosaics may have

been based on some Philonic-inspired Jewish Hellenistic prototype. On this particular scene, see Prigent, *Le Judaïsme et l'image*, 298 n. 182; see also Kogman-Appel, "Bible Illustration," 74–75.

67. Brenk, *Die frühchristlichen Mosaiken*, 77–80. See also Sande, "Egyptian and Other Elements," 77–79.

68. Chaeremon, who was himself a *hierogrammateus*, was of an inferior rank compared to Manetho, who was an *archierus*, or high priest. See also Orton, *Understanding Scribe*, esp. 59–61, 108–10, for a detailed discussion of various aspects of the status of scribes in the different ranks. The Roman satirist Juvenal mentions an Egyptian sacred scribe Petosiris as a charlatan in his *Satire* (6.580). St. Augustine, in his *Enarrationes in Psalmos* (56.9), has this pejorative assessment of the relationship of Jewish scriptures and tradition to Christianity: "The Jew carries the book from which the Christian takes his faith. They have become our librarians, like slaves who carry books behind their masters; the slaves gain no profit by their carrying, but the masters profit by their reading," as quoted by Miles, "Santa Maria Maggiore's," 70. The idea of the somewhat humbler status of the *grammateus* as "secretary," "scribe," or "clerk" is discussed by Monfasani, "Aristotle as Scribe," esp. 196–97.

69. See Withers *Hexateuch*, 144–55.

70. See Mellinkoff, *Horned Moses*, 6 and fig. 7, fol. 254v of Rome, Bibl. Apost., MS Vat. Gr. 746.

71. Cornford, *The Republic*, 118.

72. On the omphalos itself, see Holland, "Mantic Mechanism," 204–14; see also Barb, "*Diva Matrix*," 200; for an illustration of the omphalos at Delphi, see Wycherley, *Pausanias*, V, pl. 76.

73. For numismatic examples of Apollo seated on the omphalos, see Ackerman and Gisler, *Lexicon*, 2/2 #306, a fourth-century B.C.E. *stater* of Delphi; and #459, dating to the third century B.C.E., where Apollo is seated on a *Netzomphalos*, with its reticulated "bumps."

74. On Midrash Tanhuma (reference is to Ezek. 38:12), see Lauterbach, "*Tanhuma, Midrash*," 12, 45–46.

75. See Ameisenowa, "Tree of Life," 333.

76. See Wright, *Geographical Lore*, 53–57.

77. On Moses as Musaeus, see van Kooten, "Moses/Musaeus/Mochos," 107–38.

78. See ch. 4, nn. 145, 146. Pan, interestingly enough, was said to have the power of inspiration and prophecy and to have instructed Apollo in these important matters. See Schoff, "Tammuz, Pan and Christ," 517.

79. See Edwards, "Atticizing Moses?," 67.

80. See Barnhouse, "Text and Image," 20 n. 5. On the Smyrna Octateuch itself, see Weitzmann and Bernabò, *Byzantine Octateuchs*.

81. See Ginzberg, *Legends of the Jews*, 3, 119.

82. Ibid., 3, 147.

83. Ibid., 6, 59 n. 30.

84. The "sapphire" referred to in these and other texts is not the modern sapphire, as that stone was apparently not actually known to the ancient world, but rather is to be understood as lapis lazuli. See Bunta, "In Heaven or on Earth," 39 n. 51.

85. See ch. 4. Heath, "Homer or Moses?," 1, makes a case for the influence of contemporary visual imagery from the immediate environment, coins, sculpture, etc., on Ezekiel's literary imagery: "Moses' throne vision has strong visual appeal, yet its relationship to contemporary material culture has been absent from the wide-ranging scholarly debate on this scene."

86. See note 25 above. Further on the mines of Serabit el-Khadim, associations with the goddess Hathor, the presence of numerous large, round-topped stelae, and the so-called *protosinaitische Schrift* found there and discussed by the British Egyptologist Flinders Petrie and later by Alan Gardiner, see Lehman, *Moses: Der Mann aus Ägypten*, 160–64. On the possible connection between Moses and Serabit el-Khadim, see Cazelles, *À la recherche*.

87. Bischoff and Lapidge, *Biblical Commentaries*, 349; emphasis mine.

88. Ibid., 199–201, 233–40.

89. Ibid., 389.

90. See Barnhouse, *Text and Image*, 201–3. Mellinkoff, "Serpent Imagery," 52, notes that the serpent-headed staff has "small dog-like ears."

91. On the *was* scepter, see Martin, "*Wās.*"

92. Aldred, "Dendur," fig. 15.

93. For an example of a *carynnx* on the reverse of a Roman first-century B.C.E. silver denarius, see Broderick, "Veil of Moses," 279, fig. 7. For an actual first-century B.C.E. Celtic example, see Farley and Hunter, *Celts*, fig. 75.

94. Quoted in Charlesworth, *Pseudepigrapha*, 2, 902; emphasis mine.

95. Mellinkoff, "Round-Topped Tablets," 28–37.

96. Ibid., 28–29.

97. Illustrated in Manaphēs, *Sinai*, 110, fig. 35.

98. See Brown, "Eastwardness of Things," 17–49.

99. Withers, *Hexateuch*, 153, quotes Ælfric in his *Preface to Genesis* linking the idea of the unity of the two testaments, one old and the other new, to the human body's "two eyes and two ears, two nostrils, and two lips, two hands and two feet."

100. Mellinkoff, "Round-Topped Tablets," 36–37.

101. Ibid.

102. See Brown, "Role of the Wax Tablet," 1–16; see also Rouse and Rouse, "Wax Tablets," 175–91. There are also examples of round-topped wooden tablets from ancient Egypt; see Sauneron, *Les prêtres*, 69.

103. Illustrated in Shanks, "Is This Man a Biblical Archeologist?," 36. It should be noted as well that on this stele and that of the so-called Restoration of the Theban Temples, also in the Cairo Museum, the two vertical feathers on the crown of the god Amun are very tall, like those in the images of the horned Moses in Claudius B.iv after their initial appearance on folio 105v. For the "Restoration" stele, see fig. 81 in Desroches-Noblecourt, *Tutankhamen*, 135. For additional images of the Merneptah Stele and the so-called Moabite Stone of ca. 850 B.C.E. in the Louvre, see Phillips, *The Moses Legacy*, 88.

104. Mellinkoff, *Horned Moses*, 4, figs. 2, 4.

105. On the cult of Melqart-Hercules, see Mettinger, *No Graven Image?*, 95–100, esp. figs. 5.5, 5.6.

106. See Neudecker, "Cippus."

107. See Martin, "Stele," 1: "Der häufig bogenförmige obere Abschluss der Stele ahmt das Himmelsgewölbe nach."

108. Wildung, *Saints*, 70.

109. As described in Leipoldt and Morenz, *Heilige Schriften*, 89 n. 3.

110. Illustrated in von Dassow, *Egyptian Book of the Dead*, pl. 22.

111. Wolska-Conus, *La topographie chrétienne;* and Wolska-Conus, *Cosmas Indicopleustes*, 121–27. See also Anderson, *Christian Topography;* and Kominko, *World of Kosmos*, 42–52.

112. Roberts and Donaldson, *Ante-Nicene Fathers*, 2, 511; emphasis mine.

113. Ibid.

114. Mellinkoff, *Horned Moses*, 82–83. In a review of Mellinkoff's *Horned Moses*, McCulloch suggests that Isidore himself may have been influenced by the earlier text of the *Physiologus* (ca. end of second century C.E.) where the antelope's (or ibex's) two horns are said to signify the two Testaments. In connection with the *Physiologus* text on this point, see Brown, "Paten and Purpose," 162–67.

115. Mellinkoff, *Horned Moses*, 98.

116. Henderson, *Early Medieval*, 178–79.

117. Ibid.,179.

118. See Avner, "Sacred Stones," 31–41.

119. Withers, *Hexateuch*, 149.

120. Philo makes this point in his *Questions and Answers on Exodus*, Marcus, 2, 83 (41): "Why are the commandments written on 'tablets of stone'? Tablets and written documents are hand-made things and what is written in them is easily destroyed, for in tablets there is wax, which is easily rubbed away, and in papyrus-rolls the writing is sometimes spread out and sometimes seems obscure."

121. See color pl. XX, p. 66, in Backhouse, *Golden Age.*

122. On the "Kopf mit der Binde," see Hoffmann, *Taufsymbolik*, 89–91, fig. 51.

123. See the article "Vittae," in Daremberg-Saglio, *Dictionnaire*, 5, 950–57.

124. See the article "Infula," in Daremberg-Saglio, *Dictionnaire*, 3/1, 515–16.

125. Ibid., 953.

126. Bonnefoy, *Mythologies*, 568.

127. Daremberg-Saglio, *Dictionnaire*, 951.

128. Ibid.

129. Illustrated in Lippold, *Skulpturen des Vaticanischen Museums*, 3/2 Tafeln, pl. 123 (I) 40. See also Venit, "Tomb from Tigrane Pasha," fig. 25, 726–28. On a carved relief from Ostia, illustrated in Alföldi-Rosenbaum, "Kaiserpriester," 38, fig. 5, is represented a priest of the goddess Cybele, called an "Archigallus," shown wearing a diadem-like crown from which extend two vertical hornlike ornaments. Four nude male figures representing the seasons on the so-called Badminton sarcophagus, a third-century C.E. carved marble Roman work of very high quality in the Metropolitan Museum of Art, New York, are depicted with rolled diadems on their heads; the figure of Summer directly to the right of the seated Dionysos on the sarcophagus displays hornlike vertical "sprigs" similar to those

of the "Archigallus" on the Ostia relief cited just above. See Alexander, "Roman Sarcophagus," 43.

130. On the suffering of Moses, see Feldman, *Philo's Portrayal*, 289–91.

131. Illustrated as color pl. IV, 56–63, in Parker and Little, *Cloisters Cross*. The earliest extant representation in art of the Brazen Serpent is found on folio 25r of the sixth-seventh century C.E. so-called Syriac Bible of Paris (Paris, Bibliothèque nationale, syr. 341), illustrated as fig. 47 in Sörries, *Christliche-Antike*, 87–89, but it is completely different from how the serpent is represented in Claudius B.iv. See Graepler, "Eherne Schlange." On the possible occurrence of brazen serpent imagery in the seventh-century Anglo-Saxon Staffordshire Hoard, see Brown, "Mercian Manuscripts," 23–66.

132. Illustrated in Broderick, "Veil of Moses," fig. 3.

133. Philo, Colson and Whitaker, *Philo, Allegorical Interpretation* 2 (77–87), 275–76.

134. Mellinkoff, "Serpent Imagery," 51–64, fig. 3,

135. See Gibson, *Liverpool Ivories*; illustrated as item 133 in Weitzmann, *Age of Spirituality*, 155–56.

136. Ackerman and Gisler, *Lexicon*, 2/2, 884 (#264).

137. Ibid., 879 (#267); also in the Vatican Museum, 879 (#157).

138. See D'Aronco and Cameron, *Old English Illustrated Pharmacopoeia*. Illustrated in Temple, *Anglo-Saxon Manuscripts*, fig. 188.

139. Voights, "One Anglo-Saxon View," 9; see also Voights, "A New Look," 40–60.

140. Justin Martyr, *Dialogue with Trypho*, 69, in Coxe, ed., *Ante-Nicene Fathers*, 1; emphasis mine.

141. On Imhotep, see Sethe, *Imhotep der Asklepios der Aegypter*.

142. On the relationship of Thoth-Hermes and Imhotep in the Greco-Roman period, see Silver, *Images of Moses*, 84.

143. Gameson, *Role of Art*, 172 and n. 104, remarks on Moses's great size in this illustration in contrast to a similar image of Moses in the ninth-century San Paolo Bible (Rome, Abbazia di San Paolo fuori le Mura) to which the Hexateuch image is often compared (see Swarzenski, *Monuments*, pls. 58–59). Although the author makes no specific mention of Moses as a giant, see Cohen, *Of Giants*, 17–28, in reference to the idea of giants in Anglo-Saxon culture in general.

144. Kraeling, *Synagogue*, 82 n. 242, as cited by Goodenough, *Jewish Symbols*, 10, 119 n. 82.

145. Ibid.

146. As in note 121 above.

147. I owe this observation to my colleague Forrest Colburn. It is also significant that Isis priests were barefoot during ceremonies (see Lafaye, *Histoire du culte*, 137), as was the high priest in the Jewish temple. On this point, see Weitzmann and Bernabò, *Byzantine Octateuchs*, 178. Weltin, "Quid Athenae," 158, in commenting on the concept of *imitatio diabolica*—the idea that pagan *daemons* consciously adumbrated Jewish and Christian beliefs and rites by "stealing" them and "recycling" them as their own—reflects Justin Martyr's claim in I *Apology*, 62: "Priests of pagan religions took off their shoes when entering their temples because they had heard of Jahweh's words to Moses: 'Put off thy shoes.'" Origen, in his *Exodus Homily XII*, says of Moses, "In the Law, therefore, Moses has only his face glorified;

his hands have no glory, nay rather they have even reproach; nor do his feet have glory. He is ordered to remove his sandal, so there was no glory in his feet." Further on the "barefootedness" of Moses, see Tigchelaar, "Bare Feet and Holy Ground," 17–36. See also Moro, *I sandali di Mosè*.

148. See Hall, "Moses and the Church Fathers," 97. Further on this topic, see Watson, "Gregory of Nyssa's Use of Philosophy," 101–2, discussing Gregory's interpretation of God's command to Moses to remove his sandals as related to removing the "dead and earthly covering of skins" that was placed around human nature at the fall of Adam and Eve.

149. Moses's horns are depicted with various colors in Claudius B.iv, beginning as yellow on folio 105v (fig. 10), becoming reddish-brown on folio 136v (fig. 18), a reddish-pink on folio 138v (fig. 12), and finally blue on folio 139v (fig. 14). While his blue horns on folio 139v may at first seem the most outlandish, perhaps simply an aesthetic whim of the artist, blue is often associated specifically with several Egyptian gods, most notably Amun, who is often represented as having blue skin; see Sethe, "Amun und die Acht Urgötter," 101–19. At Tuna el-Gebel in the wall paintings of Maison 21 where Amun is depicted carrying the symbol for the "breath of life" (fig. 26), the god Horus is depicted with a blue body, Anubis is shown with a blue hair wig, and the seated Osiris has blue feathers on either side of his *atef* crown; illustrated in color in Gabra, *Rapport*, pls. 25–27. Griffith, "God's Blue Hair," 329–34, discusses the Homeric motif of Zeus and other celestial gods in ancient Greek texts and art as well as ancient Egyptian art as having blue hair and eyebrows.

EIGHT Conclusion: All Horns/No Hats

1. The presence of this extrabiblical scene in the Byzantine Octateuchs of the eleventh and twelfth centuries C.E., themselves based on much earlier exemplars, contributes an additional connection to this venerable cycle of Old Testament illustrations demonstrated in other examples by Henderson, *Studies*, 1, 76–215.

2. See Feldman, *Philo's Portrayal*, 342.

3. See Colson, *Legatio ad Gaium*, 1 (91–96), 47–48. On this phenomenon, see the description and analysis of Scott, "Plutarch and the Ruler Cult," 117–35. Ephippus of Olynthus, a contemporary of Alexander the Great, is quoted by Athenaeus that "Alexander used to wear sacred clothing during his dinners, sometimes the purple robe of Ammon, the shoes and horns, like the god"; see Collins, "The Royal Costume," 377. See also Edmunds, "The Religiosity of Alexander," 380; and Nock, "Notes," 25.

4. See Colson, *Legatio ad Gaium*, 1 (79), 41.

5. See Colson and Whitaker, *De gigantibus*, Philo, 2 (13, 59).

6. See Feldman's remarks, *Judaism and Hellenism*, 4, about the influence of Philo on these Christian Church Fathers. For an in-depth analysis of the meaning(s) of Moses in the apologetic/historical project of Eusebius, see the important study by Damgaard, *Recasting Moses*, esp. 125–35, 153–81.

7. The situation with the unique and "exotic" attributes of Moses in Claudius B.iv is analogous to the equally puzzling image on folio 19r of London, British Library Cotton MS Vittellius CIII (in Temple, *Anglo-Saxon Manuscripts*, 115–17, fig. 188), an illustrated Old

English pharmacopeia, where the figures of the putative author Aesculapius in the company of the centaur Chiron and the philosopher Apuleius Platonicus are depicted without discernible prototypes, as D'Aronco observes in notes to the EEMFS facsimile, *Old English Illustrated Pharmacopeia*, 27, stating, "The three figures are strongly archaistic and suggest that the Anglo-Saxon artist, although innovating upon the tradition by fusing different figures and subjects into a single scene, must have used models that were either very old or that reproduced other models dating from classical or late classical antiquity." On this idea of classical or late classical models on which the image may have been based, see also Voights, "One Anglo-Saxon View," 3–16. Thus far, no immediate prototypes for these striking figures have been discovered. However, because earlier *comparanda* are no longer extant does not invalidate the possibility that such protoypes did exist, especially as unusual iconographic or stylistic *Spuren* (traces) are present as in Vittellus CIII and Claudius B.iv. For a detailed account of the survival of "pagan" mythology in later Early Christian and Byzantine art, see Weitzmann, "Survival," 43–68. See also Seznec, *Survival.*

 8. See ch. 7 above. Again, in reference to the observation by Webster, "Imagining Identities," 47, following Meyvaert's hypothesis that Bede himself, possibly based on a reading of Josephus's *Antiquitates*, executed the addition of the priestly frontlet to the image of the seated Ezra on folio Vr of the Codex Amiatinus, that there is "the possibility of an Anglo-Saxon interest in and visualization of the high priest's insignia," I have suggested that as Amiatinus had long been in Italy before Claudius B.iv was being illustrated, it is more likely that the image of Moses wearing the insignia of the biblical high priest might have been found in an exemplar or model being utilized by the Claudius B.iv artists than to have been invented by them as they would not have had access to the kind of texts (such as the late Hellenistic Jewish and non-Jewish apologists) that had presented Moses as a hierophant, or high priest, as he is not characterized as such in the Bible, unlike Bede, who, according to Meyvaert, had access to the text of 3 Ezra, where there are several references to Ezra as *pontifex*/high priest.

 9. These two works, for example, do not appear in Lapidge, *Anglo-Saxon Library.*

 10. On Theodore and Hadrian's sources for their commentaries, see Bischoff and Lapidge, *Biblical Commentaries*, 190–242.

 11. Foley, "Archbishop Theodore," review, 671.

 12. As suggested by Henderson, "Losses and Lacunae," 5, "The contribution of Theodore, his bringing of fine continental manuscripts, must have been significant." See also Dumville, "The Importation of Mediterranean Manuscripts," 96–119.

 13. On the general topic of religious propaganda in Hellenistic Judaism and early Christianity, see the essays in Fiorenza, *Aspects of Religious Propaganda.*

 14. See Roullet, *Egyptian and Egyptianizing Monuments.*

 15. See, for example, the depiction of an Isiac *hierogrammateus* with two feathers on his head from the Isis temple at Pompeii (VIII, 7, 28, Soprintendenza per I Beni Archeologici delle Province di Napoli e Caserta, inv. 8925) illustrated in Arslan, *Iside*; also Tam Tinh, *Le culte des divinités*, 27–35. A number of small, enigmatic details in the Claudius B.iv illustrations seem to echo Isiac details, for example, a peculiar-looking staff, or wand, being held by Joseph's steward on folio 64r, which resembles an equally enimagtic staff, or wand,

being held by a standing female figure in a painting of an Isaic procession from the Casa del Centenario in Pompeii. The figure is illustrated in DeVos, *Il'egittomania in pitture*, 41, fig. 21, where the figure is described as carrying a "caduceo."

16. See Bergman, *Salerno Ivories*, 13, 18, 25, 28–30, 34, 45–46.

17. On the various aspects of the evaluation of the style of the Claudius B.iv illustrations, see Withers, *Hexateuch*, 53–85. See also Withers, "A Sense of Englishness." Gameson, *Role of Art*, 69, for example, characterizes the artists of Claudius B.iv as "mediocre." More work needs to be done to gain a better understanding of the style of the Claudius B.iv illustrations and possible connections with Amalfitan works such as the Farfa Casket illustrated in Bergman, *Salerno Ivories*, fig. 154, and the ivory crucifixion plaque, fig. 158, in the Metropolitan Museum of Art, New York. On the ivories, see Bologna, *L'Enigma degli avori*, 2 vols.

18. See Wright, *Roman Vergil*; see also Sörries, *Christliche-Antike*, 123–24, 127–30.

19. See the important article by Budny, "Biblia Gregoriana," 237–84; see also Marsden, "Gospels of St. Augustine."

20. See Gameson, *Earliest Books of Canterbury*; Gameson, "Manuscript Art at Christ's Church," 187–220; Gameson, "Earliest Books of Christian Kent," 313–74; Gameson, "Context and Achievement," 29; see also Lapidge, *Anglo-Saxon Library*.

21. Grafton, *Bring Out Your Dead*.

22. Interest in Panofsky and his philosophy of interpretation as one of the "founding fathers" of art history has seen a renaissance of late. See Holly, *Panofsky*; Michels, *Transplanteierte Kunstwissenschaft*. The most trenchant criticism of Panofsky's methodology is to be found in the publications of Keith Moxey. See in particular Moxey, "The Politics of Iconology," 27–31; and "Semiotics and the Social History of Art," 985–99; see also Lang, "Chaos and Cosmos," 47–70.

23. On the concept of bricolage, see Derrida, *Writing and Difference*, 278–94.

24. On the idea of the *cento*, see McGill, *Virgil Recomposed*.

25. Tertullian, *De prescriptione haereticorum*, 39.

26. Irenaeus, *Adversus haereses*, 1.9.4:4.

27. On this work of Clement's, see Itter, *Esoteric Teaching in the "Stromateis,"* 15–31.

28. See Boylan, *Thoth* (1922), 150 n. 4: "The speculations of Voelter are often highly ingenious, but they are, for the most part, quite out of relation with facts and do not deserve to be seriously discussed." Boylan makes this remark after having said that students of the history of religions are probably familiar with "Voelter's attempt to argue from the presence of Thoth-worship in Sinai to [make] a connection between the Hebrew leader Moses and Thoth." He seems, however, to be unaware of the fact that that is precisely what Eusebius reports in his borrowing of Artapanus's assertion that the Egyptians themselves saw this link between the two. Whether that was in fact a historical reality is not in question when it is a matter of Assmann's "mnemohistory," the visual equivalent of which I have explored here. The more recent studies of Manfred Görg, *Ägyptiaca-Biblica* (1991) and *Die Beziehungen* (1997) and, most recently, Noegel, "Egyptian Origin of the Ark of the Covenant," 223–42, have argued for more direct connections between ancient Israel and Egypt than scholars such as Boylan would permit.

29. Gameson, "Study of Early British Books," 719.

30. Similarly, Bernabò writes in Weitzmann and Bernabò, *Byzantine Octateuchs*, I, 8, "No Middle Byzantine painter can be credited with the invention of such rare and bizarre iconographies as the renowned case of the camel-like serpent tempting Eve which does not appear in Byzantine sources."

31. On the later development in the Middle Ages of anti-Semitic aspects of the horns of Moses, see Mellinkoff, *Horned Moses*, 121–37.

32. See Panofsky, *Studies in Iconology*, 3–5, where Panofsky begins his classic study of iconography by invoking the example of an acquaintance who greets him on the street by removing his hat. Panofsky goes on to say, "Neither an Australian bushman nor an ancient Greek would be expected to realize that the lifting of a hat is not only a practical event with certain expressional connotations, but also a sign of politeness. To understand this significance of the gentleman's action I must not only be familiar with the practical world of objects and events, but also with the more-than-practical world of customs and cultural traditions peculiar to a certain civilization."

33. Ibid., 7.

34. As commented on by Mellinkoff, *Horned Moses*, 131–36.

35. See, e.g., Bertman, "Anti-Semitic Origin," 1–11. In other contexts, especially on-line, persistent interpretations suggesting that Jerome made a "mistake" in translating the Hebrew verb *qāran* as "was horned" sometimes have a subtle anti-Semitic tone, as in the statement on the website of Grace Church of Sacramento, California: "A Bible translator might therefore understand this verb from Exodus 34:29, much like the noun, as referring to literal animal horns or to something like light radiating from Moses' face. Jerome decided on the former. . . . Thus in their (Latin) Bible, Moses had animal horns! (Jerome lived in Palestine, Bethlehem, while he did his translation. I hope an unbelieving Hebrew teacher did not perpetuate this prank!)" (www.gracesacramento.org). The author continues, "St. Augustine (354–430 A.D.), an expert in Latin confessed: 'A Christian teacher who is to expound the Scriptures must know Greek and Hebrew in addition to Latin. Otherwise, it is impossible to avoid constant stumbling." He concludes this exposition by saying, "Otherwise, Moses ends up with animal horns!" Interestingly, on his way to becoming a ubiquitous symbol of evil and the satanic, some time in the fifteenth century in Italy, Attila, king of the Huns, was given a pair of double-curved goat horns on a number of bronze medals; see the article signed E.W.H. in *American Journal of Numismatics* 11.1 (1876): 7.

36. And remain so to this day. In any number of contemporary graphic images, one only has to add horns to the head of a figure to transform it into something totally evil. See, for example, Angelina Jolie's character in Disney's 2014 film *Maleficent*, wearing double-curved upward-pointing horns quite similar to those on Moses's head on fol. 105v of Claudius B.iv, although they are black rather than yellow. See also the classic study of Trachtenberg, *The Devil and the Jews*. While not concerned specifically with the horns of Moses, the overview of the general issue of historic anti-Semitism provided by Wistrich, *Demonizing the Other*, 1–16, is quite useful. On the situation of Jews in Anglo-Saxon England, see Scheil, *Footsteps of Israel*.

37. See Freedberg, *Power of Images*.

38. One might also wonder how Pharaoh's daughter recognized Moses as a child of the Hebrews (Exod. 2:6), but *Midrash Exodus Rabbah* 1:20, 24, says that she recognized that the child was a Hebrew because he was circumcised. See also Feldman, *Philo's Portrayal*, 43, on this topic where he refers to rabbinic tradition that Moses was born circumcised. In Cecil B. DeMille's 1956 film, *The Ten Commandments*, Zipporah, Jethro's (Raguel's) daughter and later Moses's wife, sees a strange man sleeping under a palm tree and points him out to her six sisters. The young women speculate about his origins, as he is wearing Egyptian sandals (whatever those might be) but not an Egyptian-style robe.

39. On the subject of writing in the Book of Deuteronomy, see Sonnet, *The Book within the Book*.

BIBLIOGRAPHY

Ackerman, Hans C., and Jean-Robert Gisler, eds. *Lexicon Iconographicum Mythologiae Classicae.* 18 vols. Zurich: Artemis, 1981–99.

Adler, William. "Alexander Polyhistor's *Peri Ioudaiōn* and Literary Culture in Republican Rome." In *Reconsidering Eusebius*, edited by Sabrina Inowlocki and Claudio Zamagni, 225–40. Leiden: Brill, 2011.

Aejmelaeus, Anneli. *On the Trail of the Septuagint Translators.* Leuven: Peeters, 2007.

Agaësse, Paul, and Aimé Solignac, trans. *La genèse au sens littéral en douze livres (I–VII).* Paris: Desclée de Brouwer, 1972.

Agosti, Gianfranco. "Contextualizing Nonnus' Visual World." In *Nonnus of Panopolis in Context*, edited by Konstantinos Spanoudakis, 141–74. Berlin: Walter de Gruyter, 2014.

Aldred, Cyril. "The Temple of Dendur." *Bulletin of the Metropolitan Museum of Art* 36.1 (1978): 1–80.

Alexander, Christine. "A Roman Sarcophagus from Badminton House." *Metropolitan Museum of Art Bulletin* (1955): 39–47.

Alexander, Jonathan J. G. "Facsimiles, Copies, and Variations: The Relationship to the Model in Medieval and Renaissance European Illuminated Manuscripts." *Studies in the History of Art* 20 (1989): 61–72.

———. *Insular Manuscripts, 6th to the 9th Century.* London: Harvey Miller, 1978.

———. *Medieval Illuminators and Their Methods of Work.* New Haven, CT: Yale University Press, 1992.

Alexander, Jonathan J. G., et al., eds. *Francis Wormald: Collected Writings.* 2 vols. London: Harvey Miller, 1984, 1988.

Alföldi, Andreas. *A Festival of Isis in Rome under the Christian Emperors of the Fourth Century.* Budapest: Institute of Numismatics and Archaeology of the Pázmány University, 1937.

Alföldi-Rosenbaum, Elisabeth. "Kaiserpriester." In *Spätantike und frühes Christentum*, edited by Herbert Beck et al., 34–40. Frankfurt am Main: Das Liebieghaus, 1983.

Al-Hamdani, Betty. "The Genesis Scenes in the Romanesque Frescoes of Bagüés." *Cahiers archéologiques* 23 (1974): 169–94.

Allen, J. "Ezekiel the Tragedian." *Journal for the Study of the Pseudepigrapha* 17 (2007): 3–19.

Allen, Stephen. *Celtic Warrior, 300 B.C.–A.D. 100.* Oxford: Osprey Publishing, 2001.

Allen, Susan H. "Dionysiac Imagery in Coptic Textiles and Later Medieval Art." In *The Classics in the Middle Ages: Papers of the Twentieth Annual Conference of the Center for Medieval and Renaissance Studies*, edited by Aldo S. Bernardo and Saul Levin, 11–24. Binghamton, NY: Center for Medieval and Renaissance Studies, 1990.

Alter, Robert. *The Five Books of Moses: A Translation with Commentary*. New York: W. W. Norton, 2004.

Ambrose. *Explanatio psalmorum, XLVI. Corpus Scriptorum Ecclesiasticorum Latinorum* 64, 1999.

Amedick, Rita. "'Iesus Nazarenus Rex Iudaiorum': Hellenistische Königsikonographie und das Neue Testament." In *Picturing the New Testament: Studies in Ancient Visual Images*, edited by Annette Weissenrieder, Friederike Wendt, and Petra von Gemüden, 53–66. Tübingen: Mohr Siebeck, 2005.

Amelung, Walter. *Die Sculpturen des vaticanischen Museums*. 1. Berlin: Walter de Gruyter, 1995.

Anderson, Andrew R. "Alexander's Horns." *Transactions and Proceedings of the American Philological Association* 58 (1927): 100–122.

Anderson, F. I. "2 (Slavic Apocalypse of) Enoch." In *The Old Testament Pseudepigrapha*, 1, edited by James H. Charlesworth, 170–71. Garden City, NY: Doubleday, 1983.

Anderson, Jeffrey C., ed. *The Christian Topography of Kosmos Indikopleustes: Firenze, Biblioteca Medicea Laurenziana, Plut. 9.28*. Rome: Edizioni di Storia e Letteratura, 2013.

Anlezark, Daniel. "Abraham's Children: Jewish Promise and Christian Fulfilment." In *Imagining the Jew in Anglo-Saxon Literature and Culture*, edited by Samantha Zacher, 131–55. Toronto: University of Toronto Press, 2016.

———. *Old Testament Narratives*. Cambridge, MA: Harvard University Press, 2011.

———. *Water and Fire: The Myth of the Flood in Anglo-Saxon England*. Manchester: Manchester University Press, 2006.

Arslan, Ermanno A., et al. *Iside: Il Mito, il Mistero, la Magia*. Milan: Electa, 1997.

Ashwin-Siejkowski, Piotr. *Clement of Alexandria: A Project of Christian Perfection*. London: T & T Clark: 2008.

Assmann, Jan. "Mono-, Pan-, and Cosmotheism: Thinking the 'One' in Egyptian Theology." *Orient* 33 (1998): 130–49.

———. *Moses the Egyptian: The Memory of Egypt in Western Monotheism*. Cambridge, MA: Harvard University Press, 1997.

———. *Tod und Jenseits im alten Ägypten*. Munich: Verlag C. H. Beck, 2003.

Athanassakis, Apostolos N., and Benjamin M. Wolkow. *The Orphic Hymns: Translation, Introduction, and Notes*. Baltimore, MD: Johns Hopkins University Press, 2013.

Auslander, Shalom. "Grabbing Life by the Horns." *New York Times Sunday Magazine*, December 18, 2011, MM66.

Avner, Uzi. "Sacred Stones in the Desert." *Biblical Archaeology Review* 27.3 (2001): 30–41.

Bacher, Wilhelm. "Targum." In *The Jewish Encyclopedia*, edited by Isidor Singer, 13:57–63. New York: Funk and Wagnalls, 1906.

Backhouse, Janet, et al. *The Golden Age of Anglo-Saxon Art: 966–1066*. London: British Museum Publications, 1984.

Badawy, Alexander. *Coptic Art and Archaeology: The Art of the Christian Egyptians from the Late Antique to the Middle Ages*. Cambridge, MA: MIT Press, 1978.

Bagnall, Roger. *Egypt in Late Antiquity*. Princeton, NJ: Princeton University Press, 1993.

———. *Egypt in the Byzantine World, 300–700*. Cambridge: Cambridge University Press, 2007.

Bailey, Nathaniel. *The New Universal Etymological English Dictionary*. London: Waller, 1756.

Bakry, H. S. K. "A Statue of Pedeamūn-Nebnesuttaui." *Annales du service des antiquités de l'Egypte* 60 (1968): 15-25.

Baldwin, Robert. "Anguish, Healing and Redemption in Grünewald's Isenheim Altarpiece." *Sacred Heart University Review* 20.1 (2000): 81-91.

Barb, Alphonse, A. "Cain's Murder-Weapon and Samson's Jawbone of an Ass." *Journal of the Warburg and Courtauld Institutes* 53 (1972): 386-89.

———. "Diva Matrix: A Faked Gnostic Intaglio in the Possession of P. P. Rubens and the Iconology of a Symbol." *Journal of the Warburg and Courtauld Institutes* 16 (1953): 193-238.

Barclay, John M. G. "Manipulating Moses: Exodus 2.10-15 in Egyptian Judaism and the New Testament." In *Text as Pretext: Essays in Honour of Robert Davidson*, edited by Robert P. Carroll and Robert Davidson, 28-46. Sheffield: Journal for the Study of the Old Testament Press, 1992.

Barker-Benfield, Bruce. *St. Augustine's Abbey, Canterbury*. 3 vols. Corpus of British Medieval Library Catalogues, 13. London: British Library in association with the British Academy, 2008.

Barnard, L. W. "The 'Epistle of Barnabas' and Its Contemporary Setting." In *Aufstieg und Niedergang der Römischen Welt*, Teil 2, 17, edited by Wolfgang Haase et al., 69-72. Berlin: Walter de Gruyter, 1993.

Barnes, Jonathan. *Porphyry's "Introduction," Translated with a Commentary*. Oxford: Oxford University Press, 2003.

Barnhouse, Rebecca A. "Pictorial Responses to Textual Variations in the Illustrated Old English Hexateuch." *Manuscripta* 41 (1997): 67-87.

———. "Text and Image in the Illustrated Old English Hexateuch." PhD dissertation, University of North Carolina at Chapel Hill, 1994.

Barnhouse, Rebecca A., and Benjamin C. Withers, eds. *The Old English Hexateuch: Aspects and Approaches*. Kalamazoo: Medieval Institute Publications, Western Michigan University, 2000.

Bauer, Walter. *Rechtgläubigkeit und Ketzerei im ältesten Christentum*. Tübingen: Mohr, 1964.

Beal, Jane, ed. *Illuminating Moses: A History of Reception from Exodus to the Renaissance*. Leiden: Brill, 2014.

Beard, Mary. "The Triumph of the Absurd: Roman Street Theater." In *Rome the Cosmopolis*, edited by Catharine Edwards and Greg Woolf, 21-43. Cambridge: Cambridge University Press, 2003.

Beck, Herbert, and Peter Bol, eds. *Spätantike und frühes Christentum*. Frankfurt am Main: Das Liebieghaus, 1983.

Belleville, Linda L. *Reflections of Glory: Paul's Polemical Use of the Moses-Doxa Tradition in 2 Corinthians 3.1-18*. Sheffield: Journal for the Study of the New Testament Press, 1991.

Bennett, Adelaide. "Noah's Recalcitrant Wife in the Ramsey Abbey Psalter." *Source* 2 (1982): 2-5.

Ben Zvi, Ehud. "Exploring the Memory of Moses 'The Prophet' in Late Persian/Early Hellenistic Yehud/Judah." In *Remembering Biblical Figures in the Late Persian and Early*

Hellenistic Periods, edited by Diana V. Edelman and Ehud Ben Zvi, 335–65. Oxford: Oxford University Press, 2013.

Bergman, Robert. *The Salerno Ivories: Ars Sacra from Medieval Amalfi*. Cambridge, MA: Harvard University Press, 1980.

Bergmann, Marianne. *Die Strahlen der Herrscher: Theomorphes Herrscherbild und politische Symbolik im Hellenismus und in der römischen Kaiserzeit*. Mainz: von Zabern, 1998.

Bernabò, Massimo. "The Illustration of the Septuagint: The State of the Question." *Münchner Jahrbuch der bildenden Kunst* 13 (2012): 37–66.

———. *Pseudepigraphical Images in Early Art*. North Richland Hills, TX: BIBAL Press, 2001.

———. Review of Martin Büchsel, Herbert L. Kessler, Rebecca Müller, eds., *The Atrium of San Marco in Venice: The Genesis and Medieval Reality of the Genesis Mosaics/ Das Atrium von San Marco in Venedig: Die Genese der Genesismosaiken und ihre mittelalterliche Wirklichkeit* (Berlin: Gebr. Mann Verlag, 2014). Forthcoming.

Bernstein, Richard J. *Freud and the Legacy of Moses*. Cambridge: Cambridge University Press, 1998.

Bertman, Stephen. "The Anti-Semitic Origin of Michelangelo's Horned Moses." *Shofar: An Interdisciplinary Journal of Jewish Studies* 27.4 (Summer 2009): 1–11.

Bettenson, Henry, trans. *Concerning The City of God against the Pagans* (St. Augustine). London: Penguin Group, 1984.

Bettini, Sergio. *Mosaici antichi di San Marco a Venezia*. Bergamo: Ist. Italiano d'Art Grafice, 1944.

Bevan, Edwyn R. "A Note on Antiochus Epiphanes." *Journal of Hellenic Studies* 20 (1900): 26–30.

Bidez, Joseph. *Vie de Porphyre, le philosophe néo-platonicien*. Hildesheim: Georg Olms Verlag, 1964.

Biggs, Frederick M., ed. *Sources of Anglo-Saxon Literary Culture: The Apocrypha*. Kalamazoo, MI: Medieval Institute Publications, 2007.

Biggs, Frederick M., and Thomas N. Hall. "Traditions concerning Jamnes and Mambres in Anglo-Saxon England." *Anglo-Saxon England* 25 (1996): 69–89.

Bischoff, Bernard, and Michael Lapidge. *Biblical Commentaries from the Canterbury School of Theodore and Hadrian*. CSASE 10. Cambridge: Cambridge University Press, 1994.

Blackman, Aylward M. *Gods, Priests, and Men: Studies in the Religion of Pharaonic Egypt*. London: Kegan Paul International, 1998.

Bleeker, Claas J. *Hathor and Thoth: Two Key Figures of the Ancient Egyptian Religion*. Leiden: Brill, 1973.

Blenkinsopp, Joseph. "The Mission of Udjahorresnet and Those of Ezra and Nehemiah." *Journal of Biblical Literature* 106.3 (1987): 409–21.

Bloch, René S. *Moses und der Mythos: Die Auseinandersetzung mit der griechischen Mythologie bei jüdisch-hellenistischen Autoren*. Leiden: Brill, 2011.

———. "Quelques aspects de la figure de Moïse dans la tradition rabbinique." In *Moïse: l'Homme de l'alliance*, edited by Henri Cazelles et al., 93–167. Tournai: Desclée, 1955.

Blum, Pamela. "The Cryptic Creation Cycle in MS Junius XI." *Gesta* 15 (1976): 211–26.

Boardman, John. *The Great God Pan: The Survival of an Image*. London: Thames and Hudson, 1998.

Bober, Harry. "On the Illumination of the Glazier Codex." In *Homage to a Bookman: Essays on Manuscripts, Books, and Printing Written for Hans P. Kraus on His Sixtieth Birthday*, edited by Hellmut Lehmann-Haupt, 31–41. Berlin: Gebr. Mann Verlag, 1967.

Böhlig, Alexander, and Pahor Labib. *Die koptisch-gnostische Schrift ohne Titel aus Codex II von Nag Hammadi: Im Koptischen Museum zu Alt-Kairo*. Berlin: Akademie-Verlag, 1962.

Bologna, Ferdinando, ed. *L'Enigma degli avori medievali da Amalfi a Salerno*. 2 vols. Pozzuoli: Paparo, 2008.

Bonnefoy, Yves, et al. *Mythologies*. 2 vols. Chicago: University of Chicago Press, 1999.

Bonwetsch, Gottlieb N. *Die Bücher der Geheimnisse Henochs, das sogenannte slavische Henochsbuch*. Leipzig: J. C. Hinrichs, 1922.

Borgeaud, Philippe. *The Cult of Pan in Ancient Greece*. Chicago: University of Chicago Press, 1988.

———. "The Death of the Great Pan: The Problem of Interpretation." *History of Religions* 22.3 (1983): 266.

———. "Moïse, son Âne et les Typhoniens. Esquisse pour une remise en perspective." In *La construction de la figure de Moïse*, edited by Thomas Römer, 121–30. Paris: Librairie Gabalda, 2007.

———. "Religion romaine et histoire des religions: Quelques reflections." *Archiv für Religionsgeschichte* 5 (2003): 119–30.

———. "Silent Entrails: The Devil, His Demons, and Christian Theories Regarding Ancient Religions." *History of Religions* 50.1 (2010): 80–95.

Borgeaud, Philippe, Thomas Römer, and Youri Volokhine, eds. *Interprétations de Moïse: Égypte, Judée, Grèce et Rome*. Leiden: Brill, 2010.

Borgen, Peder. "Moses, Jesus, and the Roman Emperor: Observations in Philo's Writings and the Revelation of John." *Novum Testamentum* 38.2 (1996): 145–59.

Botterweck, G. Johannes, Helmer Ringgren, and Heinz-Josef Fabry, eds. *Theological Dictionary of the Old Testament*. Vol. 13. Grand Rapids, MI: Eerdmans, 2004.

Bowersock, G. W. "Dionysus as an Epic Hero." In *Studies in the Dionysiaca of Nonnus*, edited by Neil Hopkinson, 156–66. Cambridge: Cambridge Philological Society, 1994.

———. *Hellenism in Late Antiquity*. Ann Arbor: University of Michigan Press, 1990.

———. *Mosaics as History: The Near East from Late Antiquity to Islam*. Cambridge, MA: Belknap Press, 2006.

Bowersock, G. W., Peter Brown, and Oleg Grabar, eds. *Late Antiquity: A Guide to the Postclassical World*. Cambridge, MA: Harvard University Press, 1999.

Boylan, Patrick. *Thoth, the Hermes of Egypt: A Study of Some Aspects of Theological Thought in Ancient Egypt*. Oxford: Oxford University Press, 1922; reprint Oxford: Oxford University Press, 1992.

Breeze, Andrew. "Cain's Jawbone, Ireland, and the Prose *Solomon and Saturn*." *Notes & Queries*, n.s., 39 (1992): 433–36.

Brenk, Beat. *Die Frühchristlichen Mosaiken in S. Maria Maggiore zu Rom*. Wiesbaden: Steiner, 1975.

Bricault, Laurent, Miguel Versluys, and Paul G. P. Meyboom, eds., *Nile into Tiber: Egypt in the Roman World.* Leiden: Brill, 2007.

Brilliant, Richard. "Forwards and Backwards in the Historiography of Roman Art." *Journal of Roman Archaeology* 20 (2007): 7–24.

———. "Late Antiquity: A Protean Term." *Acta ad archaeologiam et artium historiam pertinenta* 25, n..s., 11 (2012): 29–56.

Britt, Benjamin. "Concealment, Revelation, and Gender: The Veil of Moses in the Bible and in Christian Art." *Religion and the Arts* 7.3 (2003): 226–73.

Brock, Sebastian. "St. Theodore of Canterbury, The Canterbury School and the Christian East." *Heythrop Journal* 36.4 (1995): 431–38.

Broderick, Herbert R. "The Iconographic and Compositional Sources of the Drawings in Oxford, Bodleian Library MS Junius 11." PhD dissertation, Columbia University, 1978.

———. "The Illustrated Old English Hexateuch (London, British Library Cotton MS Claudius B.iv)." In *Oxford Bibliographies—Medieval Studies*, edited by Paul E. Szarmach et al., 2017. www.oxfordbibliographies.com.

———. "Metatexuality, Sexuality and Intervisuality in MS Junius 11." *Word & Image* 25.4 (2009): 384–401.

———. "Northern Light: Late Anglo-Saxon Genesis Illustration and the Mosaics of San Marco." In *Das Atrium von San Marco in Venedig: Die Genese der Genesismosaiken und ihre mittelalterliche Wirklichkeit*, edited by Martin Büchsel, Herbert L. Kessler, and Rebecca Müller, 211–29. Berlin: Gebr. Mann Verlag, 2014.

———. "A Note on the Garments of Paradise." *Byzantion* 55 (1985): 250–54.

———. "Some Attitudes towards the Frame in Anglo-Saxon Manuscripts of the Tenth and Eleventh Centuries." *Artibus et Historiae* 5 (1982): 31–42.

———. "The Veil of Moses as Exegetical Image in the Illustrated Old English Hexateuch (London, British Library MS Cotton Claudius B.iv)." In *Insular and Anglo-Saxon Art and Thought in the Early Medieval Period*, ed. Colum Hourihane, 271–85. University Park: Pennsylvania State University Press, 2011.

———. "Visualizing Moses in the Illustrated Old English Hexateuch." In *Anglo-Saxon England and the Visual Imagination*, edited by John D. Niles, Stacy S. Klein, and Jonathan Wilcox, 145–69. Tempe: Arizona Center for Medieval and Renaissance Studies (ACMRS), 2016.

Brown, John Pairman. "From Divine Kingship to Dispersal of Power in the Mediterranean City-State." *Zeitschrift für alttestamentliche Wissenschaft* 105 (1996): 62–86.

Brown, Michelle P. "Bearded Sages and Beautiful Boys: Insular and Anglo-Saxon Attitudes to the Iconography of the Beard." In *Listen, O Isles, unto Me: Studies in Medieval Word and Image in Honour of Jennifer O'Reilly*, edited by Elizabeth Mullins and Diarmuid Scully, 278–90. Cork: Cork University Press, 2011.

———. *The Book and the Transformation of Britain, c. 550–1050: A Study in Written and Visual Literacy and Orality.* London and Chicago: British Library and University of Chicago Press, 2011.

———. "The Eastwardness of Things: Relationships between the Christian Cultures of the Middle East and the Insular World." In *The Genesis of Books: Studies in the Scribal Cul-*

ture of Medieval England in Honour of A. N. Doane, edited by Alger Nicolaus Doane, Matthew T. Hussey, and John D. Niles, 17–49. Turnhout: Brepols, 2011.

———. *The Holkham Bible Picture Book: A Facsimile.* London: British Library, 2007.

———. "Imagining, Imaging and Experiencing the East in Insular and Anglo-Saxon Cultures: New Evidence for Contact." In *Anglo-Saxon England and the Visual Imagination*, edited by John D. Niles, Stacy S. Klein, and Jonathan Wilcox, 49–86. Tempe: Arizona Center for Medieval and Renaissance Studies (ACMRS), 2016.

———. *The Lindisfarne Gospels: Society, Spirituality and the Scribe.* Toronto: University of Toronto Press, 2003.

———. "Mercian Manuscripts: The Implications of the Staffordshire Hoard, Other Recent Discoveries, and the 'New Materiality.'" In *Writing in Context: Insular Manuscript Culture 500–1200*, edited by Eric Kwakkel, 23–66. Leiden: Leiden University Press, 2013.

———. "Paten and Purpose: The Derrynaflan Paten Inscriptions." In *The Age of Migrating Ideas*, edited by John Higgitt and Michael Spearman, 162–67. Edinburgh: National Museums of Scotland, 1993.

———. "The Role of the Wax Tablet in Medieval Literacy: A Reconsideration in Light of a Recent Find from York." *British Library Journal* 20 (1994): 1–16.

Brown, Peter. *The World of Late Antiquity.* London: Thames and Hudson, 1976.

Bruce-Mitford, R. L. S. *The Art of the Codex Amiatinus.* Jarrow: Parish of Jarrow, 1967.

———. *Aspects of Anglo-Saxon Archaeology: Sutton Hoo and Other Discoveries.* New York: Harper's Magazine Press, 1974.

Brummer, Hans Henrik. "Pan Platonicus." *Konsthistorisk tidskrift/Journal of Art History* 33 (1964): 55–67.

Brunner-Traut, Emma. "Horn (als Symbol und Metapher)." In *Lexikon der Ägyptologie*, 3, edited by Wolfgang Helck and Eberhard Otto, cols. 9–10. Wiesbaden: Harrassowitz, 1982.

Büchsel, Martin. "Die Schöpfungsmosaiken von San Marco." *Städel-Jahrbuch*, NF, 13 (1991): 29–80.

———. "Theologie und Bildgenese. Modelle der Transformation antiker und frühchristlicher Vorlagen." In *The Atrium of San Marco in Venice: The Genesis and Medieval Reality of the Genesis Mosaics*, edited by Martin Büchsel, Herbert L. Kessler, and Rebecca Müller, 95–130. Berlin: Gebr. Mann Verlag, 2014.

Büchsel, Martin, Herbert L. Kessler, and Rebecca Müller, eds. *The Atrium of San Marco in Venice: The Genesis and Medieval Reality of the Genesis Mosaics.* Berlin: Gebr. Mann Verlag, 2014.

Budge, E. A. Wallis. *The Rosetta Stone.* London: British Museum, 1955.

Budny, Mildred. "The Biblia Gregoriana." In *St. Augustine of Canterbury and the Conversion of England*, edited by Richard Gameson, 237–84. Stroud: Sutton, 1999.

———. "British Library Royal 1.E.vi: The Anatomy of an Anglo-Saxon Bible Fragment." PhD dissertation, University of London, 1984.

Bugarski-Mesdjian, Anemari. "Traces d'Égypte en Dalmatie romaine: Culte, mode et pouvoir." In *Nile into Tiber: Egypt in the Roman World*, edited by Laurent Bricault, Miguel John Versluys, and Paul G. P. Meyboom, 289–328. Leiden: Brill, 2007.

Bulloch, Anthony W., et al., eds. *Images and Ideologies: Self-Definition in the Hellenistic World.* Berkeley: University of California Press, 1993.

Bunta, Silviu. "In Heaven or on Earth: A Misplaced Temple Question about Ezekiel's Visions." In *With Letters of Light: Studies in the Dead Sea Scrolls, Early Jewish Apocalyptic, Magic and Mysticism*, edited by Andrei A. Orlov and Daphna V. Arbel, 28-44. Berlin: Walter de Gruyter, 2011.

———. "One Man in Heaven: Adam-Moses Polemics in the Romanian Versions of *The Testament of Abraham* and Ezechiel the Tragedian's *Exagoge*." *Journal for the Study of the Pseudepigrapha* 16.2 (2007): 139-65.

Burton, Anne. *Diodorus Siculus: Book I: A Commentary.* Leiden: Brill, 1972.

Butt, John. *The Poems of Alexander Pope.* Chelsea, MI: Sheridan Books, 1963.

Butterworth, George W. *Clement of Alexandria.* Cambridge, MA: Harvard University Press, 1982.

Calkins, Robert G. *Illuminated Books of the Middle Ages.* Ithaca, NY: Cornell University Press, 1983.

Cameron, Alan. "The Date and Identity of Macrobius." *Journal of Roman Studies* 56.1-2 (1966): 25-38.

———. *Greek Mythography in the Roman World.* Oxford: Oxford University Press, 2004.

———. *The Last Pagans of Rome.* Oxford: Oxford University Press, 2011.

Canlis, Julie. "Being Made Human: The Significance of Creation for Irenaeus' Doctrine of Participation." *Scottish Theology Journal* 58.4 (2005): 434-54.

Capuanni, Massimo. *Christian Egypt.* Collegeville, MN: Liturgical Press, 1999.

Carey, John. "The Sun's Night Journey: A Pharaonic Image in Medieval Ireland." *Journal of The Warburg and Courtauld Institutes* 57 (1994): 14-34.

Carr, Gillian. "Woad, Tattooing and Identity in Later Iron Age and Early Roman Britain." *Oxford Journal of Archaeology* 24.3 (2005): 273-92.

Carroll, Lewis. *Alice's Adventures in Wonderland.* London: Macmillan & Co., 1865.

Carruthers, Mary J. *The Book of Memory: A Study of Memory in Medieval Culture.* Cambridge: Cambridge University Press, 1990.

Cassuto, Umberto. *A Commentary on the Book of Exodus.* Jerusalem: Magnes Press, Hebrew University, 1974.

Castastini, Alessandro. "'Hierogrammateus,' in Flavius Josephus, *Contra Apionem* I, 290." *Rivista di cultura classica e medioevale* 52.1 (2010): 133-37.

Cavero, Laura Miguélez. "The Appearance of the Gods in the Dionysiaca of Nonnus." *Greek, Roman, and Byzantine Studies* 49 (2009): 557-83.

Cazelles, Henri. *À la recherché de Möise.* Paris: Les editions du Cerf, 1979.

———. "Möšeh." In *Theological Dictionary of the Old Testament*, vol. 9, edited by G. Johannes Botterweck, Heimer Ringgen, and Heinz-Josef Fabry, 28-43. Grand Rapids, MI: Eerdmans, 1998.

Chardonnens, László. *Anglo-Saxon Prognostics, 900-1100: Study and Texts.* Leiden: Brill, 2007.

Charles, Robert H. *The Apocrypha and Pseudepigrapha of the Old Testament.* 2 vols. Oxford: Clarendon Press, 1913.

Charlesworth, James H. *The Old Testament Pseudepigrapha.* 2 vols. Garden City, NY: Doubleday, 1983.

———. *The Old Testament Pseudepigrapha and the New Testament: Prolegomena for the Study of Christian Origins.* Cambridge: Cambridge University Press, 1985.

Chazelle, Celia M. "Ceolfrid's Gift to St. Peter: The First Quire of the *Codex Amiatinus* and the Evidence of Its Roman Destination." *Early Medieval Europe* 12.2 (2003): 129–58.

———, ed. *Literacy, Politics and Artists' Innovation in the Early Medieval West.* Lanham, MD: University Press of America, 1992.

Clarke, Somers. *Christian Antiquities in the Nile Valley.* Oxford: Clarendon Press, 1912.

Clemoes, Peter, and Malcolm Godden. *Ælfric's Catholic Homilies: The First Series.* EETS 17. Oxford: Oxford University Press, 1997.

Cohen, Adam S., ed. *Eye and Mind: Collected Essays in Anglo-Saxon and Early Medieval Art by Robert Deshman.* Kalamazoo: Medieval Institute Publications, Western Michigan University, 2010.

———. *The Uta Codex: Art, Philosophy and Reform in Eleventh-Century Germany.* University Park: Pennsylvania State University Press, 2000.

Cohen, Jeffrey Jerome. *Of Giants: Sex, Monsters, and the Middle Ages.* Minneapolis: University of Minnesota Press, 1999.

Cohn, Norman. "The Horns of Moses: Old Symbols and New Meanings." *Commentary* 26.3 (1958): 220–26.

Coleiro, Edward. "St. Jerome's Lives of the Hermits." *Vigiliae Christianiae* 11.3 (1957): 161–78.

Collins, Andrew W. "The Royal Costume and Insignia of Alexander the Great." *American Journal of Philology* 133 (2012): 371–402.

Collins, John, J. "Artapanus Revisited." In *From Judaism to Christianity: A Festschrift for Thomas H. Tobin, S. J., on the Occasion of His Sixty-Fifth Birthday*, edited by Patricia Walters and Thomas A. Tobin, 59–68. Boston: Brill, 2010.

———. *Jewish Cult and Hellenistic Culture: Essays on the Jewish Encounter with Hellenism and Roman Rule.* Leiden: Brill, 2005.

Colson, Francis H., and George H. Whitaker, trans. *Philo.* 10 vols. Loeb Classical Library. London: Heinemann, 1929–2004.

Contessa, Andreina. "Noah's Ark on the Two Mountains of Ararat: The Iconography of the Cycle of Noah in the Ripoll and Roda Bibles." *Word & Image* 20.4 (2004): 257–70.

Cook, Arthur B. *Zeus: A Study in Ancient Religion.* 2/2. Cambridge: Cambridge University Press, 2010.

Cook, David. Review of Russell Gmirkin, *Berossus and Genesis, Manetho and Exodus. Religious Studies* 33 (2007): 64.

Cooke, John D. "Euhemerism: A Medieval Interpretation of Classical Paganism." *Speculum* 2/4 (1927): 396–410.

Cope, Mary McC. "The Caedmon Manuscript." MA thesis, Columbia University, 1966.

Cornford, Francis M., trans. *The Republic of Plato.* New York: Oxford University Press, 1969.

Corsano, Karen. "The First Quire of the Codex Amiatinus." *Scriptorium* 41.1 (1987): 3–34.

Coxe, A. Cleveland, ed. *The Ante-Nicene Fathers: Translations of the Writings of the Fathers down to A.D. 325.* 1. Grand Rapids, MI: Eerdmans, 1987.

Cramp, Rosemary. "Early Northumbrian Sculpture." In *Studies in Anglo-Saxon Sculpture* edited by Rosemary Cramp, 21-69. London: Pindar Press, 1992.

Crawford, Samuel J. *Exameron Anglice or the Old English Hexameron, Edited with an Introduction, a Collation of All the Manuscripts, a Modern Translation, Parallel Passages from Other Works of Ælfric and Notes on the Sources.* Hamburg, 1921; reprinted with additions by Neil R. Ker, Oxford: Oxford University Press, 1997.

———. *The Old English Version of the Heptateuch, Ælfric's Treatise on the Old and New Testaments and His Preface to Genesis.* EETS, o.s., 160. London: Oxford University Press, 1922.

Curschmann, Michael. "Oral Tradition in Visual Art: The Romanesque Theodoric." In *Reading Image and Texts: Medieval Images and Texts as Forms of Communication,* edited by Marielle Hageman and Marco Mostert, 177-206. Turnhout: Brepols, 2005.

Cutler, Anthony. "The End of Antiquity in Two Illuminated Manuscripts." *Journal of Roman Archeology* 1 (1989): 401-9.

Dalbert, Peter. *Die Theologie der hellenistisch-jüdischen Missionsliteratur unter Ausschluss von Philo und Josephus.* Hamburg-Volksdorf: H. Reich, 1954.

Daly, Lloyd, trans. *Aesop without Morals: The Famous Fables and a Life of Aesop.* New York: Yoseloff, 1963.

Damgaard, Finn. *Recasting Moses: The Memory of Moses in Biographical and Autobiographical Narrative in Ancient Judaism and 4th-Century Christianity.* Early Christianity in the Context of Antiquity, 13, edited by David Brakke, Anders-Christian Jacobsen, and Jörg Ulrich. Frankfurt am Main: Peter Lang, 2013.

Dando, Marcel. "Les gnostiques d'Egypte, les priscillianistes d'Espagne, et l'église primitive d'Irelande." *Cahiers d'études Cathares* 56 (1972): 3-34.

D'Aronco, Maria A., and Malcolm L. Cameron. *The Old English Illustrated Pharmacopoeia: British Library Cotton Vitellius C III.* EEMFS 26. Copenhagen: Rosenkilde and Bagger, 1998.

Dassmann, Ernst, et al., eds. *Reallexikon für Antike und Christentum.* 16 vols. Stuttgart: Anton Hiersemann, 1950-2001.

Day, Virginia. "The Influence of the Catechetical *Narratio* on Old English and Some Other Medieval Literature." *Anglo-Saxon England* 3 (1974): 51-62.

de Gruneisen, Wladimir. *Les caractéristiques de l'art copte.* Florence: Alinari, 1922.

de Jonge, Marinus. *Pseudepigrapha of the Old Testament as Part of Christian Literature.* Leiden: Brill, 2003.

de Lange, Nicholas. "Jewish Greek Bible Versions." In *The New Cambridge History of the Bible,* vol. 2, *From 600-1450,* edited by Richard Marsden and E. Ann Matter, 56-68. Cambridge: Cambridge University Press, 2012.

Deckers, Johannes. "Constantin und Christus. Das Bildprogramm in Kaiserkulträumen und Kirchen." In *Spätantike und frühes Christentum,* edited by Herbert Beck et al., 267-83. Frankfurt am Main: Das Liebieghaus, 1983.

Demus, Otto. *The Mosaics of Norman Sicily.* London: Routledge and Kegan Paul, 1950.

———. *Die Mosaiken von San Marco in Venedig, 1100-1300.* Vienna: R. M. Rohrer, 1935.

Denis, Albert-Marie. "Le portrait de Moïse par l'antisémite Manètho (IIIe. Av. J.-C.) et la réfutation juive de l'historien Artapan." *Le Muséon* 100 (1987): 49–65.

Deremberg, Charles, and Saglio, Edmond. *Dictionnaire des antiquités grecques et romaines: D'après les textes et les monuments.* Reprint. Paris: Hachette, 1969.

Derrida, Jacques. *Writing and Difference.* Translated by Alan Bass. London: Routledge and Kegan Paul, 2010.

Deshman, Robert. *Anglo-Saxon and Anglo-Scandinavian Art: An Annotated Bibliography.* Boston: G. K. Hall, 1984.

———. *The Benedictional of Aethelwold.* Princeton, NJ: Princeton University Press, 1991.

———. *Eye and Mind: Collected Essays in Anglo-Saxon and Early Medieval Art*, edited by Adam S. Cohen. Kalamazoo: Medieval Institute Publications, Western Michigan University, 2010.

———. "The Iconography of the Full-Page Miniatures of the Benedictional of St. Aethelwold." PhD dissertation, Princeton University, 1970.

Desroches-Noblecourt, Christiane. *Tutankhamen: Life and Death of a Pharaoh.* Harmondsworth: Penguin, 1971.

Deutsch, Nathaniel. *Guardians of the Gate: Angelic Vice Regency in Late Antiquity.* Leiden: Brill, 1999.

DeVos, Mariette. *Il'egittomania in pitture e mosaici romano-campani della irima età imperiale.* Leiden: Brill, 1980.

DeWald, Ernest T. *The Illustrations of the Utrecht Psalter.* Princeton, NJ: Princeton University Press, 1932.

De Zwaan, J. "Another Strain of Symbolism in the *CHI-RHO* as a Monogram of Christ." *Journal of Theological Studies* 21.3 (1920): 332–33.

Dillery, John. "Aesop, Isis, and the Heliconian Muses." *Classical Philology* 94.3 (1999): 268–80.

Dinkler von Schubert, Erich. "Bemerkungen zum Kreuz als ΤΡΟΠΑΙΟΝ." *Mullus: Festschrift Theodor Klauser* (*Jahrbuch für Antike und Christentum: Ergänzungsband*) 1 (1964): 7178.

———. "Tropaion." In *Lexikon der christlichen Ikonographie*, edited by Engelbert Kirschbaum, S.J., et al., 4, cols. 361–63. Rome: Herder, 1968–90.

Doane, Alger N., and William P. Stoneman. *Purloined Letters: The Twelfth-Century Reception of the Anglo-Saxon Illustrated Hexateuch (British Library, Cotton Claudius B.IV).* Tempe: Arizona Center for Medieval and Renaissance Studies, 2011.

Dodwell, Charles Reginald. *Anglo-Saxon Art: A New Perspective.* Ithaca, NY: Cornell University Press, 1982.

———. "La miniature Anglo-Saxonne: Un reportage sur la société contemporaine." *Les dossiers d'archéologie* 14 (1976): 56–63.

———. "L'originalité iconographique de plusieurs illustrations anglo-saxonne de l'Ancien Testament." *Cahiers de civilization médiévale* 14 (1971): 319–28.

Dodwell, Charles Reginald, and Peter Clemoes. *The Old English Illustrated Hexateuch: British Museum Cotton Claudius B.IV.* Early English Manuscripts in Facsimile 18. Copenhagen: Rosenkilde and Bagger, 1974.

Dolezal, Mary-Lyon. "The Elusive Quest for the 'Real Thing': The Chicago Lectionary Project Thirty Years On." *Gesta* 35.2 (1996): 128–41.

Doresse, Jean. *Des hiéroglyphs à la croix: Ce que le passé pharaonique a légué au Christianiasme.* Istanbul: Nederlands Historisch-Archaeologisch Institut in het Nabije oosten, 1960.

———. *The Secret Books of the Egyptian Gnostics: An Introduction to the Gnostic Coptic Manuscripts Discovered at Chenoboskion.* Rochester, VT: Inner Traditions International, 1986.

Dozeman, Thomas B. *Commentary on Exodus.* Grand Rapids, MI: Eerdmans, 2009.

———. "Masking Moses and Mosaic Authority in Torah." *Journal of Biblical Literature* 119.1 (2000): 21–45.

Dreyfus, F. "Divine Condescendence (*synkatabasis*) as a Hermeneutic Principle of the Old Testament in Jewish and Christian Tradition." *Immanuel* 19 (1984): 74–86.

Droge, Arthur J. "The Apologetic Dimensions of the *Ecclesiastical History.*" In *Eusebius, Christianity, and Judaism*, edited by Harold W. Attridge and Gohei Hata, 492–509. Leiden: Brill, 1992.

———. *Homer or Moses? Early Christian Interpretations of the History of Culture.* Tübingen: J. C. B. Mohr, 1989.

Dubois, C. "Zagreus." In *Dictionnaire des antiquités grecques et romaines*, edited by Charles Daremberg and Edmond Saglio, vol. 5, 1034–37. Graz: Akademische Druck-u-Verlagsanstalt, 1969.

du Bourguet, Pierre, and Monique Blanc-Ortolan. "Art, Coptic, and Irish." In *The Coptic Encyclopedia*, vol. 1, edited by Aziz Suryal Atiya et al., 251–54. New York: Macmillan, 1991.

Dumville, David N. "Biblical Apocrypha and the Early Irish: A Preliminary Investigation." *Proceedings of the Royal Irish Academy* 73c (1973): 299–338.

———. "The Importation of Mediterranean Manuscripts into Theodore's England." In *Archbishop Theodore: Commemorative Studies on his Life and Influence*, edited by Michael Lapidge, 96–119. Cambridge: Cambridge University Press, 1995.

Dunand, Françoise. *Le culte d'Isis dans le basin oriental de la Méditerranée.* Leiden: Brill, 1973.

Dundas, Gregory S. "Augustus and the Kingship of Egypt." *Historia: Zeitschrift für Alte Geschichte* 51.4 (2002): 433–48.

Durand, Maximilien. "*David lyricus* or *Jupiter fulminans?*" *Cahiers archéologiques* 50 (2002): 51–74.

Eckerman, Chris. "Thyrsis' Arcadian Shepherds in Virgil's Seventh *Eclogue.*" *Classical Quarterly* 65.2 (2015): 669–72.

Edelman, Diana V. "Of Priests and Prophets and Interpreting the Past: The Egyptian *HM-NTR* and *HRY-HBT* and the Judahite *NĀBi.*" In *The Historian and the Bible: Essays in Honour of Lester L. Grabbe*, edited by Philip R. Davies and Diana V. Edelman, 103–12. New York: T & T Clark, 2010.

———. "Taking the Torah out of Moses." In *La construction de la figure de Moïse*, edited by Thomas Römer, 13–42. Paris: Librairie Gabalda, 2007.

Edmonds, Radcliffe Guest. *Redefining Ancient Orphism.* New York: Cambridge University Press, 2013.

Edmunds, Lowell. "The Religiosity of Alexander the Great." *Greek, Roman and Byzantine Studies* 12.3 (1971): 363–91.

Edwards, Mark J. "Atticizing Moses? Numenius, the Fathers and the Jews." *Vigiliae Christianiae* 44 (1990): 64–75.

Ehrlich, Carl S. "'Noughty' Moses: A Decade of Moses Scholarship 2000–2010." *Hebrew Bible and Ancient Israel* 1 (2012): 93–110.

Eilberg-Schwartz, Howard. *God's Phallus and Other Problems for Men and Monotheism.* Boston: Beacon Press, 1994.

Eisenstein, J. D. "Mitre." In *The Jewish Encyclopedia*, edited by Isidor Singer, vol. 8, 622–23. New York: Funk and Wagnalls, 1906.

Erickson, Kyle. "Seleucus I, Zeus and Alexander." In *Every Inch a King: Comparative Studies on Kings and Kingship in the Ancient and Medieval Worlds*, edited by Lynette Mitchell and Charles Melville, 109–27. Leiden: Brill, 2013.

Evangelatou, Maria. "Word and Image in the *Sacra Parallela* (Codex Parisinus Graecus 923)." *Dumbarton Oaks Papers* 62 (2008): 113–216.

Ewald, M. L., Sr., trans. *The Homilies of St. Jerome.* 1. Washington, DC: Catholic University Press of America, 1964.

Fagiola, Marcello. "The Garden of the Gamberaia in the Seicento: The Mysteries of the Waters, the Elements and Earthquake." *Studies in the History of Gardens & Designed Landscapes* 22.1 (2002): 17–33.

Farley, Julia, and Fraser Hunter. *Celts: Art and Identity.* London: British Museum Press, 2015.

Fayant, Marie-Christine. *Hymnes orphiques.* Paris: Les Belles Lettres, 2014.

Feldman, Louis H. "Abraham the Greek Philosopher in Josephus." *Transactions and Proceedings of the American Philological Association* 99 (1968): 143–56.

———. *Jew and Gentile in the Ancient World.* Princeton, NJ: Princeton University Press, 1993.

———. "Josephus's Portrait of Moses." Part 1, *Jewish Quarterly Review*, n.s., Part 1, 82, 3.4 (1992): 285–328; Part 2, 83, 1.2 (1992): 7–50.

———. *Judaism and Hellenism Reconsidered.* Leiden: Brill, 2006.

———. "Moses the General and the Battle against Midian in Philo." *Jewish Studies Quarterly* 14 (2007): 1–17.

———. "Origen's *Contra Celsum* and Josephus' *Contra Apionem*: The Issue of Jewish Origins." *Vigiliae Christianiae* 44 (1990): 105–35.

———. *Philo's Portrayal of Moses in the Context of Ancient Judaism.* Notre Dame, IN: University of Notre Dame Press, 2007.

———. "The Reshaping of Biblical Narrative in the Hellenistic Period: A Review Essay." *International Journal of the Classical Tradition* 8.1 (2001): 60–79.

Ferrari, G. R. F., and Tom Griffith, trans. *The Republic.* Cambridge: Cambridge University Press, 2000.

Fine, Steven, ed. "Symposium on the Dura-Europos Synagogue Paintings in Tribute to Dr. Rachel Wischnitzer." *Images* 3 (2009): 136–39.

Finney, Paul C. *The Invisible God: The Earliest Christians on Art.* New York: Oxford University Press, 1994.

Fiorenza, Elisabeth S. *Aspects of Religious Propaganda in Judaism and Early Christianity.* Notre Dame, IN: University of Notre Dame Press, 1976.

Fischer, Bonifatius. "Codex Amiatinus und Cassiodor." *Biblische Zeitschrift*, NF, 6 (1962): 57ff.

Fletcher-Louis, Crispin H. T. *All the Glory of Adam: Liturgical Anthropology in the Dead Sea Scrolls*. Leiden: Brill, 2002.

———. "4Q374: A Discourse on the Sinai Tradition: The Deification of Moses and Early Christology." *Dead Sea Discoveries* 3.1 (1996): 236–52.

Fluck, Cäcilia, Gisela Helmecke, and Elizabeth O'Connell, eds. *Egypt: Faith after the Pharaohs*. London: British Museum Press, 2015.

Flury-Lemberg, Mechthild, Dietrich Willers, and Alain C. Gruber. *Der Dionysos-Behang der Abegg-Stiftung/La tenture de Dionysos de la Fondation Abegg*. Riggisberg: Abegg-Stiftung, 1987.

Flusser, David, and Shua Amorai-Stark. "The Goddess Thermuthis, Moses, and Artapanus." *Jewish Studies Quarterly* 1.3 (1993–94): 217–33.

Foley, W. Trent. Review of *Archbishop Theodore: Commemorative Studies on His Life and Influence*, edited by Michael Lapidge. *Church History* 65.4 (1996): 671–73.

Foley, W. Trent, and Arthur G. Holder. *Bede: A Biblical Miscellany*. Liverpool: Liverpool University Press, 1999.

Forbes, Clarence A., trans. *Firmicus Maternus: The Error of the Pagan Religions*. New York: Newman Press, 1970.

Fossum, Jarl. "The Myth of the Eternal Rebirth: Critical Notes on G. W. Bowersock, *Hellenism in Late Antiquity*." *Vigiliae Christianae* 53 (1999): 305–15.

Foster, Brett. "'Types and Shadows': Uses of Moses in the Renaissance." In *Illuminating Moses: A History of Reception from Exodus to the Renaissance*, edited by Jane Beal, 353–407. Leiden: Brill, 2014.

Fowden, Garth. *The Egyptian Hermes: A Historical Approach to the Late Pagan Mind*. Princeton, NJ: Princeton University Press, 1986.

Fox, Robin L., ed. *Brill's Companion to Ancient Macedon: Studies in the Archeology and History of Macedon, 650 BC–300 AD*. Leiden: Brill, 2011.

Frank, Roberta. "The Invention of the Viking Horned Helmet." In *International Scandinavian and Medieval Studies in Memory of Gerd Wolfgang Weber*, edited by Michael Dallapiazza et al., 199ff. Trieste: Parnaso, 2000.

Frankfurt, Henri. *The Art and Architecture of the Ancient Orient*. Harmondsworth: Penguin Books, 1970.

Frankfurter, David. *Religion in Roman Egypt: Assimilation and Resistance*. Princeton, NJ: Princeton University Press, 1998.

Frantová, Zuzana. "The Milan Five-Part Diptych as a Manifestation of Orthodoxy." *Arte Medievale* 5 (2015): 9–26.

Freedberg, David. *The Power of Images: Studies in the History and Theory of Response*. Chicago: University of Chicago Press, 1989.

Freedman, Harry, and Maurice Simon. *Middrash Genesis Rabbah* 1. London: Soncino Press, 1939.

Friedlander, Gerald. *Pirkê de Rabbi Eliezer*. London: K. Paul, 1916.

Friedman, Florence. *Beyond the Pharaohs: Egypt and the Copts in the 2nd to 7th Centuries A.D.* Providence: Museum of Art, Rhode Island School of Design, 1989.

Friedman, John B. *Orpheus in the Middle Ages.* Cambridge, MA: Harvard University Press, 1970.

Friedman, Mira. "L'Arche de Noé de Saint-Savin." *Cahiers de civilization medievale* 40 (1997): 123–43.

Frulla, Giovanni. "Reconstructing Exodus Tradition: Moses in the Second Book of Josephus' *Antiquities*." In *Flavius Josephus: Interpretation and History*, edited by Jack Pastor, Pnina Stern, and Menahem Mor, 111–24. Leiden: Brill, 2011.

Fulińska, Agnieszka. "The God Alexander and His Emulators: Alexander the Great's 'Afterlife' in Art and Propaganda." *Classica Cracoviensia* 14 (2011): 125–35.

Gabra, Sami, et al. *Rapport sur les fouilles d'Hermoupolis Ouest (Touna el-Gabel).* Cairo: Université Fouad 1er, 1941.

Gaehde, Joachim E. "Carolingian Interpretations of an Early Christian Picture Cycle to the Octateuch in the Bible of San Paolo fuori-le-mura in Rome." *Frühmittelalterliche Studien* 8 (1974): 351–84.

Gager, John G. *Moses in Greco-Roman Paganism.* Nashville, TN: Abingdon Press, 1972.

Galinsky, G. Karl. "The Cipus Episode in Ovid's *Metamorphoses* (15.564–621)." *Transactions and Proceedings of the American Philological Association* 98 (1968): 181–91.

Gameson, Richard. "Book Decoration in England c. 871–c. 1100." In *The Cambridge History of the Book in Britain*, edited by Richard Gameson, 249–93. Cambridge: Cambridge University Press, 2011.

———. "Context and Achievement." In *St. Augustine of Canterbury and the Conversion of England*, edited by Richard Gameson, 1–40. Stroud, UK: Sutton, 1999.

———. *The Earliest Books of Canterbury Cathedral: Manuscripts and Fragments to c. 1200.* London: Bibliographical Society and British Library, 2008.

———. "The Earliest Books of Christian Kent." In *St. Augustine of Canterbury and the Conversion of England*, edited by Richard Gameson, 313–74. Stroud, UK: Sutton, 1999.

———. "English Manuscript Art in the Late Eleventh Century: Canterbury and Its Context." In *Canterbury and the Norman Conquest: Churches, Saints, and Scholars*, edited by Richard Eales and Richard Sharpe, 95–144. London: Hambledon Press, 1995.

———. "Manuscript Art at Christ's Church, Canterbury, in the Generation after St. Dunstan." In *St. Dunstan: His Life, Times and Cult*, edited by Nigel Ramsey, Margaret Sparks, and T. W. T. Tatton-Brown, 187–220. Woodbridge, UK: Boydell Press, 1992.

———. *The Role of Art in the Late Anglo-Saxon Church.* Oxford: Oxford University Press, 1995.

———, ed. *St. Augustine of Canterbury and the Conversion of England.* Stroud, UK: Sutton, 1999.

———. "The Study of Early British Books." In *The Cambridge History of the Book in Britain*, edited by Richard Gameson, 707–22. Cambridge: Cambridge University Press, 2011.

Gardner, Nicky. "Multiple Meanings: The Swastika Symbol." *hidden europe* 11 (2006): 35–37.

Gatch, Milton McC. "Noah's Raven in *Genesis A* and the Illustrated Old English Hexateuch." *Gesta* 14.2 (1975): 3–15.

———. "The Old English Illustrated Hexateuch: British Museum Cotton Claudius B. IV by C. R. Dodwell: Peter Clemoes." *Speculum* 52 (1977): 365–69.

Georgi, Dieter. *Die Gegner des Paulus in 2. Korintherbrief: Studien sur religiosen Propaganda in der Spätanike.* Neukirchen-Vluyn: Neukirchener Verlag, 1964.

Gerlach, Peter, and Paul J. Gerlach. "Kalb." In *Lexikon der christlichen Ikonographie*, 2, edited by Engelbert Kirschbaum, S.J., 478–82. Rome: Herder, 1992.

Gerstinger, Hans. *Die Wiener Genesis.* Vienna: Dr. B. Filser, 1931.

Gibson, Margaret T. *The Liverpool Ivories: Late Antique and Medieval Ivory and Bone Carving in the Liverpool Museum and the Walker Art Gallery.* London: HMSO, 1994.

Gifford, Edwin Hamilton, trans. *Eusebii Pamphili Evangelicae praeparationis, libri XV: ad codices manuscriptos denuo collatos recensuit anglice nunc primum reddidit notis et indicibus instruxit.* London: Oxford University Press, 1903.

Gignoux, Philippe. "Homélies de Narsaï sur la creation." In *Patrologia Orientalis*, 34, edited by René Graffin et al. Paris: Firmin-Didot, 1968.

Ginzberg, Louis. "Antiochus IV Epiphanes." In *The Jewish Encyclopedia*, 1, edited by Isidor Singer, 634–35. New York: Funk and Wagnalls, 1906.

———. *Die Haggada bei den Kirchenvätern und in der apokryphischen Literatur.* Berlin: S. Calvary, 1900.

———. *The Legends of the Jews.* 7 vols. Philadelphia: Jewish Publication Society, 2003.

Giveon, R. "Sopdu." In *Lexikon der Ägyptologie*, 4, edited by Wolfgang Helck and Eberhard Otto, cols. 1107–90. Wiesbaden: Harrassowitz, 1995.

Gmirkin, Russell E. *Berossus and Genesis, Manetho and Exodus: Hellenistic Histories and the Date of the Pentateuch.* New York: T & T Clark International, 2006.

———. "Greek Evidence for the Hebrew Bible." In *The Bible and Hellenism: Greek Influence on Jewish and Early Christian Literature*, edited by Thomas L. Thompson and Philippe Wajdenbaum, 56–88. London: Routledge, 2014.

Gneuss, Helmut, and Michael Lapidge. *Anglo-Saxon Manuscripts: A Bibliographical Handlist of Manuscripts and Manuscript Fragments Written or Owned in England up to 1100.* Toronto: University of Toronto Press, 2014.

Godden, Malcolm, ed. *Ælfric's Catholic Homilies: The Second Series.* EETS, s.s., 5. London: Oxford University Press, 1979.

———. "Biblical Literature: The Old Testament." In *The Cambridge Companion to Old English Literature*, edited by Malcolm Godden and Michael Lapidge, 206–26. Cambridge: Cambridge University Press, 1991.

Goldenberg, Robert. *The Nations That Know Thee Not: Ancient Jewish Attitudes toward Other Religions.* New York: New York University Press, 1998.

Gollancz, Israel. *The Caedmon Manuscript of Anglo-Saxon Biblical Poetry: Junius XI in the Bodleian Library.* London: British Academy and Oxford University Press, 1927.

Gombrich, Ernst H. *Aby Warburg: An Intellectual Biography.* Chicago: University of Chicago Press, 1986.

Goodenough, Erwin R. *By Light, Light: The Mystic Gospel of Hellenistic Judaism.* Amsterdam: Philo Press, 1969.

———. "The Greek Garments on Jewish Heroes in the Dura Synagogue." In *Biblical Motifs Origins and Transformations*, edited by Alexander Altman, 221–37. Cambridge, MA: Harvard University Press, 1966.

———. *Jewish Symbols in the Greco-Roman Period.* 13 vols. New York: Pantheon Books, 1953–68.

Görg, Manfred. *Ägyptiaca-Biblica: Notizen und Beiträge zwischen Ägypten und Israel.* Wiesbaden: Harrassowitz, 1991.

———. *Die Beziehungen zwischen dem alten Israel und Ägypten: Von dem Anfängen bis zum Exil.* Darmstadt: Wiss. Buchges. [Abt. Verl.], 1997.

Gottlieb, Claire. "Will the Real Moses Please Step Forward." In *Jewish Studies at the Turn of the Twentieth Century*, 1, edited by Judit T. Borrás, 125–30. Leiden: Brill, 1999.

Grabar, André, and Carl Nordenfalk. *Early Medieval Painting.* Lausanne: Skira, 1957.

Grabbe, Lester L. *Did Moses Speak Attic?* Sheffield: Sheffield Academic Press, 2001.

Graepler, Ursula. "Eherne Schlange." In *Lexikon der christlichen Ikonographie*, edited by Engelbert Kirschbaum, S.J., 1, 583–86. Freiburg: Herder, 1968.

Graeven, Hans. *Adamo ed Eva sui cofanetti d'avorio bizantini.* Rome: Danesi, 1899.

Grafton, Anthony. *Bring Out Your Dead: The Past as Revelation.* Cambridge, MA: Harvard University Press, 2001.

———. *Christianity and the Transformation of the Book: Origen, Eusebius, and the Library of Caesarea.* Cambridge, MA: Belknap Press, 2006.

Graham-Campbell, James. *Viking Artefacts: A Select Catalogue.* London: British Museum Publications, 1980.

Graupner, Axel, and Michael Wolter, eds. *Moses in Biblical and Extra-Biblical Traditions.* Berlin: Walter de Gruyter, 2007.

Green, Miranda. *Symbol and Image in Celtic Religious Art.* London: Routledge, 1989.

Green, Rosalie B. "The Adam and Eve Cycle in the *Hortus deliciarum.*" In *Late Classical and Medieval Studies in Honor of Albert Mathias Friend, Jr.*, edited by Kurt Weitzmann et al., 340–47. Princeton, NJ: Princeton University Press, 1955.

Greenfield, Stanley B., ed. *Studies in Old English Literature in Honor of Arthur G. Brodeur.* New York: Russell & Russell, 1973.

Gressmann, Hugo. *Mose und seine Zeit: Ein Kommentar zu den Mose-Sagen.* Göttingen: Vandenhoeck & Ruprecht, 1913.

Griffith, Francis L. "Oxford Excavations in Nubia." In *University of Liverpool Annals of Archaeology and Anthropology*, edited by J. P. Droop and T. E. Peet, 13.3–4 (1926): 77–79.

Griffith, J. G. "Interpretatio graeca." In *Lexikon der Ägyptologie*, 3, edited by Wolfgang Helck and Eberhard Otto, cols. 167–72. Wiesbaden: Harrassowitz, 1995.

Griffith, R. Drew. "God's Blue Hair in Homer and in Eighteenth-Dynasty Egypt." *Classical Quarterly* 55.2 (2005): 329–34.

Gruen, Eric S. *Diaspora: Jews amidst Greeks and Romans.* Cambridge, MA: Harvard University Press, 2002.

———. *Heritage and Hellenism: The Reinvention of Jewish Tradition.* Berkeley: University of California Press, 1998.

Gutmann, Joseph. "The Dura Europos Synagogue Paintings and Their Influence on Later Christian and Jewish Art." *Artibus et Historiae* 9.17 (1988): 25–29.

———. *The Illustrated Midrash in the Dura Synagogue Paintings: A New Dimension for the Study of Judaism.* Jerusalem: American Academy for Jewish Research, 1983.

———. *No Graven Images: Studies in Art and the Hebrew Bible.* New York: Ktav Press, 1971.

Hadas, Moses. *Hellenistic Culture: Fusion and Diffusion.* New York: Columbia University Press, 1968.

Hadley, R. A. "Royal Propaganda of Seleucus I and Lysimachus." *Journal of Hellenic Studies* 94 (1974): 50–65.

Hahn, Cynthia. "The Creation of the Cosmos: Genesis Illustration in the Octateuchs." *Cahiers archéologiques* 28 (1979): 29–40.

Hall, Christopher A. "Moses and the Church Fathers." In *Illuminating Moses: A History of Reception from Exodus to the Renaissance*, edited by Jane Beal, 81–102. Leiden: Brill, 2014.

Hall, J. R. "The Old English Book of Salvation History: Three Studies on the Unity of MS Junius 11." PhD dissertation, University of Notre Dame, 1974.

———. "The Old English Epic of Redemption: The Theological Unity of MS. Junius 11," *Traditio* 32 (1976): 185–208.

Hamilton, G. L. "La source d'un épisode de Baudouin de Sebourc." *Zeitschrift für romanische Philologie* 36 (1912): 130–31.

Haney, Kristine E. "Death and the Devil: Another Look at the Leofric Missal." *Arte medievale* 2 (1995): 11–26.

Haran, Menahem. "The Shining of Moses' Face: A Case Study in Biblical and Ancient Near Eastern Iconography." In *In the Shelter of Elyon: Essays on Ancient Palestinian Life and Literature, in Honor of G. W. Ahlström*, edited by W. Boyd Barrick and John R. Spencer, 159–73. Sheffield: Journal for the Study of the Old Testament Press, 1984.

Harris, Robert M. "The Marginal Drawings of the Bury St. Edmunds Psalter (Vat. Bibl. Apos. Lat. MS Regina 12)." PhD dissertation, Princeton University, 1960.

Harvey, Paul B., Jr. "Saints and Satyrs: Jerome the Scholar at Work." *Athenaeum* 86 (1998): 35–56.

———. "Vulgate and Other Latin Translations." In *The Oxford Encyclopedia of the Books of the Bible*, edited by Michael David Coogan. Oxford: Oxford University Press, 2011.

Hassall, William O. *The Holkham Bible Picture Book.* London: Dropmore Press, 1954.

Haussherr, Reiner. "Sensus litteralis und sensus spiritualis in der *Bible moralisée.*" *Frühmittelalterliche Studien* 6 (1972): 356–80.

Hazzard, R. A. "Theos Epiphanes: Crisis and Response." *Harvard Theological Review* 88.4 (1995): 415–36.

Heath, Jane. "Homer or Moses? A Hellenistic Perspective on Moses' Throne Vision in Ezekiel Tragicus." *Journal of Jewish Studies* 58.1 (2007): 1–18.

Heimann, Adelheid. "Moses Darstellungen." In *Kunst als Bedeutungsträger: Gedenkschrift für Günter Bandmann*, edited by Werner Busch et al., 10–17. Berlin: Gebr. Mann, 1978.

———. Review of Ruth Mellinkoff, *The Horned Moses in Medieval Art and Thought*. *Zeitschrift für Kunstgeschichte* 37 (1974): 284–88.

———. "Three Illustrations from the Bury St. Edmunds Psalter and Their Prototypes." *Journal of the Warburg and Courtauld Institutes* 29 (1966): 39–59.

Heine, Ronald E. *Origen: Homilies on Genesis and Exodus*. Washington, DC: Catholic University of America Press, 1982.

Heiser, James D. *Prisci Theologi and the Hermetic Reformation in the Fifteenth Century*. Malone, TX: Repristination Press, 2011.

Helck, Wolfgang, and Eberhard Otto, eds. *Lexikon der Ägyptologie*. 7 vols. Wiesbaden: Harrassowitz, 1972–92.

Helck, Wolfgang. "Mond." In *Lexikon der Ägyptologie*, edited by Wolfgang Helck and Eberhard Otto, 4, 192–96. Wiesbaden: Harrassowitz, 1972–92.

Hendel, Ronald S. "Of Demigods and the Deluge: Toward an Interpretation of Genesis 6:1–4." *Journal of Biblical Literature* 106.1 (1987): 13–26.

Henderson, George. *Early Medieval*. Harmondsworth: Penguin, 1972.

———. "The Joshua Cycle in B.M. Cotton MS Claudius B.IV." Reprinted in *Studies in English Bible Illustration*, edited by George Henderson, 1, 184–215. London: Pindar Press, 1985.

———. "Late Antique Influences in Some English Medieval Illustrations of Genesis." Reprinted in *Studies in English Bible Illustration*, edited by George Henderson, 1, 76–126. London: Pindar Press, 1985.

———. "Losses and Lacunae in Early Insular Art." *Studies in English Bible Illustration*, 1, edited by George Henderson, 1–33. London: Pindar Press, 1985.

Hernández de la Fuente, David A. *Bakkhos anax: Un studio sobre Nono de Panopolis*. Madrid: Consejo Superior de Investigaciones Científicas, 2008.

———. *New Perspectives on Late Antiquity*. Newcastle upon Tyne: Cambridge Scholars, 2011.

———. "Nonnus's Paraphrase of the Gospel of John: Pagan Models for Christian Literature." In *Eastern Crossroads: Essays on Medieval Christian Legacy*, edited by Juan Pedro Monferrer-Sala, 169–90. Piscataway, NJ: Gorgias Press, 2007.

———. "Parallels between Dionysos and Christ in Late Antiquity: Miraculous Healings in Nonnus' *Dionysiaca*." In *Redefining Dionysos*, edited by Alberto Bernabé, Miguel Herrero de Jáuregui, Ana Isabel Jiménez San Crisóbel, and Raquel Martin Hernández, 464–87. Berlin: Walter de Gruyter, 2013.

Herren, Michael W. "The Transmission and Reception of Graeco-Roman Mythology in Anglo-Saxon England, 670–800." *Anglo-Saxon England* 27 (1998): 87–103.

Hesseling, Dirk-C. *Miniatures de l'Octateuque grec de Smyrne*. Leiden: Sijthoff, 1909.

Heydasch-Lehmann, Susanne. "Mose II (Ikonographie)." In *Reallexikon für Antike und Christentum*, edited by Georg Schöllgen et al., 102–15. Stuttgart: Anton Hiersemann, 2013.

Hilhorst, Ton. "And Moses Was Instructed in All the Wisdom of the Egyptians." In *The Wisdom of Egypt: Jewish, Early Christian, and Gnostic Essays in Honour of Gerard P.*

Luttikhuizen, edited by Anthony Hilhorst and George H. van Kooten, 153–76. Leiden: Brill, 2005.

Hillmer, Mark. Review of Russell E. Gmirkin, *Berossus and Genesis, Manetho and Exodus: Hellenistic Histories and the Date of the Pentateuch. Catholic Biblical Quarterly* 69 (2007): 773–74.

Hobbs, Richard. "Platters of the Mildenhall Treasure." *Britannia* 41 (2010): 324–33.

Hoffmann, Konrad. *Taufsymbolik im mittelalterlichen Herrscherbild.* Düsseldorf: Rheinland-Verlag, 1968.

Holladay, Carl R. *Fragments from Hellenistic Jewish Authors* 1 [Historians]. Atlanta, GA: Scholars Press, 1983.

———. *Fragments from Hellenistic Jewish Authors* 2 [Poets: The Epic Poets]. Atlanta, GA: Scholars Press, 1989.

———. *Fragments from Hellenistic Jewish Authors* 4 [*Orphica*]. Atlanta, GA: Scholars Press, 1996.

———. "The Portrait of Moses in Ezekiel the Tragedian." In *Society of Biblical Literature 1976 Seminar Papers*, edited by George MacRae, 447–52. Missoula, MT: Scholars Press, 1976.

———. *Theios Aner in Hellenistic-Judaism: A Critique of the Use of This Category in New Testament Christology.* Missoula, MT: Scholars Press, 1977.

Holland, Leicester B. "The Mantic Mechanism at Delphi." *American Journal of Archeology* 37 (1933): 204–14.

Holly, Michael A. *Panofsky and the Foundations of Art History.* Ithaca, NY: Cornell University Press, 1984.

Holmes, Michael W., ed. *The Apostolic Fathers: Greek Texts and English Translations.* Grand Rapids, MI: Baker Academic, 2007.

Höpfner, Theodor. "Fontes Historiae Religionis Aegyptiacae." In *Fontes Historiae Religionum ex Auctoribus Graecis et Latinis Collectos*, edited by Carl Clemen, Fasciculi 2, Pars 5. Bonn: Marcus and Weber, 1925.

Hopkinson, Neil. *Studies in the Dionysiaca of Nonnus.* Cambridge: Cambridge Philosophical Society, 1994.

Hourihane, Colum, ed., *Insular and Anglo-Saxon Art and Thought in the Early Medieval Period.* University Park: Pennsylvania State University Press, 2011.

Huet, Pierre Daniel. *Demonstratio evangelica.* Paris: Stephanum Michallet, 1679.

Hughes, J. Trevor, ed. *Pseudodoxia epidemica of Sir Thomas Browne.* Oxford: Rimes House, 2011.

Hurtado, Larry W. *The Earliest Christian Artifacts: Manuscripts and Christian Origins.* Grand Rapids, MI: Eerdmans, 2006.

Inowlocki, Sabrina. *Eusebius and the Jewish Authors: His Citation Technique in an Apologetic Context.* Leiden; Boston: Brill, 2006.

———. "Eusebius's Appropriation of Moses in an Apologetic Context." In *Moses in Biblical and Extra-Biblical Traditions*, edited by Axel Graupner and Michael Wolter, 240–55. Berlin: Walter de Gruyter, 2007.

———. "Moïse en Égypte: Religion et politique dans les fragments d'Artapan." *Revue de Philosophie Ancienne* 22.1 (2004): 5–16.

Inowlocki-Meister, S. "Eusebius' Construction of Christian Culture in an Apologetic Context: Reading the *Praeparatio evangelica* as a Library." In *Reconsidering Eusebius*, edited by Sabrina Inowlocki and Claudio Zamagni, 199–224. Leiden: Brill, 2011.

———."Le Moïse des auteurs juifs hellénistiques et sa réappropriation dans la littérature apologétique chrétienne: La cas de Clément d'Alexandrie." In *Interprétations de Moïse: Égypte, Judée, Grèce et Rome*, edited by Phillipe Borgeaud, Thomas Römer, and Youri Volokhine, 103–32. Leiden: Brill, 2010.

Iossif, Panagiotis P., "Les 'cornes' des Séleucides: Vers une divinization 'discrète." *Cahiers des études anciennes* 49 (2012): 1–60.

Irwin, William R. "The Survival of Pan." *Publications of the Modern Language Association of America* 76.3 (1961): 159–67.

Itter, Andrew C. *Esoteric Teaching in the "Stromateis" of Clement of Alexandria.* Leiden: Brill, 2009.

James, Montague R. *Ancient Libraries of Canterbury and Dover: The Catalogues of the Libraries of Christ Church Priory and St. Augustine's Abbey at Canterbury and of St. Martin's Priory at Dover.* Cambridge: Cambridge University Press, 1903.

———. "An English Bible-Picture Book of the Fourteenth Century (Holkham MS 666)." *Walpole Society* 11 (1922–23): 1–27.

———. "A Fragment of the Penitence of Jannes and Jambres." *Journal of Theological Studies* 2 (1901): 572–77.

———. *Illustrations of the Book of Genesis.* London: Roxburghe Club, 1921.

———. "Illustrations of the Old Testament." In *A Book of Old Testament Illustrations of the Middle of the 13th Century*, edited by Sydney C. Cockerell. London: Roxburghe Club, 1927.

Jánosi, Peter. "Die Ägyptologie und 'Moses, der Ägypter.'" In *Der Mann Moses und die Stimme des Intellekts: Geschichte, Gesetz und Denken in Sigmund Freuds historischem Roman*, edited by Eveline List, 29–62. Innsbruck: Studien Verlag, 2008.

Janzen, J. Gerald. "The Character of the Calf and Its Cult in Exodus 32." *Catholic Biblical Quarterly* 52.4 (1990): 597–609.

Jasnow, Richard L., and Karl-Theodor Zauzich. *The Ancient Egyptian Book of Thoth: A Demotic Discourse on Knowledge and Pendant to the Classical Hermetica.* Wiesbaden: Harrassowitz, 2005.

Jirku, Anton. "Die Gesichtsmaske des Mose." *Zeitschrift des Deutschen Palästina-Vereins* 67.1 (1944): 43–45.

Johnson, Aaron P. *Ethnicity and Argument in Eusebius' Praeparatio Evangelica.* Oxford: Oxford University Press, 2006.

Johnson, D. F. "A Program of Illumination in the Old English Illustrated Hexateuch 'Visual Typology'?" In *The Old English Hexateuch: Aspects and Approaches*, edited by Rebecca Barnhouse and Benjamin C. Withers, 165–201. Kalamazoo: Medieval Institute Publications, Western Michigan University, 2000.

Jones, Christopher P. *Between Pagan and Christian.* Cambridge, MA: Harvard University Press, 2014.

Jones, Horace L. *The Geography of Strabo.* 7. Cambridge, MA: Harvard University Press, 1983.

Joosten, Jan. "Interpretation and Meaning in the Septuagint Translation." In *Helsinki Collegium for Advanced Studies 2012*, edited by Anneli Aejmelaeus and Päivi Pahta, 52–62. https://helda.helsinkifi/bitstream/handle/10138/.../7_04_Joosten.pdf?...1.

Jordan, Louis. "Demonic Elements in Anglo-Saxon Iconography." In *Sources of Anglo-Saxon Culture*, edited by Paul E. Szarmach, 283–317. Studies in Medieval Culture, 20. Kalamazoo: Medieval Institute Publications, Western Michigan University, 1986.

Josephus, Flavius. *Jewish Antiquities*, Books 1–4. Translated by Henry St. John Thackeray et al. Cambridge, MA: Harvard University Press, 1998.

Joslin, Mary Coker, and Carolyn Coker Joslin Watson. *The Egerton Genesis*. London and Toronto: British Library and University of Toronto Press, 2001.

Joyce, James. *Ulysses*. Reprint. London: Bodley Head, 2002.

Judge, Edwin A. "'Antike und Christentum': Towards a Definition of the Field, a Bibliographical Survey." In *Aufstieg und Niedergang der Römischen Welt* 2 (Principat/23/1–Religion), edited by Hildegard Temporini and Wolfgang Haase, 3–58. Berlin: Walter de Gruyter, 1979.

Kamesar, Adam. "Jerome." In *The New Cambridge History of the Bible*, vol. 1, *From the Beginnings to 600*, edited by James Carleton Paget and Joachim Schaper, 653–75. Cambridge: Cambridge University Press, 2013.

Kapetanaki, Sophia, and R. W. Sharples. *Supplementa Problematorum: A New Edition of the Greek Text with Introduction and Annotated Translation*. Berlin: Walter de Gruyter, 2006.

Kaplan, Irene. *Grabmalerei und Grabreliefs der Römerzeit: Wechselwirkung zwischen der ägyptischen und griechisch-alexandrinischen Kunst*. Vienna: Wien Afro-Pub c/o Inst. für Afrikanistik, 1999.

Karkov, Catherine E. *The Art of Anglo-Saxon England*. London: Boydell Press, 2012.

———. "Exiles from the Kingdom: The Naked and the Damned in Anglo-Saxon Art." In *Naked Before God: Uncovering the Body in Anglo-Saxon England*, edited by Jonathan Wilcox and Benjamin C. Withers, 181–200. Morgantown: West Virginia University Press, 2003.

———. "Manuscript Art." In *Working with Anglo-Saxon Manuscripts*, edited by Gail R. Owen-Crocker et al., 205–15. Exeter: Exeter University Press, 2009.

———. *Text and Picture in Anglo-Saxon England: Narrative Strategies in the Junius 11 Manuscript*. Cambridge: Cambridge University Press, 2001.

———. "Tracing the Anglo-Saxons in the Epistles of Paul: The Case of Würzburg, Universitätsbibliothek, M.p.th.f.69." In *Anglo-Saxon Traces*, edited by Jane Roberts and Leslie Webster, 133–44. Tempe: Arizona Center for Medieval and Renaissance Studies, 2011.

Kasher, Rimon. "The Mythological Figure of Moses in Light of Some Unpublished Midrashic Fragments." *Jewish Quarterly Review*, n.s., 1.2 (1997): 25.

Kaster, Robert A. *Macrobius, Saturnalia*, 1, 2. Cambridge, MA: Harvard University Press, 2011.

Kauffmann, Claus M. *Biblical Imagery in Medieval England, 700–1550*. London: Harvey Miller, 2003.

———. Review of *Imaging the Early Medieval Bible*, edited by John Williams. *Burlington Magazine* 142.1169 (2000): 503–4.

Kedar, Benjamin. "The Latin Translations." In *Mikra: Text, Translation, Reading, and Inter-pretation of the Hebrew Bible in Ancient Judaism and Early Christianity*, edited by Martin Jan Mulder. *Compendia rearum iudaicarum ad Novum Testamentum*, 2, I, 299–338. Minneapolis, MN: Fortress Press, 1990.

Keefer, Sarah L. "Assessing the Liturgical Canticles from the Old English Hexateuch." In *The Old English Hexateuch: Aspects and Approaches*, edited by Rebecca Barnhouse and Benjamin C. Withers, 109–44. Kalamazoo: Medieval Institute Publications, Western Michigan University, 2000.

Kemp, W. "Seelen." In *Lexikon der christlichen Ikonographie*, edited by Engelbert Kirschbaum, S.J., 4, 140. Rome: Herder, 1968–90.

Kendrick, Thomas D. *Late Saxon and Viking Art*. London: Methuen, 1949.

Kerenyi, Karl. *The Gods of the Greeks*. London: Thames and Hudson, 1985.

Kerkeslager, Allen. "Apollo, Greco-Roman Prophecy, and the Rider on the White Horse in Rev. 6:2." *Journal of Biblical Literature* 112.1 (Spring 1993): 116–21.

———. "Jewish Pilgrimage and Jewish Identity in Hellenistic and Early Roman Egypt." In *Pilgrimage and Holy Space in Late Antique Egypt*, edited by David Frankfurter, 99–228. Leiden: Brill, 1998.

Kessler, Herbert L. "The Cotton Genesis and Creation in the San Marco Mosaics." *Cahiers archéologiques* 53 (2009–10): 17–32.

———. "An Eleventh-Century Ivory Plaque from South Italy and the Cassinese Revival." In *Studies in Pictorial Narrative*, edited by Herbert L. Kessler, 479–507. London: Pindar Press, 1994.

———. "'*Hoc Visibile Imaginatum Figurat Illud Invisibile Verum*': Imagining God in Pictures of Christ." In *Seeing the Invisible in Late Antiquity and the Early Middle Ages*, edited by Giselle de Nie et al., 291–325. Turnhout: Brepols, 2005.

———. *The Illustrated Bibles from Tours*. Princeton, NJ: Princeton University Press, 1977.

———. Introduction to *The Atrium of San Marco in Venice: The Genesis and Medieval Reality of the Genesis Mosaics*, edited by Martin Büchsel, Herbert L. Kessler, and Rebecca Müller, 95–130. Berlin: Gebr. Mann Verlag, 2014.

———. "Memory and Models: The Interplay of Patterns and Practice in the Mosaics of San Marco in Venice." In *Medioevo: Immagine e memoria*, edited by Arturo C. Quintavalle, 463–75. Parma, 2009.

———. "On the State of Medieval Art." *Art Bulletin* 70.2 (1988): 166–87.

———. "Pictures as Scripture in Fifth-Century Churches." *Studium Artium Orientalis et Occidentalis* 2 (1985): 17–31.

———. "The Sources and the Construction of the Genesis, Exodus, Maiestas, and Apocalypse Frontispiece Illustrations in the Ninth-Century Touronian Bibles." PhD dissertation, Princeton University, 1965.

———, ed. *Studies in Pictorial Narrative*. London: Pindar Press, 1994.

———. "Thirteenth-Century Venetian Revisions of the Cotton Genesis Cycle." In *The Atrium of San Marco in Venice: The Genesis and Medieval Reality of the Genesis Mosaics*, edited by Martin Büchsel, Herbert L. Kessler, and Rebecca Müller, 95–130. Berlin: Gebr. Mann Verlag, 2014.

———. "Traces of an Early Illustrated Pentateuch." In *Studies in Pictorial Narrative*, edited by Herbert L. Kessler, 177–90. London: Pindar Press, 1994.

———. "The Word Made Flesh in Early Decorated Bibles." In *Picturing the Bible: The Earliest Christian Art*, edited by Jeffrey Spier, 141–70. New Haven, CT: Yale University Press, 2007.

Kiilerich, Bente. "Representing an Emperor: Style and Meaning on the Missorium of Theodosius I." In *El Disco de Teodosio*, edited by Martin Almagro-Gorbea, José M. Álvarez Martinez, José M. Bláquez Martinez, and Salvador Rovira. 273–80. Madrid: Real Academia de la Historia, 2000.

———. "Symmachus, Boethius and the Consecratio Ivory Diptych." *Antiquité tardive* 20 (2012): 205–15.

Kilcher, Andreas B. "The Moses of Sinai and the Moses of Egypt: Moses as Magician in Jewish Literature and Western Esotericism." *Aries* 4.2 (2004): 148–70.

Kinney, Dale. "Instances of Appropriation in Late Roman and Early Christian Art." *Essays in Medieval Studies* 28 (2012): 1–22.

Kirschbaum, Engelbert, S.J., ed. *Lexikon der christlichen Ikonographie.* 8 vols. Rome: Herder, 1968–76.

Kisch, Guido. *Pseudo-Philo's Liber Antiquitatum Biblicarum.* Notre Dame, IN: University of Notre Dame Press, 1949.

Kitzinger, Ernst. "The Hellenistic Heritage in Byzantine Art." *Dumbarton Oaks Papers* 17 (1963): 95–115.

Kleist, Aaron J., ed. *The Old English Homily: Precedent, Practice, and Appropriation.* Turnhout: Brepols, 2007.

Kockelmann, Holger. "Philae." In *University of California, Los Angeles, Encyclopedia of Egyptology: Open Version* (www.escholarship.org/uc/item/1456t8bn#page-1), edited by Willeke Wendrich et al., 1–13. Los Angeles: University of California, Department of Near Eastern Languages and Cultures, 2008.

Kogman-Appel, Katrin. "Bible Illustration and the Jewish Tradition." In *Imaging the Early Medieval Bible*, edited by John Williams, 61–96. University Park: Pennsylvania State University Press, 1999.

———. "The Picture Cycles of the Rylands Haggadah and the So-Called Brother Haggadah and Their Relation to the Western Tradition of Old Testament Illustration." *Bulletin of the John Rylands Library of Manchester* 79.2 (1997): 3–19.

Kominko, Maia. *The World of Kosmas: Illustrated Byzantine Codices of the Christian Topography.* Cambridge: Cambridge University Press, 2013.

Koosed, Jennifer L. "Moses: The Face of Fear." *Biblical Interpretation* 22 (2014): 414–29.

Korol, D. "Horn I." In *Reallexikon für Antike und Christentum*, edited by Ernst Dassmann et al., Leiferung 124, cols. 524–73. Stuttgart: Hiersemann, 1992.

Koskenniemi, Erkki. "Greeks, Egyptians and Jews in the Fragments of Artapanus." *Journal for the Study of the Pseudepigrapha* 13.1 (2002): 17–31.

Kötzsche-Breitenbruch, Lieselotte. *Die neue Katakombe an der via Latina in Rom: Untersuchungen zur Ikonographie der alttestamentlichen Wandmalereien.* Münster: Aschendorff: 1976.

Kovacs, Judith, L. "Divine Pedagogy and the Gnostic Teacher according to Clement of Alexandria." *Journal of Early Christian Studies* 9.1 (2001): 3–25.

Kozodoy, Ruth L. "The Origin of Early Christian Book Illumination: The State of the Question." *Gesta* 10.2 (1971): 33–40.

Kracher, Albert, ed. *Die Millstätter Genesis: MS 6/19 der Geschichts-verein für Kärnten.* 2 vols. Graz: Akademische Druck- und Verlagsanstalt, 1967.

Kraeling, Carl H. *The Synagogue.* (Excavations at Dura-Europos, Final Report, 8, pt. 1.) New York: Ktav, 1979.

Krailsheimer, Alban J. "The Significance of the Pan Legend in Rabelais' Thought." *Modern Language Review* 56.1 (1961): 13–23.

Kramer, M. "Les armes de Caïn, une expression sous enquête diachronique." *Neophilologus* 84 (2000): 165–87.

Krapp, George P. *The Junius Manuscript.* New York: Columbia University Press, 1931.

Kratz, Richard, G. "Ezra: Priest and Scribe." In *Scribes, Sages, and Seers*, edited by Leo G. Perdue, 168–88. Göttingen: Vandenhoeck and Ruprecht, 2008.

Kremydi, Sophia. "Coinage and Finance." In *Brill's Companion to Ancient Macedon: Studies in the Archeology and History of Macedon, 650 BC–300 AD*, edited by Robin Lane Fox, 159–78. Leiden: Brill, 2011.

Kugel, James L. *Traditions of the Bible.* Cambridge, MA: Harvard University Press, 1998.

Kugler, Rob. "Hearing the Story of Moses in Ptolemaic Egypt: Artapanus Accommodates the Tradition." In *The Wisdom of Egypt: Jewish, Early Christian, and Gnostic: Essays in Honour of Gerard P. Luttikhuizen*, edited by Anthony Hilhorst and George H. van Kooten, 67–80. Leiden: Brill, 2005.

Kulik, Alexander. "How the Devil Got His Hooves and Horns: The Origin of the Motif and the Implied Demonology of *3 Baruch*." *Numen* 60 (2013): 195–229.

Kurth, D. "Thoth." In *Lexikon der Ägyptologie*, edited by Wolfgang Helck and Eberhard Otto, 6, 497–523. Wiesbaden: Harrassowitz, 1992.

Lachmann, Claire. "The Millstatt Genesis." Incomplete PhD dissertation, University of Hamburg, 1933, translated by Ruth Wind and now in typescript at the Warburg Institute, London.

Lafaye, G. *Histoire du culte des divinités d'Alexandrie.* Paris, 1884.

Laistner, Max L. W. "Antiochen Exegesis in Western Europe." *Harvard Theological Review* 40 (1947): 19ff.

LaMalfa, Claudia. "Reassessing the Renaissance of the Palestrina Nile Mosaic." *Journal of the Warburg and Courtauld Institutes* 66 (2003): 267–72.

Lang, K. "Chaos and Cosmos: Points of View in Art History and Aesthetics." In *Art History, Aesthetics, Visual Studies*, edited by Michael A. Holly and Keith Moxey, 47–70. Williamstown, MA: Sterling and Francine Clark Art Institute, 2002.

Lapidge, Michael. *The Anglo-Saxon Library.* Oxford: Oxford University Press, 2005.

———. *Archbishop Theodore Commemorative Studies on His Life and Influence.* Cambridge: Cambridge University Press, 2006.

———. "The School of Theodore and Hadrian." *Anglo-Saxon England* 15 (1986): 45–72.

Lauterbach, Jacob Z. "Tanhuma Midrash." In *The Jewish Encyclopedia*, edited by Isidor Singer, 11, 123–24. New York: Funk and Wagnalls, 1906.

Lehmann, Johannes. *Moses: Der Mann aus Ägypten: Religionsstifter, Gesetzgeber, Staatsgründer*. Hamburg: Hoffmann und Campe, 1983.

Lehnhardt, Andreas. "Mose I (literarisch)." In *Reallexikon für Antike und Christentum*, edited by Georg Schöllgen et al., 25, 58–102. Stuttgart: Anton Hiersemann, 2013.

Leipoldt, Johannes, and Siegfried Morenz. *Heilige Schriften: Betrachtungen zur Religionsgeschichte der antiken Mittelmeerwelt*. Leipzig: Harrassowitz, 1953.

Lester, Godfrey A. "A Possible Early Occurrence of Moses with Horns in the Benedictional of St. Aethelwold." *Scriptorium* 27.1 (1973): 30–33.

Levison, John R. "The Prophetic Spirit as an Angel according to Philo." *Harvard Theological Review* 88.2 (1995): 189–207.

Lezzi, Maria Teresa. "L'Arche de Noé en forme de bateau: naissance d'une tradition iconographique." *Cahiers de civilization médiévale* 37.4 (1994): 301–24.

Lierman, John. *The New Testament Moses*. Tübingen: Mohr Siebeck, 2004.

Lightfoot, Jane L. "The Apology of Ps.-Meliton." *Studi epigrafici e linguistici sul Vicino Oriente Antico* 24 (2007): 59–110. Available online at www.proyectos.cchs.csic.es.

Lipinsky, A. "Labarum." In *Lexikon der christlichen Ikonographie*, 3, edited by Engelbert Kirschbaum, S.J., cols. 1, 2. Rome: Herder, 1971.

Lippold, Georg. *Die Skulpturen des Vaticanischen Museums*. 3.2. Berlin: Walter de Gruyter, 1956.

Litwa, M. David. "The Deification of Moses in Philo of Alexandria." In *Studia Philonica Annual: Studies in Hellenistic Judaism* 26 (2014): 1–27. Edited by David T. Runia and Gregory E. Sterling.

———. *Iesus Deus: The Early Christian Depiction of Jesus as a Mediterranean God*. Minneapolis, MN: Fortress Press, 2014.

Liuzza, Roy M. *Anglo-Saxon Prognostics: An Edition and Translation from London, British Library, MS Cotton Tiberius A.III*. Cambridge: D. S. Brewer, 2010.

Livrea, Enrico. "Towards a New Edition of Nonnus' Paraphrase of St. John's Gospel." *Mnemosyne*, 4th ser., 41 (1988): 318–24.

Lockett, Leslie. "An Integrated Re-Examination of the Dating of Oxford, Bodleian Library, Junius 11." *Anglo-Saxon England* 31 (2002): 141–73.

Loerke, William C. "Observations on the Representation of Doxa in the Mosaics of S. Maria Maggiore, Rome, and St. Catherine's, Sinai." *Gesta* 20.1 (1981): 15–22.

Lowden, John. "The Beginnings of Biblical Illustration." In *Imaging the Early Medieval Bible*, edited by John Williams, 9–59. University Park: Pennsylvania State University Press, 1999.

———. "Concerning the Cotton Genesis and Other Illustrated Manuscripts of Genesis." *Gesta* 31 (1992): 40–53.

———. "Illustration in Biblical Manuscripts." In *The New Cambridge History of the Bible*, vol. 2, *From 600 to 1450*, edited by Richard Marsden and E. Ann Matter, 446–82. Cambridge: Cambridge University Press, 2012.

———. *The Octateuchs: A Study in Byzantine Manuscript Illustration*. University Park: Pennsylvania State University Press, 1992.

———. Review of *The Byzantine Octateuchs*, by Kurt Weitzmann and Massimo Bernabò. *Burlington Magazine* 142.1169 (2000): 502–3.

Lucas, Peter J., ed. *Exodus*. London: Methuen, 1977.

———. "Old English Christian Poetry: The Cross in *Exodus*." In *Famulus Christi: Essays in Commemoration of the Thirteenth Centenary of the Birth of the Venerable Bede*, edited by Gerald Bonner, 193–209. London: SPCK, 1976.

Lucchesi, Enzo. *L'usage de Philon dans l'oeuvre exégétique de Saint Ambroise*. Leiden: Brill, 1977.

MacEoin, Gearóid. "The Date and Authorship of *Saltaire na Rann*." *Zeitschrift für celtische Philologie* 28 (1960–61): 51–67.

MacFarlane, Katherine N. "Isidore of Seville on the Pagan Gods (*Origins* VIII.11)." *Transactions of the American Philosophical Society* 70.3 (1980): 3–40.

Macho, Alejandro D. *Neophyti 1: Targum Palestinese MS de la Biblioteca Vaticana*. 5. Madrid: Consejo Superior de Investigaciones Científicas, 1998.

Magny, Ariane. *Porphry in Fragments: Reception of an Anti-Christian Text in Late Antiquity*. Farnham: Ashgate, 2014.

Malaise, Michel. *Inventaire préliminaire des documents égyptiens découverts en Italie*. Leiden: Brill, 1972.

Manaphēs, Kōnstantinos A. *Sinai: Treasures of the Monastery of Saint Catherine*. Athens: Ekdotike Athenon, 1990.

Marcone, Arnaldo. "A Long Late Antiquity? Considerations on a Controversial Periodization." *Journal of Late Antiquity* 1.1 (2008): 4–19.

Marcus, Ralph, trans. *Philo, Supplement* I, II. Loeb Classical Library. London: Heinemann, 1953.

Marsden, Richard. "The Bible in English." In *The New Cambridge History of the Bible*, vol. 2, *From 600 to 1450*, edited by Richard Marsden and E. Ann Matter, 217–38. Cambridge: Cambridge University Press, 2012.

———. "The Biblical Manuscripts of Anglo-Saxon England." In *The Cambridge History of the Book in Britain c. 400–1100*, 1, edited by Richard Gameson, 406–35. Cambridge: Cambridge University Press, 2011.

———. "The Gospels of St. Augustine." In *St. Augustine and the Conversion of England*, edited by Richard Gameson, 285–312. Stroud, UK: Sutton, 1999.

———. "Job in His Place: The Ezra Miniature in the *Codex Amiatinus*." *Scriptorium* 49 (1995): 3–15.

———. *The Old English Heptateuch: and Ælfric's Libellus de Veteri Testament et Novo*. Oxford: Oxford University Press for the Early English Text Society, 2008.

———. *The Text of the Old Testament in Anglo-Saxon England*. Cambridge: Cambridge University Press, 1995.

———. "Wrestling with the Bible: Textual Problems for the Scholar and Student." In *The Christian Tradition in Anglo-Saxon England*, edited by Paul Cavill, 69–90. Rochester, NY: D. S. Brewer, 2004.

Martin, Luther H. "Gods or Ambassadors of God? Barnabas and Paul in Lystra." *New Testament Studies* 41.1 (1995): 152–56.

Mathews, Danny. *Royal Motifs in the Pentateuchal Portrayal of Moses*. New York: T & T Clark International, 2012.

Matthews, Thomas F. *The Clash of Gods*. Princeton, NJ: Princeton University Press, 1993.

McCulloch, Florence. Review of Ruth Mellinkoff, *The Horned Moses in Medieval Art and Thought*. *Speculum* 47 (1972): 135–36.

McEachern, Claire. "Why Do Cuckolds Have Horns?" *Huntington Library Quarterly* 71.4 (2008): 607–31.

McGill, Scott. *Virgil Recomposed: The Mythological and Secular Centos in Antiquity*. Oxford: Oxford University Press, 2005.

McGrail, Seán. *Boats of the World: From the Stone Age to Medieval Times*. Oxford: Oxford University Press, 2004.

McHugh, Michael P., trans. *St. Ambrose: Seven Exegetical Works*. Washington, DC: Catholic University of America Press, 1972.

McLellan, D. "The Great God Pan Reborn in Renaissance Florence." *Spunti e Ricerche* 14 (1999): 74-90.

Medjuck, Bena E. "Exodus 34.29-35: Moses's 'Horns' in Early Bible Translations and Interpretations." MA thesis, McGill University.

Meeks, Wayne A. "Moses as God and King." In *Religions in Antiquity: Essays in Memory of Erwin Ramsdell Goodenough*, edited by Jacob Neusner, 354-71. Leiden: Brill, 1968.

———. *The Prophet-King: Moses Traditions and the Johannine Christology*. Leiden: Brill, 1967.

Mellinkoff, Ruth. *The Horned Moses in Medieval Art and Thought*. Berkeley: University of California Press, 1970.

———. *The Mark of Cain*. Berkeley: University of California Press, 1981.

———. "More about the Horned Moses." *Journal of Jewish Art* 12-13 (1986-87): 184-98.

———. *Outcasts: Signs of Otherness in Northern European Art of the Late Middle Ages*. 2 vols. Berkeley: University of California Press, 1993.

———. "The Round, Cap-Shaped Hats Depicted on Jews in BM Cotton Claudius B.iv." *Anglo-Saxon England* 2 (1973): 155-65.

———. "The Round-Topped Tablets of the Law: Sacred Symbol and Emblem of Evil." *Journal of Jewish Art* 1 (1974): 28-37.

———. "Serpent Imagery in the Illustrated Old English Hexateuch." In *Modes of Interpretation in Old English Literature: Essays in Honour of Stanley B. Greenfield*, edited by Phyllis R. Brown, George R. Crampton, and Fred C. Robinson, 51-64. Toronto: University of Toronto Press, 1986.

Merivale, Patricia. *Pan, the Goat-God: His Myth in Modern Times*. Cambridge, MA: Harvard University Press, 1969.

Merkelbach, Reinhold. *Isis Regina-Zeus Serapis: Die griechisch-ägyptische Religion nach den Quellen dargestellt*. Stuttgart: B. G. Teubner, 1995.

Mettinger, Tryggve N. D. *No Graven Image? Israelite Aniconism in Its Ancient Near Eastern Context*. Stockholm: Almquist & Wiksell International, 1995.

Meyboom, Paul G. P. *The Nile Mosaic of Palestrina: Early Evidence of Egyptian Religion in Italy*. Leiden: Brill, 1995.

Meyvaert, Paul. "Bede, Cassiodorus and the Codex Amiatinus." *Speculum* 71 (1996): 827–83.

———. "The Date of Bede's *In Ezram* and His Image of Ezra in the Codex Amiatinus." *Speculum* 80.4 (2005): 1087–1183.

Michels, Karen. *Transplantierte Kunstwissenschaft: Deutschsprachige Kunstgeschichte im amerikanischen Exil.* Berlin: Akademie, 1999.

Miles, Margaret R. "Santa Maria Maggiore's Fifth-Century Mosaics: Triumphal Christianity and the Jews." In *Christianity in Relation to Jews, Greeks, and Romans*, edited by Everett Ferguson, 63–84. New York: Garland, 1999.

Miller, Frank J. *Ovid in Six Volumes*, IV, *Metamorphoses*. Cambridge, MA: Harvard University Press, 1984.

Miquel, Pierre, et al. *Déserts chrétiens d'Égypte.* Nice: Culture sud, 1993.

Mirsky, A. "On the Sources of the Anglo-Saxon *Genesis* and *Exodus*." *English Studies* 48 (1967): 385–97.

Mittman, Asa S., and Susan M. Kim. "'In those days': Giants and the Giant Moses in the Old English Illustrated Hexateuch." In *Imagining the Jew in Anglo-Saxon Literature and Culture*, edited by Samantha Zacher, 237–61. Toronto: University of Toronto Press, 2016.

———. "Locating the Devil 'Her' in MS Junius 11." *Gesta* 54.1 (2015): 3–25.

Monfasani, John. "Aristotle as Scribe of Nature: The Title-Page of MS Vat. Lat. 2094." *Journal of the Warburg and Courtauld Institutes* 69 (2006): 193–205.

Moore, Teresa R. "Any as an Element in Theophoric Names." *Journal of the American Research Center in Egypt* 33 (1996): 139–52.

Moro, Caterina. *I sandali di Mosè.* Brescia: Paideia Editrice, 2011.

Mosshammer, Alden A. *The Chronicle of Eusebius and Greek Chronographic Tradition.* Lewisburg, PA: Bucknell University Press, 1979.

Most, Glenn W. "Pindar, Fr. 94b. 19-20 Sn.-M." *Zeitschrift für Papyrologie und Epigraphik* 64 (1986): 33–38.

Moxey, Keith. "The Politics of Iconology." In *Iconography at the Crossroads*, edited by Brendan Cassidy, 27–31. Princeton, NJ: Princeton University Press, 1992.

———. "Semiotics and the Social History of Art." *New Literary History* 22 (1991): 985–99.

Moyer, Ian S. *Egypt and the Limits of Hellenism.* Cambridge: Cambridge University Press, 2011.

Muir, B. J., and N. Kennedy. *A Digital Facsimile of Oxford, Bodleian Library MS Junius 11.* Bodleian Digital Texts 1. Oxford, 2004.

Mulder, Martin J., and Harry Sysling, eds. *Mikra: Text, Translation, Reading and Interpretation of the Hebrew Bible in Ancient Judaism and Early Christianity.* Peabody, MA: Hendrickson, 2004.

Müller, C. "Kopftuch." In *Lexikon der Ägyptologie*, 3, edited by Wolfgang Helck and Eberhard Otto, cols. 693–94. Wiesbaden: Harrassowitz, 1992.

Murdoch, Brian. *The Apocryphal Adam and Eve in Medieval Europe: Vernacular Translations and Adaptations of the Vita Adae et Evae.* Oxford: Oxford University Press, 2009.

———. *The Fall of Man in the Early Middle High German Biblical Epic: The Wiener Genesis, the Vorauer Genesis and the Anegenge.* Göppingen: A. Kümmerle, 1972.

Murphy, Edwin. *The Antiquities of Egypt: A Translation with Notes of Book I of the "Library of History" of Diodorus Siculus*. New Brunswick, NJ: Transaction Publishers, 1990.

Mussies, Gerard. "The Interpretatio Judaica of Serapis." In *Studies in Hellenistic Religions*, edited by Maarten J. Vermaseren, 189-214. Leiden: Brill, 1979.

———. "The *Interpretatio Judaica* of Thoth-Hermes." In *Studies in Egyptian Religion: Dedicated to Professor Jan Zandee*, edited by Matthieu H. van Voss et al., 89-120. Leiden: Brill, 1982.

Mütherich, Florentine. "Die Stellung der Bilder in der frühmittelalterlichen Psalterillustration." In *Der Stuttgarter Bilderpsalter, Bibl. Fol. 23 Würtembergische Landesbibliothek Stuttgart. MS bibl. Fol. 23*, vol. 2, edited by Bernhard Bischoff and Florentine Mütherich et al. Stuttgart: E. Schreiber, 1965.

Myśliwiec, Karol. *Royal Portraiture of the Dynasties XXI–XXX*. Mainz am Rhein: P. von Zabern, 1988.

Nees, Lawrence. "The Originality of Early Medieval Artists." In *Literacy, Politics and Artistic Innovation in the Early Medieval West: Papers Delivered at a Symposium on Early Medieval Culture*, edited by Celia M. Chazelle, 77-110. Lanham, MD: University Press of America, 1992.

Neudecker, Richard. "Cippus." In *Der Neue Pauly-Wissowa Enzyklopädie der Antike*, 2, edited by Hubert Cancik and Helmuth Schneider, cols. 1207-8. Weimar: Metzler, 1997.

Neufeld, Thomas Y. *"Put on the Armour of God": The Divine Warrior from Isaiah to Ephesians*. Sheffield: Sheffield Academic Press, 1997.

Neusner, Jacob. "Judaism at Dura-Europos." *History of Religions* 4.1 (1964): 81-102.

Neuss, Wilhelm. *Die Katalanische Bibelillustration um die Wende des ersten Jahrtausends und die altspanische Buchmalerei*. Bonn: K. Schroeder, 1922.

Newberry, Percy E. *El Bersheh*. London: Egypt Exploration Fund, 1893.

Newman, Robert C. "The Ancient Exegesis of Genesis 6:2, 4." *Grace Theological Journal* 5.1 (1984): 24-25.

Niehaus, Jeffrey J. *God at Sinai: Covenant and Theophany in the Bible and Ancient Near East*. Grand Rapids, MI: Zondervan, 1995.

Nielsen, Jan T. *Adam and Christ in the Theology of Irenaeus of Lyons*. Assen: Van Gorcum, 1968.

Nilsson, Maria. *The Crown of Arsinoë II: The Creation of an Imagery of Authority*. Oxford: Oxbow Books, 2012.

Nock, Arthur Darby. "Notes on Ruler-Cult, I–IV." *Journal of Hellenic Studies* 48.01 (1928): 21–43.

Noegel, Scott B. "The Egyptian Origin of the Ark of the Covenant." In *Israel's Exodus in Transdisciplinary Perspective: Text, Archaeology, Culture, and Geoscience*, edited by Thomas E. Levy, Thomas Schneider, and William H. C. Propp, 223-42. Cham, Switzerland: Springer, 2015.

———. "Moses and Magic: Notes on the Book of Exodus." *Journal of the Ancient Near Eastern Society* 24 (1996): 45-59.

Noel, William. *The Harley Psalter*. Cambridge: Cambridge University Press, 1995.

Nordström, Carl-Otto. "Rabbinic Features in Byzantine and Catalan Art." *Cahiers archéologiques* 15 (1965): 179-205.

Nosarti, Lorenzo. "Some Remarks on the *Hymn to Light* of Dracontius (*Laudes Dei* 1, 115–28)." *Medievalia et Humanistica*, n.s., 40 (2015): 37–82.

Oakes, Peter. "Moses in Paul." In *La construction de la figure de Möise*, edited by Thomas Römer, 249–62. Paris: Librairie Gabalda, 2007.

Ohlgren, Thomas H. "The Illustrations of the Caedmonian Genesis as a Guide to the Interpretation of the Text." PhD dissertation, University of Michigan, 1969.

———. *Insular and Anglo-Saxon Illuminated Manuscripts: An Iconographic Catalogue, c. A.D. 625 to 1100.* New York: Garland, 1986.

O'Kane, Martin. "Interpreting the Bible through the Visual Arts." *Hebrew Bible and Ancient Israel* 1 (2012): 388–409.

Oldfather, Charles Henry, trans. *The Library of History* [Diodorus Siculus]; Books 1-2, 1. Loeb Classical Library, 279. Cambridge, MA: Harvard University Press, 2004.

Olszewski, Edward J. "Renaissance Naturalism: The Rare and the Ephemeral in Art and Nature." *Source* 1.2 (1982): 23–28.

Opper, Thorsten. *Hadrian: Empire and Conflict.* Cambridge, MA: Harvard University Press, 2008.

Orchard, Nicholas. *The Leofric Missal.* 2 vols. London: Boydell Press, 2002.

Orlov, Andrei A. "Noah's Younger Brother Revisited: Anti-Noachic Polemics and the Date of 2 (Slavonic) Enoch." *Henoch* 26 (2004): 172–87.

O'Reilly, Jennifer. "The Library of Scripture: Views from Vivarium and Wearmouth-Jarrow." In *New Offerings, Ancient Treasures*, edited by Paul Binski and William Noel, 4–39. Thrupp, UK: Sutton, 2001.

———. "St. John the Evangelist: Between Two Worlds." In *Insular and Anglo-Saxon Art and Thought in the Early Medieval Period*, edited by Colum Hourihane, 189–218. University Park: Pennsylvania State University Press, 2011.

Orton, David E. *The Understanding Scribe: Matthew and the Apocalyptic Ideal.* Sheffield: Sheffield Academic Press, 1989.

Otto, Eberhard. "Amun." In *Lexikon der Ägyptologie*, edited by Wolfgang Helck and Eberhard Otto, 1, cols. 238, 245. Wiesbaden: Harrassowitz, 1999.

———. "Cheriheb." In *Lexikon der Ägyptologie*, edited by Wolfgang Helck and Eberhard Otto, 1, cols. 940–43. Wiesbaden: Harrassowitz, 1999.

Otto, Eckart, and Jan Assmann. *Ägypten und das Alte Testament.* Stuttgart: Verlag Katholisches Bibelwerk, 2000.

Owen-Crocker, Gail R., et al. *Working with Anglo-Saxon Manuscripts.* Exeter: Exeter University Press, 2009.

Pächt, Otto. "A Cycle of English Frescoes in Spain." *Burlington Magazine* 103 (1961): 166–75.

———. "A Giottesque Episode in English Medieval Art." *Journal of the Warburg and Courtauld Institutes* 6 (1943): 51–70.

Page, Thomas E., and Edward Capps, eds. *Select Letters of St. Jerome.* Loeb Classical Library. London: William Heinemann, 1933.

Pakkala, Juha. *Ezra the Scribe.* Berlin: Walter de Gruyter, 2004.

Palmer, A. Smythe. "Horns of Moses." *Notes and Queries*, 9th S.V. (April 1900): cols. 284–85.

Palmer, Robert E. A. "Studies of the Northern Campus Martius in Ancient Rome." *Transactions of the American Philosophical Society* 80.2 (1990): i–vii, 1–64.

Panofsky, Erwin. "Iconography and Iconology: An Introduction to the Study of Renaissance Art." In *Meaning in the Visual Arts*. Garden City, NY: Doubleday, 1955; reprint 1982.

———. *Renaissance and Renascences in Western Art*. New York: Harper & Row, 1969.

———. *Studies in Iconology: Humanistic Themes in the Art of the Renaissance*. New York: Harper & Row, 1972.

Parker, Elizabeth C., and Charles T. Little. *The Cloisters Cross: Its Art and Meaning*. New York: Metropolitan Museum of Art, 1994.

Parker, Richard A. *A Saite Oracle Papyrus from Thebes: In the Brooklyn Museum*. Providence, RI: Brown University Press, 1962.

Patai, Raphael. *The Children of Noah: Jewish Seafaring in Ancient Times*. Princeton, NJ: Princeton University Press, 1999.

Paulson, P. "Koptische und irische Kunst und ihre Ausstrahlungen auf altgermanische Kulturen," *Tribus: Jahrbuch des Linden-Museums* (1952–53): 149–87.

Pearson, Birger A. "Earliest Christianity in Egypt: Further Observations." In *The World of Early Egyptian Christianity: Language, Literature, and Social Context: Essays in Honor of David W. Johnson*, edited by James E. Goehring, Janet A. Timbie, et al., 97–112. Washington, DC: Catholic University of America Press, 2007.

———. "Earliest Christianity in Egypt: Some Observations." In *The Roots of Egyptian Christianity*, edited by Birger A. Pearson and James E. Goehring, 132–60. Philadelphia: Fortress Press, 1986.

Perry, M. P. "On the Psychostasis in Christian art." *Burlington Magazine* 22.116 (1912): 94–97, 100–105.

Petrie, William Matthew Flinders. "Egyptian Religion." In *Encyclopedia of Religion and Ethics*, 5, edited by James Hastings, 248. New York: Charles Scribner's Sons, 1914.

Petschenig, Michael, et al. *Sancti Ambrosii Opera/Ps. VI, Explanatio psalmorum XII*. CSEL, 64. Vienna: Verlag der Österreichischen Akademie der Wissenschaften, 1999.

Phillips, Graham. *The Moses Legacy: In Search of the Origins of God*. London: Sidgwick & Jackson, 2002.

Philpot, Joshua M. "The Shining Face of Moses: The Interpretation of Exodus 34:29–35 and Its Use in the Old and New Testaments." PhD dissertation, Southern Baptist Theological Seminary, 2013.

Picard, Charles. "A Figurine of Lysippan Type from the Far East: The Tra Vinh Bronze 'Dancer.'" *Artibus Asiae* 19.3–4 (1956): 342–47, 349–52.

Pilhoffer, Peter. *Presbyteron Kreitton: Der Altersbeweis der jüdischen und christlichen Apologeten und seine Vorgeschichte*. Tübingen: J. C. B. Mohr, 1990.

Plummer, Charles. *Venerabilis Baedae Historiam Ecclesiasticum Gentis Anglorum*. Oxford: Oxford University Press, 1896.

Poilpré, Anne-Orange. "Bilan d'une décennie de réactions à l'ouvrage de Thomas F. Matthews, *Clash of Gods: A Reinterpretation of Early Christian Art*, Princeton, 1993." *AuTard* 13 (2005): 177–385.

Pollitt, John J. *Art in the Hellenistic Age*. Cambridge: Cambridge University Press, 1986.

Prescott, Andrew. *The Benedictional of St. Aethelwold: A Masterpiece of Anglo-Saxon Art.* London: British Library, 2002.

Prigent, Pierre. *Le Judaïsme et l'image.* Tübingen: J. C. B. Mohr (Paul Siebeck), 1990.

Propp, William H. "The Skin of Moses' Face—Transfigured or Disfigured?" *Catholic Biblical Quarterly* 49.3 (1987): 375–86.

Prost, Mark A., trans. *Nonnos of Panopolis: Paraphrase of the Gospel of St. John.* Ventura, CA: Writing Shop Press, 2003.

Quandt, Wilhelm. *Orphei hymni.* Berlin: Weidmann, 1962.

Quispel, Giles. "The Original Doctrine of Valentinus the Gnostic." *Vigiliae Christianiae* 50.4 (1996): 327–52.

Ramsey, Nigel, et al. *St. Dunstan: His Life, Times and Cult.* Woodbridge: Boydell Press, 1992.

Rapp, Claudia. "Imperial Ideology in the Making: Eusebius of Caesarea on Constantine as 'Bishop.'" *Journal of Theological Studies*, n.s., 49.2 (1996): 685–95.

Redford, Donald B. *A Study of the Biblical Story of Joseph.* Leiden: Brill, 1970.

Redin, Egor K. *Christijanskogo Topografija Kosmij Indikoplova.* Moscow: Moskva Tip. G. Lissnera I D. Sobko, 1916.

Remley, Paul G. *Old English Biblical Verse: Studies in Genesis, Exodus, and Daniel.* Cambridge: Cambridge University Press, 1996.

Revel-Neher, Elisabeth. *The Image of the Jew in Byzantine Art.* Oxford: Pergamon Press, 1992.

———. "Problèmes d'iconographie judéo-chrétienne: Le thème de la coiffure du Cohen Gadol dans l'art byzantine." *Journal of Jewish Art* 1 (1974): 50–65.

Richter, Jean Paul, and Cameron A. Taylor. *The Golden Age of Classic Christian Art.* London: Duckworth, 1904.

Ridings, Daniel. *The Attic Moses: The Dependency Theme in Some Early Christian Writers.* Göteborg: Acta Universitatis Gothoburgensis, 1995.

Riggs, Christina. *The Oxford Handbook of Roman Egypt.* Oxford: Oxford University Press, 2012.

Ritner, Robert K. "Egyptians in Ireland: A Question of Coptic Peregrinations." *Rice University Studies* 62.2 (1976): 65–87.

———. *The Mechanics of Ancient Egyptian Magical Practice.* Chicago: Oriental Institute of the University of Chicago, 1993.

Roberts, Alexander, and James Donaldson, eds. *The Ante-Nicene Fathers: Translations of the Writings of the Fathers Down to A.D. 325.* 3 vols. Grand Rapids, MI: Eerdmans, 1994.

Robinson, James M., et al., eds. *The Nag Hammadi Library in English.* San Francisco: Harper & Row, 1990.

Roehrig, Catherine H., et al. *Hatshepsut: From Queen to Pharaoh.* New Haven, CT: Yale University Press, 2005.

Römer, Thomas, ed. *La construction de la figure de Moïse.* Paris: Librairie Gabalda, 2007.

———. "The Hebrew Bible and Greek Philosophy and Mythology: Some Case Studies." *Semitica* 57 (2015): 185–203.

———. "The Horns of Moses: Setting the Bible in Its Historical Context." Inaugural lecture, Collège de France, February 5, 2009. www.college-de-france.fr/site/en-news/Thomas-Romer-s-Inaugural-Lecture.htm.

———. *Moïse lui que Yahvé a connu face à face.* Paris: Gallimard, 2002.

———. "Moses Outside the Torah and the Construction of a Diaspora Identity." *Journal of Hebrew Scriptures* 8 (2008): 2-12.

———. "Moses the Royal Lawgiver." In *Remembering Biblical Figures in the Late Persian and Early Hellenistic Periods: Social Memory and Imagination,* edited by Diana Edelman and Ehud Ben Zvi, 81-94. Oxford: Oxford University Press, 2013.

———. "Tracking Some 'Censored' Moses Traditions Inside and Outside the Hebrew Bible." *Hebrew Bible and Ancient Israel* 1.1 (2012): 64-76.

Rosenfeld, Eva M. "The Pan-Headed Moses—A Parallel." *International Journal of Psycho-analysis* 32 (1951): 83–93.

Rosenmeyer, T. G. "Plato's Prayer to Pan (Phaedrus 279 B8-C3)." *Hermes* 90 (1962): 34-44.

Rosenthal, Jane H. "The Image in the Arenberg Gospels of Christ Beginning to Be 'What He Was Not.'" In *Insular and Anglo-Saxon Art and Thought in the Early Medieval Period,* edited by Colum Hourihane, 229-46. University Park: Pennsylvania State University Press, 2011.

———, ed. *The Language of Forms: Lectures on Insular Manuscript Art.* New York: Pierpont Morgan Library, 2005.

Rostovtzeff, Michael I. "Vexillum and Victory." *Journal of Roman Studies* 32, pts. 1 and 2 (1942): 92-106.

Roukema, Riemer. "The Veil over Moses' Face in Patristic Interpretation." In *The Interpretation of Exodus: Studies in Honours of Cornelis Houtman,* edited by Riemer Roukema, 237-52. Leuven: Peeters, 2006.

Roullet, Anne. *The Egyptian and Egyptianizing Monuments of Imperial Rome.* Leiden: Brill, 1972.

Rouse, R. H., and M. A. Rouse. "Wax Tablets." *Language & Communication* 9.2-3 (1989): 175-91.

Rouse, W. H. D., et al., trans. *Nonnos: Dionysiaca.* 3 vols. Reprint. Cambridge, MA: Harvard University Press, 1995.

Rousseau, M. I. J. "Vexilla Regis." In *The New Catholic Encyclopedia,* 14, 635. New York: McGraw-Hill, 1967.

Rowe, A. "New Excavations at Kôm-el-Shukafa—Part II." *Bulletin de la Société Royale d'archéologie d'Alexandrie* 35 (1942).

Rubinstein, Arie. "Observations on the Slavonic Book of Enoch." *Journal of Jewish Studies* 13 (1962): 1-21.

Ruck, Carl A., and Danny Staples. *The World of Classical Myth.* Durham, NC: Carolina Academic Press, 1994.

Sande, Siri. "Egyptian and Other Elements in the Fifth-Century Mosaics of S. Maria Maggiore." *Acta ad archaeologiam et atrium historiam pertinentia* 21 (2008): 65-94.

Sanders, Seth, L. "Old Light on Moses's Shining Face." *Vetus Testamentum* 52.3 (2002): 400-406.

Sarna, Nahum M. *The Jewish Publication Society Torah Commentary: Exodus.* Philadelphia: Jewish Publication Society, 1991.

Sasson, Jack M. "Bovine Symbolism in the Exodus Narrative." *Vetus Testamentum* 18.3 (1968): 380–87.

Sauneron, Serge. *Les prêtres de l'ancienne Égypte*. Paris, 1957.

———. *The Priests of Ancient Egypt*. Translated by Ann Morrissett. New York: Grove Press, 1960.

Savage, John J., trans. *Saint Ambrose: Hexameron, Paradise, Cain and Abel*. Washington, DC: Catholic University of America Press, 2010.

Saxl, Fritz, and Hans Meier. *Catalogue of Astrological and Mythological Illuminated Manuscripts of the Latin Middle Ages*. 3/2. London: Warburg Institute, University of London, 1953.

Schade, Herbert. "Hinweise zur frühmittelalterlichen Ikonographie." *Das Münster* 11 (1958): 375–92.

———. "Das Paradies und die *Imago Dei*." *Probleme der Kunstwissenschaft* 2 (1966): 79–182.

Schäfer, Peter. *The History of the Jews in the Greco-Roman World*. London: Routledge, 2003.

———. *Judeophobia: Attitudes toward the Jews in the Ancient World*. Cambridge, MA: Harvard University Press, 1997.

Schapiro, Meyer. *The Language of Forms: Lectures on Insular Manuscript Art*. Edited by Jane Rosenthal. New York: Pierpont Morgan Library, 2005.

———. *Late Antique, Early Christian and Mediaeval Art*. New York: George Braziller, 1979.

———. "On Some Problems in the Semiotics of Visual Art: Field and Vehicle in Image-Signs." *Semiotica* 1.3 (1969): 223–49.

———. *Words and Pictures. On the Literal and the Symbolic in the Illustration of Text*. The Hague: Mouton, 1973.

Scheil, Andrew P. *The Footsteps of Israel: Understanding Jews in Anglo-Saxon England*. Ann Arbor: University of Michigan Press, 2004.

Schipper, William. "Dry-Point Compilation Notes in the Benedictional of St. Aethelwold." *British Museum Journal* 20 (1994): 17–34.

———. "Style and Layout of Anglo-Saxon Manuscripts." In *Anglo-Saxon Styles*, edited by Catherine E. Karkov and George H. Brown, 151–68. Albany: State University of New York Press, 2003.

Schoff, Wilfred H. "Tammuz, Pan and Christ." *Open Court* 26.9 (1912): 513–32.

Schreckenberg, Heinz, Kurt Schubert, and David Flusser. *Jewish Historiography and Iconography in Early and Medieval Christianity*. Assen: Fortress Press, 1992.

Schrenk, S. "Kain und Abel." In *Reallexikon für Antike und Christentum* 19, edited by Ernst Dassmann et al., 943–72. Stuttgart: Hiersemann, 2001.

Schubert, Kurt, and Ursula Schubert. "Die Vertreibung aus dem Paradies in der Katakombe der Via Latina in Rom." In *Christianity, Judaism and Other Greco-Roman Cults: Studies for Morton Smith at 60, 2, Early Christianity*, edited by Jacob Neusner, 174–80. Leiden: Brill, 1975.

Schubert, Ursula. "Egyptian Bondage and Exodus in the Ashburnham Pentateuch." *Journal of Jewish Art* 5 (1978): 29–44.

———. "Eine jüdische Vorlage für die Darstellung der Erschaffung des Menschen in der sogenannten Cotton-Genesis-Rezension." *Kairos*, NF, 17 (1975): 1–10.

Schumacher, Inke W. *Der Gott Sopdu der Herr der Fremdländer.* Freiburg: Universitätsverlag, 1988.

Schürer, Emil. *The History of the Jewish People in the Age of Jesus Christ.* Reprint. London: Bloomsbury and T & T Clark, 2014.

Schwartz, Gary S. "Theogony 175: Why a Sickle?" *Rivista di studi classici* 27 (1979): 1–12.

Scolnic, Benjamin E. "Moses and the Horns of Power." In *Judaism: Festschrift in Honor of Dr. Robert Gordis,* edited by Eugene B. Borowitz, 569–79. New York: American Jewish Congress, 1991.

Scott, Kenneth. "The Deification of Demetrios Poliorcetes, 1." *American Journal of Philology* 49.2 (1928): 137–239; 2, 49.3 (1928): 217–39.

———. "Plutarch and the Ruler Cult." *Transactions and Proceedings of the American Philological Association* 60 (1929): 117–35.

Screech, Michael A. "The Death of Pan and the Death of Heroes in the Fourth Book of Rabelais: A Study in Syncretism." *Bibliothèque d'Humanism et Renaissance* 17.1 (1955): 36–55.

Seaford, Richard. *Dionysos.* London: Routledge, 2006.

Seidel, Linda. Review of Ruth Mellinkoff, *The Horned Moses in Medieval Art and Thought. American Historical Review* 78.1 (1973): 79–89.

Seligson, Max. "Scribes." In *The Jewish Encyclopedia,* edited by Isidor Singer, 11, 123–24. New York: Funk and Wagnalls, 1906.

Servius. *Commentary on Virgil, Ecl. II. In Vergilii Carmina Commentarii.* Lipsiae, 1887.

Sethe, Kurt. "Amun und die acht Urgötter von Hermopolis." *Abhandlungen der preussischen Akademie der Wissenschaften* 4 (1929): 1–319.

———. *Imhotep: Der Asklepios der Aegypter—ein vergötterter Mensch aus der Zeit des Königs Doser.* Leipzig: August Pries, 1902.

Seznec, Jean. *The Survival of the Pagan Gods: The Mythological Tradition and Its Place in Renaissance Humanism and Art.* Princeton, NJ: Princeton University Press, 1995.

Shalem, Avinoam. "Why Is the Lion Always in a State of Fever?" *Cahiers archéologiques* 51 (2003–4): 39–46.

Shanks, Hersey. "Is This Man a Biblical Archeologist?" *Biblical Archaeology Review* 22.4 (1996): 36.

Sherley-Price, Leo, trans. *A History of the English Church and People/Bede.* Harmondsworth: Penguin, 1955.

Sherman, Randi E. "Observations on the Genesis Iconography of the *Ripoll Bible.*" *Rutgers Art Review* 2 (1981): 1–12.

Shorrock, Richard. *The Myth of Paganism: Nonnus, Dionysus and the World of Late Antiquity.* London: Bristol Classical Press, 2011.

Sieger, Joanne D. "Visual Metaphor as Theology: Leo the Great's Sermons on the Incarnation and the Arch Mosaics at S. Maria Maggiore." *Gesta* 26.2 (1987): 83–91.

Siemens, James. *The Christology of Theodore of Tarsus: The Laterculus Malalianus and the Person and Work of Christ.* Turnhout: Brepols, 2010.

Silver, Daniel J. *Images of Moses.* New York: Basic Books, 1982.

Simmons, Michael B. *Universal Salvation in Late Antiquity: Porphry of Tyre and the Pagan-Christian Debate.* Oxford: Oxford University Press, 2015.

Simon, Marcel. *Verus Israel: A Study of the Relations between Christians and Jews in the Roman Empire, 135–425*. Oxford: Oxford University Press, 1986.

Singer, Isidore, and Cyrus Adler, eds. *The Jewish Encyclopedia*. 7 vols. New York, 1901–6.

Skeabeck, A. H. "Fortunatus." *New Catholic Encyclopedia* 5 (1967): 1034–35.

Small, Jocelyn P. *Wax Tablets of the Mind: Cognitive Studies of Memory and Literacy in Classical Antiquity*. London: Routledge, 1997.

Smith, Jonathan Z. "Adde Parvum Parvo Magnus Acervus Erit." *History of Religions* 11.1 (1971): 67–90.

———. Review of Ruth Mellinkoff, *The Horned Moses in Medieval Art and Thought*. *History of Religions* 11.3 (1972): 317.

Smith, R. R. R. *Hellenistic Royal Portraits*. Oxford: Clarendon Press, 1988.

———. "Kings and Philosophers." In *Images and Ideologies in the Hellenistic World*, edited by Anthony W. Bulloch et al., 202–11. Berkeley: University of California Press, 1993.

Sonnet, Jean-Pierre. *The Book within the Book: Writing in Deuteronomy*. Leiden: Brill, 1997.

Sonsino, Rifat. *Did Moses Really Have Horns? And Other Myths about Jews and Judaism*. New York: URJ Press, 2008.

Sörries, Reiner. *Christliche-Antike Buchmalerei im Überblick*. 2 vols. Wiesbaden: Dr. Ludwig Reichert Verlag, 1993.

Spalinger, Anthony. "Stele." In *Lexikon der Ägyptologie*, edited by Wolfgang Helk and Eberhard Otto, 5, cols. 1–8. Wiesbaden: Harrassowitz, 1992.

Spanoudakis, Konstantinos, ed. *Nonnus of Panopolis in Context*. Berlin: Walter de Gruyter, 2014.

Spier, Jeffrey. *Picturing the Bible: The Earliest Christian Art*. New Haven, CT: Yale University Press, 2007.

Spronk, Klaas. "The Picture of Moses in the History of Interpretation." In *The Interpretation of Exodus: Studies in Honour of Cornelis Houtman*, edited by Riemer Roukema, 253–64. Leuven: Peeters, 2006.

Stahl, Harvey. "The Iconographic Sources of the Old Testament Miniatures: Morgan MS638." PhD dissertation, New York University, 1974.

———. *Picturing Kingship: History and Painting in the Psalter of St. Louis*. University Park: Pennsylvania State University Press, 2008.

Stählin, Otto. *Clemens Alexandrinus zweiter Band; Stromata Buch* I–VI. GCS 15. Leipzig: J. C. Hinrich, 1906.

Stambaugh, John E. *Sarapis under the Early Ptolemies*. Leiden: E. J. Brill, 1972.

Stanwick, Paul Edmund. *Portraits of the Ptolemies: Greek Kings as Egyptian Pharaohs*. Austin: University of Texas Press, 2002.

Stauffer, Annmarie. *Textiles of Late Antiquity*. New York: Metropolitan Museum of Art, 1995.

Stenton, Frank M. *The Bayeux Tapestry: A Comprehensive Survey*. London: Phaidon Press, 1965.

Sterling, Gregory E. "From the Thick Marshes of the Nile to the Throne of God: Moses in Ezekiel the Tragedian and Philo of Alexandria." *The Studia Philonica Annual: Studies in Hellenistic Judaism* 26 (2014): 115–33. Edited by David T. Runia and Gregory E. Sterling. Atlanta, GA: SBL Press, 2014.

Stern, Henri. "Les mosaïques de l'église de Sainte-Constance à Rome." *Dumbarton Oaks Papers* 12 (1958): 157, 159–218.

Stevenson, Jane. "Ascent through the Heavens from Egypt to Ireland." *Cambridge Medieval Celtic Studies* 5 (1983): 21–35.

Stichel, Reiner. "Ausserkanonische Elemente in byzantinischen Illustrationen des Alten Testaments." *Römische Quartalschrift* 69 (1974):159–81.

Storch, Rudolph H. "The Trophy and the Cross: Pagan and Christian Symbolism in the Fourth and Fifth Centuries." *Byzantion* 40 (1970): 105–18.

Strauss, Christine. "Kronen." In *Lexikon der Ägyptologie*, edited by Wolfgang Helck and Eberhard Otto, 3, cols. 811–16. Wiesbaden: Harrassowitz, 1992.

Stroumsa, Guy G. *A New Science: The Discovery of Religion in the Age of Reason.* Cambridge, MA: Harvard University Press, 2010.

Summers, Montague. *The History of Witchcraft and Demonology.* Abingdon: Routledge, 1994.

Süring, Margit, L. *The Horn-Motif in the Hebrew Bible and Related Ancient Near Eastern Literature and Iconography.* Berrien Springs, MI: Andrews University Press, 1980.

Suydam, Mary A., and Joanna E. Ziegler, eds. *Performance and Transformation.* New York: St. Martin's Press, 1999.

Swaim, Kathleen. "'Mighty Pan': Tradition and an Image in Milton's Nativity 'Hymn.'" *Studies in Philology* 68.4 (1971): 484–95.

Swarzenski, Hanns. *Monuments of Romanesque Art: The Art of Church Treasuries in North-Western Europe.* Chicago: University of Chicago Press, 1967.

Tcherikover, Victor. *Hellenistic Civilization and the Jews.* Philadelphia: Jewish Publication Society of America, 1959.

Teichmann, Frank. *Der Mensch und sein Temple: Ägypten.* Stuttgart: Urachhaus, 1980.

Temple, Elżbieta. *Anglo-Saxon Manuscripts: 900–1066.* London: Harvey Miller, 1976.

Thackery, Henry St. J., trans. *Flavius Josephus, Jewish Antiquities.* Books 1–4. Cambridge, MA: Harvard University Press, 1998.

———. *The Life/Against Apion.* London and New York: William Heinemann and G. P. Putnam's Sons, 1936.

Thomas, Roland. "Die Illustrationen des Ælfric-Hexateuch (British Library, Cotton Claudius B.IV) und ihre Vorlagen." MA thesis, Ludwig-Maximilians-Universität München, 1976.

Thomas, Thelma K. *Late Antique Egyptian Funerary Sculpture: Images for this World and the Next.* Princeton, NJ: Princeton University Press, 2000.

———. "Material Meaning in Late Antiquity." In *Designing Identity: The Power of Textiles in Late Antiquity*, edited by Thelma K. Thomas, 21–53. Princeton, NJ: Princeton University Press, 2016.

———. *Textiles from Medieval Egypt, A.D. 300–1300.* Pittsburgh, PA: Carnegie Museum of Natural History, 1990.

Thorpe, Benjamin, ed. *Sermones Catholici, or Homilies of Ælfric.* 2 vols. London: Ælfric Society, 1844–46.

Tiede, David L. *The Charismatic Figure as Miracle Worker.* Missoula, MT: Society of Biblical Literature, 1972.

Tigchelaar, Eibert. "Bare Feet and Holy Ground: Excursive Remarks on Exodus 3:5 and Its Reception." In *The Revelation of the Name of YHWH to Moses*, edited by George H. van Kooten, 17–36. Leiden: Brill, 2006.

Torjussen, Stian S. "Metamorphoses of Myth: A Study of the 'Orphic' Gold Tablets and the Derveni Papyrus." PhD dissertation, University of Tromsø, Norway, 2008.

Török, László. *Transfigurations of Hellenism: Aspects of Late Antique Art in Egypt, A.D. 250–700.* Leiden: Brill, 2005.

Torp, Hjalmar. *Leda Christiana: The Problem of the Interpretation of Coptic Sculpture with Mythological Motifs. Acta ad archaeologiam et atrium historiam pertinentia* 4 (1969).

Trachtenberg, Joshua. *The Devil and the Jews: The Medieval Conception of the Jew and Its Relation to Modern Antisemitism.* New Haven, CT: Yale University Press, 1943.

Tran Tam Tinh, Vincent. *Le culte des divinités orientales en Campanie.* Leiden: Brill, 1972.

Troje, Louise. *Adam und Zōē: Eine Szene der altchristlichen Kunst in ihrem religionsgeschichtlichen Zusammenhange.* Heidelberg: C. Winter, 1916.

Trombley, Frank R. *Hellenistic Religion and Christianization c. 370–529.* 2 vols. Leiden: Brill, 1995.

Tselos, Dimitri. "English Manuscript Illustration and the Utrecht Psalter." *Art Bulletin* 41 (1959): 137–49.

Tsevat, Matitiahu. "The Skin of His Face Was Radiant (Exodus 34.29)." *Eretz Israel* 16 (1982): 163–67.

Ulrich, Anna. *Kain und Abel in der Kunst: Untersuchungen zur Ikonographie und Auslegungsgeschichte.* Bamberg: Urlaub, 1981.

Uspensky, Theodor. *L'Octateuque du Serail à Constantinople (Album du XIIe du Bulletin de l'Institut Archéologique Russe à Constantinople).* Sofia, 1907.

Vandersleyen, Claude, et al. *Das Alte Ägypten.* Propyläen Kunstgeschichte 15. Berlin: Propyläen Verlag, 1975.

van Henten, Jan-Willem, and Ra'anan Abusch. "The Depiction of Jews as Typhonians and Josephus' Strategy of Refutation in *Contra Apionem*." In *Josephus' Contra Apionem: Studies in Its Character and Context with a Latin Concordance to the Portion Missing in Greek*, edited by Louis H. Feldman and John R. Levison, 271–310. Leiden: Brill, 1996.

van de Water, Rick. "Moses' Exaltation: Pre-Christian?" *Journal for the Study of the Pseudepigrapha* 21 (2000): 59–69.

van den Hoek, Annewies. *Clement of Alexandria and His Use of Philo in the Stromateis.* Leiden: Brill, 1988.

van der Horst, Koert, and Jacobus H. A. Engelbrecht, eds. *The Utrecht Psalter.* Codices selecti 75. Graz, 1982.

van der Horst, Koert, et al., eds. *The Utrecht Psalter in Medieval Art: Picturing the Psalms of David.* Tuurdijk, Netherlands: HES, 1996.

van der Horst, Pieter W. *Chaeremon: Egyptian Priest and Stoic Philosopher.* Leiden: Brill, 1984.

———. "Moses' Throne Vision in Ezekiel the Dramatist." *Journal of Jewish Studies* 34 (1983): 21–29.

van der Toorn, Karel. *Scribal Culture and the Making of the Hebrew Bible.* Cambridge, MA: Harvard University Press, 2007.

van Kooten, George (Geurt) H. "Moses/Musaeus/Mochos and His God Yahweh, Iao, and Sabaoth from a Graeco-Roman Perspective." In *The Revelation of the Name YHWH to Moses*, edited by Geurt H. van Kooten, 107–38. Leiden: Brill, 2006.

———. "Why Did Paul Include Exegesis of Moses' Shining Face (Exod. 34) in 2 Cor. 3?" In *The Significance of Sinai: Traditions about Sinai and Divine Revelation in Judaism and Christianity*, edited by George J. Brooke, Hindy Najman, and Loren T. Stuckenbruck, 149–82. Leiden: Brill, 2008.

van Seters, John. Review of Russell E. Gmirkin, *Berossus and Genesis, Manetho and Exodus: Hellenistic Histories and the Date of the Pentateuch. Journal of Theological Studies* 59 (2008): 212–14.

Vassilka, Eleni. "The Pronaos Decoration of the Temple of Horus at Edfu." In *Egyptian Religion, the Last Thousand Years* (Orientalia Lovaniensia Analecta, 85), edited by Willy Clarysse, Antoon Schoors, and Harco Willems, II, 948ff. Leuven: Uitgeverij Peeters en Departement Oosterse Studies, 1998.

Venit, Marjorie S. *The Monumental Tombs of Ancient Alexandria: The Theatre of the Dead.* Cambridge: Cambridge University Press, 2002.

Verkerk, Dorothy H. "Exodus and Easter Vigil in the Ashburnham Pentateuch." *Art Bulletin* 77 (1995): 94–105.

Vetusta Monumenta Rerum Britanicarum. I. London, 1747.

Vikan, Gary. "Joseph Iconography on Coptic Textiles." *Gesta* 18 (1979): 99–108.

Voights, Linda Ehrsam. "A New Look at a Manuscript Containing the Old English Translation of the *Herbarium Apulei*." *Manuscripta* 20.1 (1976): 40–60.

———. "One Anglo-Saxon View of the Classical Gods." *Studies in Iconography* 3 (1977): 3–16.

Volbach, Wolfgang F., et al. *Koptische Kunst: Christentum am Nil.* Essen: Villa Hügel, 1963.

von Dassow, Eva, ed. *The Egyptian Book of the Dead: The Book of the Going Forth by Day.* San Francisco, CA: Chronicle Books, 1994.

von Erffa, Hans M. *Ikonologie der Genesis: Die christlichen Bildthemen aus dem Alten Testament und ihre Quellen.* 2 vols. Munich: Deutscher Kunstverlag, 1995.

von Gebhardt, Oscar. *The Miniatures of the Ashburnham Pentateuch.* London: Asher & Co., 1883.

von Pauly, August F., and Georg Wissowa. *Paulys Realencyclopädie der classischen Altertumswissenschaft.* Stuttgart: Alfred Druckenmüller, 1967.

Waetzodt, Stephan. *Die Kopien des 17. Jahrhunderts nach Mosaiken und Wandmalerien in Rom.* Vienna: Römische Forschungen der Bibliotheca Hertziana, 16, 1964.

Walker, Daniel P. "Orpheus the Theologian and Renaissance Platonists." *Journal of the Warburg and Courtauld Institutes* 16 (1953): 100–120.

Warren, Frederick E. *The Leofric Missal.* Oxford: Clarendon Press, 1968.

Waser, O. "Tauros." In *Ausführliches Lexikon der griechischen und römischen Mythologie*, 5, edited by Wilhelm H. Roscher, cols. 145–47. Hildesheim: Georg Olms, 1965.

Watson, Gerard. "Gregory of Nyssa's Use of Philosophy in the Life of Moses." *Irish Theological Quarterly* 53.2 (1987): 100–112.

Webster, Leslie. "Imagining Identities: The Case of the Staffordshire Hoard." In *Anglo-Saxon England and the Visual Imagination*, edited by John D. Niles, Stacy S. Klein, and Jonathan Wilcox, 25–48. Tempe: Arizona Center for Medieval and Renaissance Studies (ACMRS), 2016.

Weisman, Stephanie. "Militarism in the Wall Paintings of the Dura-Europos Synagogue: A New Perspective on Jewish Life on the Roman Frontier." *Shofar: An Interdisciplinary Journal of Jewish Studies* 30.3 (Spring 2012): 1–34.

Weitzmann, Kurt, ed. *Age of Spirituality: Late Antique and Early Christian Art, Third to Seventh Century: Catalogue of the Exhibition at the Metropolitan Museum of Art, November 19, 1977, through February 12, 1978*. New York: Metropolitan Museum of Art, 1979.

———. *Ancient Book Illumination*. Cambridge, MA: Harvard University Press, 1959.

———. *Catalogue of the Byzantine and Early Medieval Antiquities in the Dumbarton Oaks Collection* 3 (Ivories and Steatites). Washington, DC: Dumbarton Oaks Research Library and Collection, 1972.

———. *Greek Mythology in Byzantine Art*. Princeton, NJ: Princeton University Press, 1951.

———. *Illustrations in Roll and Codex: A Study in the Origins and Methods of Text Illustration*. Princeton, NJ: Princeton University Press, 1947; second printing with addenda, 1970.

———. *Studies in Classical and Byzantine Manuscript Illumination*. Chicago: University of Chicago Press, 1971.

———. "The Survival of Mythological Representations in Early Christian and Byzantine Art and Their Impact on Christian Iconography." *Dumbarton Oaks Papers* 14 (1960): 43–68.

Weitzmann, Kurt, and Massimo Bernabò. *The Byzantine Octateuchs*. 2 vols. Princeton, NJ: Princeton University Press, 1999.

Weitzmann, Kurt, and Herbert L. Kessler. *The Cotton Genesis, British Library Codex Cotton Otho B.VI*. Princeton, NJ: Princeton University Press, 1986.

———. *The Frescoes of the Dura Synagogue and Christian Art*. Dumbarton Oaks Studies 28. Washington, DC: Dumbarton Oaks Research Library and Collection, 1990.

Weitzmann, Kurt, and Ihor Ševčenko. "The Moses Cross at Sinai." *Dumbarton Oaks Papers* 17 (1963): 385–98.

Weltin, Edward G. "Quid Athenae Hierosolymis?" *Classical Journal* 51.4 (1956): 153–61.

Werner, Martin. "On the Origin of the Form of the Irish High Cross." *Gesta* 29.1 (1990): 98–110.

Westerfeld, Jennifer. "Saints in the Caesareum: Remembering Temple-Conversion in Late Antique Hermopolis." In *Memory and Urban Religion in the Ancient World*, edited by Martin Bommas, Juliette Harrison, and Phoebe Roy, 59–85. London: Bloomsbury, 2012.

Wheeler, Brannon M. "Moses or Alexander? Early Islamic Exegesis of Qur'an 18.60–65." *Journal of Near Eastern Studies* 57 (1998): 191–215.

———. *Moses in the Quran and Islamic Exegesis*. New York: RoutledgeCurzon, 2002.

Whitby, Mary. "The Bible Hellenized: Nonnus' Paraphrase of St. John's Gospel and Eudocia's Homeric Centos." In *Texts and Culture in Late Antiquity: Inheritance, Authority, and Change*, edited by J. H. D. Scourfield, 195–232. Swansea: Classical Press of Wales, 2007.

White, John. "Cavallini and the Lost Frescoes in S. Paolo." *Journal of the Warburg and Courtauld Institutes* 19 (1956): 84–95.

Whitmarsh, Tim. "Pharaonic Alexandria: Ezekiel's 'Exagogé' and Political Allegory in Hellenistic Judaism." In *The Space of the City in Graeco-Roman Egypt: Image and Reality*, edited by Eva Subías, Pedro Azara, Jesús Carruesco, Ignacio Fiz, and Rosa Cuesta, 41–48. Tarragona: Institut Català d'Arqueologia Clàssica, 2011.

Whittaker, Molly, trans. *Tatian: Oratio ad Graecos and Fragments*. Oxford: Clarendon Press, 1982.

Wicker, Kathleen O'Brien. "De defectu oraculorum (Moralia 409E–438E)." In *Plutarch's Theological Writings and Early Christian Literature*, edited by Hans Dieter Betz, 131–80. Leiden: Brill, 1975.

Wieder, Naphtali. "The 'Law Interpreter' of the Sect of the Dead Sea Scrolls: The Second Moses." *Journal of Jewish Studies* 4.4 (1953): 158–75.

Wieland, Gernot. "*Legifer, Dux, Scriptor:* Moses in Anglo-Saxon Literature." In *Illuminating Moses: A History of Reception from Exodus to the Renaissance*, edited by Jane Beal, 185–210. Leiden: Brill, 2014.

Wildung, Dietrich. *Egyptian Saints: Deification in Pharaonic Egypt*. New York: New York University Press, 1977.

———. "Erschlagen der Feinde." In *Lexikon der Ägyptologie*, edited by Wolfgang Helk and Eberhard Otto, 2, 14–17. Wiesbaden: Harrassowitz, 1992.

———. "Flügelsonne." In *Lexikon der Ägyptologie*, edited by Wolfgang Helk and Eberhard Otto, 2, 277–79. Wiesbaden: Harrassowitz, 1992.

Williams, Ellen Reeder. "Isis Pelagia and a Roman Marble Matrix from the Athenian Agora." *Hesperia: Journal of the American School of Classical Studies at Athens* 54.2 (1985): 109–19.

Williams, John, ed. *Imaging the Early Medieval Bible*. University Park: Pennsylvania State University Press, 1999.

Wilpert, Josef. *Die römischen Mosaiken der kirchlichen Bauten vom 4–13. Jahrhundert*. Freiburg: Herder, 1976.

Wistrich, Robert S. *Demonizing the Other: Anti-Semitism, Racism, and Xenophobia*. Abingdon: Routledge, 1999.

Withers, Benjamin C. *The Illustrated Old English Hexateuch, Cotton Claudius B.iv: The Frontier of Seeing and Reading in Anglo-Saxon England*. Toronto: University of Toronto Press, 2007.

———. "Satan's Mandorla: Translation, Transformation, and Interpretation in Late Anglo-Saxon England." In *Insular and Anglo-Saxon Art and Thought in the Early Medieval Period*, edited by Colum Hourihane, 247–69. University Park: Pennsylvania State University Press, 2011.

———. "A 'Secret and Feverish Genesis': The Prefaces of the Old English Hexateuch." *Art Bulletin* 81 (1999): 53–71.

———. "A Sense of Englishness: Claudius B.iv, Colonialism, and the History of Anglo-Saxon Art in the Mid-Twentieth Century." In *The Old English Hexateuch: Aspects and*

Approaches, edited by Benjamin C. Withers and Rebecca Barnhouse, 317–50. Kalmazoo: Medieval Institute Publications, Western Michigan University, 2000.

Withers, Benjamin C., and Rebecca Barnhouse, eds. *The Old English Hexateuch: Aspects and Approaches*. Kalmazoo: Medieval Institute Publications, Western Michigan University, 2000.

Witt, Reginald E. *Isis in the Graeco-Roman World*. Ithaca, NY: Cornell University Press, 1971.

Wittgenstein, Ludwig. *Philosophical Investigations*. Oxford: Blackwell, 1992.

Wolohojian, A. M. *The Romance of Alexander the Great by Pseudo-Callisthenes*. New York: Columbia University Press, 1969.

Wolska-Conus, Wanda. *Cosmas Indicopleustes, Topographie chrétienne. Sources chrétiennes*, 141 1968, 159 (1970), 197 (1973).

———. *La topographie chrétienne de Cosmas Indicopleustes: Théologie et science au Vie siècle*. Paris, 1962.

Wood, Joyce R. Review of Russell E. Gmirkin, *Berossus and Genesis, Manetho and Exodus: Hellenistic Histories and the Date of the Pentateuch. Journal of Hebrew Scriptures* 8 (2008): r.28.

Wormald, Francis. *The Benedictional of St. Æthelwold*. London: Faber and Faber, 1959.

Wright, Charles D. "The Blood of Abel and the Branches of Sin: *Genesis A, Maxims I* and Aldhelm's *Carmen de virginitate*." *Anglo-Saxon England* 25 (1996): 7–19.

———. "Jewish Magic and Christian Miracle in the Old English *Andreas*." In *Imagining the Jew in Anglo-Saxon Literature and Culture*, edited by Samantha Zacher, 167–96. Toronto: University of Toronto Press, 2016.

———. "Old English Homilies and Latin Sources." In *The Old English Homily: Precedent, Practice, and Appropriation*, edited by Aaron J. Kleist, 15–66. Turnhout: Brepols, 2007.

Wright, David H. *The Roman Vergil and the Origins of Medieval Book Design*. London: British Library, 2001.

———. "The School of Princeton and the Seventh Day of Creation." *University Publishing* (Summer 1980): 7–8.

Wright, J. K. *The Geographical Lore of the Time of the Crusades: A Study in the History of Medieval Science and Tradition in Western Europe*. New York: Dover, 1965.

Wyatt, Nicholas. "Degrees of Divinity: Some Mythical and Ritual Aspects of West Semitic Kingship." *Ugarit-Forschungen* 31 (1999): 853ff.

Wycherley, R. E., ed. *Pausanias' Description of Greece: Illustrations and Index*. Loeb Classical Library, 5. Cambridge, MA: Harvard University Press, 2005.

Wyly, Bryan W. *Figures of Authority in the Old English "Exodus."* Heidelberg: Universitätsverlag C. Winter, 1999.

Yates, Frances A. *Giordano Bruno and the Hermetic Tradition*. Chicago: University of Chicago Press, [1964] 1991. Reprint. London: Routledge, 2014.

Young, Frances. "Greek Apologists of the Second Century." In *Apologetics in the Roman Empire*, edited by Mark Edwards, Martin Goodman, and Simon Price in association with Christopher Rowland, 81–104. Oxford: Oxford University Press, 2002.

Zacher, Samantha, ed. *Imagining the Jew in Anglo-Saxon Literature and Culture.* Toronto: University of Toronto Press, 2016.

———. *Rewriting the Old Testament in Anglo-Saxon Verse: Becoming the Chosen People.* London: Bloomsbury Academic, 2013.

Zahlten, Johannes. *Creatio Mundi: Darstellungen des sechs Schöpfungstage und naturwissenschaftliches Weltbilt im Mittelalter.* Stuttgart: Klett-Cotta, 1979.

Zauzich, Karl-Theodore. "Hierogrammat." In *Lexikon der Ägyptologie*, edited by Wolfgang Helck and Eberhard Otto, 2, cols. 1199–201. Wiesbaden: Harrassowitz, 1999.

Ziegler, Konrat. *De errore profanarum religionum.* Munich: H. Hueber, 1953.

INDEX

Aaron (Moses's brother)
 consecration of, 98
 depiction of Moses with, *fig. 20*, *fig. 25*
 hair of, 69
 head covering, 68–69, 70, *fig. 20*, *fig. 25*
 as scribe, 94
Adam, creation of
 anti-Manichaean iconography, 22–23
 as bearded man, 23
 in Coptic theological tradition, 22
 in "garment of light," 23
 in Jewish exegetical textual tradition, 22
 in medieval iconography, 21, 22
 symbolic presence of animals, 24
 on top of rocky outcropping, 23–24
Adam and Eve story
 archangel Michael instructing Adam,
 32–33
 expulsion from paradise, 32
 in medieval iconography, 27, 28–30
 Prohibition scene, 30–31
 scenes of the Labor, 32
 Temptation scene, 31
Aegyptiaca (Manetho), 61
Aejmelaeus, Anneli, 61
Ælfric, Abbot of Eynsham
 Catholic Homilies, 22
 Claudius B.iv manuscript, association
 with, 6
 on creation of Adam, 22
 on creation of the world, 19
 depiction of Moses, 3
 on expulsion of Adam and Eve from
 Paradise, 32–33
 on Moses as the "Great Commander," 49
 Preface to Genesis, 16, 18

Treatise on the Old and New Testament, 3, 22
 Vita Adae et Evae and, 32
Agosti, Gianfranco, 88
Aion (personification of time), 17
Alexander of Aphrodisias (Pseudo-
 Aristotle)
 Supplementa problematorum, 88
Ambrose, Saint
 borrowing from, 136n66
 De Paradiso, 24, 26
 on good and bad horns, 77
 on rivers of Paradise, 24, 25–26
Ammit (Egyptian animal-bodied demon), 17
Ammon (deity)
 horns of, 163n155
Amun (Egyptian god)
 in the Book of the Dead, 81–82
 feathers on the crown of, 96, 178n103
 interpretations of images of, 81–82
 painting in necropolis of Tuna el-Gebel,
 81, 157n93
 relief sculpture of barque of, 42, *fig. 7*
 wall painting from Tomb Maison, 81,
 fig. 26
Anglo-Saxon art
 in modern literature, borrowing from,
 171n1
 pictorial sources of, 126n10
Ankhpakhered, sarcophagus of, 100
Antinous
 Egyptianized depictions of, 156n84
Antiquitates Judaicae (Josephus), 4, 65, 98
Apollo (Greek god)
 in classical art, representation of, 103
 image on Roman coin, *fig. 15*
 as visual model for Moses, 5, 102

Herbert R. Broderick is a professor of art history at Lehman College of the City University of New York, and a Fellow of the Society of Antiquaries of London.

CPSIA information can be obtained
at www.ICGtesting.com
Printed in the USA
BVOW05*0920031017

496480BV00018B/57/P